A Second Life:
German Cinema's
First Decades

FILM CULTURE IN TRANSITION

Thomas Elsaesser: General Editor

Double Trouble
Chiem van Houweninge on Writing and Filming
Thomas Elsaesser, Robert Kievit and Jan Simons (eds.)

Writing for the Medium
Thomas Elsaesser, Jan Simons and Lucette Bronk (eds.)

Between Stage and Screen
Ingmar Bergman Directs
Egil Törnquist

The Film Spectator: From Sign to Mind
Warren Buckland (ed.)

Film and the First World War
Karel Dibbets, Bert Hogenkamp (eds.)

Fassbinder's Germany
Thomas Elsaesser

A Second Life: German Cinema's First Decades

edited by

THOMAS ELSAESSER

with

MICHAEL WEDEL

AMSTERDAM UNIVERSITY PRESS

Cover (front): Still from DIE SCHWARZE KUGEL (Franz Hofer, 1913).
Cover (back): Asta Nielsen in ENGELEIN (1913) Both courtesy of the Nederlands Filmmuseum, Amsterdam.

Cover design: Kok Korpershoek (KO), Amsterdam
Typesetting: BEELDVORM, Leiden

ISBN 90 5356 172 2 (paperback)
ISBN 90 5356 183 8 (hardbound)

CONTENTS

5

Preface and Acknowledgements

What is the German Cinema? One immediately thinks of certain labels and names that mingle notoriety with fame: Expressionism and THE CABINET OF DR. CALIGARI, Ufa and- METROPOLIS, Marlene Dietrich and Leni Riefenstahl, film emigration and *film noir*, Joseph Goebbels and JUD SÜSS, THE MARRIAGE OF MARIA BRAUN and the *New German Cinema*. Taken together, such names stand for very contradictory values and entities: CALIGARI may stand for 'film and the visual arts'; Ufa for nationalist hubris and Alfred Hugenberg or for the failure of Europe to challenge Hollywood in the twenties, while Fassbinder, Herzog and Wenders (like Pabst, Murnau and Lang before them) stand for the German film artist and film *auteur* par excellence.

And the cinema before World War I? Mostly, it seems to exist only as preparation, pre-text and precursor. Emperor Wilhelm II's passion for the cinematograph is seen as symptomatic for a cinema of *Führer* figures, where royalty inspecting troops becomes the precursor of all the Prussian-military propaganda films, rather than, for instance, the Kaiser turning out to have been the first German film star and a figure from operetta.[1] THE STUDENT OF PRAGUE (1913), one of the few films well-known from the teens, becomes the premonition of all the *Doppelgänger* and malevolent alter-egos, rather than an experiment in cinematic space and film technology using standard Gothic and fairy tale motifs,[2] and Asta Nielsen announces the coming of film as art in Germany, rather than facilitating the introduction of a crucially different exhibition practice.[3]

In other words, early German cinema is rarely considered *sui generis*, making its own contribution to the processes of modernity and modernisation at the turn of the century in one of Europe's most dynamic societies. Instead, we think we already know what this cinema is about, what its films 'mean': not unlike the other periods and figures of German cinema alluded to above, this 'pre-history' and 'archeology,'[4] too, have become a matter of cultural semiotics, a bricolage of meaning-making elements, yielding not so much a history of German film as testifying to a persistence of German film fantasies.

What then should be the function of a book on this period? To translate some of Wilhelmine cinema's totems and icons into an ordered procession of facts and figures, causes and consequences, while rescuing masterpieces and resurrecting reputations? Yes and no are the answers the following essays will be giving. Of course, such a foray into uncharted territory hopes by definition to break new ground, stimulate new interest and whet new appetites: the films to be discovered among the proverbial treasures of the archives have not been 'seen,' except by a handful of professionals and aficionados, sometimes for close to a century. If the present book helps to make them better known, and to a wider public, then one of the aims is already met. The other objective might, perhaps less modestly, be described as the attempt to give firmer contours to the discursive spaces

that may one day relocate the three or four known 'facts' about the German cinema before 1918.

By concentrating on the years from 1895 to 1917, the essays give themselves a definite time frame, using as their – perhaps a shade too convenient – closure the moment when Ufa was founded. For most film historians, this was the point at which the German cinema became worth talking about. No more. The landmark for recent revisions of early German cinema was the retrospective held in 1990 during the 'Giornate del cinema muto' in Pordenone, Italy, whose title *Before Caligari*, in a double irony, both endorsed and contested the received wisdom and the implied teleology.[5]

Intended to mark the cinema's centenary, *A Second Life: German Cinema's First Decades* stands in the tradition of Pordenone's pioneering work, not least because virtually all contributors are regular guests there.[6] Yet to the extent that they are also practitioners of the new scholarship in early cinema, their presence here refers back to another collection, of which this volume is in some sense the companion. The idea for a book on the teens arose in 1989, when for reasons of size I needed to reduce the final section of *Early Cinema: Space, Frame, Narrative* to only two essays representing the 'European' cinema.[7] Because of extensive viewing of early German material, in preparation for the 1990 Pordenone event, I also became aware of the holdings of the Nederlands Filmmuseum.

In Amsterdam I was fortunate to find a number of equally keen and considerably more expert collaborators, one of whom has put together a preliminary inventory of extant prints in archives of German films up to 1917, a labour of love that has greatly helped the preparatory work on this volume.[8] My thanks therefore go in the first instance to Michael Wedel who has supported this project as author and assistant from start to finish, giving generously of his time for some tasks made thankless because their traces have all but vanished in the finished product. Many of those whom we approached did respond, and it is gratifying to be able to thank them here for their willingness and enthusiasm.

For previously published material I thank the copyright holders for permission to reprint and translate, notably the editors of *KINtop* (Martin Loiperdinger, Frank Kessler and Sabine Lenk), Hans-Michael Bock of *CineGraph*, Christa Jordan of *edition text + kritik*, Claudia Dillmann of the *Deutsches Filmmuseum Frankfurt*, as well as the editor of *Cinema Journal*. Special thanks must go to the translators Cathy Brickwood, Alison Fisher, Ivo Blom and Karen Pehla, who all had to work under considerable time pressure. Financial assistance for the project has come from the special fund of the College van Bestuur, University of Amsterdam and the Department of Film and Television, as part of its '100 Year Cinema' celebrations.

Insofar as an editor can lay claim to something which consists essentially of the work of others, this book is dedicated to the memory of my grandmother, Else Sommer (1879-1964), Wilhelmine citizen and film fan from first to last.

Thomas Elsaesser

Early German Cinema: A Second Life?

Thomas Elsaesser

'Zweimal gelebt'

German cinema is best remembered for its so-called 'Golden Age'– the Expressionist films of the twenties – and for its long line of outstanding individual directors. But the double spotlight on art cinema and auteurs, reflecting this national cinema's struggle for cultural respectability and a penchant for psychological introspection, has only deepened the shadows surrounding another side: the history of its popular cinema. An obvious case in point are the first two decades, where the standard histories have little to report as being worthy of detailed study. Because of Germany's catastrophic social and political history for almost half a century, it was tempting to look to the cinema to uncover hidden truths of the nation and its soul. Especially after 1945, the explanatory deficit about the origins and rise of national socialism was so great and the memory of the regime's blatant use of the cinema as a propaganda instrument so keen that an account of the German cinema of whatever period found itself offering its own version of hindsight history.[1]

Perhaps a blessing in disguise, the period least suited for such a retrospective teleology was the cinema prior to World War I. Against the background of either documenting the roots of nationalism, or rescuing from the debacle an international, self-confident avantgarde tradition, the early film business seemed haphazard, inconsequential. The films themselves, compared with the contemporary output from other countries, notably France and Denmark, looked ponderous and stylistically 'retarded.'[2] The more obvious parallels with early cinema elsewhere – its wide appeal to spectators from all walks of life, its canny opportunism and unashamed sensationalism, and above all, its many connections with the other mass media of the time were often passed over in silence or seen merely as negative blemishes. Paradoxically, however, those very first decades of innovation and experimentation, of consolidation, rapid change and major crises can tell us more about this cinema as a 'national' cinema than any number of symptomatic masterpieces.

From this perspective alone one might speak of 'A Second Life' for early German cinema, in the face of critical hostility and a quite specific historical agenda, which had little use or sympathy for a cinema of stars and genres, preferring one of artistic ambitions and original talent. But the link of German genre films to those made in other countries on the one hand, and to Wilhelmine Germany's print and image culture on the other hand, must be one of the foremost tasks for any film historical re-vision. As to the stars, when one comes across their names in film credits or trade journal adverts, their lives are now so little-known that it requires major biographical searches even to establish basic dates. Their faces in star photographs or collectors' postcards, by contrast, immediately evoke a period at once

totally alien and yet recognizably 'German,' and they also carry with them the unmistakeable glamour of the movies.

A second life, too, is therefore claimed for the early audiences and their tastes: little seems to have survived either in the nation's memory or in its archives from the initial phase of reception history, when from all accounts German films and German film stars were popular and much appreciated. In the meantime, the amount of source material has grown, as historians have turned to the trade press and daily newspapers, which has cast doubt on the often-repeated assertion that Germany had no film culture to speak of before World War I.[3] In this sense, *A Second Life* is as much a reminder of this cinema's first life as an attempt to give its films new currency and attention. Although we are still far from understanding what kind of life the cinema used to lead among its audiences when it was dominated by travelling showmen or made its entry into the urban centres of the fast-growing German Reich, it is clear that from 1896 onwards a lively and diverse awareness of cinema developed in Germany just as it did in other European countries.

Yet there is a third meaning the title wants to bring into play, now emblematically focused on a film from 1912, called ZWEIMAL GELEBT, which translates as 'A Second Life.' Concerning a woman whom a forbidden love almost literally brings back from the dead in order for her to live a brief though, one assumes, happy second life (before her memory returns and tragedy ensues), the film is remarkable not least for the very divergent judgements it has given rise to in several of the articles that follow. Title and subject are emblematic, I want to suggest, also because even the early German cinema appears not to escape the doubling and mirroring effects, the mises-en-abyme, repetitions and returns we now associate with 'expressionist' cinema. But does this entitle one to invoke a genealogy? So many films from the early period – and notably those of Max Mack and Franz Hofer –

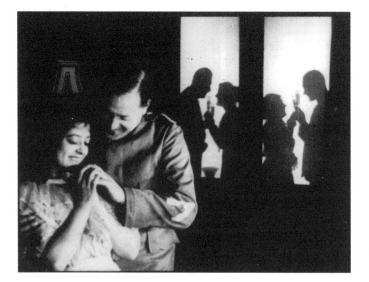

HEIMGEKEHRT
(Franz Hofer, 1914)

HEIMGEKEHRT
(Franz Hofer, 1914)

display such a sophisticated grasp of filmic processes and contain so many references to the cinematic situation as one of 'doubleness' that one is tempted to make 'zweimal gelebt' the motto of Wilhelmine cinema itself. Yet for this very reason one must not jump to conclusions, and differentiate between the formal analysis of such duality and duplicity (referring us to the complex ontology of the cinema as representational mode), and the 'political' or ideological interpretation these features invite as proof of a national style or the propensities of the national character. The presence of motifs of the double and structures of sometimes vertiginous symmetry in films like DIE SCHWARZE KUGEL (ill. p. 275) and DER MANN IM KELLER (ill. p. 147) as well as THE STUDENT OF PRAGUE or DER ANDERE indicates that the dividing line between the self-consciously literary (and later, national) cinema known as the *Autorenfilm*, and popular genre cinema comprising detective series, melodramas and comedies was not as sharp as is sometimes assumed. Nor does it mean the cinema of the teens 'prepared' the more illustrious twenties, other than across determinate continuities and breaks, such as the essays that follow are trying to redefine.

The high-brow/low-brow gap is not the only one open to revision. The fact that the cinema in Germany has been, at least since World War I, judged as a political phenomenon has given rise to a number of ideological histories (about the cinema reflecting authoritarian, nationalistic or racist values) and ideologies serving as histories (implicitly told from the point of view of 'art,' of 'realism,' or of 'progressiveness'). Such politicisation assumes that German cinema, too, is part of that 'Sonderweg' (separate development) into modernity, with all the catastrophic consequences implied in the titles of the German cinema's most famous studies, Siegfried Kracauer's *From Caligari to Hitler* and Lotte Eisner's *The Haunted Screen*. Yet, with a national cinema that like no other has been open to retrospective teleologies, the first move of any reevaluation might just as plausibly be to question this assumption, and plead for a certain 'normalization.'

Given the grave testimony of Kracauer and Eisner, however, the term 'normalization' must seem not only revisionist, but apologetic in intent, part of a by now notorious tendency in recent historiography by which at least German art and culture might have their innocence restored. Precisely because this is not my aim, I feel obliged to retain the term, despite its ambiguous connotations. Two circumstances in particular make the word seem apposite. Firstly, the focus here is indeed on a cinema that was normal, in the sense of ordinary and widely available, and secondly, this cinema can only be understood within a comparative approach, one capable of establishing what might have been the 'norm' or 'norms' of film style, of film production and film reception during any given period between the years 1895 and 1917, against which exceptions (and possible 'Sonderwege') can then be judged. So far, research into the primary material has above all yielded fragments, individual films isolated from the contexts they were once part of. The wider, comparative horizon will hopefully readjust the picture. Film history in the eighties made it its aim to infer, test and verify such norms, and to it we owe the work of Noël Burch and Barry Salt, Ben Brewster, Tom Gunning and Charles Musser.[4] When one adds the monumental research enterprise that has examined the origins and stabilisation of the 'mode of production' of classical Hollywood cinema,[5] one realizes the potential rewards of proceeding in this way.

Since several authors in the present volume discuss the German cinema within such a broadly comparative framework,[6] one can already deduce that as far as periodization is concerned, the years 1902-1906 and 1907-1913 are the crucial ones for understanding the further history of cinema also in Germany. The first period consolidates exhibition practice around fixed-site cinemas, creates a film business centred on the short film and the 'numbers programme,' and sees the change from buying and selling films to exchanging and renting films. The second period has among its typical features the move from storefront cinemas to purpose-built houses and movie palaces. With it comes the introduction of the three to five-reel feature film (still surrounded by short films) as the presentational programme norm. Around 1910 one also finds the introduction of new strategies of distribution and marketing, which in due course were to redefine crucially the social space and the experience 'cinema,' giving it the shape it was to retain for the subsequent seventy years, indeed almost up to the present day.

Thus, following on from the comparative perspective, to normalize early German cinema means to 'internationalize' it, that is, to see its developments in more than a one-country context. This seems the proper direction to take, not least because both the legendary Brighton FIAF meeting of 1978 and the subsequent annual Pordenone retrospectives have shown that film production and cinema exhibition up to World War I were a highly international business, making nonsense of an idea of national cinema that does not at the same time take note of tendencies in other major film producing countries, such as France, Denmark, Italy and, of course, the United States. Only in the interplay between different film industries can something like a norm be framed that might in turn serve as reference point to appraise German cinema.[7]

'Normalization' and the 'New Film History'

In this sense, the present volume reflects some of the priorities of what has come to be known as the new film history.[8] Put briefly, its principles oblige one to look first of all at how the cinema emerged and developed as an industry, what the nature of its 'product' or 'service' was, how production, distribution and exhibition were organized at a given time and in a given place, and finally, what other forms of popular entertainment similarly traded in established cultural values or created new ones. But the 'new' film history is also a cultural ethnography, asking what modes of perception and cognition the films first relied on or simulated in their audiences; what other media were drawn into the struggle for the cinema's 'right to be,' and thus what social places and public spaces movie-going helped to transform.

Such questions, of course, shift attention to areas of cinema studies where, in Douglas Gomery's memorable phrase, 'film viewing is really an inappropriate research method.'[9] It alerts one to issues of visual culture and modernity, as well as to the fact that early German films do not always readily seduce the untutored eye: where they are unexpected, they do not always enchant (like early French Pathé films) or disturb (like Yevgenii Bauer's Russian films), where the narratives are formulaic, the film forms do not look familiar (as in early American films), and where the acting is non-naturalistic, one does not marvel at its extravangances (as in Italian diva films). At times, one has the feeling of no longer possessing the cultural or emotional key to unlock their brittle charm. There are exceptions, of course, like the films of Max Mack or Franz Hofer (two names featured prominently in this volume), but with directors, one needs to be wary as to what one considers the norm and what the exception. Are, for instance, the films of Bolten-Baeckers and Adolf Gärtner the norm, and those of Joseph Delmont and Charles Decroix the exception, and where does one fit in the films of Emil Albes, Emerich Hanus or Walter Schmidthässler? Do directors matter at all in this cinema, when they are often not even mentioned in the credits? How representative of German women were the roles played by Henny Porten, quite different not only from those of Asta Nielsen, but also distinct from Dorrit Weixler's or Wanda Treumann's parts, not to mention Lissy Nebuschka (known as the 'German Asta Nielsen') and Hanni Weisse, or the two female stars created by Ernst Lubitsch in the mid-teens, Ossi Oswalda and Pola Negri?

Fortunately, films in sufficient numbers have survived to preclude such questions from being purely rhetorical. Even if it should prove true that much of the early German output looked inept in its day[10] or did badly in its home market,[11] the films remain an invaluable record for the roots of domestic and public leisure life, while printed sources, such as trade journals, newspaper articles, hand bills and postcards testify to the popular appeal of many German cinema stars and picture personalities. These are the areas where one can expect new scholarship to make the most immediate impact, especially seeing how much of the historical work done on early cinema in Germany over recent years owes its existence either to anniversaries or to prestige cultural occasions at local and regional level.[12]

Yet this fieldwork, too, requires a certain amount of 'normalization,' now under-
stood as the need to apply to German cinema studies a historically critical stance, where a
certain transparency in method and procedure refers itself to verifiable sources and opens up
to inspection its filmic or printed evidence. Two exemplary studies, both the result of years
of painstaking research among archives, have helped to clear a path and indicate the nature
of the problems confronting the historian. Both are explicitly committed to the 'new film
history,' both recognize the need to rethink quite radically our approach to early German
cinema, and yet their methods as well as their conclusions could not be more different.

Although neither regards this cinema as a pre-history, one author sees it as a kind
of counter-history and draws as sharp as possible a contrast between Wilhelmine cinema
and Weimar cinema, a contrast allegedly due to profound structural changes in their respec-
tive 'public spheres.' Based on a new interpretation of the films considered as canonical
works, and conducting a careful study of the contemporary debates about reception and
audiences, Heide Schlüpmann succeeds in making this cinema strange, different, and yet
familiar, fully justifying her title 'The Uncanny Gaze.'[13] Looked at from the vantage point of
a Weimar Cinema qualified as 'patriarchal,' and concerned with 'male potency,' Wilhelmine
cinema for Schlüpmann appears as something like a refuge for a different conception of the
body and of femininity, one that offers especially the female spectator a novel form of visual
pleasure.[14] What links her work to the 'new film history' is the fact that *Unheimlichkeit des
Blicks* is not a positivist-archival history, but one guided by a number of theoretical con-
cepts, above all the distinction, first formulated by Tom Gunning, between a 'cinema of
attraction' and the classical narrative cinema as a 'cinema of narrative integration,'[15] which
Schlüpmann both genders and periodizes, seeing those features as symptomatic for German
film history.

Just how different a starting point has been chosen by Corinna Müller becomes
evident when one realizes that her book does not discuss individual films at all, steers clear
of past and present theorists, and sets out to challenge the very distinction attraction/narra-
tive integration which forms the conceptual basis of Schlüpmann's study. Müller begins by
asking herself why Germany, given its above average interest in living pictures and its po-
tentially huge market, apparently did not develop a thriving indigenous film production on a
sound economic basis until after the Great War? The traditional answer is that the German
bourgeoisie was culturally prejudiced against the cinema, and thus industrialists and finance
capital doubted the cinema's long-term prospects and refused to invest. This seems classical
'retrospective teleology' even if for once of an economic rather than ideological kind.

Müller's *Frühe deutsche Kinematographie* is a case study rather than a compre-
hensive history, which nonetheless helps to recast a good deal of the early history, not least
because it convincingly shows that the German cinema of the first two decades, when meas-
ured by international criteria, behaved in ways exceedingly 'normal.'[16] She took the evi-
dence amassed in regional and local studies about exhibitors, picture houses, programme
bills, admission prices, advertising in the newspapers in order to build her case, outlining a

comparative framework and making visible a causal nexus within which a more plausible, because immanent and structural, reason can be given for why German film production did not develop in quite the same way as it did in Denmark or even France.

Far from being anarchic, haphazard and amateurish, the early German film business, according to Müller, followed very distinct patterns and organizational principles, namely, those of the variety theatre. In particular, two principles typical of variety – the programming policy and its internal structure – survived the variety show as the dominant form of mass entertainment, remaining in place and exerting a determining influence on the development of fixed-site cinemas in Germany. The German film business, in other words, developed (just like the American and British one) as an exhibition-led industry whose commodity or product was the short film-based numbers programme, with editorial (but also economic) control largely in the hands of exhibitors. A cut-throat competition among cinemas in this exhibition-led industry used up vast quantities of film, devaluing films so fast that the profit margins for home producers practically disappeared and the business sucked in cheap foreign (mainly French) imports. Only when this vicious cycle was broken and profitability restored by means of a novel distribution system did German film production take off, and it did so well before the war and thus without the artificial barriers to imports that the outbreak of hostilities between France and Germany created.

Certain new research perspectives are opened up by this argument, both nationally (encouraging one to find out more about the exhibition situation, the variety theatre and the numbers principle, with its own aesthetic and narrative coherence)[17] and internationally (to identify how exactly the balance of power on the German market shifted from exhibition to distribution and production when films began to circulate according to the Pathé system that first institutionalized artificial scarcity of access and put a premium on priority). To this day, the same manipulation of time and location advantage typifies the rationale of cinema chains and the practice of exclusivity. The findings also suggests that it makes sense to divide the first decades more clearly into distinct phases, with one belonging to the 'pioneers' (and their different definitions of the uses of the cinema), while the others are centred on the constitution of a 'market' (national and international) as well as a standard product, which in turn defines not a use, but an experience, itself differentiated by genres, stars, audiences and exhibition spaces. What follows is a sketch of some of the implications, when considering periodization along these lines.

The Beginnings up to 1907: Showmen and Pioneers

Although it seems perverse to argue that the cinema was not 'invented' in France, it is nonetheless true that Max and Emil Skladanowsky showed projected moving images to a paying public at the Berlin Wintergarten on 1 November 1895, almost two months earlier than the Lumière brothers' performance at the Salon Indien of the Grand-Café. Max Skladanowsky, a typical fairground operator and showman, began experimenting with 'living photography' around 1887. From 1892, in collaboration with his brother Emil, he construct-

ed an ingenious if inelegant double projection apparatus which he patented in 1895 under the name of 'Bioskop.' Running at 16 frames per second with two identical film strips projected simultaneously, while a rotating shutter alternately masked one image on each projector, the Bioskop proved a technically imperfect, but nonetheless solidly popular variety attraction.[18]

Even chauvinists would have to agree, though, that it was the Cinématographe Lumière that brought moving pictures to Germany and secured their popular success. A noted chocolate manufacturer and slotmachine operator, Ludwig Stollwerck showed an early interest in commercially exploiting the Lumière invention in Germany.[19] He also contacted R.W. Paul, the British manufacturer who had successfully copied Edison's kinetoscope. Stollwerck left important eyewitness accounts of the coming of the movies, unique in their vividness and sharp insights.[20] Lumière operators toured Germany from 1896 onwards, and in their wake a number of notable showmen plied their trade with tent-movies and *Wanderkinos*, making the cinematograph known in neighbouring countries, such as The Netherlands and Belgium, and setting up successful businesses that lasted well into the first decade.[21]

The real competition to the Lumière Brothers' projector in Germany, however, were the machines devised by Oskar Messter, the Wilhelmine cinema's first universal film genius. He alone, for a brief period, combined all the functions which were eventually separated under a rigid division of labour: inventor of an improved projector, manufacturer of photographic and cinematic equipment, head of a film production company, director of 'Tonbilder' (sound-on-disk filmed opera-scenes),[22] fictional scenarios and actualities (he pioneered the newsreel), distributor and even cinema owner.[23] Since his career spans the entire period of early cinema, and since he was able to sell his companies to the consortium that set up Ufa, Messter is indeed an emblematic figure in many respects, serving as founding father, as the human face and 'character' in an industry increasingly run according to established business practices. As a filmmaker-producer Messter covered the entire range of popular film subjects and genres: scenics and actualities, detective films and social dramas, domestic melodrama and historical epics, romantic comedies, operas and operettas. He also helped lay the foundation for the German star system, for among the actors who started with Messter were the leading names of the German silent era: Henny Porten, Lil Dagover, Ossi Oswalda, Emil Jannings, Harry Liedtke, Harry Piel, Reinhold Schünzel, Conrad Veidt. Messter, more than anyone else, determined the future shape of German commercial cinema, and the titles in his catalogue alone were indicative of the thrills and pleasures the cinema offered audiences by way of entertainment, show values, sensations and sentiment. His literary adaptations were distinctly middle-brow: hits from the burgeoning mass-market in printed fiction, folklore and fantasy, or the popular culture on offer from the related entertainment media: operetta, folk theatre, variety acts, solo performers of songs made familiar by the sale of sheet music and gramophones.

Yet Messter's almost mythical reputation as everyone's favourite image of the

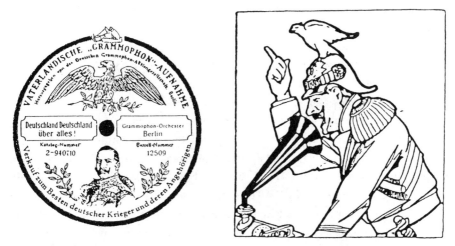

Wilhelmine modernity: The Kaiser as gramophone star and media manipulator

cinema's inventor-engineer-entrepreneur must not obscure a distinctive feature, not shared by those who followed: to him, making films for public exhibition was only one aspect of the invention we call the cinema. If one looks at the rivals for the claim of having pioneered and invented the cinema in Germany – Messter and Skladanowsky, Alfred Duskes and Paul Davidson – the distinction to draw is thus not between documentary and fictional, and not even between the scientific-analytical uses of the cinematic apparatus and the illusory-synthetic ones,[24] it turns on their relative conception of the social significance of the device itself. The Skladanowsky Brothers were inventors and showmen, they backed the cinematograph rather than X-rays as a novelty which would attract an audience. As their efforts were directed towards exploiting the cinema as a form of entertainment, so Messter efforts were guided by an inventor-engineer's way of thinking. Not content with attracting a paying public to his shows, he wrote to schools, retired army officers, and state officials suggesting a variety of uses for the cinematograph, including scientific, military, educational, administrative and investigative ones.[25] The other important aspect of Messter's thinking was entrepreneurial: unlike the Skladanowskys, he successfully monopolized and integrated the various stages of the whole cinematic process, building his own projectors and cameras, making the films himself and distributed them, much as the Pathé Brothers were to do in France. Like them, Messter realized at a very early stage that a crucial aspect of cinema is to exert and maintain control over all the diverse associated technologies and practices.

The modernity of his strategies lies at the heart of Messter's relevance for the development of the German cinema. Style, genre or subject matter were for him, during the first decade at least, a matter of assigning to the invention different exploitation contexts: a *modus operandi*, in other words, which shuffled the elements of cinema – technology, films, users – so that films were exchange values that commanded different use-values, rather than vice versa, in contrast to the second decade, when the fixed use value 'entertainment' was

demographically and culturally upgraded via exclusivity (restriction of access) and longer films to suit (or lure) a better-paying public. Messter adapted to the second phase as well, perhaps because he understood how to develop cinema around its capacity to combine services to different users with supplying commodities to a single market. This distinguishes him not only from the 'scientific' strand for whom the cinematograph was a precision instrument (Etienne-Jules Marey), but also from those who were supposedly gripped by a 'gothic' male obsession and, like Frankenstein, wanted to recreate artificially and mechanically the very essence of life. Noël Burch identified this tendency with Thomas Edison,[26] but it could be said to lie also behind the fantasy of German cinema, if one's view of this cinema is shaped by homunculi and mad scientists, by Dr Caligari and his medium Cesare, by Dr Mabuse and the Golem, by Nosferatu and his vampire acolytes, by Rotwang and his robot from METROPOLIS. Nevertheless, there is a sense in which Messter the inventor, the optical instrument and precision engineer, partook in a fantasy that went beyond the scientific desire to see more closely, to trace what escapes the human eye, and to generally intensify the look. Just visible behind Messter's bonhomie and factory-owner's pride are the bachelor machines that Villiers de L'Ile-Adam described in his famous Edison novel, *L'Eve future,* where the combined alchemy of optical, electrical and chemical substances do indeed constitute something like a new life elixier.

Finally, Messter's resourcefulness when it came to new uses for the cinematic apparatus, among which spectacles for public viewing were only one instance, marks a possible limit for the 'cinema of attractions,' since the term suggests that one can seize in one particular use – that of entertainment – a multiplicity of what are more properly 'applications,' whose histories, as we now realize in the age of 'smart' bombs, micro-surgery and surveillance cameras, had – after Messter – temporarily gone 'underground,' while the entertainment cinema with the feature film at its centre became the publicly most visible face of these applications.[27] On the other hand, the 'cinema of attractions' directs our attention to exhibition sites and audiences, rather than production sites and makers.

Not the Film but the Programme

A cinema performance around 1907 was still modelled very closely on Germany's highly developed variety culture, with its own sequence of attractions, ranging from gags and comic sketches, via sentimental duos, acrobatic acts and magic tricks to dances, review numbers and solo performances from famous plays, operettas or favourite operas.[28] The still extant films made between 1896 and 1906 bear out the pattern. Max Skladanowsky's 1897 views of Berlin (DIE WACHE TRITT ANS GEWEHR), the comic turns (BROTHERS MILTON KOMISCHES RECK), or the quite carefully staged street scenes (EINE KLEINE SZENE AUS DEM STRASSEN-LEBEN IN STOCKHOLM) in which too much comic or mock-dangerous business is going on to be taken in at one viewing all confirm that these films were made with an already constituted entertainment audience in mind. Subject matter and format were determined by the dou-

1896/97: Note the yet tenuous presence of the cinema in the variety context, e.g. the announcement of Messter's Biograph at the bottom of the Wintergarten programme and the 'Living photographes' at the Herrnfeld theatre; also present are the operetta and music hall intertext, with the future film subject 'Robert und Bertram.' Both the Metropol and the Apollo theatres were soon to become luxury cinemas.

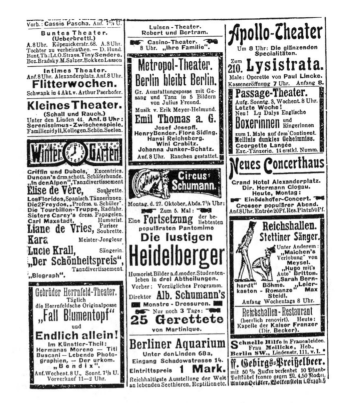

ble media intertext of variety theatre and music theatre, or even the exhibition context of fairground and circus.

In many of these 'genres,' Pathé and Gaumont were the uncontested world leaders. But Messter, too, had different numbers in production, ranging from musical preludes, actualities, comic turns, dramatic sketches, slapstick ('derb-komisch') and sentimental drama ('Rührstück'). He even did multiple versions: one could buy an 'artistic' DANCE OF SALOME and, for specialized audiences, a 'blue movie' version.[29] Where his firm had a commanding lead was in the 'Tonbilder' – more popular in Germany and Austria than elsewhere in Europe – which required from cinema-owners substantially higher investments in technical apparatus and operating costs, a telling disadvantage when it came to the price wars investigated by Müller. Audiences expected the spectacle to be discontinuous and varied:

> The room is darkened. Suddenly we float on the Ganges, palms. The Temple of the Brahmins appears. A silent family drama rages, with bon vivants, a masquerade, a gun is pulled. Jealousies are inflamed. Herr Piefke duels headlessly and then they show us, step by step, mountaineers climbing the steep demanding paths. The paths lead down to forests, they twist and climb the threatening cliff. The view into the depths is enlivened by cows and potatoes. Then the arc lamp hissingly announces the end. Lights! And we push ourselves into the open daylight, horny and yawning.[30]

These quick changes of story and scene, in a programme that would have been made up of around eight to ten different items, none longer than three minutes, is typical for the cinema in its variety theatre phase. Given the innumerable accounts, mostly by writers and intellectuals, of the typical film performance, one has the impression of a chaotic, disorderly, haphazard accumulation of bits-and-pieces:

> As simple as the reflex of pleasure is the stimulus that provokes it: detective stories with a dozen corpses, one chase of the villains more hair-raising than the next in rapid sequence: grossest sentimentality: the blind beggar is dying and his dog sits faithfully by his grave. A piece with the title 'Honour the Poor' or 'The Lobster Queen.' Gunboats: and when the Kaiser or his generals appear on parade not the slightest sign of patriotism moves the spectators; rather, snide and spiteful surprise.[31]

The fact that few of these films have survived can only reinforce the impression of volatile inconsequence. But a study of the trade-press and more bread-and-butter reviewing indicate that cinema-owners had a very sophisticated sense of how to schedule the films into a programme, with its own dramatic shape, planned transitions and overall unity, no less coherent than the variety programme it replaced. The episodic and fragmented nature of the spectacle was further mitigated by the presence of the lecturer ('der Erklärer') who would provide a running commentary, sometimes explaining the action, but more often making irreverent jokes and improvising little routines. Between the disparate segments he was not only the link, but also the filter, the frame and the perspective, shifting and varied, through which the audience experienced the spectacle. The power of the word, as opposed to music was of crucial importance here, for the lecturer's ironic distance to the action allowed an audience to respond with that hostility or hilarity towards figures like the Kaiser Wilhelm II -'first German movie star'- which Döblin (in 1909!) mentions.[32] Mühl-Benninghaus, below, confirms this point when he quotes the derisive reaction of soldiers in the *Frontkinos* when faced with so-called authentic war footage in the newsreels: they jeered back at the screen, insulted at the sight of so much improbability, and so blatant a propaganda effort. His comment can usefully be compared with that of Egon Friedell who remarked that the cinema was an 'expression of our time – short, rapid, military'[33] and contrasted with the view of film historian Friedrich v. Zglinicki, who argues that the authorities tried to get rid of the 'Erklärer,' because they suspected him of stoking up 'class hatred,' an accusation made by the right, but which found a curious echo in the objections to the cinema voiced by left-wing 'Kino-reformers':

> For the capitalist it is a business, and among the exploited are not only the poorly paid projectionists, pianists, lecturers; the exploited are above all the audience, the mass whose voyeurism, hunger for sensations and receptivity for erotic stimulation are the targets of the cinema entrepreneurs' speculative calculations, and in whose interest it is to constantly increase these show-values (...). The direc-

tion of their efforts is thus diametrically opposed to the tasks and goals of adult education and other cultural movements. But just as threatened by the cinema as social ethics, public morality and sexual calm is the physical health of the population.[34]

One can here see that such a programme did not reflect a 'national identity' or nationalist ideology. Rather, it represented the cinema's most international phase, as can be judged when viewing samples from different countries – at festivals like Pordenone – where a remarkable degree of homogeneity, if not in quality (very variable), then in genres and modes, quickly (re-)creates what must have been a comforting sense of familiarity. It suggests, beyond individual talent and national particularity, the strong pressure on the makers exerted by a well-defined and stable set of spectatorial expectations. However, given the comments just quoted, one can understand why this cinema was nevertheless an 'ideological' battleground, even if the political lines were almost impossible to draw. Its ease of access, unpoliced transnational trade and quasi-universal popularity made it a natural melting-pot of good intentions and paranoid fantasies among reformers, teachers, politicians, trade-unionists and social workers. The more valuable, even if less colourful, information about film-watching up to 1910 therefore does not generally come from the writers or poets, but from the reformers and their volunteers, whose field reports one has to read only slightly against the grain, in order to gain useful first-hand data about composition of audiences, programme content and numbers sequence, as well as about the physical conditions of the cinemas as more or less salubrious public spaces.[35] Among the colourful accounts, another passage from Alfred Döblin can be cited, who draws attention to the location of cinemas before 1910 in working-class districts, the so-called *Ladenkinos* (converted shop cinemas):

A typical 1890s variety programme (left) and the cinema programme that replaced it (right)

They're in the north, the south, the east, the west side of town, in smoke filled rooms, sheds, disused shops, large halls, wide fronted theatres (...) but only the low haunts in the North have the special genre, on a level well above the mere artistic (...). Inside, at the end of a pitch-dark room with low ceiling, the square of the screen, six foot high, no bigger than a man, shines across the monstrous public, a mass mesmerized and rooted to their seats, by this white eye with its rigid stare. Pairs of lovers are squeezed in the corner, but carried away by what they see, their unchaste fingers stop pawing each others' bodies. Consumptive children breathe flat gasps of air, and shiver quietly through every bout of fever. The men, exuding unpleasant smells, stare until their eyes are ready to fall out of their sockets. The women, in stale-smelling clothes, the painted street whores are bent forward on the edge of their seats oblivious to the fact that their head-scarf has slid down their neck.[36]

Döblin's graphic description from 1909 implicitly concedes that these types of theatres had by then already become exotic, which refers one back to the fact that what ultimately determined the production of films was the 'production' of audiences. The variety format, as well as the wide spectrum of admission prices (from 30 pfennig to 3 marks) indicates that early cinema – contrary to what historians have sometimes claimed – was not aimed at working class audiences alone, but catered for demographically broad target groups, and numbered among its audiences men, women and children, with young males already then forming the majority among the cinema-going public, although in one source, a clear distinction is made between 'errand boys' whiling away time between odd-jobs and 'young men from the public schools' hoping for a sexual conquest.[37]

In the same vein, it has been argued by the noted sociologist Emilie Altenloh that early German cinema was particularly aware of its female audiences, feeding a veritable 'cinema-addiction' not only with genres of gender-specific appeal such as mother-daughter stories, dramas of shipwrecked lovers and women waiting, but also in comedies where women had the freedom to invent for themselves sexual identities by putting on men's clothes (so-called 'Hosenrollen') or, as female detectives, gain visual and vicarious access to social spaces and thus to experiences normally out of bounds to women, whether married or unmarried.[38]

Creating a Stable Market and Attracting a Middle-Class Audience

What was the German cinema's domestic production base which supplied this demand? It seems that prior to 1911 filmmaking in Germany suffered from an apparently inordinate number of small firms (Georges Sadoul lists 51)[39] eking out a precarious existence. The major production firms were Messter (see Martin Koerber), Alfred Duskes (with its Pathé connections, see Frank Kessler/Sabine Lenk), Vitascope, Projektions-AG 'Union' (Paul Davidson, see Peter Lähn), Deutsche Bioskop and, finally, Deutsche Continental.[40] Although the history of production companies is still one of the least researched areas of early

German film, and although the figures published in trade journals are notoriously difficult to verify, it is variously estimated that during the period 1905-1910 only about 10% of the films shown in Germany were of German manufacture, with French film imports (30%), US (25%), Italian (20%) and Scandinavian (15%) making up the majority shares.[41] Herbert Birett's *Index of Films Shown* roughly confirms these percentages, but since a listing by titles gives little information about the number of prints (or feet of film) imported, no conclusions can be drawn from such figures about relative popularity and market penetration. According to the 'feet-of-film-imported' calculated by Kristin Thompson, about 30% of all films show in Germany during this period were of American origin[42] which would put U.S. imports slightly ahead of French ones. A popular joke about French films in Germany implied that by the outbreak of the war, Pathé had recouped more money from exporting to the German market with its films than the French government had paid in reparations after the Franco-Prussian war of 1870-1871.[43] Whatever the truth or source of this story, it takes for granted the fact that Pathé was the most important single foreign force in Germany. The essay by Sabine Lenk and Frank Kessler greatly illuminates this vexed question of the French presence, letting us see how involuted the trading relations between the two countries were, and how even such detailed studies as theirs do not allow one to generalize about either impact or influence of the foreign firms and their films. Emilie Altenloh – quite helpfully – identifies in her 1914 study the German-origin films shown in the cinemas neither as a total figure nor in percentage terms, but by genres. Accordingly, it seems for instance, that under 'drama,' German productions did relatively well (12%), whereas under the heading 'humorous sketches' only 3% of her sample were German. But here, too, one needs to bear in mind that one reason why foreign competition was so strong was that both French and American firms could offer German exhibitors whole programme packages, compared to domestic producers who were often limited to one or two genres.

Almost as difficult is an objective assessment of the exhibition basis. Corinna Müller has provided valuable new information, especially for the first decade, which shows that cinema-going reached quickly and deeply into the social fabric, both in the countryside and the cities. Again, figures that simply compute one type of exhibition venue can give a misleading picture: 'In 1902 Germany had only two fixed site cinemas (in Hamburg and Würzburg), twelve years later (at the start of the war) several thousands had opened their doors, with an estimated two million attendances a day. In England, by 1912, there were six thousand, and in the USA fourteen thousand cinemas.'[44] This suggests that Germany was not one of the world's leading cinema nations, when in fact, due to its size and population, it has always been the largest European market, for domestic as well as foreign firms.

Generally, the picture of a rapidly growing infrastructure of cinemas seems correct, but statistics adduced by Georges Sadoul try to show that, compared with other countries, there were fewer cinemas for a population as large and as urban as that of industrialized Germany.[45] The same figures are used by Dieter Prokop, in order to argue that the cinema was, after all, an underdeveloped business in Germany, with the implication that the

weakness of the exhibition sector was largely to blame for the backwardness of German film production.[46]

Here, more detailed field-work brings some necessary corrections. In his essay, Peter Lähn traces the rise of entrepreneur Paul Davidson, who opened his first picture palace in 1906 and by 1910 had built up a sizeable chain of 600-1000 seater luxury cinemas. It is therefore around this time that financial power can be seen to concentrate itself in the hands of certain exhibitors, who chose to become themselves large-scale buyers and importers, and thus distributors, in order to supply their venues. Similarly, as Evelyn Hampicke points out, a cinema-owner like Paul Oliver could amass not only a fortune in exhibition, but develop into a force to be reckoned with at the level of distribution and even production, within a relatively short space of time, right in the middle of the war.

What actually marks the transition from the first to the second decade most decisively is that the exponentially rising demand up to 1905 had in fact, by about 1906-1907, stabilized and even started a downward trend. Trade journals talked about a deep crisis, cinemas closed, and commentators predicted with unconcealed glee the terminal decline of this five-day wonder of which the public had already tired. What actually happened was a structural transformation, so that in order to understand the crisis in cinema-going around 1907, and the structural changes that remedied it, one has to move decisively away from the films themselves, as well as from looking for the reasons among the lack of interest by financiers or lack of talent among production companies. As we saw, attention must focus on the way films were traded and how they were presented. The emergence of a national cinema in the first instance depends on building up an institution – of which production is only one part – whose purpose it is to ensure that spectators do not just see this or that particular film, but come back, time and again, week after week.[47]

Stars and Genres

What typifies the second phase, in Germany as elsewhere, then, is initially the fact that a generation of cinema entrepreneurs came on the scene who understood how to build these audiences by building better cinemas, in more glamorous locations. If the first decade, emblematically, is that of Oskar Messter, the second belongs to the Paul Davidsons and David Olivers, entering the film business from the exhibition side, before moving to distribution and production, and in the process, becoming at once experts in the local (what customers in Frankfurt or Breslau, Hamburg or Dresden 'want') and the global (where to find what they want in the international market: Davidson with Pathé, Oliver with Nordisk).

For only once the distribution practice of the Monopolfilm – the 'solution' to the crisis and the 'engine' for restructuring the exhibition sector by bankrupting smaller cinema-owners – had established itself as the norm, did the domestic production sector begin to be profitable again, which often enough was by then in the hands of exhibitors (to Davidson and Oliver, one should add the names of Ludwig Gottschalk and Martin Deutler). Due to their money and buying power the film business witnessed the extraordinary expansion of

production and the experiment of the full-length feature film between 1911 and 1913, to which the German cinema owed its first flourishing of a narrative star-and-genre cinema.[48] It helped to bring into existence a production profile that included the famous *Autorenfilm* and Paul Wegener's mock-gothic fairy-tales, as well as helping Asta Nielsen to her well-deserved national and international fame.

It is at this point that Asta Nielsen properly comes into the picture, whose magnetic pull greatly aided the establishment of the Monopolfilm as the dominant business practice, and the star as its most visible embodiment. We know that Nielsen is central to early German cinema, but we can now see that the logic that propelled her is almost directly inverse to the way it is traditionally pictured, where the Nielsen films are said to be the breakthrough to screen art, finally freeing the cinema from its commercial constraints.[49] It would be more accurate to say that because of the commercial imperatives of making films more valuable by creating the scarcity called 'Monopol' or exclusivity, introduced in order to halt overproduction and thus the collapse of prices and profits, an actress like Asta Nielsen could attain the fame she did. That kind of surplus exhibition-value she brought to the film-product was not grounded in her films' *artistic* ambition, but in their universal appeal is usefully demonstrated when one recalls that one of the first successful Monopol films on offer for distribution by PAGU, Nielsen's future business partners, was not a dramatic film at all, but the Johnson vs. Jeffries boxing match from July 1910 in Reno. As in the United States, then, the consolidation of the new commodity 'cinema' in Germany emerges out of a combination of longer films, restriction of access, transformation of programming policy, and building up of picture personalities or 'stars.'

The shift of emphasis draws attention to one feature in particular: the connection of the cinema to the world of commerce and marketing, of consumer goods, fashion, lifestyle, travel – what used to be called, dismissively 'Die Konfektion' (the rag trade). One can clearly observe it in the example of Ernst Lubitsch, brought from the theatre to filmmaking by Davidson, and whose early films were frequently set in the milieu of garment shops or department stores (see Karsten Witte's essay on SCHUHPALAST PINKUS). Featuring locations and intrigues that effectively mirrored or parodied the cinema itself, the films not only exposed how clever young men were making their fortune by trading on the vanities and anxieties of a new breed of (often female) consumers. Lubitsch also understood – and demonstrated in action – how in this world of make-believe, imposture can become itself a higher form of sincerity, and flattery the subtle pact film stars conclude with their public.

It is sometimes argued that the early cinema knew no picture personalities, since the mix of programme numbers did not allow for either individuation or identification. But what one finds in the German cinema, from the first Messter production onwards, are star performers. Admired for their special skills and extraordinary talents, proven in the performance arts of circus and variety, these were artists doing lightning sketches, strongmen like the Brothers Milton, operetta virtuosi like Franz Porten, Tilly Bébé the Lion Tamer, magicians, gagmen and gymnasts. Thomas Brandlmeier's essay on German film comedy

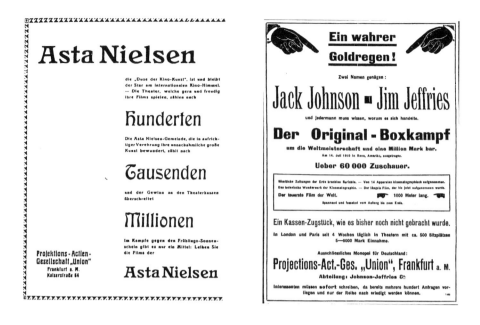

gives a good indication of how this world of skilled performers, with names like Josef Gi-ampietro, Alexander Girardi, Hans Junkermann (the lead player of WO IST COLETTI?, dis-cussed in several essays), Wilhelm Bendow, and, of course, Karl Valentin, formed the bed-rock of the early cinema, in its crossover phase with variety theatre, which found itself mostly written out of film history. This is because scholars of German cinema – with the exception perhaps of Barry Salt[50] – have not paid the necessary attention to operetta as perhaps the key genre and media intertext that shaped the German cinema. A form as cru-cially dependent on music was unlikely to catch the attention of those looking for the roots of 'silent cinema,' but the example of Messter's Tonbilder, the plots of so many German films from the teens and early twenties,[51] and the strongly developed music cultures in Ger-many at all social levels amount to incontrovertible (though even in this volume under-represented) evidence for suggesting that popular and middle-brow music forms and music tastes may well be the hitherto hidden 'norm' of the early German cinema of the 1902-1909 period.[52]

In comparison to the vaudeville and variety theatre performers, it is fair to say that the picture personalities of the second phase were built up differently. In its links with 'die Konfektion,' the cinema's chief assets were stars who could be loved not for special skills, but for what might be called their uncommon typicality or special ordinariness. Hen-ny Porten as much as Hanni Weisse, Ernst Reicher or Harry Piel provided the role models for an upwardly mobile audience, showing to perfection how to behave as governess, daughter, or unmarried mother, and sporting the clothes, the gestures and attitudes fitting the man about town, the gentleman or intrepid detective.

Since genres are the conduits for stereotyping socially acceptable and transgres-

sive behaviour, they are the most obvious ways in which the cinema interfaces with its public, and thus with the situated knowledge, the prejudices and preferences, in short, with the cultural codes but also the shifting norms and values of a given community. The specificity of a nation's cinema might therefore be most readily accessible via the genres its audiences preferred. For reasons that are touched on in the essays by Tilo Knops and Sebastian Hesse, but also Sabine Hake, the detective film is not only a key genre for certain processes of self-definition and self-reflexivity regarding the cinema as a whole, raising questions of narrative, plotting, agency and so on, but via its rich interna-

2x Josef Giampietro

tional pedigree (notably Danish and French, as well as American) locates the early German cinema firmly in the crucial arguments about modernity, the city and nostalgia.

It is true that in Germany's genre cinema one can note some specific variations, so that, for instance, the general star cult included the particular cultural capital associated with a 'name' from the stage or the literary establishment (from Albert Bassermann and Paul Wegener as key actors, to Hugo von Hofmannsthal, Gerhart Hauptmann and Paul Lindau as representatives of the literary establishment). Yet the principle remained largely the same, and it indicates that Germany, on the eve of the world war, was poised to experience an expansion of production as well as a concentration of all the branches of the film business which together amount to the quantum leap that led to a qualitative change. Into this situation, the outbreak of hostilities in 1914 could only have sown confusion, since in

view of the more muted and indirect causal nexus outlined here between cinema and politics, the impact of the war on the film business is far from easy to determine.[53] Rather than assuming, as film historians have tended to do, that the war meant a radical rupture in the German film business, either in order to explain why the German cinema only 'properly' got under way after 1918, or to argue the inverse, namely that the import restrictions and the absence of foreign competition from 1914 onwards stimulated the growth of German domestic production, a careful reading of the evidence now suggests a more nuanced judgement.[54]

The essays by Jeanpaul Goergen and Rainer Rother, for instance, indicate how closely self-advertising for the cinema, product promotion and military propaganda belong together, so that the divide between the industrial adver-

Albert Bassermann and Hanni Weisse in DER ANDERE (1913)

tising film, the military propaganda discourse, and what Sabine Hake names self-referenti-
ality in early German cinema is often difficult to draw, indicating that the whole issue of
fiction and non-fiction, of documentary, faked footage, and the *Kulturfilm* so typical for
German cinema in its reform-movement phase[55] needs to be looked at anew, in the light of
the rediscovery of both filmic and non-filmic evidence.

Among the 'rediscovered' non-fiction films of the teens, one of the key works
must surely be a Messter production from 1916, now only known under its post-war title,
which translates as THE POLDIHÜTTE STEELWORKS DURING THE GREAT WAR. As Kimberly
O'Quinn points out, there are at least three distinct genres or discourses skilfully interwoven
and present simultaneously: that of the industrial advertising film, the technology-as-spec-
tacle 'cinema of attractions' genre, and finally, we find here the blueprint for the formally
experimental, ideologically complex 'city film' one usually only associates with the twen-
ties. POLDIHÜTTE raises once more all the issues of the argumentative structuring and visual
patterning of non-fiction material debated in the seventies among film scholars when re-
assessing the Lumière heritage of the factory film (process-as-progress forming a strong
basis for narrativity). At the same time, POLDIHÜTTE also gives a most intriguing twist to the
standard industrial film, whose routine narrative (taking the viewer from raw materials to
finished product, followed by display, dispatch, consumption) cannot but be highly ironic,
and – one assumes – not only in retrospect, when one realizes that the products here readied
for consumption are grenades, as beautifully ominous and ominously beautiful as such fet-
ish objects of male technology are depicted in the films of Walter Ruttmann or Fritz Lang.

In POLDIHÜTTE a form of detached, dare one say, lyrical gaze motivates the slow pans, the atmospheric images, the precision editing. An eerily ordered life of the city-factory of the future is captured in the drama of a steel-mill in a rural setting, living from smoke and fire, from heat and noise, driven by machines to which are attached the armies of men and women toiling on the shop-floors and in the yards, but also the white-coated lab technicians and engineers. The film is poised on the cusp between a 19th century mode of perception that turns a man-made environment into a natural idyll, for the benefit of a self-flattering contemplation of human progress, and a 20th century constructivist view of the first machine age, with the machines themselves – veritable anthropomorphic monsters – representing only one species of mutant creatures in the huge hangars to be erected, or amongst the test stations, where crankshafts are turned for aeroplanes, and giant suspension springs predict the pressures and shocks the new century is called upon to absorb. It is as if the filmmakers, commissioned to promote the propaganda effort of the German Reich, had already realized how heavy industry and warfare, mass-production and mass-destruction were to become the dominant face of the century. POLDIHÜTTE is the recto to METROPOLIS' verso, indicating that Lang's film may be looking back at Wilhelmine military 'modernism' as much as it agonizes over its fascination with American 'Fordism.'

On the whole, then, the war affected the institution cinema in Germany quite unevenly, helping some branches to come into their own, but also posing new challenges to the production side which already experienced its major upturn before August/September 1914.[56] If at first, the rather extreme (and as Mühl-Benninghaus below points out, unworkable) censorship measures took their toll, it seems that by 1916, the industry was booming again, before the severe shortages around 1917-1918 once more reduced production output. Films as exceptionally rich by any reckoning as DAS TAGEBUCH DES DR. HART, POLDIHÜTTE, HOMUNCULUS or DER GELBE SCHEIN – to name only those that are mentioned in the essays here from the years 1916/1917 – give some indication of the diversity which the feature-length production in Germany was capable of sustaining. The only assertion one can therefore make with some confidence is that the war distorted the 'natural' economic development of the German film business, just as Germany's defeat severely handicapped it, mainly because of export embargoes, loss of audiences in occupied territories (such as Belgium), and the general shrinking of the market that had been available to German films during the war when the exhibition base had artificially expanded with *Frontkinos*, for instance. As it happens, not the end of the war per se, but another external economic factor, Germany's hyper-inflation in 1921, became the main catalyst of its international recovery, but that is another story.[57]

Forms of Perception and Constructions of Space

Thus, rather than dwell only on the economic or institutional infrastructure, it seems important to begin to assess anew the effects that the revolution in exhibition practice, the move upmarket into consumer culture, and the shift to the full-length feature film as the central

element of the programme were introducing to film form and film style. As several contributors point out, in this respect, the teens in Europe generally and in Germany in particular have not fared well in the critical literature. Often seen as 'derivative,' 'transitional,' 'backward,' the films are above all, because of the middle-class orientation, considered as either irritatingly enslaved or interestingly indebted to the theatre and the (bourgeois) stage. With the theatre as (negative) 'norm' in mind, the production of the teens can then be checked for exceptional works that clearly do not have the stage as pretext. Conversely, the films can find themselves severely judged in comparison to an international contemporary practice that had already left the theatre behind, developing more intrinsically filmic means of story-telling. This is the case made, for instance, by Barry Salt, who is not at all surprised that even German audiences shunned domestic productions in favour of American films, given their manifest stylistic defects. Deploying his detailed knowledge of international filmmaking in the teens, he can present histograms and tables, of the kind he is justly famous for: average shot length, shot scales and cutting rates prove that German films are 'slow,' by comparison with American, French, Italian and Danish productions of the time. Salt has rubbed in the 'sins' of German films by itemizing the general lack of scene dissection and continuity editing, the tableau-like framings and frontal acting, paired with overcomplicated or poorly constructed plots, much of which seems to reconstruct a 19th century theatrical narrative space, all but devoid of spectacle, pace and narrative verve.

In contrast, Sabine Hake has tried to look at German production of the teens with the criteria of self-referentiality and the self-conscious use of the medium in mind. In quite a large number of films she detects narrative devices that clearly refer to the medium itself, putting in play the audience, as in the satire of a hypocritical film-reformer WIE SICH DER KINTOPP RÄCHT ('The Revenge of the Cinematograph'); by featuring protagonists who are engaged in filmmaking (DER STELLUNGSLOSE PHOTOGRAPH , a photographer in search of a job, with its rare scenes of a portrait photographer's studio); or starring Asta Nielsen in DIE FILMPRIMADONNA, an amusing film-within-a-film parody of the business.

A related criterion – that of 'expressivity' – can be found in Kristin Thompson's essay. The detailed investigation of one film's formal strategies and principles of narrative construction, derived not from theatrical staging or the story on which DIE LANDSTRASSE is based, demonstrates a will to style and filmic expression that Thompson has noticed in very diverse films from a number of countries, and that has led her, more broadly, to argue for something like a filmic avantgarde already for the teens, in contrast to the more common assumption of the birth of the film avantgarde with THE CABINET OF DR CALIGARI. Leonardo Quaresima, too, in his essay on HOMUNCULUS, strongly argues for this film to be seen as experimental, and as such, a 'missing link' between the fantastic films of the early teens, like THE STUDENT OF PRAGUE, and the more famously stylized fantasy films from the twenties.

Similar with respect to their formal rigor, both Salt and Thompson aim at distilling filmic specificity, in order to derive from this the notion of a cinematic style which might be posited as a period norm, useful not only in distinguishing the cinema from the theatre,

DORRIT WEIXLER

Dorrit Weixler in DAS ROSA PANTÖFFELCHEN (Franz Hofer, 1913)

but also for calibrating 'good practice' and comparative, international criteria, against which some films, in Salt's case DIE LIEBE DER MARIA BONDE, and in Thompson's Paul von Worringen's DIE LANDSTRASSE can be seen as (interesting) exceptions.

Thompson comes to some intriguing conclusions, notably that the treatment of space deserves special attention. This argument has been central to a number of readings of European films, for instance, the Scandinavian films from the teens, including the famous STUDENT OF PRAGUE, whose enigmatic director Stellan Rye is featured in a separate essay by Caspar Tyberg.[58] Michael Wedel, in his essay on Franz Hofer's HEIDENRÖSLEIN has extended this approach to cinematic space, in order to extrapolate from it a new theory of genre, especially as it applies to melodrama, and the distinct regimes of knowledge this genre deploys. In melodramas, the pressure of other stylistic paradigms, as well as media intertexts is very notable, and Jürgen Kasten, looking for Heinrich Lautensack's signature on ZWEIMAL GELEBT, gives a reading of the relation between stage and screen across screenwriting, at a point where it seems to establish itself in Germany as an independent practice. Since Michael Wedel situates this same film's spatial configurations in the context of the particularly enigmatic 'commercial' strategy of its director Max Mack, ZWEIMAL GELEBT is indeed the film around which something like a debate develops, especially intriguing in view of the fact that ZWEIMAL GELEBT is also singled out by Salt as particularly inept,[59] just as according to his criteria, there is little to commend the films of Franz Hofer, in turn the objects of glowing and very detailed analyses by Yuri Tsivian and Elena Dagrada.

Might it be possible, by way of concluding this introduction, to spell out a little what seems involved in this debate, if necessary by situating the arguments so far summarized within a slightly different conceptual frame? For instance, I would want to suggest that film production in the teens can best be defined in two directions simultaneously and so to speak, two-dimensionally: one dimension pertains to the narrative and stylistic implications of the new feature-length format, while the second dimension concerns the spectator-screen relationship, considered in its constitutive, philosophical dimension (as discussed by so-called 'apparatus theory'),[60] but also in its context-dependent history (as discussed, for in-

stance, by Charles Musser's history of 'screen-practice').[61] The two dimensions are inter-connected but nonetheless independent variables, which need to be examined separately, and which do indeed require a very careful scrutiny of the films themselves. The essays by Heide Schlüpmann and Michael Wedel, by Jürgen Kasten, Ivo Blom and Elena Dagrada can – and should – be read as returning with fresh eyes to a number of films and filmmakers, arguing implicitly that our notion of norm and deviation, but also any argument about filmic specificity must be carefully grounded in historical intertexts, so that neither the theatre (in Schlüpmann's reconsideration of Asta Nielsen's use of profilmic, scenic, filmic and intra-diegetic spaces) nor painting (in Ivo Blom's essay on the pictorial and touristic representa-tional conventions), neither proscenium space (Jürgen Kasten) nor illusionist space (Michael Wedel) should have an a-priori value assigned to it, regarding its filmic specificity or lack of it. Elena Dagrada's detailed and sensitive look at Hofer's films, with the parame-ters of point of view and space in mind, shows how much such a close reading can yield in new information, but also how a knowledge of historical intertexts and a cognitive approach to narration can bring to life a filmmaker whose work was hitherto all but absent from the pantheon of cinema.[62] But it is above all Yuri Tsivian's comparative study of spatial features, compositional details and character blocking in films by Yevgenii Bauer and Franz Hofer that openly challenges the one-dimensional picture we have of the teens as a period tyran-nized and stultified by the theatre, for he demonstrates how at the very heart of theatricality and pictorialism a genuinely original conception of cinematic space and narrative form can emerge.

Putting in Place: Screen Space, Audiences and Self-Reference

Two films from the early teens raise these issues in exemplary form, if only because their relative directorial anonymity would indicate that one is dealing here with formal features so much taken for granted as to constitute the invisible presence of a 'norm.' Since both films were also very popular at the time, while today the reasons for this popularity almost wholly elude us, they pose the sort of challenge mentioned earlier: what might film history gain from examining the films themselves? Picked more or less at random, the films are two Messter productions, RICHARD WAGNER (Carl Froelich/William Wauer, 1913) and DES PFAR-RERS TÖCHTERLEIN (Adolf Gärtner, 1912). In the case of RICHARD WAGNER, the focus is on film length and what it can tell us about a film's social function and intended audience, while with DES PFARRERS TÖCHTERLEIN the screen-spectator relationship is the point at is-sue, defining its generic identity as melodrama, but also its sociological value as interpreta-ble document.

RICHARD WAGNER, at a length of 70 minutes, seems at first sight one of the more strangely 'inept' films when judged by our contemporary taste or Barry Salt's evolutionary scale. Slow, choppy, devoid of story-telling skills, its succession of tableux convey the over-whelming impression of stasis: more an illustrated picture book than a dramatic narrative (see illustr., p. 000). Yet given that length correlates directly to the conditions of reception

(and the structural changes the early film programme underwent) and thus defines generic identity as well as marketing strategy (the 'Monopolfilm'), the film might become interesting once we regard it as the solution to a problem we may no longer feel as such, namely of how to tell a longer story within determinate conditions of reception, still dominated by the numbers programme. As to its generic identity, one would expect a film about Richard Wagner to belong to the *Autorenfilm*, aiming at the better-paying middle-class audience, looking for cultural respectability. Yet judging from the publicity material, Richard Wagner appears to have been treated as something of a folk hero, whose fictionalized life belonged less to the (later) genre of the musician's bio-pic than to the oral narratives of youthful rebels and national saviours, like William Tell or Andreas Hofer, about whom Messter had already made a film in 1909. Once one regards RICHARD WAGNER under the double aspect of hybrid genre (bridging – like its hero – the cultural divides of 'high' art and 'low' entertainment), and 'transitional' form (in the move to the long feature film), the apparent solecisms and stylistic unevenness may turn out to have their own logic. In other words, the argument would be that the 'medium' the film intertextualizes is not Wagner's music or his operas, but a popular literary or semi-literary genre, maybe even fairy tale and myth (one notes, from the advertising, that it played as one of the big Christmas pictures of 1913). RICHARD WAGNER was a film made for a mass (family) audience, while at the same time possessing an identity as an *Autorenfilm*, involving a 'name' personality from the arts, which goes to show that the concept of the *Autorenfilm* was a marketing concept before it was a quality concept, or rather, the quality concept is also a marketing concept.[63] What, however, becomes evident only when viewing the film itself is that its narrative structure is heavily marked by the numbers principle, and thus represents a distinct stage within the narrative transformations occasioned by the change in film length. Bearing the variety programme in mind, and recalling the distinctions between the various 'genres' of the short film, one can in RICHARD WAGNER, without too much difficulty, recognize a range of spectacle attractions and genres from the pre-1910 international cinema: there is the (British) restaged documentary [in the 1848 revolution scene], the (Danish) detective serial [as Wagner hides in the doorway to escape arrest], the (French) *film d'art* [the encounter Wagner and List], the (Biograph or Pathé) historical reconstruction [the tableau including Friedrich Nietzsche, where in the USA it would be Lincoln, or Dreyfus in France], and there is even a Meliès-type trick film scene, when Wagner is shown telling the story of Siegfried and the helmet that makes him invisible. As especially this last episode shows, the film takes great care over its narrational procedures, putting in place several narrators, both external and internal, introduced by script and intertitles, themselves referring to different narrational levels, as in the narrative within a narrative, or the insert shot of the warrant for Wagner's arrest.

In this respect, RICHARD WAGNER seems more 'sophisticated' than many other films from 1913, while at the same time more 'primitive,' although especially among the *Autorenfilm* one finds further examples of films where the numbers principle has survived inside the continuous feature film. The phenomenon was appreciated or remarked upon as

such by the reviews, as in the case ATLANTIS (by August Blom, 1913, after the novel by Gerhart Hauptmann) and WO IST COLETTI? (by Max Mack, 1913, and discussed by several contributors).[64] The examples illustrate less the old argument about the difficult transition from short to feature length film (the problems of how to generate a longer narrative), and rather indicate how beholden the German cinema still was to the variety theatre as its structural principle, not as a performance mode or entertainment site, but as the narrative space by which spectators and films communiciated. In other words, key films from 1913, in order to reach a mass audience, practically reinvented for the long *Monopolfilm* a narrative which simulated the short film numbers programme. That this is what the audience wanted and expected is clear from many a contemporary account. As we saw, only intellectuals thought the numbers programme incoherent, and the paradox of 'primitive' and 'sophisticated' film form in RICHARD WAGNER directs attention to the fact that the film proposes to the spectator a narrative space which is no longer ours, just as its mode of address to the audience puts the modern audience in a relation to the screen we would no longer label 'cinematic.' As with so many other films discussed in this volume – by Asta Nielsen/Urban Gad, Max Mack and Franz Hofer, or Paul von Worringen, Joseph Delmont and William Wauer -, the Archimedean point around which film form in the teens in Germany seems to turn are the different levels that link audience-space to screen space and structure their registers of reference, be they theatrical, illusionist, performative, documentary, fictional. The relation screen space, audience and self-reference, which are addressed by almost all the contributors, points to the possible logic that underlies the changes of film length, of distribution and exhibition practices, as well as the cinema's relation to other arts. What in the past has sometimes been thematized, often rather polemically and antagonistically, under the heading of the presumed theatricality of early film, or conversely, the cinema's efforts to break free from theatre to find its own identity, turns out to be part not of a modernist quest for medium-specificity, but belongs to a more fundamental history of modernity in the sphere of representation and public spaces, where the cinema plays its role in the shifting and contradictory development which in urban environments at once fragmented and collectivized the masses into spectators and audiences.

The fact that in early cinema the films imagined their audience to be physically present, while in the later, narrative full-length feature film it was precisely the imaginary viewpoint of the spectator, his or her virtual presence in the representation that became the norm, indicates that what is contrasted is not theatre and cinema, but one kind of cinema with another kind of cinema. This affects quite crucially the way a film can be interpreted, and thus points to a possible interface between reception history, genre study and the formal analysis of individual films. While a reception and genre-directed approach to early German films tends to establish a socio-cultural or socio-pathological profile of Wilhelmine class, caste and status society, perhaps by pointing out the many nannies and officer's sons, or all the middle-aged lovers courting tomboys that could be their daughters, such a one-to-one correlation now seem to me to miss the crucial dimension. How can one feel confident about

interpreting the prevalence of authority figures like the military and the clergy within a political or ideological argument after having given some thought to the interplay of spectator space and screen space in some of these films? My second film example is a case in point. DES PFARRERS TÖCHTERLEIN ('The Pastor's Daughter'), an all but forgotten Henny Porten film which in its day was internationally popular,[65] emerges as important precisely to the degree that, in contrast to RICHARD WAGNER, it requires and to some extent assumes an imaginary spectator, both cognitively (insofar as narrative comprehension depends on the spectator appreciating an uneven distribution of knowledge among the characters) and perceptually (insofar as the spectator is privileged in sharing the heroine's optical point of view in a crucial scene).

More precisely, DES PFARRERS TÖCHTERLEIN combines both models of spectator-screen relationship in early cinema, that of an audience imagined as physically present, and that of an audience both 'present' and 'absent.' In fact, it makes the conflicts between two modes the very heart of the drama, readable today – in the multiplications of diegetic and non-diegetic audiences, and the discrepancy between optical and 'moral' point of view – as the mise-en-abyme of the historical audience's dilemma. One can speak of a veritable object lesson in teaching a new form of perception and reception, of understanding narrative logic and character motivation psychologically (the hallmark of film melodrama), designed to force the spectator to put him/herself into the place of the protagonist, and no longer understand the protagonist as the (re)presenter of feelings and actions.

Such a reading would suggest almost the opposite of a traditional sociological interpretation in the manner of Kracauer: a major is needed (in, for instance, another forgotten, but 'normatively' useful film, DIE KINDER DES MAJORS ['The Children of the Major']) not because he reflects the militarism of Wilhelmine society, but in order to motivate efficiently at the level of story-world a most subtle narrational structure about who knows what, when and about whom, allowing the film to introduce the convention of the duel, and thereby obliging the spectator to experience the situation of the brother seeking satisfaction on behalf of his jilted sister as irresolvable and 'tragically' inevitable.[66] Similarly, the pastor needs to be a pastor in DES PFARRER'S TÖCHTERLEIN so that the complex architecture of gazes which culminates and climaxes the film – the daughter witnesses how her father marries the man she loves to the woman he left her for – can actually be physically motivated, creating an explosive dramatic space (See Figs. 1-4, below). In addition, only the 'local' or 'cultural' knowledge of the spectator that this concerns a protestant church, and within the church, the physical location of the altar, gives the film its full (melo-)dramatic pathos, since it stages the conflict as the drama of spaces and gazes. What is significant is the pastor's physical position, seeing his daughter appear in the organ loft at the other end of the altar while the bride and bridegroom, kneeling in front of the altar, are oblivious to the drama unfolding between father and daughter, over their heads and behind their backs. In this film, then, it is the pastor who motivates the church setting, which motivates the space, which in turn allows these complex interchange of gazes and uneven distribution of knowledge to be

Fig.1

Fig.2

Fig.3

Fig.4

DES PFARRERS TÖCHTERLEIN (1912)

physically embodied. Across the pastor as bearer of multiple significations, a space of suspense and drama is created which no other profession could have conveyed as economically.[67]

These cursory examples of a reading, informed so evidently by present historical and theoretical preoccupations, once more return one to the question of 'normalization,' for they open up the difficulty of assuming that a historical period not only has a norm, but 'knows itself' (i.e. is self-reflexive, or self-expressive) through this norm by deviating from it. Just as likely, and here I come to the fourth meaning of the title 'A Second Life,' the mirroring, the self-referentiality, the mises-en-abyme, and the different types of expressivity and stylization – but also the shadow of hindsight falling on a pre-history – only help to confirm that in the history of the cinema, as in all history, the phenomena analyzed neither 'know themselves' in the terms we know them, nor are they ultimately sufficient on to themselves, as the idea of 'normalization' misleadingly and ideologically suggests. We therefore, inevitably, have to 'normalize' our own demand for normalization, which is to say, relativize any presumption we might have to 'know' how Wilhelmine society has 'lived' its cinema and represented it to itself: on the contrary, the films will forever demand from those who rediscover them 'a second life.'

Section I
Audiences and
the Cinema Industry

The Kaiser's Cinema:
An Archeology of Attitudes and Audiences

Martin Loiperdinger

Lost cultures are typical subjects for archeology, especially when they dispensed with any recognised form of writing or when only puzzling ruins remain to be deciphered. The cinema of the Wilhelmine period is such a culture. Very little is known about the beginnings of film in Germany before World War I, but this is certain: it has become an exotic phenomenon, which cannot be understood in light of the modern concept of cinema.

Just insignificant relics survive from the Wilhelmine period: a small fraction of the films shown then as well as a few of the buildings. Besides the remains of films and theatres, there are only indirect sources of information: contemporary accounts, police reports, photographs and architects' drawings, programme advertisements in yellowed magazines. Few systematic investigations of these sources have so far been undertaken. Even specialists have decidedly hazy notions of film performances, of the audiences, and of the meaning that films had for them in those days.

Two general assumptions about early German cinema in particular require more thorough re-examination: first, that it was a 'working class cinema' and second, that the cinema went through its 'rascal years' ('Flegeljahre') during the Wilhelmine period before becoming mature in the Weimar years. Both notions are retrospective constructs, having been developed later, and from a high culture view of film art – with a stake in seeing early cinema as a primitive transition phase towards a higher destiny. I am concerned to show that such assumptions can be criticized or re-investigated by simply looking once more at the evidence and source material that has survived from the period itself.

'Cinema' in the following refers neither to the architectural features of the facades or the interiors of fixed exhibition sites, nor to a canon of filmic masterpieces defined by period, style or place of production. The films and their performances before World War I had little in common with what has been shown in cinemas later. It took the new medium at least twenty years to develop the classic standard programme, and the evening-length feature film with supporting programme shown in a purpose-built cinema only began to dominate the industry towards the end of World War I. Before the War, the usual format was the number programme, consisting of short films made up of different genres, and lasting between one and two hours.

Given these facts, a serious look at early cinematography of necessity demands a broader definition of cinema, seeing it in the context of a wide-ranging and expansive technical, social and cultural history.[1] One might call it a new 'social space' where watching

films implied a social event and a communal experience, shaped by multiple factors and conditions, bounded by location, size and decor of the exhibition site at one extreme, and the nature of the film programme presented at the other. In particular, the focus is on the public, who come to the cinema of their own free will, paying for the pleasure of seeing the programme. But the definition also includes the various businesses involved in the production, distribution and performance and their specific economic interests. Finally, there are the governmental controls imposed on the cinematographic fact – from building permits and fire regulations to censorship of films and taxation of tickets – and the response to the medium in the sphere of the press, public opinion and politics.

The 'Rascal Years' and 'Working-Class Cinema'

In his popular bestseller *Immortal Film*, Heinrich Fraenkel gave the chapter on the early cinema the title 'The Rascal Years.'[2] With this or similar metaphors, German film historians have labelled the period before the full-length feature film ever since, suggesting that the cinema first became mature and acceptable as an art when eminent playwrights and famous stage actors consented to becoming involved. The term 'rascal years' emphasises the separation between art and entertainment, a divide initially policed by the 'intelligentsia of the printed word' who in Germany wielded much cultural power. The analogy with badly behaved rebellious youths automatically calls for the domestication of early cinema, especially when with hindsight it became clear that the rascal had indeed turned into a respectable adult, and the cinema had metamorphosed into a serious art form – precisely what the cinema reform movement had been demanding when it first used this patronizing and pejorative language around 1908/1909.

At the same time, calling it 'the rascal years' lends a certain romanticism to obscure beginnings that escape categorization. Siegfried Kracauer speaks of the 'freedom of the film from cultural ties and intellectual prejudices' and writes: 'During the whole era the film had the traits of a young street arab; it was an uneducated creature running wild among the lower strata of society'[3] – but he, too, seems to breathe a sigh of relief that those days would not last.

No matter where they place the emphasis, for most commentators the early cinema was rough and uncouth. Whether the metaphor inflected the audiences or the audiences determined the metaphor, the cinematograph of the fairgrounds, touring cinemas and nickelodeons became associated with the working class. Media sociologists and film historians alike can declare with conviction: 'Before World War I the cinema was mostly frequented by the working class.'[4] 'For the first fifteen years the German nickelodeons and cheap movie houses were mainly sanctuaries for the illiterate, poor, and unemployed.'[5] Even leaving aside the insinuations, such categorical statements are imprecise: who is this 'working class' whom Dieter Prokop describes elsewhere as 'the urban lower class'? And did the public for the first permanent cinemas really consist of members of socially stigmatised classes?

Blue Collar, White Collar, Casual: The Public

Let us first turn to the beginnings of film sociology in Germany. The cinema public of Mannheim, a large industrial centre 80 km south of Frankfurt, was professionally analysed in 1912 by means of an extensive questionnaire which Emilie Altenloh had prepared for her social science doctoral thesis.[6] The evaluation classified the answers according to social class and gender: the conservative elite of the Reich, particularly its male academics, beholden to a notion of 'Bildung' (bourgeois education and high culture), did indeed stay away from the cinematographic theatres. That much conventional film historiography can take over from Altenloh. But beyond this unsurprising fact, the class nature of early cinema becomes much more complex. Altenloh does not feel she can talk of 'working class': for instance, adult working-class men, who in Mannheim were generally members of the Social Democratic Party or organised in trade unions, were also seldom in the cinema. The Social Democratic workers' movement with its dense network of local leisure and education clubs had developed its own political culture which extended beyond merely securing its members' interests against the state and big business. Party and union members were bound into an oppositional subculture of the workers' movement 'from cradle to grave,' which means that the cultural aspirations of social democracy were often similar to the ideals of the educated classes: 'raising' the worker's self-esteem through his participation in middle-class cultural capital was one of the declared goals of the social democratic education policy. Thus, as far as the cinematograph was concerned, the workers' movement broadly agreed with the conservative cinema reform movement, rejecting the cinema as an 'epidemic' and a 'scourge.'[7] Altenloh's investigation revealed that the organised skilled working class hardly took advantage of the leisure opportunities represented by Wilhelmine cinema. Thus, it could not have been the 'urban working classes' that freqented the ever more numerous cinemas.

According to Altenloh, children, adolescents of either sex, and women made up a large percentage of the cinema-going public, often the family members of these hardworking skilled male providers mentioned above. Working-class women considered the cinematograph 'a very important form of entertainment.'[8] The significant number of children and adolescents among the public is also confirmed by the complaints of the cinema reformers that the 'provocative films' were endangering the morals of the youth. They called for (and sometimes managed to implement) restrictions, banning children from the cinemas. The highest level of attendance was noted by Altenloh for male adolescents who held menial jobs in the service industries – delivery boys, or low-rank office clerks, who mostly came from families of day labourers.

It does not necessarily follow, however, that the cinema-going public was primarily composed of members of the lower classes. Altenloh found that a very similar pattern emerged between 'women from the upper classes' and 'the young [female] shop assistants, except that the [latter] go to the cinema more often.' In the smaller towns, it was the cinema that relieved the boredom of the better-off women and showed them 'what everyone was

dressing in Paris, the hats they wore.' In the big cities, the women particularly enjoyed going to the cinema in the afternoon after finishing the shopping, to recover from all the bustle in the department stores and the noise of the streets.[9]

The conclusions Altenloh reached thus lead to a hypothesis that contradicts conventional wisdom: the most significant feature of the cinema-going public before World War I was not its proletarian origins (however significant a proportion this represented) but its class and gender diversity. The findings were the more telling, since they came from a decidedly industrial centre with a large working population. Contemporary accounts in the trade press tend to characterise the public as white collar, or casual and mixed, for whom the cinemas functioned as a welcome opportunity to break a routine schedule and take advantage of the continuous performances, with their mix of short films of different types and genres. Altenloh noted that one major reason for the increase in cinema attendance even among the educated classes was the fact of 'not being tied to a schedule' as in the theatre.

To comprehend the social and political importance of the cinema in the Wilhelmine period, one must follow up every clue as to the composition of the public and to the presentation of the event itself. In this context, the social topography of the film theatre can be very informative: the hypothesis of the proletarian public was founded on the fact that most cinemas were established in the working class areas of cities and that industrial cities had a greater density of cinemas relative to inhabitants. Prokop, for example, supports this view by comparing Essen and Düsseldorf: 'The "working-class town" Essen had 21 cinemas for 295 000 inhabitants in 1910; the "civil servant town" Düsseldorf had only 10 cinemas for 359 000 inhabitants in 1910.'[10] This has little meaning until the size of the cinemas and their precise locations are known. Recent studies of local cinema history indicate that theatres were first built in busy thoroughfares in the city centre – often near department stores and train stations or dance palaces and music halls. Such a location would suggest that they catered to a casual public rather than to a proletarian one living locally. In the case of Cologne, Bruno Fischli concluded that 'it is time to do away with the popular but simplistic viewpoint that the early period of the cinema was a time of the "proletarian cinema" – the Cologne cinema history, for one, disproves this standard theory.'[11]

In the darkness of the movie theatre, certain social and mental modernisation processes may well have got underway that would otherwise not have taken place on such a mass scale in the hierarchical society of the Empire. The cinemas were public 'grey areas' that brought together anonymous people from disparate sections of the population, united by their common choice of entertainment. It is precisely this social and cultural heterogeneity that turned the big-city casual audience into the modern masses and the cinematograph into a modern mass medium – despite the status limitations of the domineering Wilhelmine aristocracy and the siege mentality of class consciousness among working class movements.

Politically speaking, the 'modernity' of the Wilhelmine cinema in this double turn against the corporate state and class consciousness is ambivalent: On the one hand,

Heide Schlüpmann[12] puts forward convincing arguments for claiming that there was a 'secret conspiracy' between cinematography and women's emancipation in Wilhelmine society, basing herself on surviving German fiction films from 1909 to 1915. From another perspective and basing oneself on other source material, notably actualities and newsreels, one could argue the case that Wilhelmine cinema as a modern mass medium contributed to 'emancipating' Germans of both sexes outside the middle-class into becoming citizens: citizens who acknowledged a fatherland and who could demonstrate that they had the requisite patriotism, when the fatherland in the person of the Kaiser called upon them to take up arms at the beginning of August 1914.

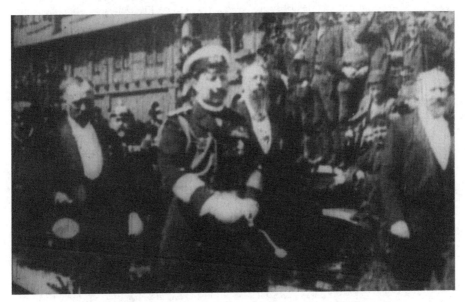

S.M. DER KAISER WILHELM II AUF DER VULKANWERFT IN STETTIN AM 4. MAI 1897

The Navy League Propaganda Effort

Recent discussions of the cinema reform movement and the public debates it generated in the teens and earlier over 'smutty films' and threat to public morals tend to overlook a significant aspect of early German cinema and the films on show: the cinematograph's targeted use, already since the turn of the century, as a vehicle for nationalist sentiment and militarist propaganda. The Navy League, the Colonial League and other military or paramilitary organisations (known as 'Vaterländische Verbände,' 'associations of patriots') had seized on the new medium as a means of advertising their aims, but also as an important source of revenue. Ahead in the game of systematic film propaganda was the Deutscher Flottenverein ('German Navy League'), a tightly organized network at the national, regional and local level throughout the Reich, drumming up public support for arming the navy. The Navy League used traditional advertising such as chocolate box illustrations and cigarette collectors' cards featuring navy subjects. Quick to exploit the new medium of moving

images, it entered into film exhibition early, and on an impressively vast scale.

Navy League film propaganda began in Kattowitz (today's Katowice), the center of the Upper Silesian mining area, a region away from the coast. According to a detailed report in the League's organ *Die Flotte*,[13] only a few, mostly from the educated middle-class, attended the League's lecture meetings. Thus, in August 1900, the Kattowitz branch organized a fairground exhibition. The main attraction was a real German battleship which could be entered and viewed by thousands who had never before seen such a big ship. A few months later the Kattowitz activists tried to repeat this enormous naval propaganda success. Because real battleships were not to hand, Gustav Williger, General Manager of the 'Kattowitzer AG,' organized a series of film shows supported by the Deutsche Mutoskop- und Biograph-Gesellschaft. The public response to these Biograph screenings exceeded all expectations: from March 3rd to 12th, 1901, audiences of some 24,000 attended 19 Biograph performances and were enthusiastic about the manoeuvres of the German navy seen on the screen. About 40 'living pictures' were shown, introduced by short lectures.[14] The effect of the moving sea, the gunpowder smoke and funnel smoke apparently stirred powerful patriotic feelings. The League's activists distributed copies of Navy songs among enthusiastic audiences who all joined in. This level of audience participation owed much, indeed, to the 'living pictures' of the Biograph, as ordinary people in the mining area of Kattowitz had never seen big ships moving or firing their guns on the open sea. The Biograph 'worked': not only in the technical sense of replicating views of the navy, but also in the political sense, making the screenings mass manifestations of popular support for the navy rearming program.

The Biograph film-shows in this industrial centre of Upper Silesia became the starting point of large-scale navy film propaganda activities, organized by local branches of the Navy League in all parts of Germany. Until 1907, the League's journal *Die Flotte* published facts and figures on 'Kinematograph' screenings, detailing the numbers of spectators at the shows as well as the number of new members recruited. The impact of the cinematograph was seen as a simple stimulus-response relation. Obviously, local branches reported on viewers who shortly after having attended the film shows applied for membership. Reported attendance figures of around one million viewers each year from 1903 to 1906 might have been exaggerated, but it is a fact that the Navy League's Biograph and Cinematograph travelling exhibitions were very popular. The trade press, for instance, complained about

heavy loss of revenue among commercial exhibitors who suffered from the unwelcome competition of the Navy League's propaganda film-shows.[15]

According to the League's annual report of 1903, the cinematograph was credited with turning the Navy League into a 'Volksverein' (an organization with popular appeal). Its impact was ascribed to the pictorial evidence which attracted people who never would have come to a conventional lecture meeting. Having attended the naval film screenings, Navy League members and non-members alike went home with the feeling that the navy was an important element of German life.[16] These statements indicate a fairly modern way of thinking politically, by making use of a propaganda technique that is based on the typical mass media communication strategies of our century still very much in use today in cinema and television: arguments unfolding pro and contra a given object or case are replaced by just *showing* the object or case. Then and now, it is visual (self-)evidence that stops the argument.

Film Star Kaiser Wilhelm II

Long before Asta Nielsen stepped before the camera in June 1910 to play her first role in AFGRUNDEN, an imposing array of film stars of another sort were already appearing on the screen of German cinemas. These actors can be called stars because they were mentioned by name in the advertisements of the production companies and even in the titles of the films themselves. If in feature films, stars were first introduced towards the end of 1910 via the novel marketing device of the monopoly film[17]; in the actuality and newsreel genre, it had always been customary to name the persons shown, who resemble stars in their magnetic attraction for the public. Already known and famous, they need no special build-up through exclusivity, since they already possess appeal and visibility by virtue of their political and social standing in the imperial hierarchy. These first film stars of the German cinema were the members of the royal family – especially Emperor Wilhelm II, the Empress, and Crown Prince Wilhelm, Crown Princess Cecilie and their children. As far as costumes, extras and array of famous names were concerned, no feature film from before World War I achieved the extravagance that the Hohenzollern Dynasty could display at their public gatherings and social rituals. The cult of the monarchy in the German Reich supplied the actuality genre with a wide range of unbeatable subjects that were also cheap to produce. As the presentation and display of imperial power were arranged by the court's masters of ceremony or heads of protocol and financed by the state, film producers were spared all manner of expenses, from costumes and props to fees for the aristocratic star cast.

The film industry had every reason to be grateful. It devoted a massive tome of film history to Wilhelm II on the occasion of the ruler's 25-year jubilee. In fact, *Der Deutsche Kaiser im Film*[18] was produced as an international effort, with extensive participation by foreign film companies with subsidiaries in Germany. In addition to the national companies Duskes and Projektions-AG Union, the French market leaders Pathé Frères, Gaumont and Eclipse were involved, as were Vitascope, Edison, the German Mutoscope and Bio-

graph Society and the Italian firm Ambrosio. The Emperor was not only apostrophised as 'one of the most active friends and supporters of film art,' he was revered as 'the most interesting of all personalities at whom the lens of a cinematograph has ever been aimed.'[19] These expressions of devotion and respect should not be seen as mere grovelling before the monarch. From the beginning of the cinematograph recording life in the German Reich, reporting on the court was a mainstay of the actuality genre, actively supported by Kaiser Wilhelm II, who became the most frequent sight in actualities originating from Germany. With over 100 film titles listed in the trade press advertisements,[20] Wilhelm II towered above other actors from all genres. The monarch who was nicknamed the 'Reisekaiser' ('travel emperor') was such a suitable subject not only because of the appeal and prominence of his appearances. As the embodiment of the political system, he was physically very present in public life and on state occasions where he became the object of a camera. Judging by the titles of the films in which the Emperor is named and which indicate the events and activities that were filmed, it is fair to say that Wilhelm II was no stranger to the 'photo-opportunity' and the 'media event.' His name promised the movie-going public a colourful variety of traditional and modern scenes from the imperial role repertory. The majority were occasions of public representation which later (under the motto 'red carpet treatment' or 'Hats off to Authority')[21] became the staple topics of the newsreel: State visits abroad, the numerous domestic walkabouts called 'Emperor Days,' foundation stone ceremonies and the consecration of memorials all portrayed the Emperor as statesman. Parades and manoeuvres accentuated his role as supreme military commander. Finally, the multitude of visits to shipyards and the launchings of warships made the arming of the fleet appear his personal concern. Wilhelm II also showed himself a friend of popular modern luxury sports, by opening the sailing regatta in Kiel every year and attending automobile races. He displayed a feudal lifestyle during the St. Hubert's Day hunt, pheasant shoots and royal hunting parties. Even on semi-private trips abroad, he showed himself accommodating to cinematographers.

Human interest as 'holiday-makers of the nation' was provided by the Hohenzollern princes as well. For example, already in 1902 three production companies were competing to bring to the public multi-shot films about Prince Heinrich's trip to America: the (domestic) Internationale Kinematographen-Gesellschaft from Berlin, the Edison Company, and Lubin from New York. Responsible for the genre 'Home sweet home' was the family of Crown Prince Wilhelm, Crown Princess Cecilie and their small children, where the Hohenzollern Dynasty was revealing its common touch. The 1913 de luxe volume *Kronprinzens im Film* sets the tone for how the cinema public was meant to respond: 'Yes! Our Crown Prince is like a member of our own clan: he lives with us, belongs to us, and is already half King and half still one of us! And when his dear loving wife is shown at his side and adorable children are playing at his feet, it seems as if in our hearts we are all on first name terms!'[22] In contrast to the supposedly salacious 'smutfilms' denounced by the cinema reformers, this offered the public a completely harmless, even politically desirable keyhole perspective. The Cologne Germania-Film-Companie advertised its 14-part filmstrip, DIE

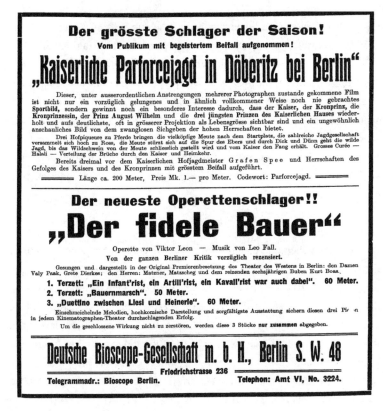

Der Kinematograph, no. 96, 28 October 1908

KINDER UNSERES KRONPRINZEN-PAARES BEIM SPIEL IM NEUEN GARTEN ZU POTSDAM, as a first-class repertoire piece. The 205 meters of film at 1.50 marks per meter were offered for sale to cinema owners with the promise: 'These images afford a glimpse into the informal domestic idyll of our Crown Prince's family.'[23]

Giving the impression of human intimacy with this form of 'home movie' of the family life of the Hohenzollerns is a typically modern media strategy. The repeated emphasis on informality contrasted sharply with the 'Prussian' staging of troop parades and military manoeuvres. As hybrid ceremonial form, the Wilhelmine 'Kaiser cult' was a fairly precise mirror of an autocratic system that oscillated between the Grand Prussian Monarchic ideal, and the middle class/industrial nation-state.[24] Consequently, the Hohenzollern Dynasty presented itself on the screen as an amalgam of traditional and modern elements. However, the rituals, meant to stabilise the ruling structure, appear especially ambivalent in the performance context of the cinematograph: Emperor and Crown Prince become part of a mixed programme of spectacle attractions, reflecting a colourful society, from which in reality they are very distant. In performance and appeal, the court ceremonies of the Hohenzollerns were no different from a troupe of circus acrobats doing their stunts, or slapstick comedians, operetta singers, dancers, alternating with the crafty scoundrels, drunkards and

naughty boys that thrilled, amused and enchanted the public. Maybe this meant that Kaiser Wilhelm II came closer to the operetta stars than His Majesty would have wished, but by playing his part in the cabinet of curiosities that was the numbers programme, his contribution to the 'nationalisation of the masses' (as the process of German national identity formation has been called)[25] must be seen in a more nuanced way. In the dawning age of technical reproducibility, the Kaiser cult on film did not unambiguously reinforce the aura of Wilhelm II as the incarnation of the political system, and may well explain why he faded from public memory fairly quickly when a new generation of film stars came to prominence in the post-war years, and the Prussian monarchy reshaped its image around a Frederick rather than a Wilhelm who had lost the Great War.

Research Perspectives

The history of the Wilhelmine cinema before World War I offers an enormous variety of materials for a cultural and social (media) history. The new medium film, together with other, technologically based forms of communication provided part of the economic incentive which, within a decade or two, gave rise to a prospering leisure industry. In a country whose industry was expanding rapidly, such a leisure industry could develop the social momentum which allowed the disparate masses of the industrial cities to bind into a new sort of public. In the darkness of the urban shopfront cinemas and nickelodeons, this public – every day and a thousand-fold – formed and re-formed itself, becoming real to themselves in the common experience of the screen events.

This essay, then, implicitly indicates also a research perspective that could move the traditional, work-and-text oriented German film history towards a more comprehensive cultural history. Film production and cinema reception, generally referred to as 'context,' can no longer be regarded as peripheral factors, to be added on to a more or less immanent interpretation of individual films. Rather, they must be considered constitutive conditions and permanently present forces, shaping the developments as well as the constraints of specific media practices. Such a perspective is broadly congruent with the concepts, methods and case studies of the 'New Film History,' which has already produced excellent work in outlining the international field of force in which early cinema developed.[26] On the other hand, with respect to Germany, the massive expansion of cinematographic activity just before World War I suggests investigating Wilhelmine cinema as part of the social and 'everyday' history of the Reich. Analogous to the numerous local and regional studies of the political culture at the end of the Weimar Republic, it might be time to devote more energy to microanalytical studies of the Wilhelmine cinema, based on local sources. The long-term aim would then be to combine the international perspectives of contemporary *film historiography*, archives and collections with locally focused *cinema history*: only then can we hope to decide to what extent this exotic lost culture of Wilhelmine cinema can be recovered as part of Germany's historical 'modernity.'

Oskar Messter, Film Pioneer: Early Cinema between Science, Spectacle, and Commerce

Martin Koerber

Oskar Messter started at a time when three preoccupations central to the new medium of cinematography – science, spectacle and commerce – were still inextricably caught up with one another, and in the person of Messter they continually competed with each other, often in a very antagonistic way.

From his childhood years, Messter seemed predestined for a career in film. His father had been running his own successful company, Ed.[uard] Messter, Optical and Mechanical Institute, in Berlin's Friedrichstrasse, since 1859. Engaged in the production and retailing of optical instruments, spectacles and, in particular, microscopes and other medical instruments, the firm was built up from very modest beginnings, but the optician had regular and steady contact with the theatre and show business. Eduard Messter made optical instruments for showmen, supplied magic lantern performances and was a pioneer of electric theatre lighting.

Oskar Messter, whose autobiography opens with a chapter headed 'My Father – My Model,' was to emulate him a few years later on the cinematographic front with similar ventures in the commercial sphere. He was forever travelling, collecting film footage of all news items he could lay his hands on, stopping only to visit cinema owners and to try to sell them his latest equipment and films. At countless conferences – as a representative of the interests of film producers – he struggled with the problems of film policy and finance.

'Ventures in Completely Unknown Territory'
Messter's involvement with 'living photographs on a continuous strip' started in 1896. At the beginning of the year he was still an optician and a mechanic running his father's business. Twelve months later he had developed and built machines for recording and projecting moving images and was managing a cinema where the films he had made could be shown.

The fact that the secret of the *Cinematographe Lumière* was kept until 1897[1] meant that Messter was unable to copy the form of image transport used in this apparatus with a gripping transport mechanism, which was soon to prove unsuitable for projecting. The mechanism of an English projector, brought to him to repair, was to lead him to another film transport mechanism – a blade with a few deep indentations abruptly moved forwards on a pin disc, creating the sturdy transport of the frame between the projection stages. Often equipped with four indentations (others versions exist with seven, five or three), this mechanism became known as the 'Maltese Cross' due to its resemblance to the medal with the

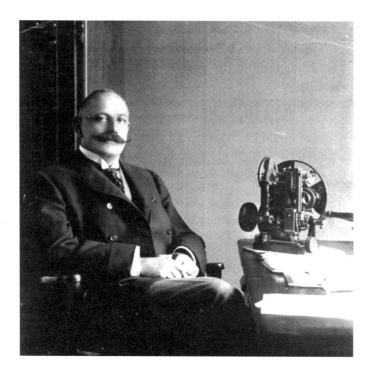

Oskar Messter

same name. Messter had not 'invented' the Maltese Cross: it had long been a familiar switching mechanism, to be found not only in Germany, but internationally, particularly in sewing machines, Morse telegraphs and music boxes. In 1896 other designers were also trying to solve the problem of the intermittent film transport with the aid of crosses and pin discs. In April, the French designer Coutinsouza registered a patent for the Maltese Cross; Robert Paul's projectors with their seven-slotted disk had been on sale in London since March and were selling well. Among the first buyers were Georges Méliès and Charles Pathé, later two of the greatest internationally famous film pioneers, who contributed to the rapid spread of this construction principle.[2] In Berlin, independently of Messter, the mechanic Max Gliewe hit upon the Maltese Cross gear when confronted with the problem of how to replace a faulty *Isolatograph* used in a projection hall Unter den Linden, soon to become Messter's property.[3]

Messter concluded a deal with Max Gliewe, according to which the gear mechanism built at the Gliewe & Kügler workshop would be delivered exclusively to Messter.[4] As a result, Messter was soon in a position to complete orders without delays (a problem faced by Paul's projectors), since he now had the expertise of Gliewe & Kügler at his disposal whenever needed. The end of 1896 saw a period of close co-operation between Messter and the mechanical workshop of Bauer & Betz, which Messter was soon to take over entirely. Georg Betz and Oskar Messter carried out tests together and jointly registered patents on their cameras and projectors, but were only granted protection of their registered

designs ('Gebrauchsmusterschutz'). Their trade mark was MB, intertwined in an octagon.

The reason why the manufacture of cinematic apparati progressed so rapidly was the fact that Messter's first projectors were much in demand with showmen – the only purchasers at this initial stage. The first projector had been sold to a Russian Showman on 15 June 1896 and the company records of Ed. Messter up until the end of 1896 indicate sales and orders of 64 Messter projectors. Other indications that business was booming are the numbers of extra and spare parts sold. In film sales an entirely new branch of business was opening up.[5]

In commercial projection in Germany, Messter was preceded by the short appearance of the Skladanowsky Brothers at the 'Wintergarten'-vaudeville in November 1895, and by travelling shows with the Lumière apparatus in early 1896. While he was still testing his first prototype projectors, not very far from his business in the Friedrichstrasse, in a backroom of the Wilhelmshallen Restaurant at 21, Unter den Linden, Berlin's first projection hall opened on 26 April 1896. The venture was not a financial success and when a new owner also disappeared leaving huge debts, the landlord closed it down. Messter acquired the assets – including the *Isolatograph* that Max Gliewe had been working on – and re-opened the premises – renaming it the 'Biorama' by popular competition – on 21 September 1896.

But even under Messter's directorship, the Cinema Unter den Linden did not prove a success. The attraction of the 'living photographs' was not sufficient to draw a large public on a regular basis to a programme consisting of a few short films which were over in less than ten minutes. However, Messter's presentations became a big hit when shown as part of a complete variety programme. By the end of 1896, performances involving his machines and films featured regularly on the programme of the Apollo Theatre in Berlin, a highly regarded entertainment palace. Similar theatres in other cities, like the Hansa Theatre

Henny Porten

in Hamburg, adopted Messter's presentations in their programmes. Soon Messter's operators or the inventor himself were travelling to these venues with their projectors and films.

In order to assemble a constant supply of films which were both original and topical, Messter began filming in autumn 1896. Once again, he constructed the necessary camera himself, building the projection mechanism, with a few alterations to the shutter and the film gate, into a light-proof box. The first films made with this simple machine consisted of footage shot outdoors: street scenes with parading soldiers, flowing traffic and railway scenes, and generally reminiscent of the films made by Lumière from the end of 1895 onwards. Only a few hundred metres from his office Oskar Messter found a subject that even today no report on Berlin can be without – the Brandenburg Gate.

After only six stormy months, then, the firm Ed. Messter became Germany's first film factory. Located in premises which had previously housed the optical company and the electric motor factory of Bauer & Betz which stood next to it, production was almost completely geared towards the manufacture of projectors, cameras and other devices, as well as to the shooting, developing and copying of films. One year later, at the beginning of 1898, the *Special Catalogue no. 32 on Projection and Recording Apparatus for Living Photography, Films, Graphophones, Shadow Apparatus, Spotlights etc.* of the Ed. Messter company appeared. As well as containing a basic treatise on 'Living Photography,' its more than one hundred pages were dedicated to Messter's products, and illustrations provided an insight into the production process. This catalogue also contained 84 films made by Messter, between 18 and 24 metres in length. Some of these appear to have imitated subjects first shown in the Lumières' films. No. 59 even quotes two Lumière films in one go – the famous SORTIE D'USINE and L'ARROSEUR ARROSÉ, in which a garden hose plays tricks on its user:

> FABRIK-AUSGANG. The clock has struck twelve, and men and women stream out of the factory gates. A careless gardener, who is watering the street, sprays the passers-by, causing them to quicken their pace. Witty.[6]

Along with films about cities, films on natural subjects such as waterfalls, floods and wild animals (filmed, of course, in the Berlin Zoo), and a few 'piquant' shots (such as No. 6, IM ATELIER ['In the Studio'], showing painter and model in a suggestive pose), military subjects were another strong point of the programme. Parades, battleship launchings and other such events marked the beginning of 'visual reportage,' which soon became one of the regular ingredients of the film programme in the music hall. Messter's catalogue of cinematographic events documents the experiences and knowledge gained over an 18-month period and shows that, in Germany too, early cinematography was evolving from an experimental curiosity into an industry.

Messter undoubtedly felt at home in the patriotic, militaristic spirit of the age, his enthusiasm for technological innovation and his gift of turning this into company profit were completely in line with the public image of the *Gründerzeit* entrepreneur. He was

similarly combining his business acumen and his patriotism, when – as soon as the experimental phase was behind him – he began actively wooing the imperial court. Showing 'living photographs' to His Majesty was ideal for winning royal patronage, in turn a favourable advert for the newly established film industry. But Messter also saw this as a good opportunity to acquire footage of the Kaiser, his court and family – a particularly hot item in his film programmes. One way of getting closer to the Kaiser was through the latter's enthusiasm for the imperial fleet – an enthusiasm shared by large numbers of the public. Many of Messter's next films therefore had a distinctly maritime flavour. On 4 May 1897, he filmed the Kaiser at the Vulcan shipyard in Stettin, where he was attending the start of the steamer 'Wilhelm der Grosse.' With S.M. DER KAISER WILHELM II AUF DER VULKANWERFT IN STETTIN AM 4. MAI 1897 Messter achieved a 'marvellously sharp, accurate picture which renders His Majesty clearly visible.'[7] Messter filmed hundreds of maritime subjects, partly out of scientific interest and partly as a chronicler and hunter in search of interesting cinematographic images. In the years that followed, Oskar Messter made generous use of his reputation as the man who filmed the Navy. He continued to film the Kaiser and the Empress, princes and princesses and to shoot footage of manoeuvres, regattas and ship launches, as well as on land, when the Kaiser unveiled monuments, took parades, holiday excursions and suchlike. These were a staple of his films on offer, and those featuring the Kaiser himself were always presented as the high point of a Messter show.

The Brief Blossoming of the Sound Picture
As early as 1896, in Messter's *Biorama* Unter den Linden, a phonograph was used to provide a musical accompaniment to the 'living photography.' This was no arbitrary back-

Messter's studio at Blücherstrasse 32

ground music, but a series of pieces specially selected to accompany the images.

On 7 November 1902, Léon Gaumont showed films in Paris with the projector linked up to a gramophone. Oskar Messter was working on a similar invention, which he presented very successfully under the name *Biophon* in the Apollo Theatre, Berlin, on 29 August 1903. Both Messter and Gaumont were able to take out patents on their inventions and made an agreement over their operation: Gaumont was to supply no sound pictures to Germany and Messter agreed to do the same in France; the apparatus was sold by both producers as a common concern under the name *Gaumont-Messter Chronophon-Biophon*. A joint company, planned by Messter, which was to exercise a worldwide monopoly on sound pictures did not come into being, but his 'Tonbilder' remained a huge commercial success, as long as Messter could claim the technical superiority of his product over that of his German competitors. Part of his *Kosmograph* company was involved in the management of Messter's own *Biophon* cinemas in Berlin and in several other German cities. By 1913 five hundred *Biophon* projection machines had been sold to managers of other cinemas. Flourishing sales of sound pictures, initially produced exclusively by Messter, were therefore guaranteed, and these had a much higher market value than 'silent' images.[8]

Initially, *Biophon* sound pictures were shown as a new attraction in the music halls, in which Messter's *Kosmograph* was to be seen throughout the country. However, the arrival of the sound picture also contributed to the establishment of permanent cinemas, which took off from about 1905 onwards. Sound pictures brought cabaret numbers and famous comedians onto the scene, including Otto Reutter, Robert Steidl and Gustav Schönwald. But there were serious programmes too: one of Messter's first *Tonbilder* features the tenor Siegmund Lieban singing the prologue from the opera *Bajazzo*. Messter employed the big names of the Berlin theatre and directors such as Franz Porten and Albert Kutzner, who had some experience in opera.

For a few years, Messter concentrated almost exclusively on the production of sound pictures, and by 1907 they took up an 83% share of his company's entire turnover, rising to 90% in 1908.[9] The reaction of other German film producers was to begin making their own sound pictures and manufacturing apparatus. Alfred Duskes marketed a *Cinephon*, Karl Geyer built the *Ton Biograph* for the German Mutoskop und Biograph, Guido Seeber developed the *Seeberophon* and later used Messter's *Synchrophon*; as head of the technical department at Deutsche Bioscop he devised ingenious trick shots on a *Synchroscop*.[10] Germany soon boasted a dozen different sound processes, each in competition with one another, and each achieving roughly similar results.[11]

The fierce competition led to a drastic drop in the prices for sound pictures. Several firms undercut Messter, using the play-back process for the recording of sound pictures in order to substitute inexperienced (and cheaper) actors in the staged scenes for the stars of opera and stage whose voices they used in the recordings. The price per metre gradually sank to that of the 'silent' film rate of around 1.00 mark, which even with good sales could not cover the production costs, at least double those for 'silent' films. By 1908, the peak year of the

Tonbilder, Messter's net income sank by 54%, and in 1909 he had to declare a loss.[12] By then, Messters Projektion had produced some 450 *Tonbilder*. But by the end of 1909, the tide had turned: sound picture production had dropped from 40 to 3, while feature film production was rising steadily: instead of 8 in 1908, 10 new feature films were on offer in 1909.[13]

A Home-grown Star Saves Messters Projektion

> People will understand that I was rather reticent about making artistic films, because the success of these would not be due solely to my technical accomplishments. (...) I had to accept the fact that my task as a film producer was to engage capable artists for the script, for the direction and for the performance. It only remained for me to decide which film should be shown, which cast should be chosen, and what kind of set should be used. Then I had to provide the necessary capital and keep an eye on the shooting. (...) Despite all my experience I soon came to realise that, even when a film was finished, I could not predict with any certainty that it would recoup the money invested in it.[14]

In his memoirs Messter fails to mention that while still the undisputed boss of his companies in 1910, he had surrounded himself with a highly competent management team. From 1909 there was the brilliant sales representative, Maxim Galitzenstein, who managed to reverse the drop in sales.[15] Galitzenstein had good contacts with the cinema owners and was able to provide valuable feedback. From the Neue Photographische Gesellschaft, Messter took over Leo Mandl, who soon managed to 'reorganise a business that was on its last legs.'[16] Mandl was probably responsible for the restructuring of the Messter firms in 1913, creating a group of companies, with the clear aim towards vertical integration and a division of labour between the individual companies, both of which were rare moves in the German film industry of the time. The third important partner was Viktor Altmann. That Messter, Mandl, Galitzenstein and Altmann constituted a powerful team and represented a certain epoch of the film business is suggested by the fact that as late as 1929 the four featured in a set of cartoons captioned: 'The pioneers of the German film industry.'[17]

In the early years of Messter's career, the moving image had been an attraction in itself. Later, the sensation of 'singing and talking living photographs' ensured a comfortable profit. But in 1911 the time had come to find a new means of securing loyal and long-lasting public interest in the films made by Messters Projektion. Messter found it in the actress Henny Porten. She had already appeared in a few earlier sound pictures (MEISSNER PORZELLAN, 1906), but she came to prominence in 1910. Over a period of two or three years she was carefully turned into a star, and the 'Porten film' finally became a trade mark for films that 'sold themselves.' In the early days, posters advertising Messter films did not even mention her name.[18] In the autumn of 1911, however, the film TRAGÖDIE EINES STREIKS ('Tragedy of a Strike') included a short prologue in which the actress greets the audience like old friends. This film proved to be Messter's most successful production of the season.

The next step was to circulate photographs of Henny Porten, showing the star in various poses from Messter films. The photographs were also presented in an attractively framed 'tableau' for cinema owners to display in their foyers. In May/June 1912, Messter embarked upon an advertising campaign in the *Erste Internationale Filmzeitung*. Unusually lavish, full-page ads with photos, as well as pull-out supplements with portraits and an autograph in which Henny Porten expressed her gratitude for all the attention she had been shown, won her a place in everyone's heart. It illustrates well the sophisticated, long-term strategy of the early Porten campaign: the *Erste Internationale Filmzeitung* was a trade journal particularly influential in Berlin and especially with cinema owners. Messters Projektion gambled on the snowball effect this would have and judged it more effective than the rather blatant advertising directly to the public. In the spring of 1913, the name Henny Porten also came up in the cinema sections of the Berlin daily newspapers. Messter did not have to pay a penny for the privilege, since these columns were paid for by the cinema owners.

Henny Porten became the most prominent prop of Messter's commercial success. The growing demand for his films even led to a drastic increase in prices. 'The first Porten films closed, in 1914, with an average price of 2.50 marks per metre, which rose to 3.25 marks in 1916, and later to 3.75, and in 1917 to 7 marks per metre.'[19] Thanks largely to Henny Porten, Messter's films became hits worldwide. For the German market, 20 prints – including replacement prints – were produced before the World War I, 'for Austria it was 10 prints, for Denmark, Sweden and Norway 5, for Holland and the Dutch East Indies 2, for England and her colonies 15, for North America 30, South America 15, Italy 5, Spain and Portugal 3, Russia 20, Japan 1-2, the Balkans 2, Bulgaria, Serbia and Greece 2, France and Belgium 5 and for Switzerland 1 print.'[20]

The Porten profits were partly invested in order to found the Autor-Film, a production company within the Messter group almost exclusively given over to the preparation and exploitation of the Henny Porten series and the commissioning of the films from the parent company.

The success of the charismatic star also allowed the firm to push through and impose the so-called 'Monopolfilm' distribution system. Before this date, the measure of a film's success was the number of prints sold. In selling prints of a film, the producer was, however, handing over the control of future exploitation. Many film-buyers made their living from the resale to second or third parties of prints they had bought, and which – after their initial run – could be advertised on the market at knock-down prices. These 'second-hand films' choked the market, cut down the period for which films could be shown and affected the prices paid for new productions. The Monopolfilm promised a way out of this dilemma by selling not prints, but the right of exhibition, limited by time and place, i.e. for a fixed period and in a given region. For the film producers, the monopoly system had the advantage of guaranteeing minimum returns, because the agreed exclusivity made it impossible for the films to be passed on, exchanged or 'shuttled' back and forth between owners

without restriction.[21] In 1914 Messter entered directly into the market, by establishing within the Messter group the Hansa film distribution company, which made him increasingly independent of regional distributors and made sure that profits from exploitation flowed back directly into production.[22]

Messter the Film Producer Goes to War

The outbreak of the World War I in August 1914 threw the German film industry into disarray. In the film factories, preparations were under way for the autumn/winter season of 1914/15, when the very backbone of the business was dramatically transformed: actors, directors and technical personnel were called up, many of the comedies already in production were no longer what the public wanted or the censor permitted, the raw materials essential for production were rationed, and – a serious blow for the cinema owners – the French film companies which had dominated the market were declared 'enemy aliens' and were closed down.

Oskar Messter, now 48 years old, was a lieutenant in the reserves and had not seen service since 1896. In September 1914, however, he joined up as a volunteer. With the assistance of a contact in the Berlin Press Association, a certain major Schweitzer, he entered the press unit of the Deputy General Staff in Berlin. This enabled him to see his company through the hard times of the beginning of the war and to open it up to new fields of activity.

Messter's first task was to prepare censorship regulations for photographic and cinematographic war reporting. The military had very little experience with the new media of photography and film, but they were very concerned about the uncontrolled broadcasting of inappropriate images of events and the effect these might have both domestically and abroad. They were also worried about the implications for espionage. Messter's *Guidelines for War Photographers and Filmmakers*, which appeared on 8 October 1914, made it abundantly clear that reporters were expected to behave in a 'patriotic' manner. Photographers had to deliver three prints from every still taken to the press department of the Deputy General Staff, which would decide whether or not the material could be shown. Aside from this limitation, photography was generally permitted. The regulations for camera operators wanting to shoot footage were more stringent. They required special permission. Only five firms were granted this privilege – including Messter's, of course. They had to use specially marked film stock, while developing and copying were carried out under military supervision. Negatives and master copies became property of the General Staff and after being passed by the censor, were only available for rental. Scenes banned by the censor had to be destroyed and the General Staff also had the right to purchase prints for further use and exploitation as it saw fit. These restrictions led to accusations against Messter of using his position in the General Staff to obtain privileges for his firm and to stifle the competition.

Whatever the case, the war footage undeniably helped bring about a rapid increase in production for Messter's firms. Following DOKUMENTE ZUM WELTKRIEG in Sep-

tember, he announced, on 1 October 1914, the production of a weekly newsreel, the MESSTER-WOCHE. The first 'Kriegswochenschau' (war newsreel) was shown on 13 October 1914, and its items were a model of how to report events from the 'viewpoint of the Fatherland' and comply with the stipulated restrictions.[23]

In May 1915, 'Messter's War Cinemas' opened at various locations on the Western front – in the former city theatre in Bruges, in Ostend, Comines, Cambrai, Charleville, at the Command Headquarters and at certain locations close to the front line. Even though the profits from these cinemas were donated to war widows and orphans,[24] it was an excellent way to advertise the firm's 'patriotism,' and – as long as costs were covered – compensated for the loss of audiences on the home front.

For Messter the film technician, a new military field of action opened up at the beginning of 1915. A captain he had befriended asked Messter to lend him a film camera so that he could film from the air. Messter declined, judging the camera unsuitable for such a purpose, but he applied himself to the production of a camera with a superior focal length and a larger format, suitable for filming open country and air reconnaissance work.

The military contract for the manufacture of the first 'Reihenbildner' ('serial image camera') went to Ed. Messter and another Messter company, the 'Projektionsmaschinenbau GmbH,' although later on, Ernemann and the machine construction division of Geyer also became beneficiaries of contracts. By the end of the war a total of 220 'Reihenbildner' had been manufactured and put to use on all fronts in reconnaissance flights. For an army which was becoming increasingly caught up in a confused war of attrition, the serial image camera offered a welcome means of providing an aerial view of a battlefield mainly experienced from the perspective of the trenches.[25] These military contracts given to Messter's firms were – like the censorship regulations before – grounds for allegations that he was profiting from his position to gain an unfair competitive advantage. On the other hand, the film industry welcomed the boost to the production of raw film stock resulting from the use of the 'Reihenbildner,' thus helping Agfa (the main producer of film stock) to avoid closure, since the authorities had wanted drastically to reduce the use of raw materials, with the result that all film production would have had to cease for the duration of the war.

Besides his work on the technical side of film in the interests of the military,[26] which permitted his companies to survive thanks to 'work of vital service to the war,' Messter also found time to become chairman of the 'Association for the Preservation of the Common Interests of Cinematography and Related Groups', where he represented the interests of the film industry with the authorities. His military involvement added extra weight to these interventions. In August 1916 he wrote the memorandum 'Film as a Political Medium,' where he pointed out the lack of pro-German film propaganda in neutral countries,[27] while criticising the measures taken against film producers – including Messter's companies – in the areas of censorship and taxation.

As the war worsened, the state and the military increasingly began to adopt a more open attitude towards the arguments of the film producers. The army's Supreme Com-

mand is known to have played a leading role in the establishment of Universum Film AG (Ufa), which was the recipient of massive capital investments from the German Reich at the end of 1917. Messter's film companies, his distribution firms, his cinema in the Mozartsaal and his workshops merged with Ufa. Messter must have been very satisfied with the sum of 5.3 million goldmarks[28] acquired from this transaction.

The sale made Oskar Messter a rich man, but it also cut him off from his life's work. After an exemplary career as a self-made man, he retired to a farm in the Bavarian Alps, in Tegernsee, where he intended to live off his fortune. It soon became clear, however, just how impossible this form of existence was for him. Thus, while the extraordinary career of this restless spirit was far from over by 1917, and his various activities in one way or another connected with film continued up to his death in 1943, his major contributions to the German cinema 'logically' culminated with the creation of Ufa and found a drastically simplified common denominator in the Weimar dream-factory. A Wilhelmine personality, he embodied the enterprise of modern Germany's 'founding fathers,' where fierce nationalism and patriotism could go hand-in-hand with an unblinkered, inquisitive mind-set, in which science and business, popular entertainment and education seemed to form a unity, held together by the promise of technology to improve the human animal. Only pioneers can be so self-assured.

Der Kinematograph, no. 496, 1916

The French Connection: Franco-German Film Relations before World War I

Frank Kessler and Sabine Lenk

Introduction

It is well known that before World War I the French film industry played an important, if not the leading, role in Germany. Starting with the cinema's earliest years, and continuing well into the teens, Germany's western neighbour dominated the international market in all relevant fields: film production, distribution, as well as exhibition. In this essay we would like to give several examples to illustrate how the French presence developed in Germany, what sort of shape it took, and how French companies and their products were received. Additionally, we will sketch the forays German companies made into the French market. As such, it is no more than a first glimpse into the complex question of Franco-German relations, since little research has so far been conducted either in Germany or in France. Nevertheless, we have attempted to put together some of the pieces of this puzzle, in order to outline connexions which may eventually help us not only to gain a more specific sense of early German cinema in its international context, but also to add to current investigations evaluating the French contribution to German film culture.[1]

In a sense, the first days of the cinema were symptomatic of future Franco-German film relations. If we time-travel back a hundred years to November 1, 1895, we see the Brothers Skladanowsky presenting their Bioskop in the Berlin Wintergarten. In Paris, on 28th December, the Brothers Lumière introduce their Cinématographe in the Salon Indien du Grand Café to a paying public for the first time. The latter event, as it turned out, was of far greater consequence for the introduction of film to Germany than the Skladanowsky's chronological 'first.' Thus, it was the chocolate manufacturer Ludwig Stollwerck who secured a contract for the Deutsche Automaten-Gesellschaft (DAG) for the first commercial exploitation of the Cinématographe Lumière in the German Reich, although, in the event, the DAG secured for itself only 30% of the gross income.[2] The Brothers Skladanowsky, on the other hand, never succeeded in presenting their invention in Paris. While the reasons have not been fully explained, it is evident that the Bioskop had no commercial future either in France or in Germany.[3] The episode anticipates future developments: French firms massively crowded into the German market, while German efforts in France went more or less unnoticed.

When consulting contemporary sources for the period up to the outbreak of World War I, one might easily conclude that French film companies dominated the cinematic landscape of the German Reich. This was no doubt the case, but trying to document it quantitatively is by no means easy. For instance, taking Herbert Birett's index of films ex-

hibited in Germany between 1895 and 1911 as a starting point,[4] one arrives at the following picture:

Year	Total	Pathé	Gaumont	Eclair	Eclipse
1905	827	120	20		
1906	578	170	80		2
1907	1117	190	100		60
1908	1986	30	170	20	60
1909	3052	350	320	10	210
1910	3376	470	180	1	160
1911	4605	280	130	30	30
1912	5417	650	330	130	170
1913	5869	380	360	190	120
1914	3373	190	190	110	70
1915	1498	20	10	1	5

These figures are based solely on the number of titles imported. But since it is impossible to trace how many printss of each film were in circulation, we need to relativize the numbers, on the assumption that a substantial group of French titles were outperforming the rest in terms of popularity and profit. At the same time, not every film distributed by Pathé – the basis for these figures – was necessarily a Pathé production, so that the relativization needs to be relativized once more. Finally, the first years are not fully documented due to incomplete runs of trade journals, like *Der Komet* (the paper of the fairground operators), or because dedicated cinema trade journals, such as *Der Kinematograph* only started being published in 1907.[5] One would have to research the daily press: an enormous undertaking which has not been tackled systematically. In Birett's *Das Filmangebot in Deutschland*, Lumière films are not included at all, and there is only one Méliès film. In an unpublished filmography of Star Film's presence in Germany, Birett has, however, documented 82 titles which in turn represent only a small part of the approximately 450 Méliès films. Thus, market penetration may have been both quantitatively and qualitatively more extensive than the figures indicate.

Even if only a few actual records of film imports from the first few years seem to have survived, it is reasonable to assume that contacts with French production firms must have been extensive. Arthur Mellini, conservative-national editor-in-chief of the *Licht-Bild-Bühne*, describes in an article not otherwise excessively pro-French[6] the situation of the German film industry after the start of World War I as follows:

> France gave the world the gift of cinematography and I can personally attest that many of the smaller German producers sent their employees to Paris after 1896 in order to find out how it is done. The spies came back across the border, richly laden with intellectual booty.[7]

It is safe to say that, apart from technical know-how, films were imported as well, especially since, at that time, films were indeed ordered directly from the producers. But to assess accurately how far French films had captured the German market, one would have to work systematically through the daily press and reconstruct the patterns of local film exhibition.

The French Presence in Germany, the German Presence in France
For French film producers, the German Reich was undoubtedly a most attractive market. National competition was not up to par (even as late as 1914, firms such as Messter, PAGU and Vitascope were unable to satisfy the demand from German cinemas out of their own production), and there were a great many more urban conglomerations in Germany (by 1910, 48 such fully developed urban centres existed) than elsewhere in Europe. This huge market, finally, was situated right at France's doorstep. In Birett's list one finds between 1895 and 1911 (not counting the various Pathé subsidiaries) the French film companies Eclair, Eclipse, Film d'Art, Film des Auteurs, Gaumont, Lux, Le Lion, Georges Mendel, Théophile Pathé, Photo-Radia-Films, Films du Polichinelle, Radios as well as Raleigh & Robert (a company located in Paris and headed by the Englishman Charles Raleigh and the German Robert Schwobthaler). The number of French firms and labels in Germany even increased after 1911.

The French presence took on various forms: some Paris companies immediately established their own branches. Examples are Théophile Pathé and Eclipse. The latter had already set up an office in Berlin in 1907, barely a year after the firm's founding in 1906. Normally, Eclipse abroad worked with the respective national distribution companies, but in Germany, it had the use of the offices of the Urban Trading Company (established in 1903 by Charles Urban), to which it was at least nominally attached until 1908, when it bought out the British partner.[8] At around the same time, Théophile Pathé, one of the brothers of the Pathé Frères founders Charles and Emile, started directly distributing his films in Germany. He had already worked in Berlin before 1905, as a salesman for cinematographs and optical equipment, founding the production company 'Théophile Pathé et compagnie' in July 1906. Until 1910, it specialized in documentaries. When the firm closed in 1913, Théophile Pathé was already a veteran of the Franco-German film business.[9]

Other firms gained a toehold by first employing German companies to organize their distribution before opening a branch office. This was the case with Eclair. Founded in Paris in 1907, Eclair signed a contract with the 'Kinematographen- und Films-Industrie-gesellschaft' in May 1908. The latter seems to have exploited mainly second-hand films and therefore did not make the Eclair films their priority. In the summer of 1911 Eclair opened its own office in Berlin Friedrichstrasse, the centre of the German film business. Although the original company, renamed Deutsche Eclair, was put into compulsory liquidation in 1917, it had already in 1915 under the new name of Decla and the management of, among others, Erich Pommer begun its illustrious rise as one of the most important production houses of the early Weimar Republic.[10] Hardly less convoluted stories could be told about

firms like Lux, Le Lion (which traded directly from Paris until 1909)[11] or Film d'Art, the last distributing its costly art films first via Pathé Frères, before taking charge of its own foreign sales,[12] after letting the Pathé contract lapse in December 1909.[13]

But the most important company by far, and not only in Germany, was of course the 'Compagnie générale de phonographes, cinématographes et appareils de précision', better known as Pathé. Already during its founding year in 1896, Pathé appointed a German representative in Berlin.[14] Its first German head office opened in 1904, also in Berlin. Soon regional offices followed in Cologne, Düsseldorf, Hamburg, Frankfurt a.M., Karlsruhe, Leipzig, Munich and Posen. In the German trade papers, Pathé is the most frequently cited foreign production company, not surprisingly perhaps, given the fact that with its worldwide distribution network, it was perceived as the dominant international player. Pathé's capital resources and profit margins were regularly commented on, in a tone shifting between admiration and concern.[15]

Germany's presence in France during this period, on the other hand, is under-researched and seems to have hardly left a trace. A few leads exist, thanks to a list of Paris production and distribution companies researched by Thierry Lefebvre and Laurent Mannoni from the *Annuaire du commerce et de l'industrie cinématographique*[16] in 1913. Relatively few foreign firms appear to have had branches in France, with the exception of Edison, Vitagraph, Nordisk and Cines, as well as a few smaller companies. According to this list, not a single German company had a branch in Paris. Instead, films were distributed via agents. Paul Ladewig's 'Union des grandes marques cinématographiques' represented Messter; Charles Helfer represented Eiko; 'Braun et Cie' took care of Royal Films (Düsseldorf) and Dekage-Film-Gesellschaft (Cologne), while the 'Agence moderne cinématographique' distributed Imperator-Film Berlin. One other name worth mentioning is the 'Agence E. Hebert' which offered an Asta Nielsen series including, among others, LA SUFFRAGETTE (DIE SUFFRAGETTE, PAGU, 1913), LES ENFANTS DU GÉNÉRAL (DIE KINDER DES GENERALS, PAGU, 1912), CE QU'UNE FEMME VEUT and LES MISÈRES DE LA VIE. LA SUFFRAGETTE was also distributed by International Star Film, evidently in the southern part of France. In addition, Ernest Hebert apparently represented the 'Literaria-Film-Gesellschaft,' having registered this company at his own agency's address in Paris on October 29th, 1913.

As to what part of the French market might have been captured by German films remains anyone's guess. Since no equivalent to Birett's index of films exhibited exists for France, it is not even possible to reconstruct the titles. Again, only local research into film exhibition could help to reconstruct the picture and give insight into the presence of German films in France. Messter, for one, appears to have calculated five copies for France of his Henny Porten films (the same figure as for Italy, Belgium and Scandinavia), while 20 copies were destined to go to Russia, 15 copies to England, including the overseas dominions.[17] The absence of French subsidiaries of German firms does allow one, however, to draw the conclusion that there was a definite imbalance in the countries' two-way traffic.

On the other hand, French trade journals, such as *Le Courrier cinémato-*

graphique and *Ciné-Journal*, did send correspondents to Berlin who reported more or less regularly on current developments. In the journal *Le Cinéma* from 1913 and 1914, one finds reports and portraits of German film stars such as Henny Porten, Asta Nielsen, Mia May, Friedrich Kayssler, Erna Morena, Lotte Neumann, Otto Treptow and Resl Orla. The Orla worked for the Literaria-Film-Gesellschaft, whom we shall return to as examples of German-French cooperation. The director Franz Hofer, at the time still an actor, was introduced to French readers as a particularly versatile player, and 'l'un des meilleurs artistes étrangers.'[18]

Given this paucity of documentation, very little can be said about the extent – if any – of German companies' involvement in the day-to-day French filmmaking business. There are some indications, though, that French firms took an interest in what went on in Germany. At a meeting on March 11th, 1909, in Berlin of 'all sectors of the business, including film distributors and cinema owners,' there were, among various foreign firms, representatives of Gaumont-Berlin, Lux-Berlin, Pathé-Frères-Berlin and Eclipse-Berlin also present. The meeting, chaired by Oskar Messter, was designed to discuss 'the Paris negotiations of March, 15th, where the demands and suggestions of German cinema owners and distributors are to be aired.'[19] Another meeting took place on March 25th, in order to constitute the German section of the 'Filmverband I.E.F.,' or 'Comptoir international des Editeurs de Films.' Oskar Messter was elected chairman, with Gertrud Grünspan, head of the German Lux, as secretary.[20] A few months later, Director Grassi of Gaumont became treasurer, and thus board member of the 'Zweckverband Deutscher Kinematographen-Interessen,' which indicates that French firms seem well-represented on German professional bodies.[21] It is difficult to gauge from these trade reports whether the appointments were strategic, in that the German bodies wanted to ensure the support of the French companies' German subsidiaries, in cases of conflict of interest, or whether the country of origin played no role. The fact remains that representatives of French firms in Germany took on active roles in the various trade organisations, and represented the interests of the German film industry, to whose 'emergency fund' of 1912, set up to 'fight the enemies of cinematography,' Pathé Frères, Gaumont and Eclair contributed financially.[22] Similarly, when (also in 1912) the German film industry paid tribute to 'the most interesting of personalities a camera lens has ever been aimed at,' that 'active patron and friend of cinematography,' Kaiser Wilhelm II, on the occasion of the 25th anniversary of his reign, the firms Pathé, Gaumont and Eclipse were in evidence, at least in the commemorative volume, *Der Deutsche Kaiser im Film*.[23]

Examples of German-French Cooperation
As already mentioned, at the beginning of German-French film relations stands the commercial exploitation of the Cinématographe Lumière in Germany by Ludwig Stollwerck and the Deutsche-Automaten-Gesellschaft. Another attempt at cooperation, in the autumn of 1908, was also the result of a German initiative. The producer-director Heinrich Bolten-

Baeckers contacted Charles Pathé, with the aim of setting up an equivalent to the French Film d'Art, inviting him to attend a meeting he had arranged with a number of German stage authors and published writers. Despite positive reactions from the writers, Pathé, for reasons unknown, withdrew from the venture after only a few weeks, whereupon Bolten-Baeckers had to shelve his plans.[24]

Evelyn Hampicke, in her paper on Pathé, also mentions contacts between a Paris film company and two German firms: Alfred Duskes' firm as as well as PAGU-Vitascope (represented by Paul Davidson and Julius Greenbaum). On December 28th, 1912, Pathé and Duskes set up the 'Literaria Film GmbH' with French capital. A glass house studio was built in Tempelhof equipped with the most modern facilities for film production. Yet despite the fact that there was an in-house laboratory, Literaria negatives were sent to Paris.[25] As customary for Pathé, the strategy was to keep as much central control as possible even over the company's own foreign branch offices. Literaria's legal status is difficult to determine. In advertisements, Literaria appears as a subsidiary of Pathé Frères & Co., but in the Berlin Chamber of Commerce register, only Duskes signed as partner. It is remarkable that Pathé should have waited until 1912 to open a production branch in Berlin, given that Germany represented one of the firm's most important markets. Equally puzzling is the fact that Literaria, as mentioned above, was not registered in Paris until October 1913, and that it should appear under the name and address of Ernest Hebert. In papers documenting the forced expropriation of foreign companies in Germany after the outbreak of World War I,[26] there is a report by Literaria's official receiver, Otto Mosgau. According to his statement, Duskes produced mostly independently, and Pathé bought his films (at 24 pfennig per meter). If the options were not taken up by Pathé, Duskes was free to market the films in Germany. This reflects the fact that Pathé had given Literaria a long-term credit of 30,000 marks as a financial basis, but was not in fact Literaria's co-proprietor. Similar business arrangements existed with PAGU-Vitascope: Pathé bought the negatives and developed them in Paris for (world-wide?) distribution. On July 1st, 1914, Pathé also took a lease on a Berlin studio, originally built by Julius Greenbaum in 1913 at Weißensee, paying 41,000 marks a year. This expansion by Pathé into the German market came to an abrupt end only a month later, when war was declared.[27]

Gaumont's fortunes in Germany are also worth mentioning. Shortly after the founding of a first branch office in the German Reich, an interesting proposal for cooperation was being discussed between Léon Gaumont and Oskar Messter. Already by November 1902, Gaumont owned the rights to a satisfactory (gramophone disk-based) system of sound-image synchronisation, and Gaumont's catalogue advertised 'sound pictures' in 1904. Messter's also began marketing 'Tonbilder' by August 1903, and together, the two firms soon captured not only their respective national markets, but occupied a kind of world monopoly. Already in 1903 plans were afoot on the German side to stabilize this market situation. In particular, Messter was interested in concluding a contract which could 'assure the joint exploitation and pooling of patents with legal protection secured worldwide.'[28] To

this end, Messter wanted to found a company to which both firms contributed their sound film rights and patents, in order to share the future profits. Gaumont, however, was not interested, presumably because it considered its position on the world market to be the stronger of the two. Nonetheless, the two firms came to an amicable agreement to divide the territory up between them, and to refrain from competing in each other's national markets. In Austria, they traded under the name Gaumont-Messter-Chronophon-Biophon.[29]

The Image of French Films in Germany

As is evident from what has been said so far, no clear picture emerges regarding the reception situation: French firms dominated the market, and German exhibitors heavily depended on their products. This means that in many respects, it was *business as usual*, overriding considerations of national provenance. Yet the economic power of Germany's traditional 'arch enemy' was a thorn in many people's sides and triggered German nationalist reflexes. Strictly speaking, Pathé, Gaumont and the others were simply competitors on the market, but even in the years before World War I, Pathé was attacked for producing 'tendentious films.'[30] Significantly, in the struggles over the most important change to revolutionize the film business in Europe, namely Pathé's 1909 attempt to move from film sale to a monopoly rental system, the fact that the instigator was French played no role (especially since Pathé's French rivals were equally opposed). The measure split the emergent industry along different lines. In an open letter to the 'Zweckverband' (the official industry lobby), one representative claiming to 'speak for all those concerned but who would rather not start an argument' wondered whether the 'association should concern itself with the interests of all its members, or whether it should be representing the interests of the producers against Pathé Frères?'[31] – thus hinting at the well-known conflict of interest between producers and exhibitors. As late as July 1914, when public opinion was already being prepared for war, the *Licht-Bild-Bühne* commented on the takeover of Union-Vitascope by Pathé as 'a further step on the way to capitalist centralization of the film business,' without falling in with anti-French sentiment or attacking Pathé.

In general, then, French firms were given the relatively neutral treatment of competitors. As from about 1913 onwards anti-French feelings were being stirred up and propaganda polemics came to the fore, French firms reacted in different ways. Pathé continued to advertise with its own French-sounding name 'Pathé Frères & Co' and kept its own distribution. Léon Gaumont decided to have his films handled by well-known German distributors (such as Martin Dentler, Ludwig Gottschalk, Johannes Nitzsche) whom for the most part he bought up; he also founded the 'Deutsche Gaumont Gesellschaft' on September 12th, 1913, investing 99% of the capital, with the remaining 1% owned by his (French) manager. The name convinced many that they were dealing with a German company; even the official receiver, appointed in September 1914 to liquidate the assets, appears to have taken some time before understanding the complex ownership situation.[32] Eclair, as mentioned, turned itself into 'Deutsche Eclair' in 1914, again in a move to counter anti-French sentiment.[33]

From the end of July 1914, the German film industry went on the offensive 'against all that is foreign, especially (...) foreign films.'[34] A 'Deutscher Filmbund' (evidently representing producers and distributors) called upon cinema owners to stop showing foreign films.[35] An unsigned leader in the *Licht-Bild-Bühne* (probably by Arthur Mellini) remarked sarcastically: 'All of a sudden we are being told that our supposedly German film programmes were really French all along, and since now we're ashamed of this anti-national situation, we're clearing the decks: no more French films on German screens.'[36] Indirectly, the article hints at the various factions behind the campaign: German nationalism and patriotic pro-war enthusiasm are a welcome pretext for German film producers to get rid of the giants of the trade, Pathé and Gaumont, and to force cinema owners to exhibit domestic films.[37] Mellini, in another article, well aware of the envy, jealousy and hypocrisy, can only hold up a mirror to German producers: 'I bet that whoever throws the first stone at Max Linder is also the one least capable of imitating him, and that he who rails the loudest against Pathé is also the one who most often used to frequent its German subsidiaries. Who had started lecture tours with educational films and who had introduced the first weekly newsreels, if not the French?'[38] The *Licht-Bild-Bühne* here takes sides with the cinema owners, primarily interested in popular film programmes and little bothered about the origin of their films. In general, the French contribution was not called into question. Ferdinand Hardekopf even attributed the invention of intertitles to the French: 'Ingenious Pathé, in a move meanwhile imitated by everyone, started conveying to the public those parts of the action which could only be understood with the help of commentary (letters, description of settings) no longer by employing a film-explainer, but by printing words onto the film itself.'[39] As far as quality is concerned, the French were recognized to have set the standards. About a 1909 (German?) series extolling 'the joy of horse riding,' the reviewer remarked that 'these are films whose realism, quality and naturalness would be impossible to surpass even by a French production.'[40]

To what extent the German public actually perceived French films as French is difficult to judge. In most cases, cinema-goers would have been quite unaware and unconcerned, since the films were 'Germanicized' by way of titles, characters' names and intertitles. French comics were re-baptised: Calino was called 'Piefke,' the child star Bébé became 'Fritzchen,' Rigadin was 'Moritz,' and Gavroche 'Nunne.'[41] Intertitles were sometimes criticised for containing translation mistakes or nonsense. Teachers often used these examples as part of their complaint against the 'nuisance factor cinema,' and the trade press expressed the hope that 'a responsible letter campaign (...) might persuade French and English film producers to show a little more consideration for the linguistic sensibilities of their German audiences.'[42] Here, too, however, there were voices who suspected darker designs: 'When a classic Gallic comedian and his typically French wife are constantly being addressed as "Herr und Frau Lehmann," it is a little far-fetched to complain about this as an insult to the dignity of the German people; even if it does signal a regrettable lack of taste, and an attempt to mislead (by trying to disguise the irritatingly incessant projection of French screen insanities).'[43]

How differentiated perceptions could be of French economic dominance in the cinema industry and French ideological influence via the films is shown by an example from an unlikely source, discovered by Herbert Birett: the *Ostasiatischer Lloyd-Shanghaier Nachrichten*. In a first notice from July 1907, the cinematograph is characterised as 'one of the most popular entertainments,' adding that all seven establishments in town showing moving pictures acquire their films from Pathé.[44] In August 1911, it is reported that a certain Mr. Pasche earned himself the gratitude of the whole German expatriate community in Shanghai by having installed in his 'New Point Hotel' an 'image projecting machine' and having signed a contract with the 'leading supplier of the product,' i.e. Pathé, for 'only the most up-to-date films.'[45] Even if the reviews of the programmes themselves are somewhat patronizing, the decision to sign a contract with Pathé is endorsed as a straightforward sign of quality. Two years later, in April and May 1913, a series of articles complain about 'the coarsening of the screen':

> The firm Pathé Frères, leader in the field of film production, greatly promotes French interests. Pathé films are shown in all big cities around the globe, they glorify French institutions, inventions, the army, the navy, and, in order to secure a market also in English-speaking parts of the world, they do not hesitate to praise the brother-in-arms across the channel (...) while on purpose ignoring events in Germany altogether. As far as I can judge from the vantage point of Shanghai, the cinema seems to have become the equivalent of the British-French global press campaign against us, keeping silent about anything which might put Germany in a favourable light. (...) As long as the French film firm dominates the globe, there seems little chance that the German situation will receive fair coverage.

But this point of view did not pass without comment in subsequent issues:

> One cannot hold it against the well-known French firm Pathé Frères from Valenciennes that it is primarily concerned with French achievements on screen. It is not true, however, that it does so exclusively. Pathé Gazette, for example, often shows pictures of different events in Germany and other countries. Last Sunday, for example, in the Apollo Theater, a parade, inspected by the German Kaiser, was very well received indeed by those Germans present in the theatre. In any case, the patriotism of a French firm is praiseworthy in itself, and one cannot demand of it that it applauds the achievements of a nation that every Frenchman considers his arch enemy. It seems ridiculous and highly deplorable, on the other hand, if German cinemas show pictures of French war actions, glorifying the events of 1870/71, as the writer of this article had occasion to note in Stuttgart last year.[46]

Considered 'agitation' by some, accepted as legitimate representation of national interests by others, French films seem to have been critizised only insofar as German cinema owners

failed to make a better choice (and by implication, German film companies failed to provide better products). Elsewhere, similar discrepancies can be observed: 'Schundfilms' ('film trash') were criticized, especially when of French provenance, but Pathé's commitment to educational cinematography 'towards which it has turned its careful attention' was praised and held up as exemplary.[47]

The picture thus emerging of Franco-German relations is lively and complex. The only kind of periodization possible is that, after 1913, a more explicit trend towards anti-French commentary can be found, but even here, as we saw, the line is not a straight one. As the example of the *Ostasiatische Lloyd* shows, one would have to research the available sources more systematically in order to see what sort of generalizations are tenable. Remarkably enough, most of the positions, sentiments and complaints from the teens echo down the decades almost without change. Ironically, the French film industry, then the world leader, became itself one of those national cinemas also feeling the mixture of admiration, resentment and envy towards another successful world leader – the United States – which in the first two decades was Germany's stance towards France.

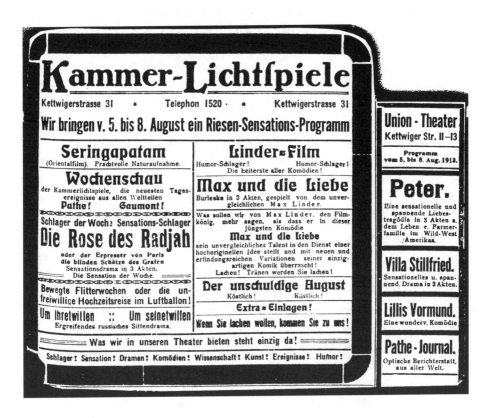

French imports on the German market

The Danish Influence:
David Oliver and Nordisk in Germany

Evelyn Hampicke

The 'Danish influence' on early German cinema has always been proverbial, associated as it is with a procession of stars and directors who became household names in Wilhelmine Germany: from Asta Nielsen and Olaf Fønns to Viggo Larsen, Gunnar Tolnaes and Valdemar Psilander, from Stellan Rye and Urban Gad to Alfred Lind and the legendary cameraman Axel Graatkjaer. Less known is the fact that their fame depended on an international industrial infrastructure, and little understood are the ways a handful of entrepreneurs put it in place, keeping this transfer of talents going in the turbulent years that followed Germany's declaration of war on its neighbours to the east and west, but not to the north. One of the most colourful and influential among the businessmen who seized their chances was David Oliver. His association with Nordisk was crucial to the Danish connexion, as it would be to the foundation of Ufa.

The period leading up to the outbreak of World War I and the first months of the war were marked by major activity in the German film industry: mergers, splits, new formations at any price. The market demanded to be serviced. Pathé, the great rival, had been eliminated. Nordisk, a Danish film company with international operations, took advantage of this situation to expand its German subsidiary, Nordische Films Co. The firm, which had been operating in Germany since 1906, evolved over the succeeding few years into the country's largest distributor. It was run by Ole Olsen, director of the Danish parent company, and the German businessman David Oliver. Oliver brought with him the Berliner Kammerlichtspiele on Potsdamer Platz and numerous picture palaces in the provinces, particularly in the eastern part of the country, all of which he owned.

Under orders from the Copenhagen–based parent company, the German subsidiary pursued a strategy of securing the German market for Nordisk productions – irrespective of political developments – as well as of developing Nordisk's influence with a view to future prospects after the war had ended. As a consequence, Nordische Films required a certain amount of capital to finance new establishments and acquisitions on the German market. The wartime situation made it advantageous to carry out business via a German executive or, even better, via a company registered in Germany.

On 6 February 1915, the Nordisk Films Kompagni in Copenhagen decided to increase its share capital from 2 to 4 million kroner. One million was put at the disposal of the board to secure closer ties with other foreign companies and to acquire the assets of those partners who preferred a cash payment to owning shares. Production was, where possible, to

be boosted so that it would be operational when peace came. At that point Nordische Films maintained German branches only in Berlin, Breslau, Düsseldorf and Leipzig: there was room for expansion. David Oliver started building up the distribution company Nordische Films into a successful, shrewdly protected horizontal group of companies that its competitors regarded with great hostility.

On 23 March 1915, Oliver Films concluded a partnership agreement in Bremen. The company handled the production, purchase and sale as well as distribution of films, all of which hinged on a basic capital of 50,000 marks. On 28 April 1915, the company was entered in the Berlin register of companies as No. 13 732.

Although film distribution was listed as one element of Oliver Films's activities in the register of companies, the general sales operation was run by Nordische Films. However, these being times of political upheaval Oliver Films was able to produce, purchase, sell and distribute films. The firm remained flexible and, if threatened with separation from the Danish parent company or even in case of a forcible takeover of administration on the part of Nordische Films, it could continue to run the company's entire business as a purely German firm. Acquiring the former property of Vitascope in Lindenstrasse, Oliver appointed Hermann Fellner, former head of Vitascope and of the Projektions AG 'Union' (PAGU), as artistic director.

Oliver Films began to enter the German market from July onwards. Its advertising posters featured polar bears balancing on a globe and a sleepy lion atop a stately pedestal. It was not long before the first disapproval was voiced. The *Lichtbild–Bühne* assessed the situation on 7 August 1915 as follows: 'If he (Ole Olsen) has secured Mr Oliver to carry out his plans in Germany then we must exercise great caution, especially since Oliver has proved himself to be a connoisseur of our theatre relations.' By this time David Oliver had indeed become something of an expert about the German film business. He had been a theatre–owner since 1905. His cinemas made huge profits, providing him with the means to take risk. He was familiar with the German distributors and had been doing business with them for years. And, more importantly, he was aware of the needs, the problems and the weak points of the sector. On 23 April 1915, Oliver registered as a member of the Press and Propaganda Committee. He later became a member of the executive committee of the Association for the Preservation of the Common Interests of Cinematography and Related Groups.

Shortly after the founding of his own company, in the spring of 1915, Oliver clinched another successful business deal. In order to secure and expand the production potential in the west of Germany he acquired from PAGU the large–capacity Union Theatre chain, for one million or – if one believes other sources – 700,000 marks. According to Oliver, the purchase was financed from his own profits made in his theatres, and Nordisk was not involved in any way. Later accounts from Ole Olsen, however, point to the role of Copenhagen in the deal. PAGU and Oliver merged their theatres to form the new company Union–Theater–GmbH. At its head sat chairman Oliver. Glücksmann, another director, was transferred from PAGU to run the new company. Chairman Paul Davidson also joined the

new company's board of directors. Since the beginning of the war, somewhere in the region of 65 cinemas had become regular customers of Nordische Films, and all of them were quite satisfied with the swift service it offered.

The growing influence of Nordische Films generated fears in the German film industry – among distributors as well as some theatre–owners. PAGU, although the largest film company at the time, was recovering from dire financial straits. Its business relations with Pathé had been destroyed by the onset of war, and the amalgamation with Jules Greenbaum's Vitascope did not yield the desired success. With the proceeds from the Union Theatre sale, PAGU had the opportunity of putting production back on its feet. It was to stick to production. The sales of PAGU's films were ensured by the distribution contract with Nordische Films. Oliver's Nordische Films Co. had 7000 metres of film per week for distribution: of these, PAGU and Oliver Film supplied 2000 metres and another 2000 metres were bought in Germany; Nordisk supplied 2000 metres from Copenhagen, while the remaining 1000 metres came from Sweden (Svenska) and America (American Biograph and Kalem). Advertising posters made a great show of the firms Nordische had under contract, handling them as an extra string to the company's bow. A glance at the distributed productions of

Die Lichtbild-Bühne,
10 July 1915

these firms explains the self–confidence with which the distributor Oliver recast the problem of competition as an issue of quality. Nordische Films delivered to its own theatres as well as to those with which it had a distribution contract. But the criticisms made against Nordisk/Nordische were increasingly mollified when David Oliver entered the debates of the various organisations in the German film industry. The speakers emphasised that their personal attacks were not directed at Mr Oliver. He had a long–standing reputation as a man of honour, his official explanations were received with complete confidence, and his trustworthiness was uncontested. The very fact that David Oliver was the link between the various companies and was at the head of Nordische Films seemed in the eyes of the cinema owners to guarantee a rosy future, because Mr Oliver's interests were known to lie chiefly with the German exhibition sector, into which he had invested a great deal more capital and which he regarded as a much greater obligation than his role in Nordisk. He could therefore be counted upon, in the event of a conflict, to put his theatres' interests before those of Nordisk.

In conflicts Oliver would, of course, represent the interests of Nordisk, of Nordische Films, but also of Oliver Films, as well as of other firms for which Nordische acted as distributor. The interest of the firms working with Nordische Films was a common one, and was in accordance with that of the parent company in Copenhagen: the conquest of the German market and the securing of profit for all the companies involved. In order to reduce the threat to this sector of the German film industry and to avoid any confrontation, Oliver made concessions to the German film industry. In August 1915, he opened his theatre to the latest Henny Porten films, which had not been shown in the leading Berlin picture palaces. In the summer of 1915, he conceded, wherever financially possible, to the demands of the theatre–owners and the film industry. For example, he gave them assurances that no further cinemas would be acquired by his firm.

Oliver was a producer, a distributor, and a theatre–owner. The competition was raging at all levels. But Oliver was an experienced businessman, who protected his enterprises on all fronts. He exploited the requirements of the German market, expressed by the theatre–owners in discussions within the German film industry in August 1915, for more short films – a demand that was not being met by German producers. Nordische Films included in its distribution lists some of these 'small pictures.'

Oliver Films presented production figures which rivalled the proportions of PAGU productions. In its second year of existence, Oliver Films registered a total of 48 films in its distribution for Nordische Films. In 1917 it produced 72, in 1918, 50 films. The records of Oliver Films' production figures for 1915–19 are to be found in Herbert Birett's *Verzeichnis in Deutschland gelaufener Filme*. The production policy of the company was an interesting one, since it included both feature films and documentaries. There were comedies, detective films, melodramas, alongside documentary films, films about cities and reports on field hospitals, events at the front, and on the industry. Documentary film production continued until 1919. These films had a more limited range than the feature films the

company produced. IM KAMPF UM VERDUN, KIRSCHBLÜTE IM ELBTAL, LEICHTATHLETISCHE WETTKÄMPFE DES 19. ARMEEKORPS, WINTER IM HARZ, UNSERE HELDEN AN DER SOMME were just some of the titles on offer.

The company placed an increasing emphasis on its purely German orientation, and the firm appeared to brag with its commitment to all things German: 'We claim and can prove wherever necessary that our company works only with German capital and that, in the same way as all other firms in our sector, it deserves the blessing of our Fatherland. It is our company's efforts to instill the German spirit into German films that have won us the best that Germany has to offer for our company.'[1] This raises the question of the nature of the links between the various enterprises. In the newspapers of the day, there was talk of the dangers of trusts; PAGU, Oliver Films and Nordische Films were depicted as subsidiaries of Nordisk. It can be assumed that PAGU had a business relationship with Nordische Films in the form of a purchase/distribution contract, but that beyond this it acted independently. It was only the dreaded deficit balances and acquisitions of capital from the PAGU/Vitascope/ Pathé period that caused a certain dependence on a strong and above all business–minded partner capable of safeguarding production sales. It could certainly not be described as a subsidiary company in the narrow sense of the term. Furthermore, Davidson, who sat on the board of the Union Theatre chain, and Fellner, artistic director of Oliver Films, brought with them other influences and obligations. And in his official statements David Oliver would always stress that Oliver Films was not in fact a subsidiary company.

This state of affairs called for a new approach to the trust debate: 'The PAGU and Oliver Films operate in Germany and their entire net profit stays in Germany. As far as the theatres are concerned, the vast sums spent on rent, cinema taxes, lighting and so on stay in Germany. Approximately four–sevenths of the purchasing and distribution of films remains in Germany, the other three parts abroad. The entire net profit remains in Germany.'[2]

The capital obligations between the firms involved were to remain clear, limited and incontestable, as Oliver constantly pointed out, guaranteeing the accuracy of his statements by stressing the financial liability involved, but there were obligations as far as personnel were concerned, a dependency particularly reinforced by the common interest in commercial survival and profit. There was evidence that personnel would transfer in the course of financial transactions between the enterprises, in the form of either exchanges between firms or following the direct intervention of David Oliver in the commercial running of the various enterprises.

What the records show is that in August 1915 David Oliver was a partner in Nordisk in Copenhagen, company director of Nordische Films (the largest distribution firm in Germany), owner and director of Oliver Films, and owner and director of the Union–Theater–GmbH. Oliver had to ensure that he was legally unimpeachable. Yet even today we cannot be certain as to the true nature of the foreign capital issue in the group's enterprises. Conjecture about the actual interconnections between Nordisk, Oliver and Nordische Films gives something like the following picture:

1) It would have been possible for Oliver, as a partner of Nordisk, to have used this company's capital. This could even have been the case during the war period, since Nordisk was supported by capital from German banks. It is also possible that the acquisitions in Germany were carried out with Oliver's capital or with the capital he took in Germany and secured, as a countermove, by the aforementioned 'shares issue.' Foreign credit for the war period and its aftermath appeared lucrative. On 13 December 1918, Nordisk, whose shares at the stock market had risen from a loss value to more than 180 points in the previous month, announced that it had sold a part of its foreign interests on favourable terms. This indicates there was pressure to dispose of their significant involvement in cinemas and film production companies in Germany.[3] In 1921 the shares in Nordisk were transferred to the Deutsche Bank consortium.

2) Nordische Films was a true subsidiary of Nordisk. Its official managing director was Ole Olsen, but David Oliver figured in this function as well. Oliver was not a mere puppet of Olsen, but rather acted as his deputy, enjoying far–reaching powers. Nordische Films was, with its separate enterprises, a vertical group of companies able to withstand a split with the parent company in times of war and remain operative and competitive, even if the subsidiary company abroad became subject to punitive measures. All the functions performed by Nordische Films could easily have been carried out by Oliver Films, according to the company contract of 1915. From the end of 1916 on, Nordisk no longer sold completed films to Germany, and repeated requests for import were turned down on the German side. Rumours began to spread that Nordische Films would abandon the business. A full page insert in *Der Kinematograph* of 27 August 1917 warned the company's competitors of unfair competition manoeuvres.

Oliver provided war loans amounting to a total of 1.25 million marks. Before Ufa had even entered the register of companies, Oliver Films initiated proceedings against the take–over of several theatres in Rhineland–Westphalia: a Westphalian bank was found to be involved, and a large distribution company was accused of buying up cinemas. In 1918, Nordische Films, the firm established by David Oliver, but probably under contract from Nordisk Films Kompagni and consisting of Oliver Films, the theatre companies of Nordische Films, and the distribution firm Nordische, merged with Ufa. The PAGU followed suit.

David Oliver, managing director of Nordische Films, became the first expert in his division at Ufa, with an annual salary of 44,000 marks plus a profit sharing bonus. He was responsible for the theatre and distribution side. In May 1919 he became a member of the board of Decla. In 1920 rumours began circulating about an imminent merger of Decla–Bioscop and Ufa. On 2 December 1920, David Oliver left the board.[4] His place was taken by Rudolf Meinert, and Erich Pommer took over the production aspect. From this point on,

Der Kinematograph, 10 July 1915

there is little trace of David Oliver in the film business except as property developer and real estate financier.[5] In the five years of his brief but significant involvement in the cinema industry, however, he could claim to have navigated innumerable Danish films – and with it their stars – through the stormy seas of nationalist propaganda and import regulations, providing German audiences with some of their most cherished entertainment fare. What in retrospect could all too easily appear to have been only a minor footnote to the 'Great War' has nevertheless the always useful lesson of 'non olet.' Ole Olsen's and David Oliver's activities are a timely reminder of the early cinema's truly international outlook: how else could a German entrepreneur have single–handedly defended the German market against domestic competition on behalf of a Danish company?

Paul Davidson, the Frankfurt Film Scene, and AFGRUNDEN in Germany

Peter Lähn

The year 1905 saw the emergence in many German cities of the first locally oriented film companies. The permanent exhibition centres drew new consumers from all levels of society, and from the middle of 1906 onwards, 'regular establishments' proved so popular that the cinematography business experienced a boom. The city of Frankfurt am Main played a leading role in what was an exceptionally successful period for the development of the German film industry, from 1916-1918. The economist Karl Zimmerschied even referred to Frankfurt am Main as the birthplace of the Ufa conglomerate.[1] Zimmerschied is alluding to the beginnings of an economic concentration in the film industry – the 'projection joint-stock company Union' in Frankfurt, founded by the businessman Paul Davidson and later known as PAGU (for: Projektions-Aktiengesellschaft 'Union').

On 21 March 1906, within days of the opening of the first local cinema in Frankfurt, the four partners – Paul Davidson, Hermann Wronker, Julius Wiesbader and Max Bauer – founded the Allgemeine Kinematographen-Theater Gesellschaft, Union-Theater für Lebende und Tonbilder GmbH (AKTG). It was Davidson who took over the role of managing director and put his personal stamp on the company, while the remaining three partners stayed out of the limelight. Davidson was born in Loetzen, East Prussia on 30 March 1871. After completing his management studies he worked in the textiles trade.[2] His activities in Frankfurt date back to 1902, when he became director of a Frankfurt night-watch and security firm, regarded as the first of its kind in Germany. The department store owner Hermann Wronker was the co-founder of the company. He ran department stores in Hannover, Nuremberg, and other cities, but the chain's headquarters were based in Frankfurt. Julius Wiesbader, born on 26 November 1868 in Heidelberg, owned the 'Julius Wiesbader Mattress and Upholstery Factory' and was the director of the patent development company 'Sanitas.' He was also part-owner of the real estate management firm 'Max Bauer & Julius Wiesbader.' Max Bauer, born in Frankfurt on 6 May 1870[3] and Julius Wiesbader owned valuable property at 60 Kalverstrasse, where August Haslwanter had set up his first cinema. Haslwanter's commercial success may have been the impetus for the two real estate salesmen to join Davidson and Wronker in founding a company which would develop a nationwide cinema chain. The capital they raised – at least 20,000 Reichsmark – was sufficient to establish a limited company, but it is safe to say that the partners put greater sums at the disposal of the company for setting up a successful cinema chain.

The AKTG opened its first cinema in June 1906 in Mannheim, called 'Union Theatre.' The abbreviation 'U.T.' became the brand name and was synonymous with superi-

or cinema theatre culture well into the 1920s. The company expanded rapidly, and new 'U.T.' cinemas were opened almost monthly: in July 1906 in Frankfurt am Main at 17 Grosse Gallusstrasse (the owners of the property being Wiesbader & Bauer); in August in Cologne in the Hohestrasse 23-25, then in Elberfeld, Ludwigshafen, and Düsseldorf, always on prime commercial sites. In February 1907, the AKTG also opened a theatre abroad, in Brussels (36 Place Broukere).[4] Little else is known about the activities of the AKTG abroad, except that the company also opened international 'Union Theatres' in Amsterdam (March 1911) and Strasbourg (autumn 1913). According to Zimmerschied, a businessman by the name of Pollack had had 'an option right until 20 February 1910 on [the AKTG]'[5]:

> He first wanted the company to be turned into a Belgian joint-stock company and merge it with the Société générale des théâtres cinématographes. This would have become the first company to operate internationally on a grand scale. But no use was made of this option right.[6]

No evidence of these activities has come to light either on the part of the AKTG or of correspondence between Pollack and Davidson. The successful expansion and even exceptional economic success of the AKTG is proven by the profits for the financial year 1907, which amounted to 98,067 marks. Profits on this scale were also recorded for the following years.[7]

In addition to its national activities, the AKTG pursued local Frankfurt interests. Apart from the U.T. in the Gallusstrasse, referred to in the trade press as 'Theater du Nord,' it opened in November 1907 the second U.T. cinema, at 74 Kaiserstrasse. But other financiers with large sums of capital were buying into the Frankfurt cinema business. In 1907 the 'Edison Theatre' opened at 14 Schäfergasse, under the management of Messrs Höhn and Eichenauer. The cinema was equipped with an Edison projector and showed American productions. The Frankfurt film theatre scene moved further ahead with the opening of 'sound picture theatres'[8] specially built for showing 'Tonbilder.' These forerunners of the sound film were based on Messter's system, the 'Biophon,' which he had presented in a Berlin music hall with great success as early as 1903.[9]

In the Biophon process, sound and image were recorded separately. Having first recorded an aria or song on gramophone, the appropriate scenes would be staged and mimed in a film studio, sychronous with the sound. In the early days three minutes was the maximum length on technical grounds. While not the only inventor (both Edison and Gaumont had similar ideas), Messter's commercial edge was largely due to his superior techniques of synchronically creating an impressively 'natural' effect. The most popular 'Tonbilder' featured opera arias, as well as variety acts by famous comedians. But it was not until 1907, with the rise of the local cinemas, that Messter's business really began to boom. Initially, he was able to sell his reproduction apparatus on the German market without any competition. The Frankfurt businessman Heinrich Putzo saw demonstrations of these sound pictures in Messter's Berlin 'Biophon Theatre' at Unter den Linden in April 1907, and with-

in three months he had raised the capital to enter the sound picture theatre business in grand style. He founded the Deutsche Tonbild-Theater GmbH with the aim of opening sound picture theatres in several German cities. This made him the third financier in Frankfurt to attempt to spread his activities in the cinematic field to other cities. Putzo cooperated with Messter on a commercial basis and obtained from him not only the Biophon projection equipment, but also a large quantity of the sound pictures, which were also produced and sold by Messter.

The premiere of the Frankfurt 'sound picture theatre' at 54 Zeil [a Frankfurt street] took place on 8 June 1907 to a 'completely packed house.' Newspaper reports noted that this opening had been preceded a day earlier by a test presentation where

> high society accepted the invitation to observe the progress that had been made in the field of the art of projection, especially with respect to speaking, living photographs. The long-held desire to create such a work of art which would appeal even to the educated sectors of society has now finally been realised and is unlikely to disappoint the Frankfurt public.[10]

The programme of the premiere was typical of Messter's sound picture productions – a mix of cultural performances and appeals to patriotism and national pride, in keeping with the tastes of the times – which on this occasion included musical sound pictures as well as documentary footage of the Kaiser, the latter also a Messter speciality.[11] The equipment of the 'sound picture theatre' at 54 Zeil set high quality standards and was described by the reviews as 'extremely elegant in every respect, extremely practical and tasteful, and equipped in a manner entirely fitting the modern age.'[12]

Fierce competition between the various cinema theatres in Frankfurt forced the other cinemas to provide the same level of comfort and service. Only three months later, in September 1907, the trade magazine *Der Kinematograph* reported that 'the Frankfurt cine-matographic theatres' were trying hard 'to win favour with the public by frequently chang-ing programmes. A further advance is that some theatres have done away with the annoying orchestra accompaniment and replaced it with suitable piano compositions which illustrate the pictures projected on their screens.'[13] Only a year had passed since Davidson had set up the first 'U.T.' with 'wooden benches and orchestra.' Davidson and the AKTG responded to the success of the 'sound picture theatre' by establishing their own sound film theatre in Frankfurt in November 1907, at 74 Kaiserstrasse. The two cinemas embarked upon a com-petition that proved lucrative for both parties. The 'sound picture theatre,' for instance, scored a major hit with its 'Caruso gramophone presentations' shown simultaneously with a guest appearance by Caruso at the Frankfurt opera. The demand for the Caruso sound pic-tures far outstripped that for his opera performances, and his presence on the screen of the 'sound picture theatre' lasted for weeks: 'The Caruso gramophone presentations are also unequalled in the naturalness of their reproduction and their purity, and have a simply stun-ning effect, giving the public the impression that they are actually seeing and hearing the

great Italian artist in the flesh.'[14] Sound film production was a huge success both in terms of quality and quantity, and the reputation that the cinema theatres gained as a result paved the way for new kinds of audience. Messter acted on this strategy for quality and won prominence for his sound picture recordings, able to afford the kind of fees that attracted even the likes of Caruso.[15]

Rising to the challenge, Davidson countered with another qualitative innovation when he presented a real sound film premiere to the public: 'From 1 January the Union Theatre at 74 Kaiserstrasse will bring out an entirely new hit and 8 themes from *Der Walzertraum*, the latest operetta by Oscar Strauss, with the original cast from the Vienna Carltheater.' The operetta had been premiered in Vienna on 5 March 1907, and the sound picture extracts were presented to the public with all the status of an opera house premiere. Heinrich Putzo, who in the meantime had become the owner of sound picture theatres in Braunschweig and Magdeburg, took over another theatre in Frankfurt and became a competitor of Davidson, as well as his neighbour: he opened a cinema at 50 Kaiserstrasse, the site of the former 'Kinephontheater.' Under the new name of 'Boulevard Theatre,' it staked its success on 'humorous and actuality genres.'[16]

Thus, the greatest service performed by the sound pictures was not to introduce a new technology, but to enhance the social status of cinema among those at home in the world of the established arts. Shortly thereafter, the 'Tonbilder' as a genre went into steep decline, either because they experienced a dramatic fall in profit margins due to the huge drop in prices for sound pictures in 1909, or because they had fulfilled their purpose as cultural bait for the better-off. Putzo, the cinema entrepreneur, for instance, experienced financial difficulties in 1910 and was unable to prevent the rapid bankruptcy of his company.[17]

After these stormy beginnings of Davidson's AKTG, the years that followed saw a period of commercial consolidation. As indicated, the company's annual profits between 1908 and 1910 averaged approximately 100,000 marks.[18] In 1908 the AKTG opened two more picture palaces, in Pforzheim and Mannheim, and in 1909 more cinemas were built in Frankfurt and Berlin. The AKTG continued to aim for an upmarket image in their cinemas, without losing sight of the popular aspects of the business. At the opening of the new 'Union Theatre' in Berlin's Alexanderplatz in September 1909, the trade press noted its affordable entrance fees, 'which, at 30 pfennigs and upwards, made it accessible to all sectors of society.'[19] Davidson's business strategy proceeded along two lines, setting prices which would draw the broadest possible public but equipping the theatres in a style that would also attract the well-heeled spectator. The *Frankfurter Adressbuch* of 1909 praised the 'U.T. in the Kaiserstrasse as the most exclusive and elegant theatre of its kind in Germany' and one which 'attained the very highest level in both its technical equipment and its programming.'[20] With his strategy of 'affordable luxury,'[21] Davidson put pressure on other, smaller cinemas. But it was not only the drop in entrance fees that characterised the crisis of the film industry in 1909. Arthur Spamer, a political scientist, described the film industry already in 1909 as an industry of luxury goods, which existed for no other purpose than to gratify the needs which

it had itself created.[22] Despite the huge demand, there were more films on the market than there were cinemas to show them. Spamer estimated the over-production of films at somewhere in the region of '10,000 metres per week.'[23] This surplus of films did not, however, affect the commercial activities of the AKTG. It had sufficient financial resources at its disposal to continue investing in the cinema industry and expanding its activities. With a strong presence in Berlin, the AKTG developed the most important film market in Germany, and this in a period of market recession.

The expansion of the AKTG, though, could not be wholly financed in its existing form as a limited company. The partners in the AKTG decided to take the next step and on 12 March 1910 signed a contract setting up the projection joint-stock company 'Union' (PAGU), which was entered in the Frankfurt register of companies. The PAGU expanded its activities from equipping and running cinematographe theatres to 'the manufacture and the sale of films and film apparatus.'[24] The PAGU therefore became not only the first German film company quoted on the stock exchange, but also the first to be involved in the four vital spheres of cinema exhibition, distribution, film production and equipment manufacture.

> The PAGU has a basic capital of 500,000 marks at its disposal, made up of 500 shares at 1,000 marks each. The shares are in the name of the holder and have been issued at face value (...). The only member of the board is the businessman Paul Davidson (...).[25]

The founders of the company were the Frankfurt businessmen already active in the AKTG, Wronker, Wiesbader, Bauer and Davidson, as well as a manufacturer from Mannheim, Heinrich Hellwig. The first board of directors also included Albert Schlöndorf, an industrialist from Düsseldorf, and the lawyer and city councillor Max Jeselsen from Mannheim.[26] The AKTG continued to exist as an independent firm for a short period, but was gradually liquidated from 1911 onwards, winding itself up in May 1912.[27] In June the PAGU moved 'its new, greatly expanded commercial enterprise' to 64 Kaiserstrasse.[28]

The PAGU's initial expansion was in the exhibition sector, concentrating on Berlin. In 1910 the PAGU founded five theatres there, with the U.T. at 21 Unter den Linden setting the standard for high quality in the field. An idea of the increase in audiences at the U.T. can be gauged from some in-house statistics: in 1910 2.5 million visitors are recorded, with the figure rising to 6 million in 1912.[29]

In Frankfurt, meanwhile, Davidson fought over every single spectator. The rival 'Hohenzollern Theatre,' which had opened for business in June 1910, defended itself in a letter against a lawsuit threatened by PAGU over unfair competition. The bone of contention was the 'Hohenzollern' advertisements in which the cinema described itself as 'Frankfurt's biggest cinematograph theatre' showing 'the latest pictures.' The management self-confidently opened its books to prove that it was unsurpassed in Frankfurt in terms of box-office figures:

The best confirmation of the quality of our presentations is the number of visitors to the Hohenzollern Theatre. From 8-17 July – a period of ten days – our theatre welcomed a total of 6523 visitors, if our records of ticket sales are anything to go by. No other cinematograph in Frankfurt is in a position to make a similar claim. We are therefore not in the least perturbed at the prospect of legal action by the 'Union'-Theatergesellschaft.[30]

It would appear that the 'Hohenzollern Theatre' was quicker to adapt itself to new developments in the marketing and exhibition sector than a vertically integrated company could, however innovative its overall business strategy. Thus, the cinema sensation of 1911 – AFGRUNDEN, Asta Nielsen's first film under the direction of Urban Gad – had its first Frankfurt showing at the 'Hohenzollern Theatre':

> (…) the Hohenzollern Theatre in the Hohenzollernstrasse, near Bahnhofplatz, since the middle of last week has been showing the sensational theatre drama in two acts from Urban Gad, entitled AFGRUNDEN. If ever a film exerted great powers of attraction then it is this one (…) We see a lively, exciting, shattering drama presented in a realistic, purely objective manner which, despite lasting a full 45 minutes, manages to satisfy all the demands made in our hyper-modern age.[31]

DER FREMDE VOGEL (1911):
Eugenie Werner, Hans Mierendorff, Carl Clewing, Asta Nielsen, Grete Karsten, Louis Ralph
(from left to right)

The film was in many ways a turning point, also showing the way to a new marketing concept: the so-called 'Monopolfilm.' The Düsseldorf film distributor Ludwig Gottschalk had purchased the exhibition rights and with it pushed through the new distribution system, based on granting an exhibitor 'monopoly' or exclusivity for exploitating a given film within a specified territory.[32] Even if PAGU was left standing in this case, it profited from the new distribution policy. At the same time as AFGRUNDEN, Davidson was marketing his own monopoly film, the American boxing title fight JOHNSON VS. JEFFRIES, which was shown in both the 'Boulevard Theatre' on the Kaiserstrasse and in the 'Sound Picture Theatre' on the Zeil.[33] For Davidson this much-advertised sports attraction was an attempt to test the effectiveness of the monopoly film as a distribution concept. The results convinced him, and from then on, PAGU wanted to enter distribution and especially production, but in style. He was looking for an opportunity to translate the quality formula of his film theatres into the production sector, and Asta Nielsen seemed made for it. On 1 June 1911 Nielsen and Urban Gad, with Paul Davidson as senior partner, formed the 'International Film Sales Company,' which ensured the European-wide exploitation of the Asta Nielsen/Urban Gad films. Davidson has described how he came to make this crucial decision for the economic prosperity of PAGU:

> (…) I had not been thinking about film production. But then I saw the first Asta Nielsen film. I realised that the age of the short film was past. And above all I realised that this woman was the first artist in the medium of film. Asta Nielsen, I instantly felt, could be a global success. It was 'International Film Sales' that provided 'Union' with eight Nielsen films per year. I built her a studio in Tempelhof, and set up a big production staff around her. This woman can carry it (...). Let the films cost whatever they cost. I used every available means – and devised many new ones – in order to bring the Asta Nielsen films to the world.[34]

PAGU developed into the most prestigious production company in Germany. The contract with Asta Nielsen involved 24 films, divided into annual series. The first series met with huge acclaim and succeeded in setting the aesthetic standard that raised filmmaking to the status Davidson had aimed for. But the commercial success of PAGU's policy also distanced the company increasingly from Frankfurt. All decision making of any importance took place in Berlin, and at the end of 1912, PAGU relocated its head office. In a brief report in a trade paper, one finds the matter-of-fact statement that 'this relocation comes in the wake of a further expansion of the company and the setting up of a film factory. A branch office will be maintained in Frankfurt am Main.'[35]

Munich's First Fiction Feature:
DIE WAHRHEIT

Jan-Christopher Horak

While Berlin was the centre of the German film industry in the first half of the 20th century, Munich could after 1919 claim the title of Germany's second city of cinema. The Geiselgasteig Studios and the Stuart Webbs Atelier in Grünwald, the Arnold & Richter Studios in Schwabing, as well as other production facilities, turned out a steady stream of films throughout the twenties, thirties and forties. In the post-World War II period, Munich's Bavaria Studios in Geiselgasteig actually advanced to West Germany's most important production centre, when most of the Berlin studios were taken under Russian control in 1945, and later turned over to the Defa. True, the great silent German expressionist films and the 1920s classics by Lang, Murnau, and Lubitsch were shot in Berlin, but Munich produced its share of historical epics, including STERBENDE VÖLKER (1921, Robert Reinert), MONNA VANNA (1922, Richard Eichberg), HELENA OF TROY (1923, Manfred Noa), WATERLOO (1928, Karl Grune), LUDWIG II (1929, Wilhelm Dieterle), Stuart Webbs Detective Films, and especially 'Heimatfilms,' including DER OCHSENKRIEG (1920), DIE GEIERWALLY (1921, E.A. Dupont), THE MOUNTAIN EAGLE (1926, Alfred Hitchcock), and DER WEIBERKRIEG (1928, Franz Seitz). If Berlin had its Ufa Konzern, Munich had the 'Emelka-Konzern' (founded in 1918 as the Münchner Lichtspielkunst A.G.), which like Ufa, evolved into a horizontally and vertically organized film company, including production, distribution, exhibition, studios, and laboratories. Until the mid-twenties the guiding light behind the M.L.K. or 'Emelka' was Peter Ostermayr, like Oskar Messter one of the forgotten pioneers of German cinema.

Born on 18 July 1882 in Munich, Ostermayr had inherited his father's photography studio, but soon branched out into motion pictures: in 1907 he and his brother Franz (later known as Franz Osten) founded an itinerant film projection company (Wanderkino), called the 'Original Physiograph Compagnie.' When a nitrate fire and poor business put an end to the venture, Peter and Franz Ostermayr turned to an activity closer to their roots, making films, all the while continuing their photographic portaiture business. In 1908, they began producing a series of 'scenics' of Munich and the Bavarian countryside and actualities of current events, which they sold to Gaumont, Pathé Frères, Eclair, and Messter. A year later, Ostermayr founded the Münchner Kunstfilm Peter Ostermayr, converting a portion of his roof-top photography studio in Munich's Karlsplatz into a film studio.[1]

Then, in 1910 Ostermayr directed his first fiction film, DIE WAHRHEIT ('The Truth'), which, however, was never commercially distributed. Just why this film was never released is unclear; there are no censorship records and no press reports. Like much of Munich's early film history, this film has been the subject only of anecdotal narratives,

while little rigorous historical research has appeared. This essay cannot fill the gap, but it will attempt to read 'against the grain' two of the few original sources available, an unpublished autobiography of Peter Ostermayr and the film itself,[2] in order to reach some tentative conclusions about the state of the early German film industry in Munich.

In 1910 the German film industry was at the cusp of a major breakthrough which in a few short years would lead to the founding of Ufa as a major player in the European film industry. Even though French film companies, like Gaumont and Pathé, supplied the majority of films screened in German cinemas at this time, German film production was beginning to expand, as cinemas continued to sprout up everywhere. In Munich alone, the number of cinemas doubled between 1910 and 1913, reaching a total of over 50 (Berlin had three times as many in the same period). Meanwhile, Paul Davidson, founder of the largest German cinema chain, established the Projektions A.G. 'Union' in 1910, enlarging his exhibition operation to include distribution and film production. In 1912, he signed an exclusive contract with the Danish actress Asta Nielsen, soon to become Europe's most popular actress.

While in 1910 only four major companies produced films in Germany, the Deutsche Mutoskop- und Biograph, the Vitascope GmbH, Duskes Kinematographen und Film-Fabriken GmbH, and Messters Projektion GmbH, several important companies were founded in the next two years, including the Projektions-A.G. 'Union', the Continental-Kunstfilm GmbH, and the Eiko Film GmbH.[3] The expansion of Berlin's industry appears even more dramatic when considering smaller companies: while at the beginning of 1909 there were 28 production companies, the number had increased to over 70 by 1911.[4] In 1912 the Babelsberg Studios were built by the Bioscope Film Company, and a year later the Vitascope Studios at Weissensee (later purchased by Joe May) were constructed. It is indicative of the state of affairs that while all this activity was going on in Berlin, Munich was just taking its first steps towards becoming a production centre. In his autobiography, Peter Ostermayr writes:

> As already mentioned, the era of shooting interiors on open air stages had passed. Films were now produced in glass houses, usually empty photography studios. I had a photo studio, even if it wasn't empty. Initially, the littler studio, used for film developing, would have to do. So I had a glass house and a cameraman, myself... The littler studio was cleaned out. Using background flats from the photography studio, I had sets painted. The door was cut out of canvas and stretched over a frame. No matter if it vibrated when being open and closed, that also happened in the films we projected in the 'Physiograph Comp.'[5]

Thus, while in Berlin film companies had begun to build huge free-standing glass studios, specifically designed for film production and capable of enclosing large sets, Ostermayr was merely setting up a roof-top studio, the kind that had been in existence in Berlin's Friedrichstrasse since before the turn of the century.[6]

Ironically, Ostermayr could just as well have shot his film in a warehouse, since he goes on to describe his efforts to darken the studio by placing drapes *outside* his glass roof.

Leaving them inside the windows would have made them visible in the frame. Furthermore, he was only able to hang his six newly acquired arc lights in a row from the highest point of the glass roof, since they, too, would have been visible in the frame in any other position. The actors were thus exposed to strong lights in the centre of the studio, but light levels fell off significantly at the edges, forcing Ostermayr to stage all his action centre frame.

Finding props for the backstage scenes was relatively easy, since Ostermayr's photography studio was equipped with numerous backdrops for the genre portraits popular at the time. Ostermayr used personal furniture from his home for the set for the doctor's office. The improvised set decorations saved Ostermayr the cost of hiring an art director. However, as Ostermayr admits, he had failed to keep abreast of the times. His sets looked cheap and old fashioned, when compared to the newest films coming from Berlin: 'The Berlin productions had not stood still, just as the development of the dramatic films made great leaps forward from month to month, even from week to week.'

Once shooting began with his crew of stage actors, none of whom had ever appeared before a movie camera, Ostermayr had to send the rushes to Berlin to Pathé's laboratories, since Munich was still without a motion picture lab. Given the cost of raw film stock, Ostermayr could not afford to shoot each scene more than once, having previously rehearsed the scene with the actors.[7] After each day's shooting, Ostermayr worried about the quality of the exposed material, until the lab confirmed that the negative was printable. The film was completed in six days at a cost of 900 Reichsmarks.[8] It had a length of 490 metres and was edited by Ostermayr himself.

With the finished film in his luggage, Ostermayr took the first train to Berlin, in order to screen it for some representatives of Pathé's German distribution company, and hopefully make a sale. According to Ostermayr:

> After the lights were turned on, I looked at my 'buyers' with a nervous grin. I was ready for anything. The gentlemen, there were six against one, praised the photography in particular. Oh, that was medicine for my wounded heart. The acting, too, was not bad, but the sets left much to be desired! They were out of date. A half a year earlier they would have been fine, but considering the films that had since appeared...[9]

To make a long story short, Ostermayr did not make a sale. In fact, he never sold the film, although apparently a Munich film distributor was interested in buying DIE WAHRHEIT sight unseen. But Ostermayr was too proud to confess that he had been rejected by the world-class competition in Berlin, and told the interested party that he was close to making a deal in Berlin. Ostermayr chalked up the experience as an apprenticeship exercise and shelved the film, having first received the blessings of his co-financier.

If this autobiographical narrative is in any way true, then it contains at least one lesson for historians of early cinema. While much emphasis has been placed on the development of film techniques, especially camerawork and editing, little attention has been paid to

advances in art direction. Yet, as this anecdotal account makes clear, art direction was an important criteria of value in an expanding film market. Like the Hollywood film moguls of the next generation of film manufacturers, early producers were very cognizant of making every mark, franc, or dollar visible on the screen. This was especially true in this transition period from *film d'art* (which still made do with painted sets) to the *Autorenfilm*, i.e. between 1908 and 1912.

It must also be pointed out that, as Corinna Müller has noted, the expansion of German film production had led to an oversupply of films. Quoting *Die Lichtbild-Bühne* she writes: 'The sales chances of an individual producer were thus limited, because, as was noted in 1911, "the individual film distributor today can consider only a limited number of film producers when selecting a weekly program."'[10] Of the approximately one hundred new subjects available weekly, thirty to forty percent could not be sold.[11] It is therefore not surprising that Ostermayr, as a novice film producer, was unable to find a buyer for DIE WAHRHEIT. Significantly, after the failure of DIE WAHRHEIT, Ostermayr's second film, MUSETTE (1912) was banned by the Munich police.[12] His first successful film was not completed until late 1913: ACH, WIE ISTS MÖGLICH DENN premiered at Munich's Sendlingertor Cinema in the presence of 'the cream of society.'[13] Indeed, it was not until the post-World War I period that Ostermayr's production companies began producing more than a handful of fiction films a year.

DIE WAHRHEIT tells a simple story. Karl Wolter, a successful theatre actor, begins to lose his sight. He is treated by a doctor who is loathe to tell the actor he will become competely blind. Instead, he writes a letter to the theatre director, asking him not to fire the actor due to his illness. The actors's fiancée, the actress Inga Lara, leaves him, sinking the actor into a deep depression. In order to learn the truth about his condition from his doctor, he invents a ruse: he puts on a beard and poses as his own father. He commits suicide when the doctor confesses the truth.

Looking at DIE WAHRHEIT today, the film seems not nearly as bad as one might believe, given Ostermayer's account. In fact, compared with similar efforts in Germany and Scandinavia, the film is definitely a respectable first effort. Certainly, the film has its defects. Common to all early cinema, the film's continuity does not conform to classical narrative modes of address. For example, the scene in which the actor walks across a city street and is nearly killed by a passing car was shot twice and is shown back-to-back (in the first take the driver shoots out of frame before coming to a stop to scream at the actor, as seen in the second take). This doubling of action was not uncommon in the very early days, but by 1910 was certainly considered a 'mistake.' In two different spaces an insert and intertitle, respectively, are cut into the film prematurely, well before, rather than during, the action they refer to. Finally, the shots continue long after the central action in the scene has been completed, again a not uncommon occurrence in early cinema.

Then there is the matter of sets. The interior sets in the opening scenes at the theatre are obviously painted backdrops. Not having the funding for filming in a real theatre

Street: Car accident

Pagliacci

Theatre

Doctor's office

with an audience, Ostermayr relies on a shot, reverse shot construction to show the actor performing 'Pagliacci' and his adoring fiancée in a box watching him. The doctor's office, too, is only sparsely decorated. What makes the painted sets all the more obvious is that Ostermayr shoots several other scenes outdoors: the actor leaving the doctor's practice and nearly being run over by a motorcar, two scenes in front of the stage entrance, the actor sitting in a park, and a confrontation scene between the actor and his faithless fiancée in her garden. Furthermore, all the interior scenes are extremely cramped and staged centre frame, due, as noted above, to the small size of Ostermayr's studio and the position of his arc lamps. As a result, virtually all the scenes are constructed as static, two-person confrontations, with the only movement coming from characters moving forward or backward through a door at stage centre.

One can argue, however, that such a *mise-en-scène* would soon become conventional as melodrama, and indeed, DIE WAHRHEIT can be analysed as a male melodrama. Thus, Karl Wolter's illness can be read as a kind of male hysteria, brought about by a fear of

Garden of fiancée

castration. In fact, as a man he can never live up to the great roles he plays on the stage. It is significant that the actor celebrates a triumph in the role of Pagliacci, a character who is indeed 'castrated' by his actress-wife's infidelities. And if to confirm the narrative on stage, it is his blindness off stage that precipitates his fiancée's infidelity: 'I loved him as a great actor. Now he means nothing to me.' Two more scenes signify his symbolic castration. Unbeknownst to Wolter, it is the actress who is sitting in the car that almost runs him down, while in a later scene in her garden, he is powerless when confronted with her new lover. Finally, however, it is his prowess as an actor which allows him to play his last role, in order to find out the truth of his condition. Unable to cope with both the loss of his professional stature and his fiancée, and facing a future as an invalid, Wolter commits suicide. It is his last act of free will.

No doubt, this first fiction feature by a Munich film production company will remain a footnote to the history of the German film industry. It took the closing of Germany's border and the concomitant elimination of the French competition to give Munich the boost needed to establish a functioning film industry. By 1918 several film producers were at work in Munich, including Peter Ostermayr's Münchner Kunstfilm, Moewe-Film, Bayerische Filmindustrie A. Ankenbrand GmbH, Rolf Randolf-Filmgesellschaft, Jost-Film, Weiss-Blau-Film, and Leo-Film. Writing a serious history of these companies and their production will be the next step in filling a gap in the history of German cinema.

Moving Images of America in Early German Cinema

Deniz Göktürk

The better movie theaters showed mostly American pictures. How we laughed at funny, fat John Bunny and his jokes! Although we saw a lot of French films as well, Pathé-films with Max Linder and little Fritzchen Abélard, for example, nothing had the dramatic tension and nothing suited our youthful fantasies better than the American films of that time.[1]

For George Grosz and his friends America was a thrilling imaginary space which they knew from the adventure novels of their childhood – Grosz told of copying by hand as a boy of nine a whole volume of James Fenimore Cooper's *Leatherstocking Tales* – and which they found revived in the movies. They would dress up as urban cowboys at studio parties, portray themselves in American style, or even Americanize their names, and they frequently depicted American scenes in their sketches and paintings, which drew on the realm of adventure novels and movies, providing them with fantasies of liberation and escape from the narrow world of a small town upbringing. At the same time, these works were interspersed with reflections of life in the urban jungle. The violent features of the shady individuals populating a typical frontier town were grounded with impressions of crime and violence in wartime Europe, where streets, cafés, and cinemas were full of soldiers and prostitutes.[2]

The overwhelming experience of global industrial power, culminating in 'national conflicts' and wars, pours out in a cascade of hasty, fragmentary exclamations. This futuristic whirl is, however, permeated by a counter movement of archaic imagery. Irrational forces undermine the rationalised American business world: the engineers reveal themselves to be 'black magicians in American smokings.' Grosz associates the engineer, the paradigm of the industrial, techno-rational world, with the figure of the gold-digger.[3] The modern embodiment of control and power is thus blended with the qualities of a pre-industrial type of adventurer. This amalgamation can also be observed in the sketch *Der Goldgräber* from 1916. The gold-digger is an adventurous-looking sailor, decorated with tattoos, a necklace, a pistol and a knife. He stands in the midst of a waste landscape with a spade and a pipe in his hands. A whisky bottle and a morphine syringe point to an urban underworld. In the background lies a dock area, where at the centre of a row of houses the inscription 'Cinema' jumps right into the eye – the locus of origin for those adventurous scenarios.

German reactions to early cinema often tended to be interwoven with utopian or dystopian projections of America. The films from the United States transmitted fascinating-

ly immediate impressions of American scenes which were understood as being more 'authentic' than the information which any of the print media had provided hitherto. At the same time, current writings of American lifestyle still provided the backdrop against which these new pictures were perceived. Throughout the political spectrum, America served as a highly ambivalent symbol which contained both the fascination and the anxiety caused by rapid modernization in progress on both sides of the Atlantic. Many elements fundamental to German notions of America as a model for modernity and a good deal of the cultural hierarchies still defended today crystallized in the early 20th century around the rise of the new mass medium film. Whereas for conservative critics 'Schreckbild Amerika' served to explain everything they abhorred about the emerging mass culture, the identification of film with America was also used in a positive sense. In 1913, the writer Walter Hasenclever wrote an apology for the 'Kintopp':

> The 'Kintopp' remains American, ingenious, and kitschy. There lies its popularity and its success. And no law passed in the Reichstag will prevent the Kintopp from making good profits, because its modernity lies in its ability to satisfy in equal measure both idiots and 'brains' – according to their psychological structure.[4]

What was admired about American film was its down-to-earth and concise style of narration. In 1911, Karl Hans Strobl, a writer of adventure novels, characterized cinema as 'theatre in top speed' to which 'the American principle' of 'the whole ox in the stock cube' applied. 'The hasty, nervous pace' of this new art which was like 'an automat restaurant of visual pleasure' suited 'the tension of our life' best, as 'everyone knows how hard it is to listen to one of those endless Wagner operas at the end of a working day.'[5]

Prior to World War I, Germany was largely a film importing nation. As Kristin Thompson has shown in her study on distribution history, during the years 1912 and 1913 approximately 30% of the dramatic films released on the German market came from the USA. The American film industry thus held the top position ahead of other exporting countries like France and Italy.[6] Emilie Altenloh's pioneer study on audience sociology of 1914 confirms these figures.[7] Although the outbreak of World War I led to a closure of the national market, imports of foreign films never ceased completely.[8] Foreign films still made their way to Germany through the neutral countries like Denmark or the Netherlands. Censorship entries reveal that American films produced by Kalem, American Biograph, Selig, Tannhouser, or Carl Laemmle's IMP were still imported into Germany because the USA remained neutral until 1917.[9]

The cultural significance which American films came to carry upon entering the German context becomes evident in the variety of appropriations and transformations of the Western theme throughout cultural spheres ranging from 'high art' to 'pulp'. The Western was one of the first internationally popular genres in film history. By 1908, its locations, plotlines and characters were already codified.[10] The genre emerged at a time when the

George Grosz,
The Golddigger
(1916)

American West was being romanticized by young Easterners like Theodore Roosevelt, the painter Frederic Remington, and Owen Wister, the writer of the first prototypical Western novel *The Virginian* (1902).[11] Around the same time, Edwin S. Porter filmed THE GREAT TRAIN ROBBERY (1903) for the Edison Manufacturing Company and established the basic Western formula of crime, pursuit, and punishment.[12] Lewis Jacobs called this first narrative Western the 'bible of all directors' because of its new technique of cross cutting parallel lines of action.[13] In the following years, THE GREAT TRAIN ROBBERY had great success in the nickelodeons and was followed by a number of remakes. In Germany, too, it was shown with titles like DER GROSSE ZUGÜBERFALL or DER ÜBERFALL AUF EINEN AMERIKANISCHEN EXPRESSZUG. Since 1894, the Edison Manufacturing Company had European representatives, first in London and from 1906 also in Berlin.

Broncho Billy Anderson alias Gilbert M. Anderson (that is Max Aronson, 1882-1971) played the passenger who is shot by the bandits in THE GREAT TRAIN ROBBERY – one of his first film parts. In 1907 he founded the production company Essanay together with George K. Spoor and created the coarse cowboy Broncho Billy who appeared for seven years in a series of more than 350 films.[14] Broncho Billy's name figured in every title as a

trademark. He was a star, before the film industry established the Hollywood star system. His team produced about one film a week in California. The films did not add up to a series with a continuous plot line. Each film was a self-contained short drama. Broncho Billy played different roles, sometimes he was the villain, sometimes the sheriff, but mostly a *good bad man*, a tough guy with rough skin and a soft heart – a type that would be further developed by William S. Hart and other screen cowboys.

Many of the Broncho Billy films were also shown in Germany. Essanay established a representative in Berlin in 1911. Local police headquarters were responsible for the censorship of films. From 1912, the decisions of the censors in Berlin and Munich became a guideline for other regions as well. However, censorship and distribution in different cities were still very inconsistent at that time, as can be seen in the censorship entries.[15] Violent scenes generally tended to be cut. However, the cinema reform movement complained that the bans were frequently ignored. In any case, the censorship entries give evidence of the widespread distribution of Broncho Billy films.

David Wark Griffith started his career just like Broncho Billy Anderson as an actor for the Edison Manufacturing Company. From 1908 to 1914, as a director for the Biograph Company, Griffith produced around 450 films. Many of these one- to four-reelers, for example, his early Westerns like LEATHER STOCKING (1911), THE LONEDALE OPERATOR (1911), THE LAST DROP OF WATER (1911) or THE GIRL AND HER TRUST (1912) made their way to Germany, as documented by German censorship entries.[16] THE BATTLE AT ELDERBUSH GULCH, which shows an elaborate use of cross-cutting technique and culminates in a thrilling last minute rescue, was released in Germany in November 1913 – four months before it was released in the USA.[17] American film producers were concerned with satisfying the German market from a very early stage. Business records of the Biograph Company for the year 1908 (held by the Museum of Modern Art in New York) carry the entry 'German title cards' for some films. Apparently, American production companies produced films with titles in foreign languages geared for particular foreign markets, but unfortunately, there is not enough material to generalize this assumption. Griffith's last Biograph production JUDITH OF BETHULIA, a historical costume drama of four reels, was presented in Berlin in April 1914 as 'the greatest triumph of modern film art', although the director's name was yet to become a brand name and therefore was not mentioned in the trade journal's advertising. But the two films which made him famous, THE BIRTH OF A NATION and INTOLERANCE, were not released in Germany until 1924.

The romantic visions of the American West presented by the movies had always been nostalgic reconstructions of a bygone past, rather than representations of contemporary reality. The formalized sets and plots of the Western could easily be transferred to other countries. In fact, 'Spaghetti' and 'Sauerkraut' Westerns were being produced parallel to the import of American productions from a very early stage. In France, Eclair produced the Arizona Bill series starring Joë Hamman as early as 1908. In Germany as well, there were appropriations of the genre already before World War I. Some titles and film

descriptions can be traced in the trade press such as DER PFERDEDIEB. DRAMA AUS DEM WILDEN WESTEN (dir. Viggo Larsen, prod.: Vitascope Berlin, 1911) or WILD-WEST-ROMAN-TIK. DRAMA AUS DEM WILDEN WESTEN (prod.: Deutsche Bioscop, 1911). The films, however, have not survived.

Western scenes were also integrated as episodes into globe-trotting adventure films. In the studios of Deutsche Bioscop in Babelsberg, EVINRUDE. DIE GESCHICHTE EINES ABENTEURERS (1913) was produced by Stellan Rye as director, Guido Seeber as photographer, and Hanns Heinz Ewers as script writer – the same team who had one month before completed DER STUDENT VON PRAG. HEIMAT UND FREMDE, produced in 1913 by Projektions-AG 'Union', also displayed a whole spectrum of adventurous settings: 'Officers, accountants, cowboys' all made their appearance in an European metropolis as well as in Chicago and the Wild West. The well-known stage actor Emanuel Reicher and his son Ernst, who was soon to become famous as star-detective Stuart Webbs, acted in this film directed by Joe May.[18] In the same year, Harry Piel directed MENSCHEN UND MASKEN (Part II), produced by the Vitascope Berlin, starring Hedda Vernon and Ludwig Trautmann, which also treated the Wild West as one episode in a series of global adventures. The episodic structure survives in DIE JAGD NACH DER HUNDERTPFUNDNOTE ODER DIE REISE UM DIE WELT, a film of the 'Nobody' series which was also produced in 1913 in Berlin by Karl Werner. The female detective Nobody follows the hero on his journey around the world which he undertakes following a bet with his friends to bring back a particular 100 pound note within three months. At great speed they pass through Cairo, Bombay and Nagasaki to eventually arrive in a Wild West composed of images familiar from American Westerns.

In those years, the Wild West as a constructed cinematic space also began to attract German writers. Willy Bierbaum in his review of HEIMAT UND FREMDE took the 'sceneries of a Wild West made in Germany' as evidence for the advanced standard and superb capability of film production.[19] Karl Hans Strobl gave an amusing account of an disillusioning encounter in an Indian reservation in Wyoming – whether he actually undertook the journey remains doubtful. The story of his 'strangest American adventure' titled 'The Daughter of the Redskin' was not published in a literary journal, but in the film trade paper *Lichtbild-Bühne* on 25 February 1911. Equipped with moccasins, a folded up wigwam, and an interpreter, he set off into the 'wilderness' in search of 'romanticism' – already put in inverted commas by himself. Trotting through the forest he is making fun of himself 'for playing leatherstocking in an Indian reservation.' But all of a sudden the interpreter stops, listens, shakes his head, dismounts and places his ear on the ground. While the narrator is still thinking that he must be fooling around to secure a bigger tip, some Black Foot Indians on the warpath actually appear, and pass by the astonished tourist. Then he notices an Indian couple in a clearing.

Really, they were holding each other by the hands, looking into each other's eyes, they embrace, the young man presses his hand on his heart just like an

Italian opera tenor. Then he starts telling her something with great gestures, and it appears to me as if he was trying to persuade her to escape with him. But although they are less than five steps away from us, I cannot hear a single word, neither in Indian nor in any other language.

The idyllic scene is interrupted by a 'dignified old Indian,' the chief, who drags his resisting daughter back to the village and marries her off to another man. Strangely enough these scenes, too, take place rapidly and without a single word: 'I knew from the literature, of course, that Indians were very silent people, but I would never have imagined them to be that silent.' The lover then proceeds to kill the newlywed groom with a tomahawk and is then put to torture at the stake. The watching narrator is shocked and grabs his gun to rush to his help for the sake of 'civilization.' But he is stopped by the interpreter: 'What you do stupid things? Speckled Opposum will soon be rescued.' Which happens accordingly. When the rescued young man with the bride comes galloping towards them, the narrator jumps up overwhelmed by joy because 'true love has once again won a victory.' Just then somebody shouts: 'Stop!' And the whole Indian party stops. Even the dead arise calmly. The tourist is aghast.

> The chief was grinning with dignity: 'Oh, we do little spectacle for cinema. We all be under contract with big white chief of running picture.' Suddenly, an American appears, and behind him a huge camera is wheeled on a cart by two workers. 'Yes, Mister,' he says patting my shoulder, 'and a damned good picture it will be. A sensational film: The Daughter of the Redskin. In two days you will be able to see it in Frisco.[20]

Unlike former authors of adventure novels, Karl Hans Strobl in his little story does not attempt to present real or imaginary adventures as being authentic and repeatable. On the contrary, the disillusioning experience of non-authenticity, the decline of romanticism, and the marketing of the American West through mass media form the theme of his narrative. In cinema, the writer loses his innocence and realizes that there are no adventures left in reality. Instead, he focuses on the production of surrogate thrills. In modern times, the hunger for adventure can only be stilled by staged spectacles, in tourism or in cinema.

Arthur Holitscher in his widely read travel book about the USA also reported on location shooting in Colorado. He met a Vitagraph team filming HEART OF A MAN directed by Rollin Sturgeon. A romantic scene had to be filmed several times due to technical problems. Meanwhile Holitscher interviewed 'Eagle Eye' who was waiting for his scene: 'As an authentic Apache with pigtails he was making 40 dollars a week, without pigtails he would only make 10. When asked about his squaw, he answered that his squaw was a "fraw" and came from Leipzig.' Holitscher took the opportunity to present himself in a photograph in the company of a Vitagraph cowboy in front of a bizarre looking rock, and went on to praise the advantages of cinema over theatre.[21]

Arthur Holitscher, author of a widely read travel report *Amerika Heute und Morgen* (1913) which had considerable impact on Franz Kafka and other writers of the time, posing with a Colorado Rock and a Vitagraph-Cowboy

Only gradually did the Western develop into a male genre where women appeared as subordinate figures. That women held a more significant position in the early Westerns is also suggested by Emilie Altenloh's description of the successful formula which early American dramas always followed. According to Altenloh, there would often be a woman or a girl at the centre of the action who would defend a log cabin against hostile Indians, holding out until rescue arrived at the last minute. Along with the rescue usually a lover of the 'good boy' type would appear.[22] Apparently, the Western was not always dominated by self-satisfied male stars. Perhaps even the legendary 'little salesgirls' found a role in the early Western dramas. The screen cowboys with their formalised gestures of power, control, and self-assertion clearly appealed to compensatory fantasies. While in real life in modern industrial societies the power of the individual was increasingly limited, imagination found recourse in the archaic qualities of masculinity. The front or the frontier were the only places left where a man could prove his strength and manliness.

Although the war would make imports of films from overseas more difficult, and the supply of fresh Westerns diminished, the Wild West remained a highly fascinating imaginary playground, even for writers of 'high literature.' The expressionist author Kasimir Edschmid wrote his cowboy novella 'Der Lazo' (1915 in *Die sechs Mündungen*) under the influence of cinematic experiences. 'Der Lazo' starts off in an European city and develops into a fantasy of liberation in the American West. Raoul Perten, a listless youth, rebels against the orderly and boring life which he is leading with his rich uncle where horseriding or car racing as experiences of speed are the only breaks from boredom. Suddenly, a bright poster of a steamer makes him leave everything behind and cross the Atlantic 'tween decks. On the way he rids himself of old habits and adopts a new gait and masculine gestures in

order to be respected in the rough male world. He does not stay long in New York City, but quickly moves further West by train with the land stretching past him for five days like a huge screen. The West opens up as an escapist fantasy, but at the same time elements from home are transposed into the American scenery. Raoul is employed as cowboy on a farm, heroically resisting the attractions of the farmer's daughter before fighting in a duel with a down-at-heel German baron who is also working on the farm. A ritual of proving one's masculinity which was common in the European bourgeois society, the hated domain of the 'fathers,' is thus reproduced in the Wild West. In the end, Raoul rides off: proud, alone, and upright. The figure of the lonesome cowboy riding off toward the horizon seems to follow the composition of a film image.

What was visual pleasure for some was for others a thorn in their flesh. While the movies carried liberating impulses for schoolboys or apprentices who dreamt themselves out of the harsh discipline of their everyday life, respectable citizens did not approve of the Western craze which had seized German youth. In their campaign against 'trash,' the religiously orientated Cinema Reform Movement ('Kinoreformbewegung') was concerned with protecting women and children from the raw attractions and decadent influences of 'bloodthirsty' and 'obscene' Westerns or detective films. Youngsters were said to be in danger of being de-sensitised and criminalised by watching violent films. Konrad Lange, a professor of art history in Tübingen, was one of a number of voices demanding a national German cinema unspoiled by foreign influences. He criticised the fact that the owners of film theatres did not take seriously the laws and regulations which prohibited admitting children to films which the censors considered harmful. As an example, Lange cited the showing of ROTE RACHE: FARMERDRAMA IN 5 AKTEN ('Red Revenge, Farmer Drama in 5 Acts') in a Tübingen theatre. Apparently, the professor was already unpopular enough not to be admitted to the theatre himself, and the local press refused to publish his rabble-rousing propaganda. In his book *Das Kino in Gegenwart und Zukunft* he therefore published a report written by a student of his:

> A wild Indian woman in high head-dress, her face contorted in an animal expression, is mysteriously prowling around a lonely house in the mountains. Suddenly Bill (the farmer) appears in a narrow pass beneath her with a gun in his nervous fist. There – the tension is at its peak, raging music lashes the audience's nerves – Pitjana captures her victim with a well aimed lasso and strangles him gleefully while he is tormented by pain. In the last minute his wife comes to his rescue. Pitjana vanishes, only to reappear a few minutes later, and to stab the wife. End of act three. The auditorium is illuminated. I see a bunch of children sitting in front of me. A little girl, about five years of age (!), is fighting back her tears, others remain grave. It seems to have deeply affected these children's souls. Perhaps it was the first dead person they ever saw, and they believed it was all reality...[23]

Section II
Popular Stars and Genres

Early German Film Comedy, 1895-1917

Thomas Brandlmeier

Like it or not, every version of German film history takes the Skladanowsky Brothers as its point of departure. Their Wintergarten programme was geared to international variety: the exotic, the foreign, the grotesque. No German folk dancing here, but Italian country dancing and Cossack dancing. No horses or dogs performing dressage, but 'kangaroo boxing'. No 'Jahn – the Father of Gymnastics,' but the 'comic horizontal bars.' In 1896 they presented short staged comic scenes, not set at the Munich Octoberfest, but at the Tivoli in Copenhagen, not at Berlin zoo, but Stockholm zoo. The scene outside the Tivoli is famous: a group of pleasure-seekers all bumping into one another, the climax coming when a cyclist – played by Max Skladanowsky himself – comes zooming out of the back of the screen and mows down the stumbling, arguing crowd.

Conformist Comedy

The era of variety and circus-based cinema was geared towards the sale of film-copies, rather than rental. Only very little of this material still exists – in Germany a few fragments of Skladanowsky, Seeber and others, mostly Messter. More than a decade of film history remains relatively shrouded in mystery. Attempts to draw conclusions from these few remnants have unearthed two tendencies in German cinema. One was the celebration of the exotic, the sensational, the unusual: TANZ DER SALOME (1906, first version 1902), DIE SCHLANGENTÄNZERIN (1909), TILLY BÉBÉ, DIE BERÜHMTE LÖWENBÄNDIGERIN (1908), APACHENTANZ (1906), AKTSKULPTUREN (1903), NACH DER REITÜBUNG (1906). Tilly Bébé, who toured through Germany with her lions in the years of the *Kaiserreich*, enjoyed a fame equal to that of Mae West a decade later. Wherever she appeared, the local press would be falling over itself to come up with the most tantalising articles. Her combination of animal trainer and brothel madam had something of both the repressed and the forbidden about it. TILLY BÉBÉ was made relatively late in her career but is perhaps the best example of an exotic-erotic-escapist tendency which crossed over easily from the general entertainment industry to cinema.

The development of comedy in German cinema is embedded in another tendency which can equally be traced back to German popular entertainment and which transformed a potentially taboo-breaking scene of violence into something affirmative, sociable and humorous. The central role in this process was played by the Messter production. The earliest surviving example is AUF DER RENNBAHN IN FRIEDENAU (1904), which features the popular variety performer Robert Steidl and includes a well-tried number based on a classic *coup de théâtre*. A crowd of spectators, facing the camera, watch an (invisible) bicycle race track,

bodies and heads swaying and bobbing as they follow the action. Steidl, a comic genius, weaves his way to the front, past the surging mass. Of course, his weaving turns into pushing and shoving, with predictable consequences, in a sketch that lasts a mere four minutes.

Messter had the capital, and he could afford to give the public whatever was the best. His 'Tonbilder' showed opera stars singing popular arias, but also presented the top earner of the German variety industry, Josef Giampietro, with the couplet 'Komm, Du kleines Kohlenmädchen.' Alexander Girardi was featured singing the hackney cab song. These two Austrians were among the superstars of their day, and they managed to simultaneously parody and adroitly embody the age's official jaunty optimism. Messter's films quickly became intertwined with the entertainment industry of his age, and while careful never to overstep the limits of social consensus, he also set trends. Gerhard Daumann and Bobby – whose identity remains a secret to this day – became his comic house stars. MER-ICKE AUS NEU-RUPPIN KOMMT NACH BERLIN (1911) seems to be the only early Daumann film still in existence. The film shows the ways of the world in the big city, with the man from the provinces an easy prey for the wiles of the metropolis. But appearances are deceptive, and the satire is double-edged. While the street scenes function as an objective yardstick of comic difference, a scene set in a restaurant exposes the comedy of exposure also as a verdict on the provinces: the fellow has no manners. 'German beer-belly humour,' as Hans Siemsen described it in 1923. The formula may be rather harsh, but the point is made. Daumann, one of the most popular German film comedians of the period, was consciously marketed as 'German,' set against 'grotesque farces ... and ridiculous buffoonery.'[7]

Messter's comedy production, with its novel devices, was the German dirty joke variant of early film comedy. Given the lack of surviving material, these early films can be studied only by examining the literature. The 1898 Messter's catalogue itemises the contents of the film DER KAMPF UMS DASEIN:

> In the corridor of a hotel we see the door of a guest room and next to it the toilet. A guest walks into the toilet but at the same moment the gentleman in the adjoining room appears, also intending to use the toilet. He finds door 00 locked – his face is a picture of suffering and vexation. Another gentleman appears, wearing only his trousers, who impatiently knocks on the door. Eventually the first man leaves the 'loo just as the two other men are throwing themselves at the door, in an attempt to break it down. A punch-up ensues, and they bump into the waiter who at that moment enters, carrying a tray of coffee. The waiter falls over. An extremely humorous subject, which always causes great hilarity – a first-class picture.[2]

The social-Darwinism of the title ('The Struggle for Existence') conceals an all-too-conspicuous example of what Freud analyzed in 1905 as anal sadism, and Messter comedies, from what we know about them, continued the dirty-joke line at least up to 1910. SCHWIEG-ERMUTTER MUSS FLIEGEN (1909) is a spiteful mother-in-law joke about the harridan who

always has to have the upper hand, but finally gets her comeuppance when she tries her luck with a new technical contraption – the flying machine. EINE BILLIGE BADEREISE (1911) typically has a pair of protagonists – a married couple by the name of 'Beer.' Mr Beer, unable to pay the bill at the spa hotel where they have been staying, bets three other gentleman at his table 300 marks that he will be the first to find favour with the lady sitting at the next table. The bawdy game of libertinage backfires when it transpires that the lady in question is in fact his own wife. A similar pattern, by which the class aspect of the sketch is converted entirely into comedy, is discernible in EIN GUTES GESCHÄFT or DAS VERZAUBERTE CAFÉ of the same year.

Self-exposing Wilhelmine comedies included DER ROSENKAVALIER (1911), ZU-VIEL DES GUTEN (1913) and EIN NEUER ERWERBSZWEIG (1912). In DER ROSENKAVALIER 'masculine courtship behaviour'[3] is both acted out and thwarted at the same time. The cocky troubadour regularly falls foul of the Wilhelmine authorities and in the end is arrested by the police. In prison, he paints on the walls the roses he never had a chance to deliver. In ZUVIEL DES GUTEN a lady toys with the idea of buying a pug dog. All her admirers promptly turn up with one. The bourgeois salon is demolished by the invasion of the pugs – a comment on the masculine mating game as subtle as a bar-room joke. This time, the love token is delivered: but with fateful consequences for the recipient, and thigh-slapping merriment for the bearer. EIN NEUER ERWERBSZWEIG pours its malice on female desire when a marriage swindler takes advantage of two spinsters.

The situation with Bobby, star of the Messter series, is rather more complicated. Bobby, who plays opposite Dammann, seems to have been a crafty plagiarist. Of the four films surviving, at least three appear to be based on French, Italian or English films. BOBBY HAT HUNDEMEDIZIN GETRUNKEN (1911) is a simple story of quid-pro-quo with fatal consequences. Having swallowed dog medicine, Bobby turns into a barking, yapping canine, running around on all fours, his behaviour giving rise to all manner of obscenities which come over as wholly un-German. In fact, there are records of earlier Italian and French grotesques involving horse medicine and a similar course of events.[4] In BOBBY BEI DEN FRAUENRECHTLERINNEN (1911), Bobby dresses as a woman and attends a suffragette meeting. At the end he gets a chance to speak and makes a rousing speech which throws the women into turmoil. In the heat of the ensuing battle, Bobby's disguise slips off, and he is pursued by the furious suffragettes in a wild, cross-country chase. The suffragette grotesque, an authentically English invention, is here given a new twist. The plot of BOBBY ALS AVIATIKER (1911), unusual for the German cinema, is reminiscent of countless French and Italian comedies: Bobby builds himself an aeroplane out of useless domestic appliances, which promptly dives groundwards and crashes. What remains of Bobby – his torso and limbs having scattered to the four winds – is put in a police station where, with the aid of a few film tricks, the various parts of his body join up together again. At the end he slips away quietly. The early comedy BOBBY ALS DETEKTIV (1908) is relatively innovative by comparison and has a more comic than grotesque effect.

AUS EINES MANNES MÄDCHENZEIT (1912) was a real sensation within Messter Production. The earliest film starring the great Wilhelm Bendow, its hero tries to get a job as a maid and performs a thoroughly un-German drag-act as a result. In German cinema transvestism almost invariably serves less as a disguise in order to seduce, than to denigrate and ridicule the sex thus impersonated. Wilhelm Bendow's performance in AUS EINES MANNES MÄDCHENZEIT is among the few exceptions. As Heide Schlüpmann has shown, the advent of homosexual and bisexual discourse in the cinema of the *Kaiserzeit* is significant.[5] A characteristic of early film comedy is the tendency to stick closely to stage conventions, and Bendow picks up on this in his coquettish playing to the camera and the audience. Economic constraints (finding a job to earn a living) transform themselves into opportunities prompted by desire (playing a role in order to get closer to the object of desire). The disruption of norms and hierarchies in the world of work allow the problems of everyday life to invite the pleasure principle. Yet it is not only Bendow who relishes dressing up as a maid and pestering his pretty colleagues: the manservant, too, has fallen under the spell of the sturdy young housekeeper sporting facial hair, and even the master of the house sucks up to the seductive Bendow. For this erotic household to function, it has to maintain itself removed from reality, and both kitchen and drawing room obey the laws of desire. At the end, however, the reality principle can and must triumph. With the transvestite led away by the police, Wilhelmine order once more takes charge.

The institution of marriage took on a central ideological role in traditional bourgeois society, albeit linking sexuality and economy in often original ways. The view of this sacrosanct institution in early film comedy, however, shows significant differences compared with films made in other countries. Italy, France, and England specialised in grotesques which were thoroughly subversive. Marriage tricksters and adulterers were strikingly erotic and financially successful.[6] German film comedies, by contrast, favoured the figures of the deceived bridegroom and the foiled lover. Whereas in other European countries the illegitimate fulfilment of desire was successful, in Germany it was the failure of legitimate desire that was deemed to give pleasure to the spectator. While DER ROSENKAVALIER, ZUVIEL DES GUTEN and EINE BILLIGE BADEREISE are variations on the theme of the thwarted lover, the Bolten-Baeckers films DER KURZSICHTIGE WILLI HEIRATET (1913) and DON JUAN HEIRATET (1909) feature the foiled bridegroom, Josef Giampietro. In DON JUAN HEIRATET he plays the converted philanderer with foppish noblesse. The castration of the hero, already announced in the paradoxical title, transpires in the grimmest way imaginable: his former victims gang together and hunt Giampetro down. Only the symbolic self-castration of a suicide attempt can save him from the mob, but it is the State which brings the general affray to an end, incarcerating Giampetro and his bride – completing the metaphor of marriage as a form of prison. DER KURZSICHTIGE WILLI HEIRATET features the hero as the victim of his own vanity. Without his glasses, his loved one seems the epitome of femininity, but when the bridegroom finally reaches for his spectacles his only possible course of action is to take flight.

ES WÄR SO SCHÖN GEWESEN (1910), with the variety star Arnold Rieck, DER

HAUPTMANN VON KÖPENICK (1906), with Karl Sonnemann, and Franz Hofer's HURRAH! EINQUARTIERUNG! (1913) are not products of the Messter empire, but they could be called the first examples of the German military film and may further illustrate the relative conventionality of many German film comedies compared with their international counterparts. ES WÄR SO SCHÖN GEWESEN centres on the erotic dream of a young recruit. In the film the bullied soldier transforms into a slave-driver, but his victims are the women who show off their sturdy thighs during a march. As the meting out of punishment reaches its peak, the recruit, as expected, is brought back to the reality of the barracks with a bump, in the form of his sergeant. DER HAUPTMANN VON KÖPENICK – already in its time a remake classic – was staged in 1906 by the staff of an engineering firm which also produced films. This version has at least the charm of mimetic enactment: we watch subordinates having fun showing the comic potential of being a subordinate. HURRAH! EINQUARTIERUNG!, a very early example of female transvestism, also shows the extent to which the male domain of the military provides the perfect setting for dressing-up and cross-dressing.

An underlying sense of violence pervaded the German Empire, at least from the Customs Union (1844) onwards, producing its own effects in the arts and the theatre. In comedy, it gave rise to the dialectic of the German north-south divide, behind which was hidden the real dialectic of (economic) progress and regression. Secretly, the farmer wants to be a city gent, the craftsman an entrepreneur, and the grocer a businessman. Comedies drawn from the problems of these status-seekers manifested the comic in inappropriate forms of craftiness and underhandedness. If farce were in demand in German-speaking countries outside Germany,[7] eloquence and puns dominated the enlightened forms of German popular comedy. In this respect the film comedy of the *Kaiserzeit* is informative about geographical stratification and linguistic differentiation. WIE BAUER KLAUS VON SEINER KRANKHEIT GEHEILT WURDE (1906), MERICKE AUS NEU-RUPPIN KOMMT NACH BERLIN (1911), EINE BILLIGE BADEREISE (1911), EIN GUTES GESCHÄFT (1911) and DER KURZSICHTIGE WILLI HEIRATET (1913) are all examples of films which depend for their effects on spoken titles and the lecturer's commentaries. The near-incomprehensibility in their absence of the social types and situations portrayed exemplify the actors' reliance on wordplay and the explanatory dialogue to give their characters full depth.

It was thus only with the arrival of the sound film that the German cinema really took to the star performers of variety theatre and cabaret, who in silent films were often merely the token icons of their stage selves, underlining the fact that because of the emphasis on the pun, there is relatively little evidence of physical forms of comedy. In the typology of comic heroes, two basic forms can be distinguished: the 'August' or fool, and the white clown. The 'August' is the infantile, polymorphously perverse anarchic clown; the white clown, by contrast, draws his comedy from the battle with objects and social values, from which he usually emerges with dignity.[8] German comic traditions seem to prefer the white clown: a result of the tendency towards enlightened, domestic comedy which ties in with the predominance of punning over slapstick. On a social scale of rebellious manservant to ridic-

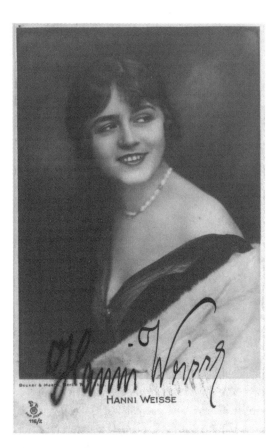

Hanni Weisse

ulous gentleman, the German tradition tends towards the comedy of the well-off fop; on a libidinal scale of undomesticated, willful child to duty-bound, inhibited adult, the German tradition seems to side with the weight of fact, acknowledging the reality principle.

Of particular interest in the context of this conformist comedy is the film DIE LIST DER ZIGARETTENMACHERIN (1916), with Wanda Treumann. This film comedy is the ideological counterpart to the melodrama DIE TRAGÖDIE EINES STREIKS, a Messter production from 1911, directed by Adolf Gärtner and starring Henny Porten. In the Porten melodrama a strike cuts off the electricity supply to a hospital, just as the child of one of the strike leaders lies on the operating table. The logic of parallel editing results in the reconciliation of the repentant workers: two divided sets of images push their way towards each other. DIE LIST DER ZIGARETTENMACHERIN also acknowledges social division, but centres on a young woman who cleverly augments her lottery winnings and thereby manages to save threatened jobs at the cigarette factory. But her capital does not go into buying the factory, but into marrying the despairing factory owner. In the first film misfortune is the consequence of the refusal to make a profit (for the bosses). In the second film, profit has to be earned outside the sphere of production, in order for production to continue. The good fortune of the working-class girl flows back into the profit-consuming class and so becomes the legitimate good fortune of the

middle-classes. But with a noticeable difference. In the comedy the ideological resolution contradicts the logic of the editing: the two settings distance themselves from each other (the comic mode), before coming together again at the level of the drama.

How Comedies Take Revenge

In contrast to the unshakeable loyalty to the system of the mainstream, epitomised by Messter's productions, WIE DAS KINO SICH RÄCHT (1912) is a film of programmatic polemical force. A particularly feared censor is 'taken for a ride' by some film people, who persuade a young actress to seduce the protector of public morals, while a hidden camera records him in flagrante delicto. A film presentation, arranged through various forms of trickery, publicly exposes the hypocrite. This is a case of the new medium of film defending its right to freedom in selecting images with remarkable confidence, adopting a gesture of conservative exposure and using it against its creator. It is very likely that Hanns Kräly, one of the actors, was also an uncredited member of the scriptwriting team. Kitty Derwall, the liberal actress of this comedy of seduction, played one of a long list of female roles of thoroughly emancipatory character.[9]

In SIEG DES HOSENROCKS (1911), Lene Voss, skilfully portrayed by Guido Seeber, recognises the fetishistic predilection of 'her' fiancé (Max Obal) for culottes. With great confidence and authority she parades up and down wearing the breeches. In those days wild teenagers were known as 'tomboys' or 'scamps.' They managed to lead satyr wood spirits by the nose. In Franz Hofer's ROSA PANTÖFFELCHEN (1913), Dorrit Weixler seduces a prince (Franz Schwaiger) and in EIN NETTES PFLÄNZCHEN (1916) Erika Glässner causes a decent middle-class household to come apart at the seams. Hanni Weisse as the TANGOKÖ-NIGIN (1913) causes mass orgies of convulsive paroxysms.

In a category of their own are the Asta Nielsen films. Cross-dressing – in DAS LIEBES-ABC (1916) by Magnus Stifter and ZAPATAS BANDE (1913) by Urban Gad – had a comic effect which drew entirely upon her many sexual identities. DAS MÄDCHEN OHNE VATERLAND offered her a Carmen role in which she could disguise herself as a man. ENGE-LEIN (1913) and DAS VERSUCHSKANINCHEN (1915) are also tomboy rebels, after Böcklin, but also on occasion with something of the wide-eyed look of a Munch heroine. The double shading of the comic-grotesque into the horror-grotesque and vice versa was always part of Asta Nielsen's artistic innovations. On one occasion she wants to commit suicide. With a sweeping, tragic gesture she hoists herself up – and a child's chair remains dangling from her hand. On another occasion she enjoys an orgy in the dormitory of a young ladies' boarding school, surreal like in Feuillade – Nielsen and Musidora were both women with a Medusa look.

Iconographic memories of variety comedians are also brought back by the bleak criminal comedy WO IST COLETTI? (1913), with Hans Junkermann, one of Germany's forgotten comic talents. Junkermann plays a detective who bets that he can remain incognito for 48 hours. The theatre of disguise and transformation this involves also parodies the

German cinema's obsession with the *Doppelgänger*: real beards are tugged, and everyone appears as an imitation of his or her true self.

Lubitsch

In a class of their own are the films directed by or starring Ernst Lubitsch. MEYER AUF DER ALM (1913) appears to be the earliest Lubitsch comedy still in existence. Lubitsch plays Meyer, a company director from Berlin, holidaying on the Königssee. Lubitsch's acting makes no secret of the fact that this Meyer is no Germanicised Herr Everybody, but a Yiddish Meir. Lubitsch's directorial involvement in the film remains unclear, but everything points to his signature. Lubitsch/Meyer plays a nouveau-riche with no tact or breeding, taking the morning air far away from his loved ones and the routine of work, but who finally becomes the dupe of various erotic Alpine adventures. At first sight, this could easily be one of the Messter repertoire. But the actor is Lubitsch, and there is something of the Kräly touch about the situations. The central impulse of comedians of Jewish origins is almost always fear, be it fear of a pogrom or fear of the bogeyman. They compensate for this with their cheekiness, in the same way as the schoolroom joker's cheekiness compensates for the other pupils' fear. Lubitsch the comic actor also existed on this razor-sharp, life-endangering dialectic; his gallantry with cigars and *Lederhosen* already pointed towards his later work.

DER STOLZ DER FIRMA (1914) shows Lubitsch as shop assistant Siegmund Lachmann, fired because his incompetence led to the shop being demolished. He wants to kill himself. But then comes a nice turn of events, which clearly refers to Lubitsch: he decides to first eat something, because dying on an empty stomach doesn't seem a good idea. After this, all his plans go out of the window. Instead, he goes to Berlin, where he fraudulently sells his expert knowledge. It is then only a few short steps on the ladder of fraud from salesman to son-in-law of the boss. Hofer's FRÄULEIN PICCOLO (1914) shows Lubitsch in a supporting role, the lead roles going to Hofer stars Franz Schwaiger and Dorrit Weixler, as so often, a tomboy in a *Hosenrolle*, a woman wearing trousers and impersonating a man. ROBERT UND BERTRAM (1915) once again features Lubitsch in a supporting role. The film follows the pattern of farce mixed with anti-Semitic tendencies. Director Max Mack saves the film by his casting. The lead is played by Ferdinand Bonn, a pupil of Possart. Lubitsch and Bonn compete for laughs as if their lives depended upon it and in so doing manage to raise the plot above the level of farce. ALS ICH TOT WAR (1916) is the earliest surviving film of Lubitsch's. It deals with an attempt to get rid of, once and for all, the tiresome mother-in-law, by staging her death. Here Lubitsch was to some extent attempting to work in the style of Max Linder, but the leaden weight of the mother-in-law plot dragged the piece down from the comic heights it occasionally reaches.

It was not until SCHUHPALAST PINKUS (1916), made in collaboration with Kräly, that Lubitsch really shone. Sally Pinkus, a sales assistant way down in the ranks of the shoe shop's hierarchy, departs from the code of the pecking order with impertinent swiftness. He

Die Lichtbildbühne, 24 January 1914

sells ladies size 40s as 35s, and his prowess as a salesman wins him huge success. He makes eyes at the sales girls, but his heart is set on the boss's daughter. Then, a rich customer appears on the scene, whom he manages to talk into lending him some money. He becomes the new boss of the Pinkus shoe emporium. He turns the loan into private capital by marrying the rich customer. For Pinkus, the shoe shop is his very own erotic playground. He fetishizes his goods to make them more marketable. The way that Lubitsch/Pinkus runs the shoe shop is an outright perversion of Marx. DER BLUSENKÖNIG (1917) features Lubitsch once again as a sales assistant. As usual, Sally Katz has his eye on all the shop girls. He ensnares Brünhilde, the plump daughter of the boss, out of pure routine. But she immediately wants to get married. The boss misreads the situation as a case of Katz wanting to marry into the business. He pays Katz off with a partnership in the firm, and the lucky Katz immediately sets off to visit the pretty supervisor of the manufacture department. The fragment that remains of the film ends with a clear indication of how the plot will develop. Sally licks his index finger and purposefully presses the doorbell.

WENN VIER DASSELBE TUN (1917) features Ossi Oswalda in her first role. Hanns Kräly had discovered her as the female imp for the SCHUHPALAST PINKUS. Werner Sudendorf describes Oswalda as having a sexuality rendered harmless by her child-like image: in 'the costume of innocence'[10] Oswalda functioned as Lubitsch's female alter ego, as he withdrew to the role of director. Oswalda outshines her partner, Emil Jannings. As one of the most important comic actresses of the period, she is able to provide something extremely rare: Berlin slapstick. 'Even her shapely legs talk like a Berliner,' as Kurt Pinthus put it. DAS

Die Lichtbild-Bühne, 12 June 1915

FIDELE GEFÄNGNIS (1917) was a Kräly adaptation of *Die Fledermaus*. Harry Liedtke took the role of Eisenstein – here called Reizenstein – while the task of playing the director's alter ego this time fell to the effervescent Erich Schönfelder. He is sent to prison for three stolen kisses – more a pleasant change of scenery than anything else for a professional skirt-chaser.[11]

The cinema of Lubitsch and Kräly demonstrated all the signs of the Wilhelmine state's decline, precisely by pointing to where things were heading. Lubitsch presented the new human type of the twenties – the cocky, successful figure who siphons off the profits of war and inflation, and regards hierarchies merely as a springboard for his ambitions. He has no sense of tradition; past and future no longer mean anything to him; he lives for the here and now. For him, reality and pleasure go hand in hand. The cinema of Lubitsch and Kräly is corrosive, caustic and pre-revolutionary in nature.[12]

Karl Valentin

This pre-revolutionary aspect is particularly true of Karl Valentin's film debut. The first film of 1912, KARL VALENTIN'S HOCHZEIT, picked up on the preoccupation of German mainstream film comedy with the figure of the hoodwinked bridegroom/lover – and did away with it forever. Valentin's bride is the fat theatre actor Georg Rückert. Seeing his future wife, Valentin decides to run away, but he cannot escape her clutches, and she finally manages to floor him, uttering the words: 'Now we are one, my darling Karl.' DIE LUSTIGEN VAGABUNDEN (1912) and DER NEUE SCHREIBTISCH (1914) were based on comic sketches from the funny papers. The *Münchner Bilderbogen* (illustrated broadsheet), its most famous writer being Wilhelm Busch, was sold worldwide: it was the prototype of the great American comic tradition. Comic-writers still enjoyed the privilege of writing for what was consid-

ered by the censors as a harmless medium. In his film adaptations Lubitsch intensified the subversive potential of the broadsheet. DIE LUSTIGEN VAGABUNDEN, starring Karl Valentin as a policeman with a spiked helmet, features two petty crooks who lead the Wilhelmine system by the nose and, at the end, literally crucify it on a fence.

DER NEUE SCHREIBTISCH is without doubt Valentin's early masterpiece. The film adopts one of the favourite themes of early film grotesque which had otherwise made a noticeable disappearance from German cinema: the systematic destruction of the bourgeois home as an attack on the bourgeois order. The conflict is sparked off by a piece of office furniture. The new desk which had been specially made to suit the hero's outsize measurements turns out to be the wrong size. The vision of a human life adapted to office furniture heralds a life-long annihilation of the self. Valentin expresses his disobedience in the form of some destructive alterations. Armed with a saw, hammer and chisel he literally demolishes the desk. There is something very un-German not only in Valentin's radical behaviour but also in his grotesque, comical movements, which place him high up in the ranks of the best of his profession. Lubitsch and Kräly, and to an even greater extent Valentin, illustrate the law of action and reaction: Repression engenders not only mass conformism, but also its radical counteraction and deconstruction.

Otto Reutter Karl Valentin

The Spectator as Accomplice in Ernst Lubitsch's SCHUHPALAST PINKUS

Karsten Witte

Money and Desire

Most comedies deal with money and desire. The common denominator of both is circulation. Hence, the almost physical urge of film comedies for movement. If for obvious technical reasons the early camera could not move or pan around, then the objects and the actors could move around the camera. Comedy depends on rapid and excessive movement, slow motion in the psychological sense would almost automatically mean a more elevated genre: melodrama or tragedy. The rapid movement inherent in comedy produces a lot of disorientation and confusion. The space tends to get fragmented, the roles people play tend to lose identity. The comicality of films depends on deliberate disguise and deception.

German film comedies are very rare, for two reasons. There are materially very few prints preserved in the archives. Only approximately a quarter of the films produced before 1918 survived. The rest could vaguely be reconstructed from the plot synopses written by the German board of film censorship, the so-called 'Zensurkarten'. Second: according to the deplorable state of prints preserved, very little research has been achieved so far on early silent film, let alone a more detailed study in the film genre. Classical studies like those by Siegfried Kracauer or Lotte Eisner ignored early film comedies altogether. These are superficial reasons to blame. There are on the other hand innate reasons why so very few film comedies were ever produced in Germany. Due to the overpowering impact of moral philosophy on general aesthetics and the masses of German school-masters volunteering for film censorship, little attention was given in public to the legitimate pleasures of the poorer classes in the cinemas. In addition to the prejudiced ban on 'money and desire' uttered in public, there was the aesthetic ban on the mass media which dared to express inhibited or oppressed sensual energies. When German film criticism emerged, it condescendingly paid tribute to the 'literate' films, the so-called 'films d'art,' and passed over 'illiterate' comedies in silence. Comedies admittingly vulgarised the noble sphere in which the circulation of money and desire was to kept invisible.

This is where Lubitsch steps in. His achievement was to render visible what used to be hushed over by the elite of screen writers. Lubitsch introduced a new tone and style, that of abrupt breaking of cinematic conventions. He unfettered oppressed emotional energies in his characters. He made the music that shook the old petrified conditions. He brought out the inherent movement by reorganising the traditional stage which he transformed into an open space.

His type-cast character in his films before 1916 is a self-made man called Meyer (being the most common name in Germany, it also was a very common first name in the Jewish community). Meyer does away with traditional education. Learning Latin does not help sweeping floors, as the experience of the apprentice in SCHUHPALAST PINKUS (1916) showed. Meyer mocks traditional schooling. His reference to empiricism cuts short all rational thinking. Reason in Lubitsch's eyes is just the shortest way between the sensual needs of a character and their immediate fullfillment. Meyer leaves out all the usual detours, Christian ethics like 'No plight, no price.' He grabs the 'forbidden fruits' without asking permisson. He does not long for adored objects, he simply wants to get them. Meyer's name in SCHUHPALAST PINKUS refers to the Yiddish slang word 'Pinke' which means 'money.' One of Lubitsch's devices is to marry money and desire.

Circular Mobilities: Order and Disorder

To illustrate the way in which Lubitsch developed this technique, I would like to dwell upon SCHUHPALAST PINKUS. Sally Pinkus is a social climber who makes his way from total failure to total success. Comedy again tends to exaggerate, to push forms into their extremes, and to cut out the distance between the starting point and the aim. Comedy does not unfold; comedy tends to explode, and the director builds his films from dense fragments of fulfilled moments.

Sally Pinkus is the man whose life-principle is the spur of the moment. The duties of general order, public conduct, etc. would call for wider perspectives. So he tends to minimalize his surroundings, his partners as well as his enemies. He is an ally of the given moment. Therefore, he would not waste his time. He is the victim of his presence, and paradoxically also the master of the moment. This may be shown in the way Sally Pinkus conquers space.

SCHUPALAST PINKUS
(1916)

The film starts with the early morning scene, the ritual of waking up. Sally refuses to stand up on time. He rather enjoys the very last moment in bed, and then hastens to school. His getting out of bed resembles more a battle with blankets than regular, modest movement. Sally escapes the bourgeois order, he flees his home.

Wherever he appears in public he is bound to throw things into disorder, not for the sake of anarchy, but for the immediate grip on wanted objects. Lubitsch tends to form circles which then break up and flee from the centre of the frame towards marginalisation. For instance, when Sally climbs up during school gymnastics, he perceives a group of girls on the other side. The authority of the schoolmaster disrupts the form of this circle. Later Sally is leaving school surrounded by another group of girls. Suddenly, his father appears. Struck by this sight, Sally runs away, and the circle of his surrounding group breaks up.

Lubitsch associates a certain emotional quality with the circular form. In the circles he (so to speak) assembles an unorthodox, natural form in which human needs can emerge without being menaced at once. Sally is the only man who succeeds in assembling circles around himself. Leaving school he joins a bunch of girls at the ice-stand. The girls feed him, and as a sign of sympathy, Sally is heaped with all their bags. Disorder of needs and objects rules the scene. Sally visibly enjoys the share of world he just got. He sticks out his tongue as he does so frequently. It does not seem sufficient to grab the world by all means of articulated gestures, it needs Sally's tongue to sense the world and taste it. The comic device as displayed in this movement tends to tempt immediacy. The fulfillment of acute desires leaves out further-ranging perspectives. School and work are transformed into playing grounds where the comical character comes to his senses which he lost in the regular surroundings. The basic needs of the comical character are sleeping, eating, and loving. The urge of expressing these needs excludes all ambiguity. Semantics do not interfere. The gestures articulate bodily needs.

This does not exclude ambiguity in the moral of the story. Lubitsch of course always revokes the meaning given to the gestures. His choreography even though it reappears on the surface reverses the meaning once it repeats itself. The circular form is not only broken up by authorities (fathers, schoolmasters) that menace the little powerless character. Once a boss himself, he tends to be ruthless and bossy. Sally as an apprentice in the shoe-salon assembled the female sale-assistants around him. Sally presumably told an indecent joke. The narrator and his audience fused. They became allies for a short moment before dissolving the circle when the manager abruptly cuts in and chases the sale-assistants off to work.

Being the boss of the shoe-salon, now called in grandiose style: 'Shoe-Palace,' Sally Pinkus inspects his own staff. One by one he cuts short the endless line of his employees and chases them off to work. He now imposes order where he used to plunge into disorder. Sally himself has become part of the movement that cuts into the circles by an abrupt vertical movement, which used to be the privilege of authority.

The permanent reversal of once established and taken for granted order in the social as well as in the aesthetical sense is a comical device Lubitsch never renounced. When he directed THE SHOP AROUND THE CORNER in 1940, the young apprentice, once promoted, almost immediately starts pushing around the new apprentice. The idea behind this mechanical reversing of social roles is to express that social climbing does not imply moral achievement. Lubitsch's comical device again starts from the ground. Ideas people have and pursue are guided by their interests, and this interest mainly consists in circulating money and desire. This is what makes a genuine comical character whose field of action reinvents the gestures of basic needs.

The Spectator as Accomplice
In this process Lubitsch involves his spectators as accomplices who appreciate and share the view expressed on the screen. The way spectators are drawn into this process is through anticipation of the narrative. Lubitsch tells the audience what is about to happen on the screen before his characters realize what's coming up to them. The narrative, however, is not conveyed as fragments of a story, but by means of sensual immediacy. The story itself becomes fragmented into littler sensual units which then swarm out to catch the attention of the audience. 'All our senses,' wrote the young Marx in his so-called 'Parisian Manuscripts,' 'fall apart into little theoreticians and collaborate making out *one* sense.' The fragmentization of interests is reflected in the rare close-up shots Lubitsch inserted in his SCHUHPALAST PINKUS. The close-ups emphasize Sally's sensual interest, for instance, the way he fetishizes the ladies' little feet; 'little' being the equivalent to 'tempting' or 'beautiful.' One of the most unexpected close-ups in this film occurs when the camera pans over the models' feet assembled in the final shoe-show. Again, in this scene it is the vertical axis which conquers the space. The ramp on which the show of boots is performed slices deeply into the centre of the frame. All the movements which are conceived to allure sensual interest are channeled on that ramp. The vertical axis functions as a sort of railway on which our perception glides into the centre of action.

Cutting in a given frame is a typical device in Lubitsch's films. Just think of the ball-sequence in ICH MÖCHTE KEIN MANN SEIN ('I Don't Want to Be a Man,' 1918). In the background are assembled the masses: dancing, spinning around in circles, when suddenly an endless chain of waiters cuts in from the foreground balancing champagne and battles to the background.

The type-cast character in Lubitsch films is a non-character, realizing himself on the spur of the moment, holding a vulgar grip on the present, upsetting pre-established order only to re-establish order. Total failure turns out to be total success... This non-character materializes as his own commodity and publicity at the same time; this character is a permanent promise to live up to his 'baser' needs.

Asta Nielsen and Female Narration: The Early Films

Heide Schlüpmann

Asta Nielsen's film debut in 1910 occurred at a time of radical changes in the cinematic public sphere. As the cinema was leaving behind its connection with travelling fairs and the variety theatre, where it had originated, it entered into competition with the theatre and prepared itself to become the mass medium of the 20th century. The Nielsen persona intervened in this process of transformation. She used the return of drama in film in order to create in the cinema what the theatre had missed out on: to become a place of female self-determination, where gender relations might be redefined. If, as Jürgen Habermas wrote, the classical bourgeois theatre had been a place for the 'self-thematization' of the bourgeoisie, where it presented and discussed its social existence, emancipated from feudalistic forms, then this function benefitted only the male and not the female members of the bourgeoisie.[1] Gender relations remained within the patriarchal system. However, the disruption of the traditional order of gender and of traditional female role models brought about by industrialization and urbanisation belatedly generated a social demand, especially among the female population, aimed at gaining a new self-confidence in gender relations. On this demand Asta Nielsen was to found her production programme.

With the cinema's adaptation to theatrical norms, it lost some of its qualities of showmanship, without thereby simply turning into the site of education and enlightenment as propagated by the film reformers. Rather, outworn dramatic forms began to develop a new life in film, becoming worlds of illusion and appearance, where realistic reproduction technologies promised the audience encounters to match their dreams and nightmares. At the very threshold, where the classical literary public sphere based on dialogue and the spoken word met the modern, technological mass public sphere of the dream factory, Asta Nielsen stood for the attempt to 'sublate' the theatre in the cinema, and thus to open the latter once more to its own repressed tradition of showmanship. By putting her body on show, the Nielsen persona opposed the illusionistic world of the drama, forcing it to reflect its changed position. Dramatic action no longer happened in the theatrical space of the present, where destiny takes place, but in a space of the past, inviting regression thanks to the accommodating darkness of the cinema. But stepping into the light of the projector, which brought the camera's recorded images onto the screen, the actress stood for the present – or rather, for the re-present-ation of bourgeois history's repressed and for a presence of visual perception which could resist the pull of the past as dream.

This transformation of the public sphere in the cinema – from a space of exhibi-

tion to a space of the reality of dreams – is directly represented in Asta Nielsen's films, first of all, in connection with the fact that she so frequently plays an artiste, and thus thematizes her own social role. There is a scene, recurring in several of her films, where she makes her entrance as artiste: in tawdry night-clubs, at the circus, on a theatrical or vaudeville stage. It is to be found in AFGRUNDEN, DEN SORTE DRØM, BALLETDANSERINDEN, DIE ARME JENNY (1912) and in many other films. All the scenes share one characteristic, namely that they represent the merger of two visual spaces: The visual space the female artiste shares with the stage and her audience, and the second space in which we, the film spectators, see stage as well as audience, but also get a glimpse of a slice of the bourgeois world beyond the perform-ance. In AFGRUNDEN the camera is placed at a 90° angle to the stage and records the female dancer as well as a part of the ornate auditorium wall at the right, including the heads of some of the musicians in the orchestra pit. But the camera also records the presence of the firemen and stagehands among the scenery, who are not involved in the performance; in their pres-ence the camera mirrors its own (detached) position. A similar construction of space is seen in DEN SORTE DRØM: however, this time, the camera is even further away, in a back-stage space leading to the circus arena through a portal framing our view of the audience sitting to one side, opposite the female artiste, performing astride her white charger. This construction of space mediates a break between the cinema audience and the audience of the artistic performance: the cinema audience sees the artist in relation to her audience and thus acquires the position of a third audience. But it does not remain an indifferent third party (as was the fireman), because at the same time as it watches the artiste in her show, it perceives itself as being addressed by her. In AFGRUNDEN Asta Nielsen performs her Gaucho-dance not to-wards the right, where the variety theatre spectators are situated, but by frontally exposing her body. Moreover, the position of the dancer is closer to the camera than to the first seats in the auditorium. The suspense generated by Asta Nielsen in this dancing performance resides, beyond all lewd fantasy, in the difference it opens up between the visual pleasure generated by the performance of an art, and another, newer kind of pleasure, kindled by the impression that beneath the artful display, a real, passionately aroused body is moving to-wards us. The difference of the spaces is recorded by the camera, but only Asta Nielsen's acting identifies the second space as that of the cinema audience. She awakens in the audi-ence a longing for the pleasures of the real, in opposition to those of illusion.

DEN SORTE DRØM, the fourth film of Urban Gad and Asta Nielsen, and the second after AFGRUNDEN to be shot in Denmark, goes one step further in its engagement with the cinema audience. For the illusion resides not only in the art, consciously demonstrated by her, it also resides in the reality, which the audience's unconscious produces all the more readily by colluding with the technical reproduction of her appearance. DEN SORTE DRØM opens with the entrance of the female artiste. We see her, from the point of view of the wings, dressed in a tight-fitting, lustrous black costume and brandishing her little whip, high astride her horse circling the arena, before she makes her exit towards the camera, a few of her circus colleagues, two waiting gentlemen, and us. This gradual approach implies

Asta Nielsen in BALLETDANSERINDEN (1912)

at the same time the crossing of a threshold. From the exhibition space of the 'dream' to the space of 'reality,' where she encounters two spectators who seek real fulfilment for the fantasy her performance has stimulated. Here – as in AFGRUNDEN – we come to see a bit of the female performer's lived reality, but we 'see' at the same time how the fantasy of the audience returns in this reality. The desire is kindled by the dream she represents and which is preserved in the publicity poster at the circus entrance and in the artist's dressing-room. In one of them, it is the age-old desire for possession, in the other it is the desire for the love of the woman who produced this dream – a modern love, respecting the autonomy of the woman.

The first, a banker, takes the female artiste for an object, a beautiful image which can be bought. The lover, on the other hand, insists on the reality of his dream. He seeks in her the 'truth' behind the image. But at the very moment when he believes to have discovered the true being of the woman, his own doubt about what is real is fatally caught up in the play of appearances. He discovers his beloved stretched out on a chaise beneath the banker's mighty body, draws a gun, and shoots. In contrast to the male protagonists, both of whose desire remains entangled in the image of the woman, the desire of the audience unfolds in the space between the images – of the dream and the reality.

Asta Nielsen's acting is always, and not only in scenes of the artiste's entrance, in a double register: one is addressed to the other protagonists, a form of gestural (substitut-

ing for verbal) dialogue, physical, exposing the body to the camera, which stands in for the physical-erotic relation to the viewer. But just as in her dramatic stage roles, where she addresses herself to the extra-diegetic epic narrating instance, and not to her partner in dialogue, she also does not address herself to the 'real' spectator. For when she directs her play beyond the dramatic space and turns towards the cinema audience, the Nielsen persona does not suggest a desire to meet the flesh-and-blood spectators in the dressing-room, in order to let her dreams become reality; rather, she wants to stage an encounter between spectatorial dreams and their filmic reality in the auditorium space of the cinema. Through her double performance register, the Nielsen persona produces in each scene of her films this two-dimensionality which is so self-evidently presented in the entrances of the female artiste. The actress becomes the source of an inner montage that defines the face of her films. Only at first sight do the films of Asta Nielsen follow other early narrative films in the simple montage principle of successive autonomous scenes. Compared to the structure of classical drama, however, the paratactic principle carried the day: dramatic action deteriorated to the level of the episode, with the dramatic performance attaining its significance from the organisation of individual episodes or the scenic entrances of the actors. In this respect, the camera seems to subordinate itself to the unities of place, time, and action. But in the self-contained and static scene before the camera, the actress reflects an 'other,' situated beyond the scene. Therefore, beyond the narrative space and time there opens another space in which the actress begins to act as well. Her acting reveals that the openness of the screen towards the space of the cinema has replaced the integrity of the stage in the theatre, and that the theatre's fourth wall has become the first wall of the cinema. In separating her physical acting before the camera from the acting within the scene, she leads the film not to an end in the closure of drama, but to another goal: to make the audience aware of its own existence in front of the screen.

The prominence such a scenography gives to the central figure is reminiscent of the Victorian 'Life Model Slides' of the Magic Lantern, where the person photographed in front of a staged or painted background possessed a peculiar presence. Also in the way each tableau replaces another, the early cinema's staging mode is reminiscent of the projection craft of the Magic Lantern, not least because both share superimposition as their most prominent narrative device. For the tension the actress builds up in each individual scene does not lead to an overall coherence formed by a dramatic curve stretching from beginning to end, but charges itself through its own repetition from scene to scene. Each film consists of more or less self-contained scenes, whose temporal sequence is also a spatial order on the screen. The inner montage of the scene refers to a sequential montage taking place in the projection space and through the act of projection itself. Although no longer staged by means of the Magic Lantern's mechanical device of superimposition, montage remains in the heads of the audience as a mechanism of continuity. The screen of the audience, endowed with memory, perceives successive individual scenes as if linked by superimpositions.

IM GROSSEN AUGENBLICK (1911) is explicitly reminiscent of the Magic Lantern tradition – a film which, in its melodramatic story of a poor mother, takes up this tradition also at the level of content. The final sequence frequently returns to a shot of a shabby hotel room, from which the protagonists look through the window at a mansion. While the heroine is waiting in the foreground for the return of the 'prison guard,' her husband, the real drama is going on in the background: a fire breaks out at the mansion. When she sees the burning building, where her child is, nothing can keep her. For the film spectator, the mansion in the window frame is a picture that comes alive just as it did in the Magic Lantern show. At the same time, it also brings to life the female protagonist: she climbs out of the window, in order, so to speak, to 'enter' the picture. But this merger of different spaces film can no longer achieve.

In the cinema, contrary to what happens in the Laterna Magica, it is not only the projector that establishes the connection between the auditorium space and the screen. Internal montage, as described above, also puts the film in a determined relation to the exhibition space. It is the actress who now bears the burden of this linkage, differently organized in early narrative cinema from what it later became when the viewer was inscribed in the film through the camera perspective. The actress is framed by the internal montage of her entrances on screen, but above all, it is she who produces the tension, to which the montage gives the form.

Asta Nielsen derives her narrational perspective not from the camera, but from the cinematic apparatus as historically evolved visual *dispositif*. In the first years of cinema, the task of montage fell to the projectionist: whether putting together single-reel films into a programme, or sequencing the different reels into a film. One could call it external montage, assembling filmic material into a coherent experience. When this became a technique on its own with the transition to longer films, the projectionist lost access to montage. Much later, André Bazin emphasized the principle of 'montage within the frame' in the sound films of the forties, contrasting it to the art of montage through editing.[2] The internal montage of Asta Nielsen's films, on the other hand, is one which is produced by the actress and in which the actress's work does not take montage out of the hands of the cutter at the editing table, but takes it over from the projectionist, who at just about the same time has to pass on his practice to the internal narrator. She, instead of the projectionist, becomes the 'narrator' of the film: a female narrator, who does not speak above the heads of the audience, but speaks by establishing a relation with it.

Melodrama and Narrative Space: Franz Hofer's HEIDENRÖSLEIN

Michael Wedel

Narrative Space: Questions of Style

If the methodological distinction between a 'cinema of attractions' and a 'cinema of narrative integration'[1] has contributed anything to the understanding of early cinema, it was to have sharpened one's sensibility for the manifold ways in which the individual style of a film mediates transitions and inaugurates differentiations in the cinema's 'discursive reality' among other contemporary forms of cultural production and popular entertainment. The abstraction inherent in trying to chart these two modes of cinematic practice in the form of a set of parameters – frontality and direct audience address on the one hand, continuity editing and the creation of an imaginary diegetic universe on the other – implies a radical 'openness' as to the articulation of cinematic space. Its 'ideal type' or paradigmatic 'virtuality' requires historically grounded re-definitions and specifications, since it is open towards different kinds of variables: internationally uneven industrial developments, national audience compositions, genre formations, and pertinent media intertexts.

Confronted with – and responding to – some of the striking stylistic 'non-synchronicities' in the international film heritage of the teens, historians have called upon a number of readily available explanations for the visible 'delay' of the German cinema: the relatively late establishment of domestic film production and the conservative pressures exerted by the reformist writings of the cultural elite were seen to be primarily responsible for the phenomenon of stylistic 'backwardness' visible in the *Autorenfilm*, a genre that epitomized the German cinema's *Sonderweg* ('separate development') well into the twenties: slow cutting rates, the lack of scene dissection and continuity editing, tableau-like framings and frontal acting paired with complicated and often contradictory plots seemed to reconstruct a 19th century theatrical narrative space devoid of spectacle and visual pleasure.

But the (methodo-)logical gaps and improbabilities of this historical narrative have become ever more evident as archive restorations have obliged scholars to revise their preconceptions in the face of the stylistic multiplicity that has come to light across the popular genre films and the versatility of their directors. With the rediscovery of the films by Franz Hofer in particular, the issue of the German cinema's backwardness has had to be rethought.[2] His idiosyncratic use of cinematic space in a series of popular genre films produced in 1913/14 (during the period that was to have been the heyday of the *Autorenfilm*) proved that German directors were indeed capable of matching international standards of narrative filmmaking. On the other hand, Hofer's ambiguous construction of a narrative space via the use of masking and silhouettes, close-ups and point-of-view shots, frontality

and direct address, internal montage and shot composition reveal a stylistic paradigm radically different from either American standards of continuous narration, or the immobile 'theatricality' of national quality productions, be they French or German. Indeed, the elegance and originality with which Hofer's visual space of 'attractionist' devices is integrated into the narrative process point to the lasting pertinence of a number of 'popular' intertexts such as the variety theatre, and the shadow play, stereoscopy and the Magic Lantern. In the first place, then, Hofer's films remind us once more that the distinction between attractionist and narratively integrated modes of cinematic space was never meant to be a self-explanatory analytical tool according to which individual films can be lined up along a linear transition, but provides instead a set of traits whose variable configurations constitute the historically unique discursive space of the individual film.

Melodrama/Social Drama: Training for Marriage?
The last point bears especially on the image of women's films in early German cinema, which, in the wake of Gunning's distinction, has been defined by a number of bi-polar models and oppositional pairs. A first opposition emerged around the two major female stars: while Henny Porten has been characterized as 'a star who fits in well with the conventions of the melodramatic scene,' Asta Nielsen has gained exemplary status as the one actress who gave 'a voice to a female presence in early cinema narratives, a voice notably absent in those adaptations of melodrama that perpetuated the stage image of women as prescribed by the dramatic sources.'[3] Along the lines of the distinction between a 'cinema of attraction' and a 'cinema of narrative integration,' Heide Schlüpmann has principally argued that the transition from the attractionist-exhibitionist form to the voyeuristic cinema of continuity in Germany not only meant a rise to cultural respectability through the co-option of famous writers and actors into the film business, but brought with it a confinement to patriarchal power structures in the narratives themselves:

> (...W)ith the establishment of narrative cinema, there was a tendency to degrade woman's history to the status of mere content for which male bourgeois culture provided the form of representation. To the extent that there remained, however, a tension between the represented story and the dramatic famework (...), there was always a chance for the actress in the film to express an oppositional standpoint. This tension can be attributed to the collision between two media (literature and film) which also implied a collision between two cultures – classical bourgeois and modern mass culture.[4]

In order to investigate the ideological reverberations of this tension in the films, Schlüpmann distinguishes between 'melodrama' and 'social drama' in Wilhelmine cinema. According to this logic, melodramas represented social problems of women in a traditionally stylized tragic structure, by which the suffering of the heroine in a male-dominated society is transfigured into an image of sacrifice that serves to domesticate the female narrative

perspective which thus becomes merely the confirmation of an always already defined femininity: 'The actress, representative of femininity, i.e. of male projection rather than articulation of female experience, no longer represents her own narrative perspective, but enforces the dominant order.'[5] In contrast to the melodrama, the social drama did not force the female narrative perspective in favour of a stereotypical representation of femininity within a dramatized story but, by appealing to the curiosity of female spectators, gave the subjectivity of the actress a 'spatial framework' in the text that derives its strength from the foundation in the mode of the cinema of attractions.[6] In conclusion, Schlüpmann states:

> The appropriation of German cinema through the melodrama developed a repressive distraction in the sublimation of the female gaze and its power. By contrast, the dramatization of the female gaze through the social drama tended towards a representation of male sexuality, of the man as sexual object. This tendency obviously collided with the influence of the guardians of bourgeois culture; social drama, unlike melodrama, disappeared from narrative cinema after World War I.[7]

Despite the strong dialectical formulation that concludes her article, Schlüpmann sees constitutive elements of the social drama shifting 'underground' into a variety of genres during and after World War I. Accordingly, the main indicator of this transition is the formation of the couple, represented within the institution of marriage, itself mediated by a particular fetishistic articulation of female sexuality:

> In this mediation lay the real significance of the objects. On the one hand, they are everyday objects that play a role as props in the course of the narrative. On the other, they possess a fetish character insofar as they appear in the place of the openly erotic attraction in the 'mistress films.' They substitute for the sexual element repressed in the representation of marriage (...).[8]

Although Franz Hofer's HEIDENRÖSLEIN may serve as an example for this historical mediation between the traditional dramatic formula of the melodrama and the explosive subversive potential of the social drama in German filmmaking of the later teens, it should be noted that Schlüpmann's argumentation itself shifts onto the content level at this point, presupposing as given and solidly established a representational logic (classical continuity cinema as the norm) which makes this displacement necessary in the first place. The present analysis wants to suggest a way of conceiving the genre's 'social' potential less along parameters of displacement on the content level, or located in diametrically opposed star images or acting styles. Instead, it suggests a mediation of another kind, one which uses the visual capacity of the cinematic discourse to externalize individual emotion and desire while, at the same time, it internalizes historical processes by rendering social conflicts in spatial terms. My analysis does not assume a linear transition from an attractionist to a narratively integrated cinema but – considering the results of a first statistical style analysis of the film which reveals only three

instances of closer framing than medium and only two moving shots – bases itself on the 'primitive' tableau. We can here take Peter Brooks at his word when he claimed that the melodramatic tableau gives the 'spectator the opportunity to see meanings represented, emotions and moral states rendered in clear visible signs.'[9] What follows is thus less a 'symptomatic' reading of the narrative itself than a deciphering of the concrete spatial 'condensations' of social and moral codes that fill the melodramatic formula.

Deep Space and Frontal Space: Condensations of a Social Code
The historical evidence for Schlüpmann's argument goes back to the sociological data assembled in Emilie Altenloh's pioneering study *Zur Soziologie des Kino* from 1914.[10] Based on a close analysis of movie theatre statistics and over 2,000 questionnaires conducted in Mannheim, Altenloh's *Sociology of the Cinema* has to be considered one of the most sophisticated sources on spectator preferences and attitudes in the context of an industrial city before World War I. The study has generally remained of special interest for its emphasis upon women as a significant part of the early cinema audience – according to Altenloh, a complex phenomenon in the interplay between capitalist marketing via genres on the side of the industry, and a socially as well as sexually determined popular taste on the side of the spectators. Altenloh already explained the transformation that set in about 1910 as a result of a combination of factors, not least of which were the rise of melodramatic narratives and the establishment of larger, more comfortable theaters in the city centres. Being especially interested in why women liked watching films, she found that they had marked preferences for melodramas and social dramas. According to Altenloh, in both genres the central narrative conflict is set up by 'a woman's battle between her natural, feminine instincts and the opposing social conditions.'[11] For the female protagonists of these dramas, as Altenloh further notes, the choice is between 'on the one hand prostitution, on the other the possibility of marriage at the side of a man, who mostly belongs either to a considerably higher or lower social grade.'[12]

Despite the common view that Hofer 'was apparently not a director of melodramas or social dramas,'[13] a view taken almost exclusively from the fixed perspective on his pre-war productions, Hofer in fact directed a number of melodramas with strong social undercurrents in the late teens, e.g. the series of films for Apollo-Film starring Lya Ley in 1916 and another series in 1918/19, starring Werner Krauss, later that year to play 'Dr Caligari.'[14] As a first run through the plot may indicate, his 1916 film HEIDENRÖSLEIN[15] can stand for a clear example of a melodramatic narrative: Little Rose has come to visit her grandparents for the summer holidays. She chances upon the young Count von Brödersdorff on one of the walks both are taking in the nearby forest. Soon after, Rose is asked to tend to the Count's mother, the local Baroness, who is suffering from rheumatic pains. On this occasion she once more meets the Count, and at this point they both realize they are in love with each other. From then on they continue to meet, though not only when Rose visits the Baroness; their love makes them bold: they have secret dates in the forest or in a small apartment the Count owns down in the village. When Rose's grandfather eventually finds

out, he is furious because of the shame her action has brought on him and his family. Because Rose entirely disappears from the public eye, the Count begins to believe the rumours of her having died of shame. He returns to the little room to imagine her funeral service, after having visions of their mutual past as lovers. Unwilling to stay in the dark about her fate any longer, he decides to go to visit her grandparents' house, where he finds her alive and well, and assures her grandfather of his intentions to marry Rose.

If, for purposes of analysis, we adopt Altenloh's narrative conflict and look how this opposition between female desires and social restrictions is visually concretized in HEI-DENRÖSLEIN, we find a pattern of spatial character movement according to a division between deep space and frontal shot composition. Established in the opening sequence, this pattern becomes the basis for an ingenious visual structure centred on the generic conflict identified by Altenloh and echoing the stages of the narrative development. Framed by two intertitles announcing the imminence of Rose's annual visit and her actual arrival, the film's first image shows the grandparents in medium long shot in the foreground of their living room. The first use of deep staging occurs with Rose's anticipated appearance in the film as she enters the front garden from the background and moves on a long diagonal axis towards the open entrance door behind which the camera is placed in the dark foreground; she enters the dark interior and leaves the shot past the camera. As the film's principal character, Rose creates the dynamic three-dimensional action-space which here, as in similar later shots, is paired with frontal staging and the character's direct eye contact with the camera, strongly connecting to elements of cinematic exhibitionism and spectacle. The shot's particular organisation of character movement, camera position and lighting could even be read as a mediation between the filmic space and the imaginary space of the darkened cinema.[16] When Rose then meets her grandmother and grandfather in the next two scenes, in one she enters into their frontal space and in the other remains immobile in the background. By contrast, she regains her initial spatial mobility only in situations in which she is either alone in the shot and/or just about to leave the sphere of her grandparents.

While this division between deep space and frontal staging in the first part of the film remains on the level of character movement and character position, there is a considerable change, once Rose encounters Count Brödersdorff: again, it is Rose who moves from background to foreground, stopping to pick some roses (!) from a bush. In the meantime, Brödersdorff has entered in the background and observes Rose while leaning at a fence which here, for the first time, visibly marks the near/far distinction, which previously had to be crossed by Rose in order to be marked as such. Now it is being bridged by the looks of the lovers-to-be; the pleasure of the male look, however, is accentuated for the audience by the metaphorical pairing of young Rose with real roses in the foreground. Although the shot's visually adroit near/far division of space here undoubtedly alludes to their social difference, the full significance of this particular shot composition for the overall narrative conflict between an unrestricted articulation of female activity and desire, and the surrounding constraints of the social and family hierarchies emerges only when, in subsequent shots, this

HEIDENRÖSLEIN (1916)

division increasingly acts as a barrier and disruption of the action space identified with Rose. With a similar spatial division, a later shot totally suppresses her diagonal movement as she leaves her grandparents' living room. In order to leave the family group sited in the foreground, she first has to move to foreground right, then exit the frame altogether, before reappearing in the background behind a window at the rear wall. The spatial configuration of this shot thus metaphorically condenses the entirety of her narrative trajectory in the film.

Looks and Mental Spaces

Even more instructively, the organisation of the subsequent shots indicates the scale of the multiple spatial codification, and particularly the gradual destruction of Rose's initial mobility. Rose enters the background of shot 28, visible inside the house through the window at which she stops to look outside to the foreground terrace. In the following shot, the door is already open and Rose is on her way to the bushes in the foreground, overgrown with white roses, obliging her to stop. While her look is directed off-screen, the image of Count Brödersdorff becomes superimposed to her left, fading at the very moment she seems to turn her eyes towards it.

Once more, her diagonal movement has been partially blocked by a door, which here is further pronounced by a cut. Her movement to the foreground is now strongly associated with the desire to recreate herself in the place where she was seen by Brödersdorff, which is indicated by the superimposition of the object of her thoughts, and further suggested by the repetitive metaphorical use of the roses. The frontal space is here finally established as the place of the heterosexual romance and thus the second socially defined sphere: even in the female protagonist's imagination it is determined by the objectifying male look. At the same time that her desire is granted visual expression, Rose's immobility exposes her to the voyeuristic gaze of the male spectator, split – as before – between the male mirror image on screen, and the pleasure to be gained from the visual metaphor aligning Rose with roses. If she were to return the look as she had previsously done, the pleasure of the voyeur would vanish like the Count's image.

Whereas this new social dimension of the near camera space constitutes an opposition to the social space shared with the grandparents, both these social spaces stand in opposition to Rose's initial action space in that they suppress diagonal movement and are instead marked by a seeing/seen pattern within the single shot that exposes her to the controlling look of either the Count or the grandfather. That this basic opposition is again predominantly constructed around the division of deep and frontal space is indicated several times in the film. Once, during one of their secret meetings, Rose enters from the far background on the familiar diagonal axis and meets the Count in the foreground, before both leave the subsequent medium shot, foreground left. A second time, when Rose is about to leave her grandparents' house through the front garden – inverting the axis of her entering the film in shot 4 -, the grandfather forces her to step back into the house and thus to remain in the foreground.

The most striking exemplification of this pattern can, however, be found when Rose and her grandfather visit the baronial estate. After Rose, framed in a very long high angle shot, diagonally approaches the (once more darkened) foreground, the next shot finds her exposed to a whole assembly of socially controlling looks, most notably that of the Count, the grandfather, and the Baroness, the Count's mother.

HEIDENRÖSLEIN thus knows two visual systems, deployed systematically and within a determinate narrative logic. The development on the level of shot space from forms of female spectacle-display to patterns of social, predominantly male control through the agency of the look is paralleled by transitions in the seeing/seen pattern on the level of the imaginary space constructed by the editing. While in the first part of the film the editing was primarily dominated by the female protagonist's active look or movement, in the course of the action this narrative agency is increasingly taken over by the two male protagonists, the Count and the grandfather, here acting as the patriarchal instance par excellence. Whereas, for example, the first of their morally and socially transgressive secret meetings was clearly initiated by Rose through a point-of-view construction relying on the near/far division, their last secret meeting, disrupted by the grandfather and thus causing their temporary separation, is driven by continuity editing of left/right screen direction, motivated by Brödersdorff's look. Like-wise, the psychological motivation for their secret meetings was initially represented as belonging to Rose's subjectivity. Yet the long flashback and the dream sequence of the funeral focalize Brödersdorff's subjectivity, leading to his making the move and finally deciding to marry her. Concomitantly, the active agency of the look is fully taken over by the grandfather, who observes Rose in a number of point-of-view constructions. Both key constituents of narrative agency, character movement and the active gaze, are split between the two male protagonists, propelling the action towards the generic outcome of 'melodrama' (marriage), which each by itself would not have succeeded in bringing about. Rose's once dominant narrative agency, on the other hand, is undermined and replaced by a male perspective which tries to prevent the formal elements that gave a cinematic 'voice' to her desires. When, for instance, her gaze and movement still seem to initiate a cut on action during a visit to the Baroness, the next shot reveals both had been provoked by the 'off-screen' sound of the Count playing the piano. Consequently, Rose's movement remains within the foreground of the two shots, the place of social interaction and control. In a similar vein, the grandfather has not succeeded in his disciplinary efforts until he can literally remove Rose from her diagonal action space by carrying her from the foreground to offscreen left after having caught her on her way to another secret rendezvous. The extent to which the film relates frontal acting and lateral character movement to oppressive patriarchal conditions towards female identity emerges for a last time in the textual relation between the only two moving shots. The camera pans to the left when Brödersdorff's 'off-screen' piano music conspiciously motivates Rose's change of action space from the diagonal to the lateral axis. In the dream sequence towards the end of the film, in which the Count imagines Rose's funeral service in the local church, the camera pans slowly to the right, away from the organ-playing priest to the grandfather and his pupils intoning

what is supposed to be a requiem. Not only does the second pan shot to the right close the space opened up by the earlier camera pan to the left; by substituting for the piano-playing Brödersdorff a priest playing a requiem, a strong connection is established between the oppressive redefinition of Rose's female narrative perspective and her imaginary misery.

Silhouettes and Hieroglyphs: Training for Effect

> Every typical space is produced by typical social relations which it expresses without the distorting intervention of consciousness. Everything denied by consciousness, everything studiously ignored participates in the construction of such a space. The images of space [Raumbilder] are the dreams of society. Wherever the hieroglyph of a spatial image is deciphered, it displays the foundation of social reality.[17]

At the end of HEIDENRÖSLEIN stands the anticipation of marriage. In this respect, 'Training for Marriage' might have been a more appropriate title for this film, one that would have made explicit much of German family melodrama's most common dramatic feature, from the teens to the sixties. In fact, it was the title of a film (presumed lost) directed by Hofer in close temporal proximity to HEIDENRÖSLEIN, and also starring Lya Ley as Rose and Fritz Achterberg as her male counterpart: DRESSUR ZUR EHE, however, was a light, comic melodrama where it is the husband who has to be trained for marriage on his honeymoon by his wife and mother-in-law,[18] reinforcing once more that this genre's social dimension unveils itself much easier under the disguise of comedy.[19]

By the time, in HEIDENRÖSLEIN, Rose's trajectory has taken the melodramatic turn to marriage, it has passed along the razor's edge between kept mistress and victimized wife. Despite the gradual erasure of the female narrative perpective, however, the film does not arrive at anything comparable to classical 'voyeuristic' cinema, with its neat narrative closure. Rather, it leaves traces of alterity as the visible mark of the melodramatic genre: the studied visual elaboration gives an overdetermined – even ironic – status to the role of Rose as mistress, by rendering the secret love scenes as pure shadow plays of silhouettes, while showing female victimization literally as the 'dream' of male subjectivity. The tableau of the last shot which seals the promise of marriage is again composed as an echo of the cinematic situation itself: the couple in the foreground is watched by the grandfather who is re-framed in a rectangle formed by the wooden trellis entwined with white roses. It is the phantasmagoric quality of such visual compositions which seems to suggest that the social reality to be read from these hieroglyphs of happy endings necessarily takes the form of an illusion. Such a closing scene suggests that in Wilhelmine Germany, as in other cultural contexts undergoing the transition to modernity, the melodramatic mode can function as a form of narrative ambiguously poised between conformism and subversion, for which film scholars have appropriated the term 'excess.' Which suggests to me, as it did to one unknown contemporary reviewer, another title altogether: less 'Training for Marriage' than 'Training for Effect.'[20]

Cinema from the Writing Desk:
Detective Films in Imperial Germany

Tilo Knops

As long as the German detective film from the Wilhelmine period had been practically forgotten, Siegfried Kracauer's verdict could remain unchallenged, that a German detective genre was hardly conceivable at that time.[1] Since the beginning of the nineties, however, even this 'unknown galaxy' of early German films has been rediscovered, and Kracauer's pronouncement has faded from view; the films of the Stuart Webbs detective series alone refute it. Specific characteristics of the Stuart Webbs films have now been worked out[2]: while productions such as the Sherlock Holmes series from Nordisk, the Nick Carter films from Eclair, the Nick Winter films from Pathé, or the Nat Pinkerton series from Eclipse were attractive because of their haphazard stringing together of film sensations, the Stuart Webbs series is considered 'a contribution to the discussion on the legitimation of early cinema.'[3] In line with the reform efforts, the German film industry attempted to present realistic plots, a treatment supported by internal logic, more psychological plausibility and convincing, individually distinct main characters, so that they would be accepted in the tradition of classic detective novels so loved by the educated public.

Such a revision recognises the qualities of the international popular film culture as at best a string of so-called sensations, although they also serve as foils for the German detective films, which display an allegedly superior 'narrative logic' and 'plausibility' when compared with the French product. This runs the risk of exacerbating the problematic, by repeating – some eighty years later – the restrictions voiced by the German reform movement aimed at the educated classes. The contemporary version modifies this, in the interest of creating a myth of alternative culture, along the lines of a 'shaking up of the normative consciousness that knows to distinguish between appearance and reality, to judge between lie and truth' (Heide Schlüpmann[4]). However, is the theatre actor Ernst Reicher's performance really to be seen as a 'Trojan horse in the war of patriarchal, property-owning bourgeois culture against the cinema,' teaching 'responsibility'?[5]

Many aspects argue for a re-evaluation of early German cinema, considered inferior or specifically teutonic for too long, especially when one recalls that up to World War I the producers, not to mention the audiences, were oriented to an international scene.[6] At the same time, however similar the development of the film form was from one country to another, varying expressions of film development already existed, beginning with the prehistory of popular cultural forms, especially with regard to the relationship between high culture and the 'trivial' arts and thus the incorporation of foreign forms. Production and distribution companies and investment in film were not equally capable of developing eve-

rywhere at an industrial scale. Cultural preferences and resentments, the urge for cultural respectability (an international phenomenon, but particularly pressing in authoritarian societies where status is linked to military codes of honour) were some of the differentiating factors, which not only manifested themselves in the cultural 'superstructure' of taste, but also in government measures such as amusement tax, building and fire police regulations, and last but not least, censorship. It was no accident that in the USA, where the development of the modern consumer society was furthest advanced, the public debate emphasised the ability of the cinemas to integrate the masses as 'democracy's theatre,' while in Germany this 'theatre of the common people' was feared precisely because of its 'egalitarian appeal.'[7] Even when simply copying foreign success formulae, German productions possessed unique characteristics, ranging from differences in production budgets, story structure, editing rhythm, and cast of actors to a preference for particular settings and camera set-ups. If it was not only in the German cinema that eroticism decentred itself towards demonstrating the civilized facade of the 'woman of quality' (à la Henny Porten or Mia May), it is nonetheless noteworthy that Paul Wegener (in 1913 already a man of 39) could get away with satisfactorily portraying DER STUDENT VON PRAG, thus showing that the Wilhelmine 'gals' had their matching 'guys.' The first sociologist of the cinema, Emilie Altenloh, credited French actors with a body language that made film drama look natural, in contrast to German actors, who seemed 'fitted into postures that felt uncomfortable even to look at.'

In this cinematic landscape, the detective film was trash incarnate. Negative judgements about melodrama and the detective film were rooted in a strong xenophobia, because especially the educated classes were fearful of foreign influence. The flowering of the German detective film thus occurred during World War I, when the foreign competition no longer threatened the underdeveloped domestic film industry.[8]

But even before the war, detective figures had appeared in German film, though perhaps in a slightly different generic context. WO IST COLETTI? (1913), for instance, is an *Autorenfilm*, a genre made prestigious by the film industry from 1912 through famous theatre authors and actors. These films were shown in 'socially acceptable cinema theatres' aimed at winning over a middle-class public. It was hoped that, once respectability had been gained for the cinema, negative public opinion against it would subside.

WO IST COLETTI? is about master detective Jean Coletti, accused in an open letter by the Berlin mass daily *BZ am Mittag* of withholding information about a certain known criminal, in order to allow him to remain in town for another 48 hours. In a counter-move, and to prove that even a well-known personality can show himself in a large city (over 1 million inhabitants) without being recognised, Coletti offered a reward of 100,000 marks to anyone who spotted him, the famous detective, in the street. Until he eventually, as expected, wins the bet, Coletti successfully outwits the population hunting for the reward through the use of various disguises, to the delight of the initiated viewers.

This German adaptation of a detective subject is strategically targeted by the producers to give the film an international flavour. The detective has a French first name, an

Italian surname, while his style of beard is specifically described as English, each trait inscribing a country whose domestic film production had established itself as a leading international player. The hope was to kill two birds with one stone: first, to attract potential export interest, and second, to appeal to the film experiences of the domestic public, whose choices were up to 90% foreign-influenced.

For the German variant of the detective genre as *Autorenfilm*, it was typical for the detective not to solve sensational criminal cases, but to be himself the centre of attention in a comedy. Detectives who reduce their talent to that of quick-change artists became authorities in their own right. Their superiority is never questioned, and outwitting the rabble, matrons and senile counts not so much thrills the public with the fear of the unexpected, but gives them the chance to feel superior to the duped participants and to marvel endlessly over the disguises.

A characteristic feature of WO IST COLETTI?, as indeed of many *Autorenfilms* of the time, is that the most important characters are first presented in the manner of the theatre, taking a call or stepping in front of a curtain. However, actors were almost less important personalities for these rituals than the author and director.[9] After the (rather lengthy) business with the newspaper and the open letter, the author, Franz von Schönthan, followed by the director, Max Mack, are seen sitting at a desk. They are selecting suitable actors and throw them – by means of film trick technique – at the ceiling. The principal actor Hans Junckermann as Coletti is seen dictating in his office, also in front of a desk, and is introduced, like his girlfriend Lolotte (Madge Lessing), as a star 'from the Metropol Theatre, Berlin.'

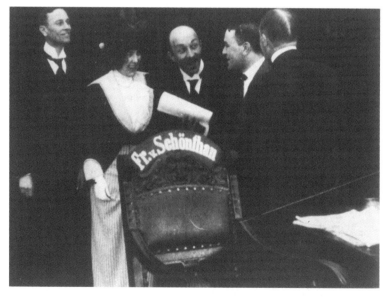

WO IST COLETTI? (1913)

WO IST COLETTI? also contributes to fulfilling the main goal of film industrial efforts at that time, advancing closer to the evening-long feature film with its length of 1554 metres, or over one hour running time (depending on projection speed). However, the transitions are still clumsy, and the stringing together of scenes from the search for detective Coletti, which allows a display of his special talents, is an old-fashioned technique, dating from films about 1904. The visual tricks also derive from earlier works such as Méliès. Furthermore, there are problems with the construction of the narrative space. By presenting the author, director and actors, a type of what is now called film-in-film construction is suggested, whose purpose is to indicate that this is a film and not reality by 'reflecting on itself,' breaking the spell of illusion cast. In those days, though, the conventions of 'illusionistic' classic narrative cinema were not yet familiar standards nor anywhere near generally employed in German films. Two scenes illustrate this. The disguised barber Anton is shown once on an upper bus platform, where the excited crowd rushes after him, mistakenly thinking he is Coletti. Later, after his true identity has been established, the entire event appears in the cinema to mock the pursuing crowd. An intertitle carried a drawing of the bus followed by the crowd along with an in-joke of that time, which even functioned as advertising for the film company Vitascope.[10] The next scene is set in the inside of a cinema hall with the search for Coletti repeated on the screen in the same sequence we had just seen, making it appear to be author-less documentation, filmed reality. In classic narrative cinema an attempt would have been made to explain why the viewer in the story could see the film from the same perspective as we can, for example, by showing a filming cameraman in the first scene.

The rules of presentation in a logical and closed space being developed by American cinema were not yet universally available. For instance, in another scene we see Coletti from a 90^0 side view disguising himself in front of a sort of make-up mirror. The mirror is on the left, Coletti in front of it on the right, and behind him to the right several metres of the furnished room are visible, the walls adorned with a flowery wallpaper. Some time later we see Coletti's face from in front, thus logically from the viewpoint of the mirror. However, instead of seeing past him a view of the room in depth, the flowery wallpaper appears directly behind his head. This is a prime example of a 'continuity break,' as it is called today. Also, the frequent direct address to the audience, the sometimes purposeful, sometimes unconscious glances and acting towards the camera, is typical of the transitional period in film history. Another, unfortunately not isolated, example involves the girlfriend Lolotte's confusion when she (allegedly) cannot tell detective Anton apart from streetcleaner Coletti, although she is talking to her disguised lover. That a familiar person could be recognised by his voice appears to have entered the realm of improbability in German silent films.

Meanwhile, the German female detective Miss Nobody remained oriented towards the chases and cheap sensational plots of her American forerunner, but without achieving the same level of suspense or acting agility ascribed to the latter.[11] In contrast, shortly before the outbreak of the World War, the serial detective Stuart Webbs was intro-

WO IST COLETTI? (1913)

136

duced in an attempt to replace foreign detective and adventure films with a character who more closely resembled Conan Doyle's Sherlock Holmes. The series became a box-office hit with the first film DIE GEHEIMNISVOLLE VILLA, while Joe May's earlier 'prize competition films' (DAS VERSCHLEIERTE BILD VON GROSS-KLEINDORF, 1913) could not attract the public even by offering a prize for the correct solution to the mystery, contrary to expectations.[12]

In DER MANN IM KELLER (1914) we find Stuart Webbs, as we might have guessed, sitting at the desk in his office, surrounded by symbols of middle-class respectability such as tasteful furniture, bookcases, oriental rugs and medieval armour. He has been asked by police headquarters to investigate a most unusual case: A small deerhound howls, and the foremost English detective is called in. The dog was found in an uninhabited house, and the detective believes that it must be howling for a particular reason. He looks around and finds in the cellar an unconscious man locked in a trunk. He frees the man, but tries to arouse this victim of a violent act in vain. After the man finally regains consciousness, he recounts to the detective, who in the meantime has already established his identity, how an anonymous letter he thought came from his bride led him to take a holiday from his job as officer in Cairo and travel to London. There he was attacked by an unknown man. The detective establishes that a double and two accomplices had got the officer out of the way so as to acquire the hand of the rich bride and sell off stolen secret documents. The pseudo-officer was promptly arrested, but the detective also wanted to capture the accomplices and more importantly secure the return of the secret documents. In the final scene Webbs invites the real officer and bridegroom to the police station, where the double is delivered tied up in a trunk. The bride is rushed over, but only with Webbs' assistance can she identify the true bridegroom.

What stands out is the weak, hardly stimulating introduction – no murder has been committed, only a deprivation of personal liberty combined with a robbery, which had already finished at the time the film began, and an attempt at deception. Although the documents concern a subject that was 'hot' just after the start of the war, namely plans for a secret weapon – it is never shown, not even unloaded. By playing down the criminal aspects the plausibility of the entire plot is affected, from the very beginning. Why should the report by Baroness de Ville of a deerhound howling in a cellar cause police headquarters to engage a detective? The other events are equally full of improbabilities. Everything is treated with more secrecy than is realistic for such a harmless riddle. Master detective Stuart Webbs must make a razorsharp deduction to locate the awful whimper in the neighbouring cellar, in fact, pinnacle of horror, through an old gas pipe. Why doesn't the frightened Baroness know even the name of the inhabitant of the villa next door, the colonial officer Lord Rawson? And why must Webbs, commissioned by police headquarters and already at the scene of the crime, first ask permission belatedly via telegraph from the lord before forcing an entry into the villa on a rescue mission? Or was it just necessary for the plot to have an important telegraphic correspondence with Cairo? Why does the fiancée entertain the toupee-wearing double at home as her betrothed for a considerable length of time, and at the end require Webbs' help to identify the correct one when confronted with both lords? Why does the

deerhound disappear from the script altogether after the tied-up lord is rescued from the cellar and after leading Stuart Webbs to his owner's address, the bride, who was looking for him in the advertisements, when he played such a significant role at the very beginning of the story? How did he get home? Why does Webbs have to disguise himself as a manual labourer in order to snoop around in the house of the lord's fiancée? Perhaps because everybody knows the famous detective – but why the public should recognise his face is not explained. The important fundamental contradiction between real and false telegrams and letters must have been equally unresolved for the contemporary audience as for one today, because too much text and data were requested at time points too far apart for the viewers to remember the connections between them.[13] All this and much more remained mysterious, as the public complained at that time.[14]

In other Webbs films there are also evident improbabilities and a lack of logic. For example, DIE TOTEN ERWACHEN had a 'powerful beginning.' In the Danish noble family von Carok, the head of the family has been shot for no apparent motive, just like the grandfather earlier. Webbs outwits the family's notary, who will conveniently inherit the family fortune after all the members are disposed of, in the scene described in the title: an attempt by the notary to poison the Countess is reported to have succeeded. To lure the rascal out of hiding, it is announced that an important document was buried in the coffin along with the Countess. Three days after the mock funeral, the notary does indeed sneak into the tomb at night and steals the document. Suddenly, the supposedly dead woman appears as an awakened ghost, scaring him into confessing. Where the Countess stayed for those three days is not mentioned. Did she really wait three days and nights in the coffin until the greedy notary appeared? Certainly, while stealing the letter, the notary did not notice that the body was missing. Thus, this key scene is not 'realistic' or plausibly justified, and the suspense is not made clear, but rather asserted.

Continuity errors did not seem to bother the producers of that period, nor the viewers perhaps even today; for example, Stuart Webbs in DIE TOTEN ERWACHEN could fall into the water with his cap and cigar case and get out dripping, with a soaked-through cap in his hand, only to continue his investigation with the next step completely dry, sometimes with, sometimes without cap and cigars. Others believed, as Karl Bleibtreu asked, that the detective and the criminal must learn how to behave from now on in the cinema like real, sensible people, not with this 'cinema criminalistic, (...) where, e.g., a Count acts like a boilerman and the simple man from the street grumbles during many of the exciting parts: "What a load of nonsense!" We can conclude that the public demands more and more a sensible treatment and sense of logic...'[15]

It is not only the lack of logic that hinders comprehension. The central problem remains of a narrative film from the transitional period, in which an economy of information transfer is missing, the system of an unsolved key mystery with constantly new minor riddles appearing and being partially solved which in the classic thriller maintains the suspense among the collaborating and involved viewer. Too much may be expected of the audience,

as for example in DER GESTREIFTE DOMINO with its letters that are mixed up at the post office, fallacious meeting places, protagonists disguised for a masked ball, and criss-crossing plans and motives, because the main characters and their motives are not psychologically clear and comprehensible, and all the mysteries are presented with the same amount of stress.

As the thrill of the film is comparatively minor and hardly any pleasure can be had in trying to solve the puzzle in Ernst Reicher's self-penned script, the film's attraction depends on the appeal of the detective figure as an increasingly successful authority role, as already seen in WO IST COLETTI?. Stuart Webbs does not engage the viewer's intelligence. His view of the situation is never questioned, he overcomes all difficulties, playfully solves all mysteries and riddles, and can accordingly be admired. The variations in knowledge on the one hand among the protagonists and on the other between the protagonists and the public, those small dropped hints which ensure suspense in a classic thriller, are not equivalent by any means.

In comparison with the exemplary Mr. Holmes, Webbs' unsubtle deduction method was criticised by contemporaries; however, Webbs is noteworthy for his dependent relationship with the authorities, the police, even given the expectations of the Wilhelmine position. The police are not treated with disdain as in the Anglo-Saxon detective models, rather the opposite applies; in DER MANN IM KELLER the police chief jests with one eye on the clock whether Webbs for once would not walk into the station promptly at 8 o'clock with the solution. In this connection it may be recalled that the introduction of film censorship in Germany referred to an allegedly low regard for the police.[16]

French detective films were completely forbidden, e.g. several Nick Winter sequels, ZIGOMAR, the FANTOMAS series and LES VAMPIRES;[17] as were also Griffith's early social critical melodramas like A CORNER IN WHEAT.[18] In public, these censorship measures were always justified by the danger of imitation. How limited the possibility was that the German film industry could make crime thrillers and detective films with image effects similar to the foreign ones was demonstrated by the surviving edited versions from the contemporary film censors. German detective films were also regularly 'forbidden for children' at least, while the permission for general release was made dependent on the removal of several scenes. These scenes involved portrayals of violence, criminality or eroticism and were considered embarrassing. Before DER MANN IM KELLER was forbidden for children in Berlin (from 1914) and 'additionally forbidden for the duration of the war' (in 1916), the censor in Munich complained in 1914 about, e.g., 'the magnified portrayal of the bound man in the trunk, when the detective shines in a signalling lantern' and further 'the detective disguised as a waiter knocks out the criminal with ether' and 'He places him in a travelling case'. The German crime thriller film ABENTEUER EINES JOURNALISTEN was totally banned in 1914 on account of two scenes: '1. A criminal plants the bomb (close-up). 2. The portrayal of the victims of the explosion under the rubble.' In DAS TREIBENDE FLOSS the following extract was criticised in 1917: 'In Act II, scene after titles 1 and 2, in which the criminal

wraps a cloth around his hand, smashes through a door, and the swathed hand can be seen for an extended period on the other side of the door.' The Webbs film DIE GRAUE ELSTER was partially forbidden in 1920 because of the following scenes: '2nd Act, 1. The dance sequence with the title: "Hello, Jonny! My girlfriend wants to dance with you!" 2. The knife fight between two girls in the low dive – 3rd Act: 1. The title: "Calm down, will you, I really can't give you anything more today." 2. The scene after the title, in which Setty strokes Jonny's thigh while he sits next to her.'

What actually remained for the German film industry then? Wherever close-ups were used, they did not present dramatic climaxes, but had a didactic purpose. Thus, in DIE TOTEN ERWACHEN Stuart Webbs was permitted to show the countess and the audience a close-up of the revolver barrel to prove that her noble husband could not have killed himself with it. This inspection, however, does not serve to decipher truly secret details, as it would have in foreign examples, nor to care what the outer appearance symbolised as in FANTOMAS and LES VAMPIRES; here no decapitated head will roll out of the trunk, simply because hideous atrocities, brutal violence and breathtaking thrill are already fundamentally forbidden. Improvisation, incoherence, and anarchy as in the French series are likewise unthinkable, as are the erotic obsessions permitted to a blond innocent like Mary Pickford, Pearl White or Lillian Gish; also, no comic figures as in the LES VAMPIRES series appear in Stuart Webbs productions, let alone the scandalous figure of a Musidora.

In summary, the detective genre received a slightly theatrical aspect, since the protagonists were given foreign-sounding names to try to garner some of the spectacular box-office success of the international models, and concentrated more on the detective as a master of disguises and on the appeal of modern technology, such as automobiles and planes, than on sensational atrocities and revelations. Spectacular furnishings eagerly moved into the picture, as already done in countless morality plays, by the frequent employment of depth of field: the collection of medieval armour and carpets, bearskins and other animal rugs by the bed, statues and oriental tapestries represented a German middle-class dream world full of unfulfilled colonial and feudal desires.

WILLIAM VOSS (1915)

Indeed, the values of Wilhelmine culture derived from the conspicuously frequent filmic use of symbolically overdetermined props. A holy relic of the middle class was of central importance for the build-up of a scene: the writing desk. In DER MANN IM KELLER not only does the opening scene show the detective sitting at his desk, the police chief is also sitting at one at the end of the film. Lord Rawson's colonial office had palm trees and a painted silhouette of Cairo as the backdrop, while in the foreground there was the heavy, authoritative writing desk, as if it were a fixed cliché for an interior shot in a German film. How is the next scene arranged, in which Rawson asks the Governor for time off? Around a writing desk in the foreground, of course. In DIE TOTEN ERWACHEN we find Stuart Webbs at a writing desk as the Countess sweeps in. Where do they start looking first? In the late Count's office, in his desk. He supposedly shot himself there. In the culprit's house as well we soon take in the well-known perspective, in the notary's office in front of the desk. In DER GEISTERSPUK IM HAUSE DES PROFESSORS an electrical shutter release for a cinematographic recording device is fixed to the writing desk, for the terrible occasion in which someone moves towards the desk and pushes the chair away. Even in the remake of the Stuart Webbs film DAS PANZERGEWÖLBE from 1926 we find the hero at a desk in front of an impressive set of bookshelves.

As the Italian cinema of fascism was called 'Cinema of the white telephone' after a fashion item of that period which was meant to symbolise the extravagant ambience of events, so the German silent film could rightly be called the 'Cinema of the imposing writing desk'; just consider the relevant scenes in DAS CABINET DES DR. CALIGARI and particularly Fritz Lang's sensationalist, espionage and master criminal films. Typical accoutrements are the weighty, leather-bound tomes on the side, next to the desk lamp and a letter holder. Usually the dark piece of furniture stands slightly off-centre in the foreground and thus faces the viewer in a respectful position in relation to the authority figure, a stratagem used not only in Wilhelmine society, as seen when visiting officials.[19]

If the distinction between early 'primitive' and classic narrative is that the former assumes more acquaintance with general cultural knowledge and awareness outside of the film, while the latter is understandable in itself, then the German detective film is marked even more obviously by the early cinema. This depends not merely on the settings and topoi of detective and trash literature; they imitate after a fashion much more the formulae of the foreign detective films which were so successful with the cinema-going public. Their filmic 'sensations' were only claims, for in reality they were as trivial and well-behaved as the censor would allow. This led in the end to the fifth sequel in the Stuart Webbs series being advertised with the expression that it passed the even stricter censorship without being cut.[20] Kracauer's thesis of a German lack of appreciation for the foreign detective genre is confirmed. Comparatively speaking, the German detective cinema may not be more narratively integrated than its foreign rivals, nor more of a 'cinema of attraction.' Its distinction may have to remain that, above all, it is the 'cinema of the writing desk.'

Ernst Reicher alias Stuart Webbs: King of the German Film Detectives

Sebastian Hesse

'What makes this film different from all the other detective films? The strictest logic, only sensations that are really credible, and psychological development.'[1] So ran the advertisement from Continental-Kunstfilm GmbH in the spring of 1914 for DIE GEHEIMNISVOLLE VILLA ('The Villa of Mysteries'),[2] the first in a series of Stuart Webbs films, the longest-running detective film series and one which was to shape the style of German cinema. By 1926 fifty films had been made,[3] all of them with Ernst Reicher[4] in the leading role. In most of them, Reicher was leading actor, scriptwriter and producer rolled into one. It was only in 1914, following a row with Continental, that he – at first together with Joe May – took the initiative of setting up his own production company, the Stuart Webbs Film Company. The model developed by Reicher served as the prototype for dozens of imitators and became the archetype of the early German detective film. During the war years the domestic market was flooded with home-made detective film series featuring gentleman investigators with Anglo-Saxon names like Joe Deebs, Harry Higgs or Joe Jenkins. German 'colleagues' were few and far between.

This genre convention was exceptional in a German film market that was otherwise thoroughly closed to the outside world in the period 1914-18: propaganda was not well served by heroes of foreign descent. Siegfried Kracauer explains the phenomenon with the 'dependence of the classic detective upon liberal democracy,'[5] In the absence of a democratic political system, the Germans would have been unable to 'engender a native version of Sherlock Holmes.'[6] There was no place in a bureaucratic society built on rank that characterised the declining *Kaiserreich* for a 'single-handed sleuth' detective 'who makes reason destroy the spider webs of irrational powers and decency triumph over dark instincts.'[7] He was rather 'the predestined hero of a civilized world which believes in the blessings of enlightenment and individual freedom.'[8] If we are to trust this thesis, the subversive side of the private detective would have appealed to the disposition of an educated public interested in emancipation, yet this explains neither the mass popularity of the genre nor the indifference with which the film censor approached the detective series during the war years.[9] Furthermore, the genre continued to hold sway during the early years of the Weimar Republic. It would seem more relevant to examine the detective film – and Reicher's impact upon it – as a contribution to the discourse of legitimation of early cinema.

The 'Reform Detective Films' around Stuart Webbs in Contemporary Criticism
The quotation opening this article confirms the extent to which film production and adver-

tising in 1914 reacted to contemporary discussions about the quality of film drama. The trade press continues this tendency, noting on the occasion of the premiere of DIE GEHEIM-NISVOLLE VILLA: 'It would be no exaggeration to say that this latest creation of Joe May's at Continental-Kunstfilm GmbH constitutes a new, infinitely complete phase in the field of the detective film.'[10] The launch of the fifth Webbs vehicle provoked the following reaction in the *Licht-Bild-Bühne*:

> There can be no argument that the concept of the detective film has retained a certain unpleasant aftertaste over the years (sic), which was expressed by, among others, the censorship department of the war ministry. To many serious critics, the typical film detective has become something of a ridiculous carica-ture. The Stuart Webbs Film Company has managed to bring about reforms and improvements in this field; all of its films to date constitute a document of the fact that the detective film no longer has to be viewed with the usual suspicion.[11]

The crux of the so-called *Detective-Film Debate* was that the cycles had deteriorated into series of hair-raising adventures lacking all plausibility. Forcing the film industry to reas-sess its own image, the criticism brought about certain reforms in the genre. Thus, shortly before the first Stuart Webbs film appeared, the *Kinematograph* devoted its lead to the de-tective film, in which the critic R. Gennencher wrote:

> A large number of recent detective films, which employed the most colossal range of possible and impossible effects, with very disappointing results, were unable to trigger any deeper impression, because they lacked one of the elements that is almost essential to the detective drama – the psychological moment![12]

This call for a greater level of psychological credibility was widely echoed in the demand for realistic plots, an internal logic to the story and, above all, convincing, original leads. All this the Stuart Webbs series seemed to provide, for shortly after the premiere of DIE GEHEIMNIS-VOLLE VILLA, the *Licht-Bild-Bühne* could hold the film up as a ray of hope for the future of the genre.[13]

Cinema Reformers and the Detective Film

While such articles appear to show the film industry (and the detective genre) in the mode of critical self-reflexivity, they are more plausibly explained as attempts not only to advertise the new, reformed kind of detective film, but also to ward off the ever more virulent agita-tion of the cinema reformers, who threatened the very existence of the film industry with their criticism of film drama (called *Schundfilm*, 'trashy film'). The reformers had, since 1907, focused on the dangers which films glorifying sex and criminality presented to public health and moral standards. The article 'Detective Film and Back Stairs Film,' in the *Licht-Bild-Bühne* of 1915, established the link. It chastised 'the current preponderance of blatant, or brutal, tasteless detective and sensation films'[14] because they played into the hands of the

reformers: 'The chief enemies of cinema could not have asked for a better gift. More censorship, restrictions placed on cinemas and other measures aimed against film – all these can be justified by blaming such films.'[15]

The reform movement was well-organized and orchestrated its campaigns across a broad spectrum of popular culture, ranging from trash films to cheap fiction – the best example being the Nick Carter series – against which the educated classes had been crusading since their appearance at the turn of the century. Thus, Robert Gaupp, a physician and psychologist, concludes, after listing the characteristic elements of early fiction film: 'The cinema drama shares all these things with the trashy detective novel. But the cinematograph has a more damaging and nerve-racking effect due to the temporal concentration of events.'[16] In 1912 the journalist and theatre critic Willy Rath linked this line of argument with the fear – typical of the time – of foreign infiltration:

> The colossal market in trashy literature came largely from abroad, particularly from Anglo-American sources, even if by now it has made this trashy filth seem like home-grown. Barely had our worthy educationalists begun to stem the tide from this direction when a second, even greater, onslaught was launched in the form of the trashy film: it, too, slavishly imitated by unscrupulous natives.[17]

In their outrage over the crime film and its literary equivalent, the bourgeois cinema reformers and the critics of the left were largely in agreement. In a 1912 article published in the Social Democrat periodical *Die Gleichheit* ('Equality'), 'nerve-racking detective dramas' were blamed for diverting the workers from the quest for moral uplift and educational advancement.[18]

The film industry soon realised that only an improvement of individual productions and a refinement of the genre as a whole could bring about the desired effect of rehabilitating an extremely popular and profitable genre, while at the same time attracting new audiences. Like the reformers, Emilie Altenloh compared the early detective film to the penny dreadful, attributing their popularity to the 'immutability of taste among the young,'[19] which, a few years earlier, had brought about the success of 'Nic (sic) Carter literature' and was now making converts in the cinema. But since the relatively limited target group for early crime and detective films mostly frequented the cheaper-priced suburban cinemas, which offered their clientele 'a long programme with as many detective dramas and dramas of manners as possible,'[20] from 1912 the pressure was on for films that could play in the more comfortable picture palaces in central locations, where the greatest profits could be made. This meant cross-breeding the popular Anglo-American formula with the classic detective novel, so beloved by the educated classes. William Kahn, scriptwriter on the Joe Deebs films and later detective film director himself, managed his bid to legitimacy by using E.T.A. Hoffmann and Edgar Allan Poe as inspiration for a contemporary detective film.[21] But it was Joe May and Ernst Reicher with their Stuart Webbs series, who most successfully targeted a public with spending power and cultural tastes to match.

The Webbs Films – An Analysis

The earliest surviving Webbs film is DER MANN IM KELLER ('The Man in the Cellar'), from 1914. In it, the detective follows the trail of a band of criminals who, on the eve of war, are plotting to steal the plans for an automatic pistol and the dowry of a rich heiress. Reicher's script is characterised by a narrative structure which seems far more complex than that of earlier detective films. Its charm lies in the gradual deciphering of several layers of deception and appearance. At first Webbs is engaged by a London widow to investigate strange noises in her house. He discovers that what she can hear is a terrier howling in the house next door, which stands empty, the sound being amplified by gas pipes in the walls. Investigating further, Webbs discovers a stranger, the dog's owner, lying unconscious in the cellar. The film now follows Webbs step by step, as he unravels the mystery: the man is Lord Rawson, an officer in the colonial guard, who was lured back to London from Egypt by a bogus telegramme. The gang leader, impatient with the slow progress of his plot, takes his victim's place in order to get his hands on his fiancée's fortune. There follows a complex game of disguise and discovery that Webbs finally brings to an end in a hotel room where he and his clients are staying.

The film clearly departs from the genre conventions of the pre-1914 period. Foreign productions – Nordisk's Sherlock Holmes series, Eclair's Nick Carter films, Pathé's Nick Winter films or Eclipse's Nat Pinkerton series – relied on an often random sequence of filmed sensations. The German crime films from 1913, in particular (the Miss Nobody series or the films of Joseph Delmont, Harry Piel, and Franz Hofer) all shared two dominant elements: chase sequences in which the camera was pointed at the world outside, and a euphoric enthusiasm for modern technological discoveries, coupled with a passable belief in their emancipatory application.[22] Cars, railways, speedboats, and aeroplanes were put to use by pursuers and pursued alike, with the camera always in on the action (often sharing the point of view of the pursued). At the same time these films disassociated themselves consciously from the symbols and insignia of a pre-modern, antiquated world, taking the plunge into a highly technological realm of rational thinking. For instance, in the second film of the Miss Nobody series, DAS GEHEIMNIS VON CHÂTEAU RICHMOND, ('The Secret of Château Richmond') the progressively minded female detective is up against a secret society gathered around a table covered with skulls. Her analytical powers allow her to decipher the mysteries of a castle littered with terrifying knights' armour. A robust faith in the achievements of modern technology and the powers of reason characterise all these films.

The Stuart Webbs films are quite a different matter. This gentleman detective resides in an office fitted out with knights' armour and a huge desk topped with a skull. Webbs epitomises the classical protagonist. Heide Schlüpmann picks up on the iconography of film heroes, when she writes that Webbs' profession is 'a kind of progression of the romance of chivalry in contemporary dress.'[23] Reicher, a man of the theatre, reworked ingredients of both the 19th century mystery novel and the classical detective novel in order to create his character. In doing so he was departing from what had become the central charac-

teristics of the genre: technology and the contemporary outdoor. Both played only a subordinate role for Webbs, the action having returned to the rather stagey look of the middle-class living room.

Technical progress was only thematised when it had to carry the plot; when Webbs, for example, dismantles the gas pipes which have served to amplify the noise from next door and which have become obsolete with the introduction of electricity. May and Reicher made an exception when it came to using optical effects to communicate the self-reflexive characteristics of the film medium. Associations with the beam of light from the film projector were probably calculated effects, for example, in scenes where Webbs searches the cellar where the officer is held captive with a battery torch. In the third film in the Webbs series, DER GEISTERSPUK IM HAUSE DES PROFESSORS ('Ghosts in the Professor's House'), this element plays an even more central role. The technical possibilities of cinematography are deliberately employed by the detective to clear up a series of mysterious break-ins in the study of a certain Professor Warming. The programme notes inform us that Webbs uses 'cinematic recording equipment with a flash attachment'[24] connected to an electric shutter release. The programme goes on to explain: 'If somebody walks up to the desk and moves the chair, an electric contact is set off automatically. The equipment is tested and works smoothly: at the slightest movement of the chair the flash goes off and the cinematograph is set in motion.'[25] May and Reicher thus provide a practical dimension to the legitimation discourse of cinema by thematising the cinematograph as a substantial means of solving crime.

But the charm of the early Stuart Webbs films also lies in another feature, which seems much more appropriate when seen against the backdrop of the contemporary political scene – one of unrest and the threat of war: the game of truth and deception, reality and fake. This was already a central theme in DER MANN IM KELLER. Both the detective and the criminals have faith in the perfect functioning of disguise. At the end, when the rescued officer and the disguised leader of the criminals come face to face, not even the fiancée can tell the real from the phoney. Webbs appears in disguise a total of four times – twice as an electrician so that he can investigate the house where Lord Rawson's fiancée lives; once as a beggar in a dive in the suburbs (one of the clearly anti-Semitic interludes in the series), and on another occasion, at the final showdown in the Grand Hotel, where he masquerades as room-service.

DER MANN IM KELLER, then, takes on board two of the major themes of its age: the 'crisis in our normative consciousness that can distinguish between reality and appearance, between truth and lies'[26] and the discourse concerning the legitimacy of film itself as a medium.[27] The political turmoil leading to war, which much disturbed the public of the day, may well have made audiences receptive to the distrust that manifests itself in such a sceptical attitude towards the truthfulness and documentary value of the film image. In the second Webbs film the threat lies in the way evil is capable of perfect mimicry, and Reicher, the theatre actor, must have relished the challenge. Taking on other identities, tirelessly slipping into the most varied of roles – all this belonged to the domain of the (theatre) actor, a figure

DER MANN IM
KELLER (1914)

whose legitimacy as a serious artist was never in question in the eyes of the educated classes.
DER MANN IM KELLER, made in 1914, can also be read as an allegory of the cinema reform
debate that raged at the time. Many of cinema's critics saw the very realism of the film image
as its central danger, especially in crime and detective films where accuracy would act as
instruction and attract unwelcome imitators. Reicher, the solid man of the theatre, however,
was 'a kind of Trojan horse in the war between the patriarchal, bourgeois culture and the
cinema'[28] demonstrating a mature, responsible attitude towards contemporary phenomena –
phenomena which could neither be ignored nor combatted by prohibition. This may explain
the iconography of the modern knight, the old-fashioned hero keeping his cool amongst the
confusions of the modern world.

Stuart Webbs the film hero was promoted as a 'psychologically credible' identi-
fication figure with clearly defined personality traits. Situations are presented in a 'realistic'
way, such as the excruciating pain a criminal is inflicting on himself when using an open
flame to burn the ropes that tie up his hands. The trade press was triumphant: 'Conan Doyle
stories, collections of famous legal cases, they all pale into significance next to such realis-
tic, stirring (sic) performances. The dead written word can only look amateurish next to the
living image.'[29]

After three well-received Webbs films, the summer of 1914 saw a split between
the May/Reicher duo and Continental Kunstfilm. From this point on, the Stuart Webbs se-
ries was produced by the Stuart Webbs Film Company, based at Dorotheenstrasse 53, Ber-
lin. The acrimonious legal battle over the separation was followed closely in the trade press.
May and Reicher took out whole-page ads to announce, for instance, that 'It is untrue that
Mr Ernst Reicher had agreed in his contract not to produce any Webbs films, since Conti-

nental had sole rights in this domain. It is, however, the case that the managers at Continental were aware that Ernst Reicher intended to produce his own Stuart Webbs films.'[30] DAS PANZERGEWÖLBE ('The Amoured Vault,' 1914) was a joint production from Reicher and May, but once war had broken out, May had to return to Vienna to do his military service, and on his return to Berlin, May and Reicher themselves split up, with May embarking on the Joe Deebs series, very much in the mould of the Stuart Webbs film.

Reicher for his part also carried on in May's absence, and the fifth Stuart Webbs film, DER GESTREIFTE DOMINO ('The Striped Domino,'1915) shows few essential changes to the formula. In the opening credits Ernst Reicher appears from behind a theatre curtain, dragging Adolf Gärtner, the resident director of his first films, with him. Both bow, as if to a theatre audience – a gimmick which must have gone down well with the audiences of the picture palaces.

In DER GESTREIFTE DOMINO Webbs, taking a break from the detective business, stumbles upon a mysterious chain of events. A letter which comes into his possession by mistake tips him off about an American millionaire whose only son has been unjustly disinherited. Webbs discovers that the guilty party is the man's stepbrother and is able to reconcile the deserving members of the family. The climax of the film is a masked ball, at which Webbs explains the true connections wearing the striped domino of the title. His disguise is so perfect that even the adoring cousin[31] of the unjustly slighted son is initially unable to recognise him. The family tragedy is resolved when the stepbrother, exposed by Webb, commits suicide rather than face disgrace. DER GESTREIFTE DOMINO also plays on the battle of truth and lies, in which Webbs himself is initially a victim. He sees in the contents of the letter he received by mistake the disclosure of a crime. In fact, it has to do with the attempt on the part of the cousin and the stepbrother to reconcile the disowned son with his fatally ill father. But even this is only half true, for Webbs is finally able to prove that the seemingly honourable son is actually the man behind a large-scale fraud.

Another noteworthy feature of this film is the middle section: the scheming son has Webbs – dressed as a detective – kidnapped. His accomplices are coloured, reminiscent of the black member of the gang of criminals in DER MANN IM KELLER. This kind of racist element is taken even further when Webbs raids an opium den. This motif is already found in the Nobody film, DIE JAGD NACH DER HUNDERTPFUNDNOTE ('The Hunt for the One Hundred Pound Note,' 1913) and was taken up again by Fritz Lang in DIE SPINNEN ('The Spiders,' 1919/20). Webbs escapes by cutting off the pigtail of an intoxicated Chinaman and disguising himself as an Asian.

The sixth film in the Webbs series, DIE TOTEN ERWACHEN ('The Dead Awake,' 1915) breaks with the traditional expectations of the viewers, so used to seeing all exotic foreigners as loathsome accomplices to Evil. The Indian servant of a nobleman is a temporary suspect, but is eventually rehabilitated by Webbs. DIE TOTEN ERWACHEN otherwise reinforces all the characteristic elements of the series. The Gothic novel aspect becomes clearer than ever, especially in the gruesome showdown in the vaults, where 'the dead

awake,' after first having stood as still as wax figures opposite the murderer. Reicher adopted a self-referential attitude towards the medium, and this play on the fairground thrills of yesteryear certainly alludes to the origins of cinematography in waxworks and shadow plays. DIE TOTEN ERWACHEN combines a classic 'whodunit' structure with well-tested filmic genre conventions, to which are added a large dose of horror. Stuart Webbs comes across as the blasé dandy more than in earlier films, dressed with unremitting casualness, whether the occasion calls for an elegant dinner jacket, sailor outfit or sporty, lord-of-the-manor garb. Acting as a superior tactician and strategist and fearless daredevil, all rolled into one, Reicher had clearly reached the pinnacle of his narcissistic capacity to produce vehicles for himself.

Ernst Reicher in
DAS PANZER-
GEWÖLBE (1926)

Postscript: Swan Song of a Genre

In the early German cinema, the Stuart Webbs series is in many respects an exception. It made obvious and conscious reference to contemporary debates in film: its enormous effect on improving its style, its extraordinary longevity and – inadvertently perhaps – its solid position in tradition. This was accompanied by a phenomenon that, to my knowledge, no other film series and no other genre can claim: the Webbs series concluded with a filmic swan song, to itself and to the whole genre, whose archetype it had become. Twelve years after DIE GEHEIMNISVOLLE VILLA, in 1926 Lupu Pick[32] produced a remake of the first and only May/Reicher-produced Webbs film, DAS PANZERGEWÖLBE, for his own production company Rex-Film (part of the Ufa).[33]

The filmic depiction of the detective figure and his surroundings in 1926 was intended to prompt comparisons with the early classics of the series. After 12 years, Reichert had little left of his youthful charm and came across as overweight and strangely

lethargic. The character's liveliness and quick-wittedness had given way to a kind of passivity that had a serene, rather pained effect. Whereas the young Webbs was surrounded by knights' armour and skulls, he now resided in a sober, functional-looking office, furnished only with a modern-looking desk and an impressive bookshelf. Similarly, the congested, gloomy drawing rooms of his clients had been replaced by light rooms epitomising the new functionalism of the 1920s. Other changes, in terms of form and décor, also confirm that Lupu Pick was more concerned with dismantling a film legend than to revival a classic entertainment genre, nowhere more clearly than in the closing sequence. Stuart Webbs, who spent the whole film looking listless and world-weary, can now safely retire to bed. The interminable list of orders his servant presents him with merely provokes the comment 'I am tired.' At this point, Webbs disappears behind a secret door in his library. Where the most famous detective figure in early cinema history had once stood proud and ready for action, there was now only a bookcase. The camera moves towards it, affording the audience a good look at the rows of books, bound like literary classics. Among them, of course, are the adventures of Stuart Webbs, alongside those of Sherlock Holmes, Arsène Lupin, Nat Pinkerton and Nick Carter. The stories have become the inventory of an antiquarian, specialising in classic detective literature, to which his own exploits can now be added. On this ironic and fond note ends Lupu Pick's strange remake, his sardonic homage to a genre that had become meaningless.

Ernst Reichert as Stuart Webbs

The Faces of Stellan Rye

Casper Tybjerg

Most discussions of DER STUDENT VON PRAG have tended to stress the contribution of Hanns Heinz Ewers, the writer of the screenplay, and Paul Wegener, the star of the film; they are both often credited with being the real 'author' of the film. In the following, I shall not attempt to resolve this question of 'authorship' in favour of one or another of the three. Instead, I will try to shed a little more light on the life and career of its director Stellan Rye.

From 1904, Rye – who came from a Danish military family and in 1900 became a lieutenant, if with more artistic ambitions – began writing poetry, short stories and occasionally self-consciously artistic pieces on military life in the weekly magazine *Verdensspejlet*. Rye soon came under the influence of another writer with a military background: Aage Herman von Kohl, three years older than Rye, had left the army to satisfy his ambitions as a writer. To Kohl, art was a grave matter indeed; its task was to aid man in his rise towards the superhuman. Paired with this Nietzschean idealism, a fascination with perversion and cruelty characterized Kohl's artistic personality, 'in whose convention-shattering genius the worshipping Rye saw the long-awaited Messiah of literature.'[1]

After a short time, however, Rye became a friend and protegé of the writer Herman Bang and contributed regularly to the newspaper *København* with which Bang was associated. Herman Bang, author of the twice-filmed novel *Mikaël* (1904), was a prose stylist of genius and one of Denmark's few great writers, a passionate lover of all things theatrical, and a gifted stage director. His famously histrionic recitations, where he would read from his own works, had made him a celebrity. His mannerisms made him an inviting target for satire, which would often gain a vicious edge by hinting at Bang's homosexuality.

Rye, too, was homosexual, and the fact that Kohl was an aggressive champion of the inviolability of the material union may have alienated him. The actor Olaf Fønss, later a famous movie star in both Denmark and Germany, has given a somewhat unpleasant description of his first impression of Rye:

> (T)his was First Lieutenant Stellan Rye, who – in honest truth was not masculine, but the opposite, despite his tall, slender figure, which was combined with a handsome, dark face. If it were conceivable that Hermann Bang could have fathered children, Stellan Rye as his son would have been a boy who resembled his father, both in his gifts and his affectations.[2]

Rye's Dramatic Debut
Fønss and Rye met in 1906 when Rye arrived at the prestigious Dagmar Theatre in Copen-

PERSONERNE I „LØGNENS ANSIGTER"

Allegro: Adam Poulsen som Maleren Paul (foroven). Johannes Meyer som Leo. Fru Anna Larssen som Johanne. Andante funèbre: Egill Rostrup som Redaktøren. Fru Oda Nielsen som Asta. Scherzo: Frk. Karen Poulsen som Fru Trolle. Fru Anna Larssen som Lily Barling. Fru Oda Rostrup som Frk. Bang. Finale: Fru Rosenberg som Mlle. Jolaire. Fønss som Mr. Duroc. Johannes Poulsen som Jean Marazzo.

Faces of Deceit (1906)

hagen to direct his own first play, *Løgnens Ansigter* ('The Faces Of Deceit'). *The Faces of Deceit* bears the subtitle *A Symphony*; it consists of four independent dramatic situations, entitled 'Allegro,' 'Andante funebre,' 'Scherzo,' and 'Finale.' This synaesthetic conceit has a definite *fin de siècle* air about it, which is also reflected in the stories. The first one concerns two artists, one middle-aged and blasé, the other youthful and high-strung, and their model, beautiful, conquettish, amoral; the young artist ends up with a broken heart. The second story is about a cruel and egoistic gutter-press newspaper editor and his former mistress; not satisfied with having taken her virtue or turned her over to his underlings to become 'the madonna of the newsroom,' he has poisoned her marriage with anonymous letters; she pulls a gun and shoots him dead. The scherzo deals with three women who meet after the death of a man all of them loved; they discover that he in different ways cruelly deceived them all. The finale takes place in a circus; a sweet-natured lady clown struggles to keep her partner-husband; he has become infatuated with a dazzling horsewoman, but she cares only for the sadistic animal trainer, who scornfully strikes the clown down with a whip; the clown, enraged by his impotence, turns on his clown-wife and strangles her.

A fashionable cynicism prevails throughout. Love is for fools, and in all four stories, the gentle and the innocent are duped and humiliated by the selfish and unscrupulous. When the play opened on September 5, 1906, many reviewers objected to it for being contrived, uneven, and overwrought, but also acknowledged its intensity: 'popular melodrama and high literary style have formed a misalliance that, like all such unions, has produced healthy and vigorous offspring,' wrote *Verdensspejlet*.[3] Other reviewers were more hostile, but there seems to have been a general agreement that the opening of *The Faces of Deceit* was an event of some importance. Rye's unusual promise as a stage director was widely

recognized. Even Fønss (the sadistic animal trainer), who clearly disliked Rye, admits that he regarded him as an unusually gifted director, an opinion which seems to have been shared by many of the actors. Clara Pontoppidan, who would soon grace the screen in a number of excellent films, wrote about Rye in retrospect:

> (H)is direction was quite an event for us, because he was so full of ideas, so daring, so unconventional (...) his big secret being of course an always searching and curious attitude towards all and everyone who might bring fresh impulses, though he certainly could manage himself (...).[4]

Johannes Poulsen, the theatre's handsome young star, who played the clown-husband, compared working under Rye with

> teaching recruits military discipline – a discipline that very much resembles the, shall we say, artistic military discipline which a drama must always contain. After all, a play must, outwardly, proceed like a gymnastics display. I think that this background along with the old, impeccable breeding of his family gives Rye a big advantage on top of his truly *heartfelt* (...) artistic abilities.[5]

The play came out in book form a few weeks after the opening, and many elements of the direction have been written into it.[6] The physical appearance and the mannerisms of all the characters are closely detailed. The dialogue is studded with directions on tone of voice, gestures, expressions. Many lines are incomplete, and there is a great number of dashes, used to indicate pauses, sometimes two or three together to designate longer ones. Even the rhythm of the lines, the emphasis on individual syllables, is indicated through the use of variations in letter spacing. On occasion, Rye attempts simultaneity effects; inserting directions for one character's reaction within another's lines, for instance. At the very end, Rye strings stage directions for several characters together as a continuous sentence that furls itself around some lines of dialogue.

All this seems to indicate a very complete directorial vision, where all the elements of the staging have been thought out and planned in the director's imagination beforehand. This is the way Herman Bang would stage plays; he was, as already mentioned, a highly regarded stage director, and he would seem an obvious influence on Rye.
Yet, in his review of *The Faces of Deceit*, Bang wrote:

> This young man, who has stood upon a stage for the first time during these rehearsals; who would appear to be bereft of all training; who could not be imagined to have any knowledge of the complexities of stage mechanics or of the laws of the drama – he revealed himself from the first instant as a born master of stagecraft.[7]

This strains credibility, and with reason. For the 1906 New Year's party of the student union of the University of Copenhagen, Rye directed a parody performance of *Lohengrin*, playing

the title role himself. Around the same time, that is, nine months before the opening of *The Faces of Deceit*, Rye was present at one of Bang's rehearsals, which he extensively described in a magazine article.[8]

Rye and Herman Bang

In Bang's novel *De uden Fædreland* (1906; English title: *Denied a Country*), a minor character appears who is said to be a portrait of Rye.[9] The protagonist of the novel is Joán, a violin virtuoso, son of a Danish mother and a Central European nobleman, ruler of a Danubian island belonging to no nation. As a child, he is ruthlessly persecuted by the boys in the nearby town, as ruthlessly as the Jew and the hunchback. Only the Rye character, 'the white officer,' a lieutenant with delicate hands, who seldom speaks but displays a refined sensibility, treats Joán with any respect. The officer feels intense distaste at the persecution suffered by the boy and looks forward to escaping from the vulgar provincialism of the town.[10]

Rye's association with Bang, however, also attracted unwelcome attention. On August 24, 1906, less than a fortnight before the opening of Rye's play, a large article appeared in the gutter paper *Middagsposten* under the headline 'The Faces of Deceit.' It disclosed the existence of an unsavory 'Men's Club' whose members 'all belong to the category "faces of deceit" – that is, men of good social standing who hide their unnatural night-time activities beneath a mask of respectability.'[11] Worse was to come. In November, a number of people were arrested (homosexual acts were under most circumstances illegal and punishable by law), and the 'Men's Club Affair' grew into a full-scale scandal. There were aggressive claims in the yellow press that Bang was questioned by the police, though this may have been untrue.[12] In an article printed November 27th, *Middagsposten* had already insinuated that Rye was implicated in the affair:

> At one of our artillery barracks it is said by a reliable source that a young, stage-minded officer has given instructive lectures on 'diseased love' to both enlisted men and cadets and convinced some of the latter to join the satanic club. The young, affected officer took indefinite leave when Emil Aae [a central figure in the affair] was arrested.[13]

But torrents of abuse were directed at Bang,[14] who finally left for Berlin in mid-1907 and stayed away for two years. Rye only left the army and was hired as a stage director at the Dagmar theatre.

Rye 1907-11

Rye was quite successful there and occasionally staged a play of his own, but none of them really came up to his initial success with *The Faces of Deceit*. In the summer of 1910, Rye worked with Pontoppidan on developing her performance as Puck in an open-air performance of *A Midsummer Night's Dream*, and it became one of the most acclaimed performances of her early career. But in January 1911 a new affair, the so-called 'military scandal,'

erupted. At the artillery barracks at Bådsmandsstræde in Copenhagen, the investigation of a theft revealed that the petty officer whose money had been stolen had, along with nine others and over a period of several years, regularly committed indecent acts (i.e., mutual masturbation) with eight older homosexual men in return for money and gifts.[15] Stellan Rye was one of the eight. He was working with Clara Pontoppidan, helping her with choreography and costume design for a dance performance she was preparing: 'Nervous and agitated he sat there, pale and confused, during all my rehearsals. He tried as hard as he could to pull himself together, he fought bravely and energetically for me, but he was not able to do justice to his great gifts.'[16]

On March 18, 1911, Rye was arrested. Along with four others (the remaining three fled abroad), he was charged with gross indecency and convicted; on June 27th, he was sentenced to three months' imprisonment. Rye decided not to appeal, but instead to petition for mercy. But the prosecution appealed; two of Rye's co-defendants had been acquitted. On November 1st, the High Court found in favour of the prosecution; the sentences were stiffened and Rye went to prison for 100 days. When he got out, Rye was a ruined men. Clara Pontoppidan describes how

> (t)he treatment inside had (...) tormented him. In the midst of his ire he would suddenly stop, pull slips of paper from his pocket and with deep sadness and tears in his eyes read poems to us, wonderful poems he had written in prison. A moment later he would again pace the room with his restless steps, as if still chained to the narrow cell.[17]

Rye left for Germany, never to return. But before he left, he wrote a film script, *Det blaa Blod* ('The Blue Blood') which was produced by the film company Skandinavisk-Russisk Handelshus and directed by Vilhelm Glückstadt. The film which was released in April 1912, is lost, but from the programme booklet we know the story: An impoverished nobleman and his woman-friend are living together, unmarried, with their child. His old uncle dies, bequeathing him a vast fortune on the condition that he marries a lady of the nobility. Yielding to the demands of tradition, he leaves his mistress and marries a suitably aristocratic young lady. The forsaken woman appears at the wedding, the child in her arms, her sanity destroyed by her anguish. She is removed, but returns, appearing in the grand ballroom, whirling madly about until she drops dead from a broken heart. The bride is about to leave, but thinks the better of it and decides to take the motherless child and, with her husband, build a new life.

Rye and the Cinema

In the bustling metropolis of Berlin, Rye was able to find both friends and work. He had become interested in the cinema. In an interview for *Lichtbildbühne*, he said:

> What led me away from the stage to the cinema? More than anything else I was excited about working *without the word* for once. I have written a number of

plays myself which were successful on the stage; on my bookshelf stand six books from my pen. So no-one can make the charge against me that I disdain 'the word.' And then I was lured by the opportunity to be able to create art, without, for once, this 'word' – almighty and until today the sole source of salvation.[18]

According to a brief biographical sketch in the same issue, Rye 'went over to the cinema from the conviction that he there would find greater and more extensive opportunities for his directorial talents than on the stage.'[19] Rye may have directed one or more films for the company Eiko in the spring of 1913. In his book on DER STUDENT VON PRAG, Helmut H. Diederichs quotes one Joseph Coböken, who recounts a meeting with Rye, to whom he refers as 'the future director of DER STUDENT VON PRAG.' Coböken tells of writing a script for Rye in one day, and Diederichs suggests that the film in question may have been DAS ABENTEUER DREIER NÄCHTE ('The Adventure of Three Nights'), passed by the censors in April 1913.[20]

When Herman Bang was staying in Berlin in 1908, one of his few friends was his doctor Max Wasbutzki and his wife Bertha. At their house, Bang had become acquainted with Hanns Heinz Ewers, an aesthete and writer of decadent horror stories.[21] Now Rye was hired to direct DER STUDENT VON PRAG. The idea of making a *Doppelgänger*-story was apparently Wegener's; it would give him the opportunity of acting with himself.[22] Ewers then developed a story and wrote a script. Diederichs writes: 'Ewers was suited like probably no-one else to create a film draft from the idea of the double.'[23]

But Rye was also eminently suitable as a director. One of his early short stories, published in 1905, is a *Doppelgänger*-story. 'Teatrum mundi' is told by a dandy who, on his way home from a party one night, comes upon a fairground. The biggest tent bears the legend 'teatrum mundi.' Within, lights still shine, casting great shadows on the tent walls. The dandy enters; it is a travelling waxworks, owned by an old man, who looks a bit like

DER STUDENT
VON PRAG (1913)

EVINRUDE - DIE GESCHICHTE EINES ABENTEURERS (1913)

God. The wax dolls are mechanical; they may be animated by pushing a button. The dandy's attention is attracted by a particular doll, in a corner:

> Then I look at the doll's face, and my breathing suddenly stops, as though it had hit a wall inside me. It is myself who stands there! The doll, the wax figure, it is myself. It is *my* features, *my* eyes, *my* frame, *my* haircut. And as it stands there, with the thumb and first finger of the left hand in the waistcoat pocket, with the coat collar turned up and a mocking smile around the slightly crooked left side of the mouth, it is me, completely, so lifelike in the dead wax. Only the eyes are somehow smaller than mine.[24]

The doll comes to life and starts speaking, the very words with which the dandy commenced the tale we are reading. Unable to stop the doll, and enraged by its self-satisfied manner, he smashes it to pieces. The old man appears, smiles sagely and says, 'Now there is one doll less in the world.'

Apart from DER STUDENT VON PRAG, Rye would make another five films written by Ewers. Only one, EIN SOMMERNACHTSTRAUM IN UNSERER ZEIT ('A Midsummer Night's Dream of Our Time'), seems to have been in any way light-hearted. In SOMMERNACHTS-TRAUM, the faerie characters of Shakespeare's *A Midsummer Night's Dream* are introduced into the modern day. Sadoul claims that this fantasy was originally performed on stage,[25] but in his book on Ewers and the cinema, Reinhold Keiner describes it as an original filmic work,[26] which is backed up by the statement in a contemporary advertisement that the film is

157 *The Faces of Stellan Rye*

'a new creation standing on its own feet.'[27] The programme booklet, which puts Ewers and Rye side by side, comments on the deeper meaning of the film (and Shakespeare's play). Puck emerges as the symbol of the poetic spirit:

> He lets two worlds, independent from each other, appear before us: The spirit realm of Oberon and the everyday world (...) Both worlds mutually complement each other, one is always the reflection of the other, sometimes a faithful mirror image, but also then and now a heavily distorted caricature.[28]

In the film, Grete Berger as Puck wears a costume which bears a close resemblance to the one worn by Clara Pontoppidan in the open-air performance mentioned above, although it is possible that they both derive from a Reinhardt staging.

One of the remaining Rye-Ewers collaborations, ... DENN ALLE SCHULD RÄCHT SICH AUF ERDEN, was not produced by Deutsche Bioscop like all the others, but by Eiko, and it has been suggested that this film was made before DER STUDENT VON PRAG.[29] However, Keiner and all the printed Ewers sources indicate that DER STUDENT VON PRAG was Ewer's and Rye's first film together.[30] ... DENN ALLE SCHULD RÄCHT SICH AUF ERDEN is about a woman who avenges herself upon her seducer by destroying his son, gloating over his corpse at the end. EVINRUDE - DIE GESCHICHTE EINES ABENTEURERS was an action-packed melodrama, starring Paul Wegener as a villainous adventurer. DIE EISBRAUT was the story of an artist who falls in love with a woman from the distant past whose body has been preserved, frozen in a block of ice. The censors, not keen on overt necrophilia, banned the film outright.[31]

The last of the Rye-Ewers films, DIE AUGEN DES OLE BRANDIS, sounds particularly interesting: An artist, played by the renowned actor Alexander Moissi, obtains from the sinister Coppeliander a device which enables him to see everyone as they really are – Ladies are whores, friends blackmailers, all are villains and liars; 'even his own mirror image mocks him with a hateful grimace.'[32] On the brink of despair, he discovers that his innocent model is as pure as she appears to be; in his love for her, the artist regains happiness. The inspiration from E.T.A. Hoffmann is clear, but the device that reveals the true faces of everyone may originate in a tale from the Arabian Nights, *The Mirror of Virgins*. The motif also appears in a fairy play by Ferdinand Raimund, *Der Diamant des Geisterkönigs*, adapted by Hans Christian Andersen as *Meer end Perler og Guld* (1849). Rye was praised for the tasteful direction of a film which was partly shot on beautiful locations in Italy.[33]

Rye was not solely a director of hair-raising dramas. He had directed comedies on stage in Copenhagen, and he made film comedies, too, like the recently re-discovered GENDARM MÖBIUS, a story about a friendly policeman. BEDINGUNG – KEIN ANHANG was a farce inspired by the tango craze which was sweeping across Europe; both masters and servants in a large household are gripped by a fever. Ernst Lubitsch had a supporting part as

a manservant. The film had the alternative title SERENISSIMUS LERNT TANGO. 'Serenissimus' was the emperor, and the censors could not accept any suggestions of frivolity in connection with His Majesty, so the film was banned.[34] There were also plans that Rye should direct a series of films with the comic Ernst Matray,[35] but only one film was made. It was shown in Denmark as STODDER-BARONEN ('The Beggar Baron'), but its original title is unknown. Matray plays a double role, as a clever thief and an elegant count. They accidentally get mixed up, the count is arrested, and the thief enjoys himself as the count.

Rye's last film was DAS HAUS OHNE TÜR. The film features secret tunnels and nefarious villains; the hero is strapped down beneath a deadly pendulum blade (like in Poe's tale *The Pit and the Pendulum*), but is rescued in the nick of time by the forces of order. There is also a masked ball and a hypnotic seance; one of the stills reproduced in Lotte Eisner's book *The Haunted Screen*[36] shows the heroine, blindfolded, on a narrow stage with a featureless black backdrop, observed by a group of upper-class spectators. Other stills show bizarre scenes played out in front of the black curtain or a skull-faced jester and a ring of little girls dancing around the heroine. Others show the hero with Napoleon or facing his own double, both pointing revolvers at each other, one white, one black.

When war broke out in August 1914, Rye enlisted as a volunteer private. He seems to have felt so well-treated by Germany that he wanted to fight for it. He fought well and bravely, was promoted and awarded the Iron Cross.[37] On November 14, 1914, Stellan Rye having been wounded and captured, died in Ypres in a French field hospital.[38]

On location in Prague: H.H. Ewers (on the pedestal), Stellan Rye, Paul Wegener, Lyda Salmonova and an unidentified person (from right to left)

HOMUNCULUS:
A Project for a Modern Cinema

Leonardo Quaresima

Research on HOMUNCULUS encounters a number of objective difficulties whose obvious-
ness is in this case no mere ritual. Directed by Otto Rippert and based on a script by Robert
Reinert for Deutsche Bioscop, HOMUNCULUS was conceived as a film in six parts, a 'series
of self-contained dramas interconnected through the title-figure'[1]: the first four (HOMUNCU-
LUS, DAS GEHEIMNISVOLLE BUCH, DIE LIEBESTRAGÖDIE DES HOMUNCULUS, DIE RACHE DES
HOMUNCULUS) premiered at the Marmorhaus in Berlin in the course of the second half of
1916; the last two (DIE VERNICHTUNG DER MENSCHHEIT and DAS ENDE DES HOMUNCULUS)
in the beginning of 1917. The film was re-released in August 1920 in re-edited form (vari-
ous secondary episodes were cut in order to concentrate on the main storyline), and shown
in three parts: DER KÜNSTLICHE MENSCH, DIE VERNICHTUNG DER MENSCHHEIT and EIN TI-
TANENKAMPF. 'Our expectations of the cinema have changed and refined in several respects
in the meantime,' one reads in an advertisement in the *Film-Kurier*[2] – 'the Decla-Bioscop
has now, in totally revising and concentrating the story material, undertaken to adapt this
great work to our new expectations [by realising a film] which has indeed the impact of a
new film.'

What is known of the work today is the fourth part of the 1916 version, plus a
short fragment from the beginning of part five. The research and reconstruction work initi-
ated by the film archive of the former GDR has never been concluded.[3] Any analysis of
HOMUNCULUS can thus be done mainly on the thematical level in reference to the detailed
plot as it is reported in the programme notes at the time of the film's first release and, for the
later version, in the *Illustrierter Film-Kurier*.[4] As far as other aspects – iconographic, stylis-
tic, etc. – are concerned, photos, reviews, and other contextual sources permit only limited
evaluation. Still, it must be said that the existence of at least one part, and thus the possibility
of verifying specific hypotheses on the basis of secondary sources, makes such inferential
work more productive than in so many other cases.

Once this inevitable preliminary remark is made, HOMUNCULUS appears to us as
one of the most important documents, if not a key film for German film production of the
teens. On the industrial/institutional level, it proposes itself as one of the founding works (at
least for Germany) of the episodic (serial) film, which was to undergo considerable devel-
opments in the course of subsequent years. On the thematic and iconographic level it like-
wise presents a series of motifs that not only anticipated, but were to become (if only be-
cause of the re-release of 1920) an influence on the German production of the twenties.

What is immediately evident is the re-working of motifs drawn both from the tradition of the Gothic novel and the serial novel of the feuilleton. It is a kind of combinatory adaptation which had fallen on fertile ground also in certain fields of German literature since the turn of the century (with writers like Gustav Meyrink or Hanns Heinz Ewers, for instance). In fact, it had constituted the proper cinematographic impulse behind some of the most original works of the *Autorenfilm* from earlier in the decade (DER GOLEM, DER STUDENT VON PRAG, EINE VENETIANISCHE NACHT, etc.). In HOMUNCULUS, this double influence seems at once more precise and the connections more complex and original. The film refers itself to the myth of the superhuman, as first established in the popular novel of the 19th century, which knew it in both a positive, 'democratic,' version, characteristic for the early period of the genre (best known from the novels of Sue and Dumas, i.e. for the characters of Dantès and the Count of Monte Christo) as well as in a negative, malevolent version typified by the 'doomed' heroes of the black novel or the great criminals of the late feuilleton (Fantomas).[5] Homunculus is first of all this: a Melmoth-the-Wanderer, a Frankenstein-like creature and epigone of the popular version of Nietzschean 'superhumanity'[6]: cruel, sadistic and at the same time the redresser of all manner of wrongs and the defender of the weak. From this oscillation of roles, this ambiguity and contradiction of behaviour and motive, both the central character and the film draw their fascination, originality, and effectivity.

From the Gothic novel comes the scientist who pushes himself beyond the limits of morality and knowledge; the artificial creature ('my father's house is a chemical laboratory, my parents are the potions and test-tubes of one unscrupulous scholar,' as Homunculus describes himself[7]); the superhuman powers (Homunculus possesses extraordinary strength, 'he breaks (...) iron sticks in two as if they were made of straw,' and the extraordinary will power: 'implacable in will, body, and nerves,' while his 'magnetic power' can heal the sick[8]). Also from the Gothic novel comes the demonic and devastating personality, the curse he puts on nature, and his origins that result in an obsessive urge for doing evil. The Frankenstein creature[9] is in this sense the ancestor and begettor of this character. The Nosferatu of Galeen/Murnau is its direct successor. This last link seems very transparent. Homunculus' features in numerous and obvious ways are already those of the vampire from 1921. From physiognomic traits (the raised eyebrows and the heavy make-up around the eyes, the claw-like hands, the high forehead and the straight shoulders) and iconographic solutions (the contrast between the face and the white hands on the dark body, the figure that slowly emerges from a stairway or appears framed by an arch – still un-expressionistically round and undistorted), to solutions of mise en scène (the effects of spot-lighting the face from below) and narrative sequence (Homunculus spied upon – by the young female protagonist of the fourth part – while he is resting, exhausted and fully dressed – still in a bed, but already as if in a crypt).

From the sensational novel comes revenge as the central motive driving the actions of the protagonist. As already mentioned, his artificial origin that has given him life also makes him feel betrayed, because it condemns him to alterity, making him incapable of

showing or experiencing love, and therefore barring him from the core-concerns of humanity: his creator and all mankind become the target of his revenge. Like the protagonists of the feuilleton novel, Homunculus is also driven by positive impulses: 'He does good, but one takes his actions for deeds of evil. Of course, his actions are out of the ordinary.'[10] He is capable of great acts of generosity: he is moved to tears at the sight of children (he had sworn to kill the first human he encountered, but at the sight of the little ones he renounces his resolve); he gives protection to orphan girls or those chased away from home, and he is ready to let them go, after restoring them to the affection of their loved ones. Just like so many heroes of the feuilleton, a double identity is constructed for him.[11]

The motif of the double extends beyond narrative construction and character personality. In the last part of the film, for instance, the protagonist is pitted against a second artificial human who in the end will fight him in a titanic battle ('in which nature participates with spectacularly elementary events'[12]) and which results in the death of both. The spectator will easily note that the battle is 'the fight of Homunculus against himself, against his own, newly born Self.'[13] We are at the heart of the most intimate sequence of the feuilleton novel: 'the infinite battle between [good and evil] neutralizes itself by its very self-contradiction, just as in this all-too perfectly dichotomized universe what is happening is the fight of the Self with the same Self. (...) Realistically or symbolically, the hero's opponent is nobody other than himself.'[14]

The universe of the sensationalist novel is a universe where the feminine figure has a narrowly circumscribed role in line with the most classical typologies of melodrama (the virgin, 'innocence betrayed,' and the fallen woman). It is a reduction which finds its full confirmation in Rippert's film. The stereotype did not escape contemporary viewers either: 'female figures (...) crop up and almost as soon disappear again. (...) All of them remain colourless.'[15] It is therefore no accident that a film parody, shown in Vienna in 1916, HOMUNKULIESCHEN, suppressed the male roles, substituting them with female equivalents. The scientist is a woman who gives life to an artificial creature; her assistant is a woman (the equivalent of the 'Famulus' Edgar Rodin who accompanies Homunculus in almost all his adventures, until he separates himself from him and becomes his opponent in the end). When this female assistant, out of negligence, drops the egg (!) from which Homunculus is supposed to be born, she quickly substitutes a real child instead: after 16 years of 'captivity' this child, now a young woman, returns to her parents, free at last to marry the man after her 'Homunculist heart'...[16]

When we look at the mise-en-scène of HOMUNCULUS (of course, only insofar as it can be judged on the basis of the available parts of the film), it, too, seems marked by forms of popular image-making: tableau scenes (the delegation of the representation of the people that go to 'parliament'; the young woman who prays in the woods), illustrations from popular novels (an antagonist of Homunculus put in chains in a prison). One also recognizes forms of popular theatrical staging: persons placed in the center of the frame, the striking of emphatic poses, naively melodramatic performances. One frequently notices

Olaf Fønss in HOMUNCULUS

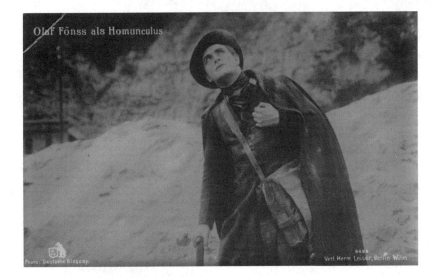

solutions to the problems of spatial organization typical of the cinema of the teens (e.g. scenes dominated and divided by a huge central and frontal staircase).

Yet HOMUNCULUS also presents unconventional and unexpected solutions. The natural exteriors, for instance, can function as original stylistic articulations and dramatic developments (in the tradition of the *Autorenfilm* or Scandinavian cinema). Among these, particularly remarkable (in the fourth part) is the space of the quarry,[17] a kind of a vast amphitheatre in which the riot of the crowd is set and their encounter with the hero. Given the incoherence of such sequences in respect of narrative continuity,[18] this space materializes in a total different way from the stereotypical atmospheric transcriptions of action into space. Not only do we find a certain spatial logic, but the contrast of the white of the rocks and the black cloak of Homunculus gives the encounter a precise expressive register (about which more will be said in a minute). HOMUNCULUS also uses calculated effects of framing; it plays with light and with contrast, in order to give an internal movement to the frame and thus underpin mobility within the compositional ratios of the screen (the crowd that breaks into the frame from below and from the dark recesses of an alley, pushing themselves into a close-up). The film adapts explicitly figurative references: examples from genre painting (the ruins of the mill at the beginning of the fifth part); romantic figurations (the protagonist enveloped in his large cloak and set against a sharply outlined landscape – like in a painting of Caspar David Friedrich); or in general 'pictorial' solutions, for instance, when Homunculus is framed in close-up at the frame edge, while in the background the serpentine of the crowd that chases him draws itself: a solution close to the one in the famous sequence in Eisenstein's IVAN THE TERRIBLE.

In particular, the film's will to style produces complex effects of clair-obscur[19] to which relevant expressive meaning is attributed. The scene in prison already mentioned, with the antagonist chained to the wall, is totally constructed on the contrast of light and shadow, of black and white: Homunculus stays in the dark, while slowly the light envelops his opponent (and also the evening dress of the latter, so improbable in such a situation that one must assume its presence has a functional role). The effect is perhaps somewhat naive and not fully controlled on the expressive level since in a subsequent scene, composed within a similar lighting scheme, we see Homunculus chained in the same position and in the same light as his antagonist.[20] Nonetheless, the lighting constitutes one of the unquestionable stylistic triumphs of the film. A remarkable (if figuratively conventional) effect of clair-obscur is also used to fix the light that emerges from the window-bars of the prison in another sequence. After his rescue, the black figure of the protagonist (little more than a silhouette) stands out against a bright background, the broken chains still dangling from his wrists, an icon in which once again motifs of rebellion and liberation intermingle equivocally with negative, black and demonic traits.

The stylisation, the reduction of a figure to a profile, a silhouette, must constitute in effect one of the recurring and characteristic expressive choices of the film. We find them back in the visualisation of death on horseback against the open skyline at the beginning of

part five.[21] Evidence for this is given in the descriptions of the programmes: 'A mysterious shadow, whose origins the assistant is trying in vain to ascertain, is falling across the room. Far, faraway, out there, by the mountain grave, an uncanny silhouette disengages itself from the clear evening sky – Homunculus,' one reads in a passage about the second part.[22] At the same time, this play on light is remarked upon also in the reviews of the time, always in relation to the second part, where the repeated use of silhouettes is adduced as evidence ('whose most magnificent examples are the crowd at the edge of the mountain, and the final tableau'[23]). The description calls attention to a scene in which 'the shadow of the restless wanderer suddenly becomes visible,' judged to be 'one of the most powerful [sequences] we have seen in a film for a long time.'[24] The final battle between the older and the younger Homunculus is similarly described: the figures are 'etched into the sky like silhouettes.'[25]

Carl Hoffmann was the cameraman of the film, and to him must go the credit for such solutions in the first place (this, too, already noted by the commentators at the time). It is hardly necessary to remark how – not least thanks to the intense activity of this same cameraman – these stylistic effects will find wide application and expressive mastery in the German cinema after the war.[26]

These high-culture aspects of style present on the level of the mise-en-scène are not isolated elements, no mere ornament used to embellish a product created solely on the basis of 'low-culture' and popular parameters. Neither is it simply the strategy of melodrama (to which is added a raised tone, a sublime register) which by itself can justify such formal elaboration. HOMUNCULUS participates, if one looks closely, in a more ambitious project in which the integration between popular and high culture stylistic dimensions plays a strategic role. Nothing less than *Faust II* by Goethe[27] is cited to vouchsafe the film's literary attributions[28]; Lessing's drama theory is invoked to explain the mechanisms of pity and terror[29]; the film is located in the development of the *Autorenfilm*, or at any rate, it is interpreted as a crucial step in the process of involving writers and dramatists in the cinema (among whom Reinert is placed, as writer for the theatre and 'modern man of letters'); the film positions itself at this turning point of German cinema[30] in order to help legitimate it as a bona fide art form.[31] This not only forges a link between HOMUNCULUS and the 1913 *Autorenfilme*, but also points forward to CALIGARI. In a review of the 1920 re-release from *Der Drache*, HOMUNCULUS is seen as one of the happy manifestations of a tendency that gives body to the most intimate essence of cinema, defined as the representation of the fantastic, the metaphysical, the irrational.[32] This is no isolated position, but reflected by other reviewers who in the postwar years also pinpoint the 'mystical' and 'fantastic' dimension of the new medium as its 'essence' and cite HOMUNCULUS as evidence and one of the most convincing proofs.[33] In the context of the debates about expressionist cinema and the resistances against cinema evolving in this direction, the film was even judged as too demanding and intellectual for a popular audience: 'I heard the audience laugh as the supernatural creature (...) with his bare fist smashed down a door and broke in two a wagon shaft as if it was a match. They probably thought this was a strongman showing off and did not

have a clue what was really at stake.'[34] – 'I fear that this part [the second, in the 1920 version] in particular, with its strong inwardness, may well not appeal to the general public. No doubt, a certain spiritual sensibility and culture are necessary, in order to fully grasp the intentions of the author and the actor.'[35]

Indeed, some aspects of the film seem to gather salient motifs of theatrical expressionism or, rather, draw on the same deeper stratum that nourished theatrical expressionism since when HOMUNCULUS was produced, some of the major texts of expressionism were still to be published, while others (*Der Sohn*, *Der Bettler*) would only subsequently attain the impact they did when expressionist mise-en-scène had given them a definitive interpretation.

Among the echoes are the father/son conflict (Homunculus first of all pours out his hatred against those who gave him life, condemning him to unhappiness); the theme of the revolution (the protagonist, in the guise of the leader of the mob, incites the masses to a revolt 'against capital.' One intertitle reads: 'the globe shall tremble from the peoples' wrath...'[36]). Similarly, the motif of mankind's regeneration, to rest on the foundation of a new humanity arising from the ashes of the earth, devastated by fire and sword (the new race being symbolized by a couple of young people raised on a desert island[37]) adds another possible point of contact between the film and the thematic universe that expressionism was about to develop.

We thus find ourselves confronted with an interesting paradox. HOMUNCULUS, prototype of the serial film, the privileged place for the development of narrative and of themes belonging to popular, sensationalist imagination, tries to construct for itself a strict relation with a high culture tradition and thereby seems to echo the most 'modern' and 'revolutionary' tendencies of the contemporary German culture.

Some of the results of this convergence were the film's communicative effectiveness and the fact that the film became interpretable as uncannily topical. This symptomatic relevance was in fact registered already at the time, before the film and its hero became transparent to the sociological and psychological reading of Kracauer, for whom 'the Germans resembled Homunculus...,'[38] and before its radicalism was once more used to generalize about film and society.[39] Presenting the new 1920 version, the *Illustrierter Film-Kurier* remarked on the 'astonishing topicality' of the film: 'Rarely did a work show more cleary and unambiguously, where the spirit of strife and disunity will lead, if it is not combatted in time with all the means available to man.'[40] – 'Such Homunculi – even if not quite displaying the same unique capabilities – are not that infrequent' as a critic from *Film und Presse* wrote, also insisting on the links of the film 'with the generally sorry state of human society.'[41]

Even if we treat the available evidence with caution, it would seem that the film was a commercial success, with a three-week continuous run at the Marmorhaus in Berlin and a no less impressive result in Prague.[42] Reviews from the twenties speak of the film as having enjoyed international approval,[43] which seems confirmed by the fact that it was

thought important enough for a parody.[44] The strongest proof of the film's success is in any case its re-release four years later (a phenomenon sufficiently rare for the cinema of the time), although it has to be admitted that this success was not repeated in 1920, for '[the positive qualities of the film] proved insufficient to awaken all that much interest in the film.'[45] By then, the logical coherence of the story was cause for complaint,[46] as was the length of the intertitles,[47] the performances,[48] and the conception of the protagonist (on which especially *Der Drache* heaped a good deal of scorn).[49]

It would seem, then, that HOMUNCULUS played a key role in the process of redefining genres of German cinema between the pre-war period and Weimar. Belonging, as indicated, to those films that pioneered the episodic film in Germany (which is the aspect most often commented on by subsequent reviewers), it remains at the same time one of the reference points for a phenomenon that belongs to the post-war period, namely the identification of genres no longer on thematic grounds but by way of stylistic definitions.[50] Contemporary sources hold the film up as the model for a cinematic genre remaking itself in the image of romanticism, giving historians like Lotte Eisner the cue to do research along these lines. The interest of this circumstance lies in the fact that whereas normally the cinema is regarded as merely following a trend first started in the other arts, in the general return to a romantic aesthetics, the cinema here comes to be seen as a stimulus and vanguard: 'film was the first (even if reviled) artform to go down the path of romanticism,' becoming something like an active agent, the motor: 'film is well on its way to rehabilitate romanticism and give it a new interpretation for the future.'[51] This turn to romanticism was also seen as the optimal way of defining the new art form's specificity: 'the fact that film in its innermost essence strives after romanticism, lies in its nature. (...) In this way, the cinema will find its way out of the initial confusion, when it chased after sensationalist effects, to arrive at the grand form of romantic style.'[52]

This concerns a transition of great interest. The text in question is one of the many attempts to define the identity of the new medium based on its limits and constraints (the lack of the word, the difficulty of attaining in film the logical, intellectual rigour of argument and language), which directly led to positing its 'natural' affinity with the universe of the fantastic. This has less to do with trying to legitimize the cinema as 'art' and more with the belief that the cinema was destined to become the new technical-expressive form through which the romantic aesthetics could renew itself and continue to expand. And while these debates found their fullest manifestations only in the early 1920s, they invariably had recourse to the films of the teens, with the following titles serving as evidence: AHASVER (dir. by the same Reinert, and again an episodic film, 1917), THEOPHRASTUS PARACELSUS (Joseph Delmont, 1916), DER GRÜNE MANN VON AMSTERDAM (Otto Rippert, 1916), and DIE MEMOIREN DES SATANS (1917, adapted from W. Hauff and also directed by Robert Heymann). Among them, the inaugurating role belongs to HOMUNCULUS, setting in train a process that was to deeply mark and identify the German cinema.

Julius Pinschewer: A Trade-mark Cinema

Jeanpaul Goergen

The advertising film is practically as old as the cinema itself. Already in 1896 Georges Méliès made advertising films built on the principles of trick-amazement, of the fabulous and the grotesque, for example, letters swirling in the air and finally organizing themselves into a brand name; Méliès' son was able to demolish huge amounts of chocolate; and, with the help of a hair-lotion, the bald-headed filmmaker turns into an Orang-Utan-like being.[1]

In 1896/7 Oskar Messter showed the advertising film BADE ZU HAUSE, which promoted a 'wave-pool-swing' (Wellenbadschaukel) of the Moosdorf & Hochhäusler company from Berlin-Treptow.[2] In August 1911 Paul Effing, engineer for cinematography, contemplated the use of trick and special effects for cinema advertisement.[3] Late in 1911 the Internationale Kinematographen-Gesellschaft in Berlin offered to produce advertising trick-films of this kind.[4] Already at that early point in cinema history, the advertising film must have been solidly established, as suggested by a report from January 1912, which mentions the astonishingly rapid dissemination and unprecedented popularity of the cinematograph as a means of advertising; there is already supposed to be an 'ambitious organisation distributing advertising films to c. 500 cinemas in Germany and Switzerland, which are shown in the same just as the regular programs.'[5] Whether this already referred to the company of Julius Pinschewer remains uncertain, but occurs rather unlikely if one considers his biography.

Pinschewer, born 15 September 1883 in Hohensalza/district Bromberg, studied political science in Berlin and Würzburg. He described how he came to found his entrepreneurial career on the advertising film:

> It was in 1910, when the author of the present, during one of his first visits to a movie theatre, was struck by the idea of bringing to life posters and trademarks for commerce and industry with the help of film, and to distribute and exhibit the thus produced films for advertising purposes in public cinemas. The first advertising films, produced at own financial risk were projected at the gathering of the *Reklameschutzverein* in Berlin in 1911. These were films of 20 to 30 metres in length and mostly performed by living persons. But among those first films was also an animated advertising film: it showed a real ring-shaped poundcake which soon transformed considerably in size, which, as revealed by a written text, was to be credited to the use of Dr. Oetkers baking powder.[6]

The first traces of Pinschewer's film economical activities can be found in April 1912: Explicitly referring to the industrial branch 'film advertising,' Julius Pinschewer became mem-

ber of the 'Verein Deutscher Reklamefachleute.' His company was situated in Berlin-Schöneberg, Innsbrucker Str. 19.[7] Already in the second half of 1913, Pinschewer placed his first, still modestly sized advertisements in the press: '*film advertising*, the most modern, most effective and cheapest advertising in selected cinemas in all parts of Germany. References from the biggest domestic and foreign companies.'[8] In 1913/14 he opened an office in London, where the advertising film as a means of product promotion is as yet unknown.[9] Earlier still, on 23 February 1910, he had placed a patent announcement in the London *Illustrated Official Journal* for 'Improvements relating to a method of presenting animated advertisements.'[10]

Showing How Soap Lathers Up
Pinschewer's idea was less the combination of advertising and film than the 'systematic distribution of advertising films in the cinemas.'[11] And he knew very well that advertising films, too, had to be designed artistically, in order to be accepted by clients and audiences alike. To have managed to steer the advertising film through commerce and industry, to cinema owners and, last but not least, towards the cinema audiences was Pinschewer's pioneering achievement.

Alongside his first press advertisements, in August 1913 Julius Pinschewer published a comprehensive essay about the benefits and acceptance of cinematographic advertising.

> Film allows industrialists and businessmen to express in a lively and thus very impressive way what one used to say with dead letters or drawings. In this way an important helper is given to industry and business, not only because of its impressive educational effect, but also its stimulus for memory. Film is capable of showing how the soap lathers up, how chocolate tastes, how fine the sewing machine works, how to handle the preserving pan, how charmingly clothes hug the living body, or how cleanly food is packed by a useful machine, etc. (...) Film advertising is especially suitable for such products which enter circulation under a *particular brand*, or which constitute in type and origin a 'class of their own' and are available everywhere and always at fixed prices.[12]

Apart from such thoughts, Pinschewer undertook statistical polls, which were executed in 600 cinemas by an unspecified 'World Company.' According to this investigation, cinema audiences indeed notice advertising films and follow their content with interest and curiosity, the films find approval and sometimes even open applause. Within the audiences 'the lower and upper middle-class as well as upper classes' – i.e. a wealthy public – outnumber workers by far:

> Generally the audiences are composed of people whose conception is more dependent on sense perception, and who therefore show less interest for reading

newspapers or books, or for the spoken word than for the easily understandable depiction in film. It is also for this reason that the woman of every age and social standing is a friend of the cinema.[13]

In 1914 Julius Pinschewer moved from Schöneberg to the centre of Berlin. In the 1914 directory he figures as the owner of the film studio at the Dönhoffplatz, advertisement publisher and head of the Harry Walden-film company, SW 19, Jerusalemer Str. 13. The 'Herstellung und Vertrieb von Harry Walden-Films, G.m.b.H' had been founded in 1912/13, dedicated to the 'production and exploitation of cinematographic films in which Harry Walden appears or plays a role.'[14] Only one film from this company could be traced;[15] this is probably all Pinschewer ever undertook to gain a foothold on the fiction film-market; throughout his lifetime he was to produce almost exclusively advertising and industrial films.

Pinschewer's studio at the Dönhoffplatz, formerly owned by a photographer, was a rooftop-studio typical for the time and was fully glazed for the purpose of optimal lighting. According to contemporary photographs, the studio was big and spacious.[16] It contained a fully fledged film factory with studios for shooting, a meter-high tricktable, office space for more than one designer, for the production of sets, and for film development and copying. Pinschewer remained in the Jerusalemer Straße until 1925; it was here that he founded the Vaterländischer Filmvertrieb and, in 1918, the Werbefilm GmbH for the artistic advertising film.

Aesthetics of the Advertising Film

From his experimentations carried out in this studio, two central priorities crystallized for him the nature of advertising film: 'clear and intelligible content at the shortest extension and interesting, gripping subject matter, which, if possible, should adapt to the taste of the cinema audience.'[17] Two genres had emerged: the trick film which shows events 'utterly impossible in real life,' as well as the *Realfilm* which worked towards the 'highest possible realism' in its representation of an event. Pinschewer's credo was that top quality standards have to be applied to the advertising film.

> For shooting an advertising film, the best light is just good enough. (...) Experience has taught us that a combination of mercury-vapour lamp light with the light of specially fitted arc lamps is most suited. In the construction of sets and decors, such as doors, windows, chimneys, etc., one should strive for the most *plastic* effect possible, where the background has to remain as indifferent as possible in order not to distract from the action. (...) An important part is *direction*, which has to be especially adapted to the shooting of an advertising film. Artistic and commercial principles have to merge in this point. First of all, utmost brevity is required. (...) For the film to be gripping and not boring, it is necessary that what is to be said is clearly expressed to the viewer in the shortest

time possible. For this reason also the selection of actors has to be a very careful one. If for the entertainment film average actors may suffice, the advertising film requires only the most gifted dramatic artists. Every wrong movement means a delay in schedule. The actor has to be capable of expressing himself in very limited time. The less generously the advertising film deals with time, the more effective it will be.[18]

Therefore, advertising films should not be longer than 30 meters, which corresponds to a duration of 90 seconds at most – in order not to bore audiences[19] and to make the purchase of advertising films palatable to cinema owners. The latter feared losses in profit, because the programme, prolonged by the advertising films, could not be repeated as often as before. And as a result, around 1912 there circulated the lamento that cinema owners could not be convinced to purchase advertising films, 'neither for money nor for good words.'[20]

Part of this effort to foster the acceptance of the advertising film was a lecture on 'Film as a Means of Advertising' which Pinschewer delivered on 14 May 1916 at the monthly gathering of the Verein Deutscher Reklamefachleute, and in the presence of representatives of the Reichstag, the Ministry of War and police headquarters.[21] Speaking at the Union-Theater in Friedrichstraße 180, Pinschewer above all emphasized the future mission of advertising after the war, when it will be the task to reclaim lost foreign markets. Pinschewer, who is introduced as 'the leading expert in this special branch of the advertisement industry,' showed approximately 25 advertising films on this occasion, promoting Eduard Beyer (ink), Continental Caoutchouc Co. (car tyres), F.A. Grünfeld (a big Berlin confectionist), Kathreiner, Kornfranck, Kgl. Fachingen, Maggi, Sarotti, and other important companies. Pinschewer announced in this talk that the majority of German cinemas in about 300 cities were affiliated to his organisation, including all Union theaters.

Pinschewer (2nd from right) at work in his studio (1914)

In order to increase the acceptance of the advertising film with cinema owners, Pinschewer freely committed himself by contract not to show more than one advertising film per programme. Furthermore, in only making propaganda for companies 'whose significance and usefulness for the national economy is assured and whose product representation in film can be done tastefully,'[22] he put himself under voluntary self-control.

Already by 1916 Pinschewer was able to list the diverse stylistic and expressive devices of his films: trick films and films for which 'the brush of the painter and the chalk of the designer are used'; films 'in which certain events, full of atmosphere, constitute the introduction to the finally appearing advertising slogan'; farcical and grotesque narratives; films for the propagation of comprehensive thoughts and complex ideas.[23]

One particularly important client for advertising films was Heinrich Franck Söhne GmbH, on whose behalf Pinschewer produced numerous films for the propagation of semolina and corn coffee until 1916. The films had titles like DER VERDACHT, EINQUARTIERUNG, DER WUNDERVOLLE DUFT, DER SCHÜCHTERNE FREIER, and each depicted a short, grotesquely sharpened scene with the advertising message comprising the surprise gag at the end.

> Thus, it is primarily great businessmen, owners of shipyards and castles, in brief, people in the prime of their lives, whose fates are depicted in the films. From this results the practical application only to show well-situated people as protagonists of the advertising film for Kornfranck and Franck-semolina, whose actions appear to the economically and socially less well-placed viewer especially exemplary and commendable.[24]

For exactly this reason, the popular actress Anna Müller-Lincke, who already in her outward appearance represented the prosperous middle-class woman, starred as the leading lady in DER NEUE HUT:

> Once more, Anna wants to get a new hat from her husband. Among the hats that the milliner sent her to choose from, the one decorated with a beautiful heron suits her really too well! But this time Anna's husband remains hard and unrelenting. In this situation, she employs a means which has proved effective in similar cases in the past: she swoons. The husband knows what to do. He rushes out of the room and soon returns with a cup of a nice-smelling drink which he holds under the nose of his unconscious wife. And you see: Anna cannot withstand the tempting smell, she is attracted by it, like the medium by its hypnotist, and savours, now fully revitalised, the mysterious drink which reveals itself to be 'Kriegs-Kornfranck' coffee.[25]

In DER ASTRONOM, shot in the observatory of Berlin-Treptow, the scholar discovers obscure signs and lines on the surface of the sun, which... spell the logo of the 'Aechten Franck' coffee! In SPUK IN DER KÜCHE, a packet of Kornfranck coffee, a coffee grinder, the can, the

pot with hot water, as well as a cup, the milk-can and the sugar go off on their own; the cup tries to escape and breaks into pieces which, as if by magic, put themselves together again, so that the 'Kornfranck' can be enjoyed![26]

In 1962 the 'Institut für Bild und Film in Wissenschaft und Unterricht' in Munich produced a three-part film DOKUMENTE ZUR GESCHICHTE DES WERBEFILMS which summarized 14 films from the archive of Julius Pinschewer. The accompanying booklet was written by Fritz Kempe; it was the first appreciation of the life and work of Julius Pinschewer. Kempe presents CORSETS GEBR. LEWANDOWSKY as the earliest still extant advertising film of Pinschewer and dates it 1910. In the style of animated pictures one sees first the clothing shop from outside, then the elegant interior where two ladies are admiring themselves in new garments, followed by another outdoor shot revealing the shop window front plus company plaque.[27]

Pinschewer's farce CARMOL TUT WOHL is dated by Kempe 1911. The bourgeois-sedate husband complains about rheumatic pains. Whereupon his wife administers a potion after which he almost immediately feels relieved, so much so that he boisterously attacks the maid, hugging and kissing her. The wife, however, loses consciousness upon this sudden change. The cause of this new-found vitality: 'Carmol does you good!'

In 1912 DER NÄHKASTEN was produced, in which needle and thread automatically sew on Prym's press-studs and demonstrate their stability. Cameraman Guido Seeber was responsible for the trick shots. Fritz Kempe describes this film as being 'of archaic conclusiveness' and praises it as 'one of the most beautiful documents of the early trick film anywhere.'[28]

Vaterländischer Filmvertrieb and Werbefilm GmbH
With his thoughts on the subject, Pinschewer takes the floor in the debate about the centralisation of political propaganda early in 1915. His primary concern is the forceful opposition to hostile propaganda with all possible means. For Pinschewer, propaganda ('the activity of states, which aims at influencing the political views of inhabitants of one's own, hostile or neutral countries') is a self-evident means in the service of warfare. The means employed to this end, like image, photography, film, flyers, are not different from those already in use for some time in commerce and industry. Film is of particular importance, because it 'works more effectively than the still image' and thanks to its universality is particularly suited 'as a means for international political propaganda'[29]:

> If one considers that the cinema is today throughout all countries the most popular place of mass entertainment, and that cinema audiences recruit themselves predominantly from the middle and lower classes, whose judgement is much easier to influence than the judgement of higher classes, one would have to look upon film as a first-rank means of political propaganda. (...) It would be desirable that films were systematically received and distributed by a still to be established central organ for the information of the neutral foreign countries, whereby

e.g. the fairy-tales about the miserable conditions in German war prison camps could be destroyed for good; furthermore, images of the destroyed areas of East Prussia, of the rationing for the wounded prisoners, etc.[30]

During the subsequent period, Pinschewer put his expertise fully into the service of the Fatherland. As an advertising expert, he served as member of the advisory council of the Deutsche Bank, participated in confidential meetings between politics and industry, and developed proposals about how to influence prisoners of war in the German interest.[31] In 1916 Pinschewer founded the Vaterländischer Filmvertrieb[32] in order to support the cinematographic propaganda for war bonds.[33] Films produced under the supervision of the Reichsbank were distributed post free and given for projection to cinema owners free of charge.[34]

Apart from films for war loans, Pinschewer also produced and distributed advertising films on more general subjects, such as DIE DEUTSCHE SOMMERZEIT (early 1916, length: one reel) and UNTER DEN FITTICHEN DES BERLINER KRIPPEN-VEREINS (June 1918, length: 126 meters).[35] In a letter to the Foreign Office from 20 January 1919, in which Pinschewer offers his services as a specialist in matters of the advertising film, he also mentions 'a number of films promoting cashless payments, films for the U-boat donation, the Ludendorff donation, the donation for German war and civil prisoners' as well as one film 'on behalf of the committee of the women's organisations in Germany, which promotes female suffrage.'[36] Pinschewer boasts that thanks to a 'carefully executed organisation,' he is in a position to have films and still advertising images projected in all German cinemas and variety-cinemas. From one inventory of cinemas associated to his organisation, which is added to this letter, it follows that in the district of Groß-Berlin alone, 18 cinemas with more than 400 seats and 28 cinemas with less than 400 seats were showing films from Pinschewer.

On 24 April 1918 the trade paper *Der Kinematograph* reported that Julius Pinschewer's Vaterländischer Filmvertrieb has joined the Ufa conglomerate, while remaining an autonomous and independent company under the previous management.[37] Also in 1918 Julius Pinschewer established the Werbefilm GmbH for the purpose of the 'creation and distribution of artistic advertising films.'[38]

Pinschewer was a producer who in almost all of his films was responsible for the artistic supervision. Although he 'never signed them, all ideas for his films came from him, he wrote the scripts and directed; each scene was checked by him, and corrected if necessary, right after the material had been developed.'[39] His first advertising films were mostly grotesque scenes – on which he worked with amongst others Anna Müller-Lincke, Olga Engl, Ernst Sachs, Inge Miron, Käte Haack, Erwin Paul Biswanger, Berthold Rosé, Otto Gebühr, Curt and Ilse Bois, Alfred Braun, and Asta Nielsen. From 1918 onwards he specialized in animation films, with a strong preference for fairy-tale and exotic subjects. From the very beginnings Pinschewer promoted brand-name products and only from 1924 on, also more general subjects. In 1920 he claimed to possess the exhibition monopoly for more than 800 German cinemas with an attendance figure of approximately four million people per week – making him the undisputed 'brand leader' in the field of cinema advertising.

Newsreel Images of the Military and War, 1914-1918

Wolfgang Mühl-Benninghaus

The Military before the War

In the nationally oriented culture of the *Kaiserreich*, with its great enthusiasm for all things military, battle, war and heroism, flickering images of torpedo boats at high sea, troops returning from the spring parade or battleship launches were shown with great success on Germany's first cinema screens.[1] This gave rise to a regular stream of films featuring Wilhelmine forces, initially from Skladanowsky and Messter, and later from other companies. The filming of military set-pieces such as ÜBERFALL AUF SCHLOSS BONCOURT, THEODOR KÖRNER, DIE SCHLACHT BEI GETTYSBURG or LIEB VATERLAND, MAGST RUHIG SEIN[2] provided the military with thematic and representational accounts of the many images of military motifs.[3]

Alongside industry, which used film as a means of advertising its products and even its factories,[4] the military was one of the first sectors to use film to serve its own purposes, even before the war. As well as having a military value, these films were intended to 'not only cultivate public awareness of the land and sea forces, but also to popularise armament.' Events captured on film served to relive actions in distant garrisons, which members of the military and the public might have heard about but not have been able to participate in.[5] Footage of military manoeuvres demonstrated how various arms and weaponry could be used to best advantage. With the aid of trick shots, 'living maps' were created to instruct the viewers in tactics, re-living such famous battles as Sedan and Austerlitz.[6]

The films produced by the military pre-1914 can be divided into two broad categories: the training film and the 'popularisation' film. In any case, many training films were also shown to cinema audiences and were employed as a form of educational film for the general public.

One of the reasons for the technical advances in cinematography during the war was its application for military purposes. This was particularly true of the serial image cameras ('Reihenbildner'), developed by Messter in 1915.[7] Although this type of military application remained a relatively isolated case and (compared to World War II) few decisive film-technological advances were due to the war, the institution cinema did experience an important increase in status under the influence of the men-and-machine battles in the trenches. The massive mobilisation of the nation's forces gave rise to a process of linking war and ideology which had been unknown until that point. It is in the framework of this 'total mobilisation'[8] that, from October 1914 onwards, war footage first appeared in Germany's

cinemas. These films later became divided into the categories of educational, orienting and propaganda films,[9] although in practice it was not always easy to differentiate between these categories.

The First War Newsreels

The cinematic trade press was extremely reluctant to carry out its first assignment in the service of the war when it came to mobilisation.[10] There was little of that enthusiasm for war one knows about from other sections of the population in the first days of August 1914. Sections of the film industry, though, did succumb to the demand for films which would help transport the audience on a wave of patriotic fervour which struck Germany in August 1914. This is indicated by decisions to remove French and English films from theatre programmes[11] and discussions held at the time about the future of German film.[12]

Anticipating a huge public interest in war films, the Berlin-based branch of the American Biograph Company asked the military command's permission on 31 July 1914 to shoot action scenes on the future fronts. In August this request was followed by a series of other applications.[13] Still in the same month, production companies including Scherl's Eiko managed to negotiate the dispatch of camera operators to the front.[14] Other firms sent their cameramen with the first consignment of troops without going through bureaucratic formalities. All attempts by these operators to join troops at the front line, however, came up against the authority of the General Staff. The fear of espionage and a certain lack of awareness of the civilian population's expectations meant that in the first weeks of the war reporting from the front was limited to military communiqués and press conferences. A mere 15 carefully vetted journalists were given permission to present more extensive press information from the front.[15] This was an initial indication of what was to typify the whole war: the top military command saw the written press as the most important medium for the presentation of war reporting. Partly as a result of discussions raised by cinema reformers concerning the relative merits and demerits of cinema, for much of the military, as well as among broad sections of the public, cinematography was considered a questionable and underdeveloped medium which could serve only as a secondary form of publicity.[16] In September/ October 1914 Oskar Messter was selected to serve as advisor to the General Staff on cinema affairs. From this point on, several film firms were given permission to shoot footage at the front. Film companies who had gone to the front at the beginning of the war without official permission were obliged to recall their operators and forbidden to show their films in cinemas.[17] The criteria for licensing war cinematographers were announced on 6 October 1914:

1. The company must be completely German, must be controlled by men of a patriotic, German persuasion, must have sufficient capital and work within the German currency area.
2. The company must use only German recording equipment, German manufacturing apparatus and German film stock, and the entire factory must be company-owned.

3. The company must not only have a reputation for reliability in every respect, but must also be responsible for dispatching representatives to the theatre of war. Photographing in the theatre of war and in territories captured by German troops is subject to the approval of the chief of the general staff of the military in the field. Applications should be addressed to the press department of the military's deputy general staff. The recording of cinematographic material requires a special licence. Photographs and cinematographic footage may only be reproduced, distributed and exhibited with the prior permission of the military censor. The activity of photographers and reporters without a pass from the general staff is strictly prohibited.[18]

From the daily press one can gather that among the firms in possession of the necessary papers were Messter-Films, Eiko Films, the Württemberg-based Express-Film, which had already been making 'newsreels' before the war, and the Bavarian company Martin Knopf, Munich.[19] What is certain is that in the first months of the war several newsreels were shown in German cinemas. Most of them offered regular footage from the front, but the Grünspan newsreels specialised in films of the Reich.[20] During the entire war period, however, only Eiko and Messter-Film produced newsreels with any regularity. When war broke out, the deputy high command banned a large number of feature films on account of the state of emergency, with the result that cinema suffered from a shortage of feature films. This was accompanied by a decline in cinema audiences. The public that did remain demanded above all images fitting the gravity of the moment. In order to meet this demand, many cinemas supplied films of troop mobilisation which the public responded to with lively interest. These films included shots of great commanders, propaganda cartoons, picture puzzles, portraits of battles, and old, partially re-cut films of military exploits on land and sea, as well as historical footage from conquered overseas territories and patriotic feature films.

The representation of the war in the cinemas was very much in line with general reporting. It was from the newly established war magazines that films took over the depiction of scenes from frontier areas located well away from enemy lines, cities, street signs, mass marches, individual soldiers, and military transport.[21] The first war edition of EIKO-WOCHE, which came out on 11 September 1914, followed the style of general photographic or cinematographic reporting.[22] The advertising for it in the trade press contained promises of exclusive footage from the theatre of war. Unfortunately, this footage has been lost, and we can only speculate whether the promised sequences were postponed (since at this point there were still no camera operators at the front) or never shot.

Under pressure from intensified film censorship, the standards set by news reporting before the war had to be relinquished.[23] In the first weeks of the war, the lack of war films made it impossible to supply the press and the cinema with reporting based on actual events. The reaction of producers and theatre-owners to the ban on filming at the front was one of patriotic compliance, mixed with demands to allow the public to participate in the historical course of events in the cinemas.[24] In an attempt to cash in on the lack of genuinely

MESSTER-WOCHE

Nr. 2

Erscheinungstag:
16. Oktober 1914

Bilder vom östlichen Kriegsschauplatz:
1. **Die von den Russen zerstörte Allebrücke in Friedland.**
2. **Insterburg.** Hotel Dessauer Hof, in welchem der Ober-kommandierende der russischen Armee, Großfürst Nikola-jewitsch und General Rennenkampf, ihr Hauptquartier auf-geschlagen hatten.
3. **Russische Gefangene,** welche von einer Patrouille so-eben eingebracht wurden.

Bilder vom westlichen Kriegsschauplatz:
4. **Totalansicht der französischen Festung Longwy** mit seinen Eisenwerken nach der Einnahme durch unsere Truppen. Nicht ein einziges Gebäude wurde beschädigt, da die Einwohner unsern Truppen freundlich begegneten.
5. **Longwy** von der Seite, von welcher der Sturm unserer Truppen stattfand.
6. **Ein von den Franzosen zerstörtes Haus bei Longwy.** Im oberen Stockwerk ist der einstige Bewohner des Hauses bemüht, noch Erreichbares zu retten.
7. **Ein Kirchhof,** dessen Mauer von den Franzosen als Ver-teidigungsstelle benutzt wurde.

Berlin:
8. **Prinz Joachim, der jüngste Sohn unseres Kaisers,** welcher vom Schlachtfelde verwundet heimgekehrt, sich jedoch auf dem Wege der Genesung befindet, zu einer Ausfahrt bereit.
9. **Abfahrt einer Autolastwagen-Kolonne nach dem Kriegsschauplatz.**
10. **Unsere brav. Verwundeten** auf dem Wege der Genesung. Wiederhergest. Mannschaften melden sich freiwillig zur Front.
11. **Aufsteigen eines Freiballons z. Beobachtungsdienst.** Ein Blick auf das Gelände vom Ballon aus gesehen. Ein mächtiges Instrument der Luftfahrzeuge ist der Höhen-meßapparat (Barograph) Nachrichtendienst vom Freiballon durch Brieftauben.

Aenderungen vorbehalten!

MESSTER-FILM BERLIN

Advertisement for MESSTER-WOCHE, no. 2, 16 October 1914

new footage, they passed off historic recordings as new ones, scenes of manoeuvres as war scenes, and footage shot well behind the theatre of war as shots from the front.[25] This tendency to create or re-create war films characterised the first weeks of the war and became part of a widespread practice which continued throughout the war.

Fears about espionage led to banning in parts of the country of the first war newsreels, which were censored by the General Staff. In all the cities in which they were shown, the public proved enthusiastic. Against this background, advertising and trailers for the weekly newsreels filled much of the space in the press that had previously been reserved exclusively for feature films. Other advertising techniques, initiated particularly by Messter-Film, presented the imprint of bogus telegrams[26] or trailers,[27] stressing the particular proximity to the front of the recordings and mentioning the dangers this involved for the cameraman.

The high command's granting of permission for the production of newsreels aroused both economic and other expectations. Newsreels were seen as a link between the real front and the home front that could help those at home to 'create a consoling picture of the courage, joy in victory and the good humour among those who had left for war.'[28] The films were also celebrated as a 'great cultural factor,' which could 'act as an absolutely authentic record of inestimable value.'[29] On the grounds of this authenticity, the newsreels were seen as 'highly valuable contemporary documents (...) which will retain a sense of the new for many decades to come,' and for this reason there were calls for the creation of an archive to house the material.[30] There is little doubt that such statements also helped enhance the social status of the cinema in general. At the same time, these expectations sprang from a basic consensus of opinion among the population that they were being shown authentic documentary material which depicted the war in its entirety until the end of 1914.

Newsreels 1915-1916
Around Christmas 1914 it became clear that the war would not be won quickly. As a result of the blockade and the restrictions it entailed, the mood of the German population underwent a transformation from the enthusiasm of the first months of the war to a more sullen mood of survival. In this new environment the newsreels met their first criticism, directed on the one hand at the censor, who was blamed for the fact that films were 'increasingly losing their appeal.'[31] Doubts also began to be voiced concerning the worth of the films. Shortly afterwards, the criticism became even more explicit:

> None of the current reporting really follows events on the ground. The war newsreels are an indiscriminate hotchpotch of genre shots and episodes which could be shown today just as well as next week, considering how little actual news they contain (...). The public has long since lost interest in this kind of genre film.[32]

The trade press, keen to give cinema audiences the most accurate picture possible of events at the front, called for more camera operators to be sent there, supporting their demand with

the argument that propaganda was better in other countries.[33] The German footage from the front was deemed inadequate: 'what have been offered to the public as war films are in fact not war films at all but only genre shots which could easily have been filmed in Grune-wald.'[34] Many shots from the front looked pieced-together, haphazard and unconvincing, with little evidence of destroyed buildings or people moving about naturally.[35] Other typical scenes featured soldiers clearing up and repairing buildings attacked by the enemy, or the sports and leisure pursuits of the soldier in battle dress. They depicted the war as 'a beautiful nature film featuring military exercises, and devoid of any unpleasantness.'[36] The limited freedom of movement enjoyed by the camera operators at the front meant that they were usually unable to come up with more than such 'harmless images.' By March 1915 cinema audiences were beginning to regard the war newsreel as something of an annoying interruption in the evening's programme which had in the meantime returned to entertainment fare.[37]

While the newspapers were able to report past events as time went on, war footage once banned was not allowed to be shown even at a later date. The vast majority of this footage was in fact destroyed by the censor.[38] The rest was put in one of the film archives set up during the war by the General Staff.[39] As a result of the censor's decisions, up-to-the-minute material was scattered far and wide, leaving 'not a single hint for the enemy.' Death could only be presented in the form of war graves, and the wounded were shown only with bandages and on the road to recovery. Furthermore, it was forbidden to focus on modern weaponry, such as certain types of ship, heavier artillery, aeroplanes and logistical equipment.[40] These restrictions combined to prevent the filming and exhibition of genuine battle scenes or other scenes of war that would have been of interest to the public at home.

Under these conditions the authorities claimed, rather disingenuously: 'We do not actually own any war reportage on film.'[41] In many newsreels the deficit had to be compensated for with intertitles. As a result, the war was experienced in the cinema more in the form of a kind of 'film writing' than of 'film showing.' The following example comes from a Messter newsreel:

> The title reads: 'A modern battlefield' but all you see is an empty field. The title reads: 'A French pilot tries to destroy German positions with his bombs, etc.' and what you see is a shot of clouds in which, if you squint your eyes, you can just about make out a tiny, moving point in the distance! The title reads: 'A telescope on the dunes' and all you see is a group of officers looking through a pair of binoculars into the distance. (...) 'A soldiers' swimming pool behind the front.' That's what war is.[42]

By the summer of 1915 small, handy tripods and a range of other equipment had been developed to enable the camera operators to work even when under enemy fire.[43] Yet the content of their films did not change. This is indicated in an account from the summer of 1916 of the ironically bemused reactions of soldiers at the front to the war footage: 'The

insincerity of these patchwork war films provokes universal hilarity. The whole place fairly shakes with laughter. What those at home gaze at in wonder is derided mercilessly here.'[44]

In the summer of 1916, the only two companies still making newsreels were Eiko and Messter. This development can only partly be explained by the content of the films. We should also take into account the high cost and the enormous effort involved in producing a newsreel. Such efforts were only profitable as long as broad sections of the population went to the cinema chiefly to watch 'the news.' The public's rush to see footage of the war was limited, however, to the first months of the war when everyone was volunteering for service and expectations of a swift end to the war were high. As the euphoria abated, under conditions of entrenched warfare and the blockade, and as the war became less and less a heroic carnival and more part of everyday life, the public's interest in the war newsreel faded. The images they contained no longer corresponded to the public's idea of war formed by the various representations of the Franco-Prussian war of 1870-71: troops advancing, cavalry attacks, man-to-man combat, colourful uniforms, etc. As early as 1909, General Schlieffen, pointing to the new technology of war, had drawn attention to the fact that in the future wars would be fought on seemingly empty battlefields.[45] This view was borne out in the pictures of the war in the Balkans, which were shown with little success in German cinemas at the end of 1913 and early 1914. They could offer the audience 'little of interest.'[46] This development continued in World War I. It offered next to no opportunities for traditional adventure, the soldier's role being largely defined by technology. Trench warfare was unsuitable for filming, and the recordings made by the few camera operators allowed to film on the front line often showed immobile soldiers, shot under poor lighting conditions.

Representations of the Military in the Second Half of the War

With the exception of the then very popular war dramas, during the first half of the war the presence of war in the cinemas was limited almost exclusively to the war newsreel. In addition, only a few films were shown, dealing for example with the rehabilitation of war invalids[47] or techniques for training war dogs.[48]

After the nomination of Hindenburg as Head of the Supreme Military Command in the summer of 1916, this situation underwent certain profound changes. Many leading personalities of the Reich, including a large number of military men, had by then become convinced that 'film was the best form of propaganda in war time.' It was thought that 'the viewer sees not only with his heart but with his soul and his feelings.'[49] As a result of this conviction, from the fifth war loan of the summer of 1916 onwards, regular and lavishly produced promotional films were shown alongside the newsreels[50] to encourage the German people to sign up for the war bonds. That same year the German Naval League began producing films again. It promoted its goals in the cinemas in the second half of the war[51] with the film STOLZ WEHT DIE FLAGGE SCHWARZ-WEISS-ROT ('The black-white-and-red Flag flutters with Pride'), and it promoted its social institutions with 'an old people's and

invalids' home.'[52] Deutsche Bioscop showed anti-French and anti-Russian films such as DIE MAROKKODEUTSCHEN IN DER GEWALT DER FRANZOSEN and DER KNUTE ENTFLOHEN. In Berlin, film producers, with state support, founded the 'Freie Vereinigung zur Förderung des Lichtspielwesens in gemeinnützigem, vaterländischen Sinne' ('The Association for the Promotion of Cinema for the Benefit of the Public and the Fatherland'), which had as its goal improving the procurement of propaganda material for films.[53] The Royal Saxony War Ministry, for instance, commissioned Messter to produce footage of troops from Saxony at the front, in order to 'provide those at home with a faithful picture of the life of their loyal sons out there, far away on the scene of bloody conflict.'[54] In addition, Deulig, founded in 1917, produced a series of partly staged industrial films[55] such as AUS DES DEUTSCHEN REICHES WAFFENSCHMIEDE or DEUTSCHE SCHUHFABRIKATION IM KRIEGE, which were intended to demonstrate the productivity of the German war economy. Various films of German cities and countryside by the same firm were also intended to strengthen the spectator's love for his or her homeland.

A key change came following a request from Austria that the Reich provide support for the production of promotional films to be shown primarily in the Balkans. On 8 August 1916, the Military Film and Photography Unit was set up in section IIIB of the General Staff.[56] A circular issued by the war ministry in August 1916 emphasised that the goal of the new unit was to 'bring to other neutral countries films of much greater potency than those previously made, which would represent the mass effect of our military, economic and industrial achievements.'[57] A few days later the war ministry wrote to the Imperial Chancellor and the Imperial Ministry of the Interior calling for the production of propaganda films which would bring about 'a boost to the civilians' morale' on a mass scale. During the interval dramatic or comic presentations were to be shown, since the cinema audience could 'not be fed with war footage and industrial films alone.'[58] Both of these documents indicate a transformation in the perceived value of film among those at top levels of the military command. In connection with the total mobilisation of all forces for the war, film was increasingly regarded as a form of propaganda from a military viewpoint. This was particularly true of non-fiction films about war, industrial plants, banking, the economy and shots of the countryside, which were increasingly produced in the period that followed. But the visible success of this new strategy came up against three main obstacles. The first was connected with the organisational structure of film production and exhibition. Complete responsibility for all issues relating to cinema fell to the deputy military commanders of the army and fortifications.[59] The lack of a clear command structure and of clearly defined roles within the 24 different army corps as far as cinematic matters were concerned made a nationwide communications policy virtually impossible in the subsequent period. Secondly, all the power of decision-making on essential matters concerning propaganda lay in the hands of the military command – men who had been raised to put the nation and their loyalty to the Kaiser before everything else. As a result their value judgements were oriented more towards the nation-state (a state built on power) than towards a nation of the people.

Both the nation-state and the 'power state' demanded society's deference to all things military. The assertion of power and of power politics was assumed unquestioningly, leaving little room for thinking in terms of the manipulation of melodrama and sentiment.[60] Thirdly, the cinema, particularly in the provinces, was one of the few forms of public entertainment available during the war. Due largely to the strictly limited range of entertainment on offer, audiences were generally 'more repelled than attracted'[61] by programmes designed as educational propaganda. Under these conditions cinema owners had to reconcile two partly contradictory positions: They had to attract a public seeking diversion and entertainment, while also needing to defer to the cinema reformers – still active in the second half of the war – by demonstrating the indispensability of the cinemas as a place of patriotism and 'attitudes loyal to the fatherland.'[62]

As a result of the establishment of the Military Photographic and Film Department, members of the imperial army took over the production of special films of the front, a task considered by the supreme command too important to be left to civilians.[63] While the newsreels were generally 'recorded a safe distance away from the real war', the official war films produced by the new film department would show real pictures from the front. The first film of this kind was MACKENSENS SIEGESZUG DURCH DIE DOBRUDSCHA (1916),[64] featuring the capture of Romania. It was followed in January 1917 by BEI UNSEREN HELDEN AN DER SOMME, which was greatly fêted in the German press, but met with little success in neutral or friendly foreign countries, not least because it was compared unfavourably with the British Somme films.[65] As part of an intensification of propagandistic activities, 30 January 1917 saw the inauguration of the BuFA (Bild- und Filmamt),[66] the brainchild of the film section of the foreign office, which produced several official films. Many of the images shown in these official propaganda films were also incorporated into the newsreels. Particularly since towards the end of the war the mood in Germany increasingly degenerated from one of endurance to one of fatalism, the newsreels' lack of footage that could grip the public became a major concern.[67] The distributors of German newsreels in neutral foreign countries were forever communicating to Germany that the content of the propaganda films was identical to that of the newsreels, with the result that the film theatres in question were 'often empty or could only muster a bored public in their place.'[68]

Besides, all the restrictions placed on the newsreels were also placed on the official films. Despite the change in attitude towards film as a medium compared with that of the pre-war period and the first half of the war, the restrictions on content remained.[69] As a result of these restrictions on content, the overwhelming majority of the preserved footage gives the impression of a war that had been traditional in nature and which had simply been given an added dimension in the form of new weaponry. None of the suffering, death, dehumanisation, nor the destruction of the countryside, of cities or of industry itself, all of which were part of this war, are to be found in the images of war from 1914-1918 – images which continue to shape our visual memory even today.[70]

There is little evidence in most of the feature films of the period of the kind of

footage seen in THE BATTLE OF ISONZO. It came to German cinemas within a week.[71] In terms of actuality, the newsreel of the LANDING ON THE ISLAND OF OESEL was also an exception, since this too was shown a mere matter of days after the event. The film, premiered at the end of October 1917, can also be regarded as remarkable by virtue of its content. Whereas war films tended to show only armed forces, this one focused on the interaction between land, air and sea forces in the taking of the island and in doing so highlighted the horrifying dimension of the war. Genuine battle scenes, however, are also missing. The film shows material, heavy guns, horses and soldiers being loaded into huge ships on the quayside at Riga. After shots of the crossing, there follow scenes of the unloading of the motorcycle divisions, the infantry and the horses, at the end of which we are shown Russian prisoners and a captured radio station.

Many of the problems could be traced to the austerity brought on by war, which in any case considerably thwarted the making of films.[72] But the German film propaganda also faced the problem of the length of newsreels and BuFA productions. Generally, the films were relatively short and could therefore only be used as a filler, the usual practice in Germany's large theatres being to show only two long films. The Austro-Hungarian film market would refuse short films altogether. In Scandinavia only a small number of first-class short films were taken up.[73] In Germany official films and newsreels could usually only be shown in small or medium-sized theatres and in cinemas on the front, run by the BuFA. A prerequisite for the marketability of propaganda films was that they formed part of a package which included entertainment films.[74]

In August 1918 there was general agreement among the participants at a conference in the headquarters of the Foreign Office that fundamental changes were required in newsreels.[75] As in previous years, a few cosmetic alterations were suggested, but the conference failed to agree on fundamental changes to production. The Foreign Office gave its support to a plan that would enable Messter-Film to film also in friendly foreign countries, making newsreels more attractive to foreign audiences. Despite all the shortcomings of Messter newsreels, from this point on, Messter was assured that couriers from the ministry would, if need be, transport his newsreels to these countries.[76]

Immediately after the war, the *Kinematograph* published the following retrospect which might stand as something like an epitaph:

> The last year of the war also brought the last war newsreels. Far be it from us to speak ill of the dead, but these war newsreels, which were gradually dying off of their own accord anyway, were not only a burden on the film programme, they were also an annoyance. They were boring and largely undeserving of their title, often being pieced together from old material rather than portraying the war. And what is more, the public was only too aware of it.[77]

Learning from the Enemy:
German Film Propaganda in World War I

Rainer Rother

When Goebbels in his speeches about film and propaganda tried to emphasize the specifics of Nazi propaganda, he inevitably mentioned the attempts Germany had made in this area during World War I. Needless to say, in retrospect these former efforts looked quite poor. For instance, speaking on 15 February 1941, on the occasion of the Reichsfilmkammer war meeting, Goebbels argued that propaganda gained a new role because of the war:

> This was so in the World War, too, only then we Germans had not understood it yet. In the World War the English chances for victory were based essentially on the attrition of the German people on the home front, so that even if Germany could put one victory after the other on its flag it was defeated morally. The result of this moral catastrophe was total military breakdown. And the English are still attempting to repeat the November 1918 experience today.[1]

Of course, Goebbels told his audience that this time the English would not be given another chance, and his view is in fact merely a version of the 'Dolchstoß-Legende' (the 'stab-in-the-back legend') already used by one of propaganda's inventors, General Ludendorff, years before. That Goebbels should allude to Germany's World War I film propaganda as a background to the propaganda war for which he was preparing is hardly surprising. Yet neither is his negative attitude towards his predecessors unusual. In fact, comparable statements, critical of the German propaganda efforts, appeared in print shortly after the war. The disparaging evaluation of the mass medium film was not isolated; judgement passed on other visual media, whose propaganda value was considered equally great, was not much better: In 1919 the journal *Das Plakat* published the following:

> We no longer need to have any hesitation in asserting that it was not only the superior military might that brought the German army to its knees, the enemy's war propaganda also had a significant influence on undermining the morale of our troops with its methodical deployment and psychological acuteness. If victory was denied to us, it was only because we could not produce equally good propaganda.[2]

This confirms that retrospective assessments immediately after the war criticised both the aesthetic defects of German propaganda and the lack of purpose and aggressiveness in the message. Ironically, the view of entente propaganda as excessively aggressive was one of the stereotypical verdicts used during the war by the military authorities of the Central

Powers in order to qualify their own propaganda as 'information.' Already then, an admission was hidden in this assessment applicable to the various types of visual propaganda: even in the war years, the German propaganda effort was inadequate and largely clueless (which, especially as far as lack of aggressiveness is concerned, cannot be levelled against written and printed propaganda material). Such 'self-criticism' was voiced more publicly after the armistice, but the shortcomings concentrated on were largely the ones already noted by the respective propaganda 'specialists' during the war, who, after all, were not blind to the generally unconvincing nature of their own product. On the contrary, practically throughout the war, they monitored the effectiveness of posters, photographs and films put out by officials to propagate the 'German cause,' openly referring to the entente's efforts as their yardstick. In particular, embassy officials serving in neutral countries supplied the 'Central Service of the Foreign Office' regularly with appropriate reports. These consisted frequently of complaints: unwilling to exonerate the failure of German forms of information management, by praising its propaganda for not denigrating the enemy or spreading a distorted picture, they openly compared the effects of the opponents' efforts and concluded that there was a lot to be learnt from them of what good propaganda should look like. This was the situation that led first to the founding of the 'Photo and Film Office' (BuFA) and then to the establishment of the Ufa, the latter not quite so obviously linked to officialdom.[3] Nevertheless, both institutions can be seen as attempts to produce a change in the means of propaganda by an organisational reform. Already with the establishment of BuFA this involved not just a rationalisation and centralisation of efforts, but more importantly a new, 'modern' pictorial language.

The goal of such endeavours can be reconstructed in the first place from the lists of defects noted. The following passage from Harry Graf Kessler is typical for the embassy reports, in this case from the German Embassy in Switzerland where he worked:

> Concerning the propaganda films, we would particularly like to see the German film industry decide to make works written by first-rate authors starring well-loved actors and actresses, that would arouse attention and sympathy for our cause in an entertaining way. An exemplary work of this type was (...) MUTTER-HERZ [i.e. MÈRES FRANÇAISES] with Sarah Bernhardt, a description of which was sent to Berlin some time ago.[4]

This aim of promoting one's own side in an *entertaining* manner with investment in stars and first-rate authors separated propaganda in the first place from didactics and rhetoric: it should not only 'inform,' it should seduce you into agreement.

Whatever the BuFA first thought about these suggestions, the resources and chances of a film being made to compete with Sarah Bernhardt were seriously calculated: less than a year after its official founding, the Office had produced a confidential discussion document, dated 14 November 1917 and stamped 'For official use only.' Taking stock of the dismal failure of previous activities, it was a reactive document in two senses: an act of self-

criticism and a reaction to the other side's success, both of which influenced the way the BuFA came to regard itself. The report, however, went further and summarized official attitudes to propaganda and information.[5]

Since the BuFA broadly shared this perspective, the memorandum did not limit itself to the official justification, by pleading self-defence in view of the enemy's machinations, but proceeded to list what it considered the essential ingredients for a successful German propaganda film:

> The propaganda film must be formed in a way so that it can compete with and even outdo the purely entertaining film. It must not only hit the instincts every propaganda wants to hit, but also has to take into account the justified desire for entertainment on the part of the masses as well as their curiosity.

The memorandum criticizes the press which in general does not support domestic films sufficiently. It regrets that only a few foreign propaganda films could be studied properly in Berlin, with the effect that the counter-propaganda does not clearly know what they are up against. And it suggests using famous and popular domestic stars in feature films with propagandistic messages. On the other hand – and following the lines of Graf Kessler's argument – the comparison serves as background for recommending the creation of rivals to the entente feature films

> which would hit the weaknesses of the entente propaganda. So far, it has not been possible to match the means and ideas and new effects of the entente prop-

DAS TAGEBUCH DES DR. HART (1917)

aganda. The film UNSÜHNBAR [featuring Adele Sandrock] is the only one that can compete with the film starring Sarah Bernhardt, MÈRES FRANÇAISES. For the first time an attempt was made to place a great German tragic actress in the centre of attention. In addition, the war bond film HAN, HEIN UND HENNY which managed to star the most famous German actress, Henny Porten, represented one of the successes of this type, and it was the first German propaganda feature film that was wildly and ostentatiously applauded in the theatres. This shows how extraordinarily rewarding it is to utilise great acting extravagance in propaganda films. To employ the power of a popular or celebrated personality in the service of propaganda is itself a means of propaganda that has been borrowed successfully from the French and will be utilised more extensively in the future.[6]

Such films with major stars, however, remained rare; Henny Porten, for example, does not seem to have been available again.[7] Of the films that were produced in Germany, only a few met the required standards – first-rate authors, famous stars, etc. Nevertheless, two films aimed at particular 'weaknesses' of the entente are considered noteworthy, consistent examples of German film propaganda. Both concentrated their story on the Polish population, displaying the advantages of Germany just as impressively as they dramatized the disadvantages of (tsarist) Russia. These were DAS TAGEBUCH DES DR. HART[8] and DER GELBE SCHEIN. They both formed part of the attempt to persuade the Polish people to support the German side, which began after the proclamation of an independent Polish state by the middle-ranking powers on 5 November 1916 (but actually planned for the victorious end of the war). DAS TAGEBUCH DES DR. HART, whose original title DER FELDARZT did not receive the authorities' approval, struck contemporary critics as a particularly successful example of film propaganda, especially because its purpose was part of the plot: the film, according to one critic,

> should above all be a propaganda film. It should show us the blessing of medical help and activities in the field, and on the other hand the self-sacrifice, the cheerful devotion to duty and the strains of a field doctor. This is not meant to be a moment of feeling but to be propaganda for a purpose. By the lively treatment, which does not avoid tension, by neatly incorporating the message, which we cannot absorb otherwise to such an extent, the viewer is kept on tenterhooks until the very end.[9]

DER GELBE SCHEIN also received praise for similarly making the message unobtrusive. It is one of the earliest German productions with Pola Negri undertaken by PAGU, which had meanwhile become part of the Ufa. With DER GELBE SCHEIN Ufa had thus at least in one instance successfully fulfilled its propaganda mission as expected by the High Command. The film was passed by the censor in September 1918 (length 1624 m) but was only shown after the war: the premiere took place in Berlin on 22 November 1918.[10]

Directed by Victor Janson and Eugen Illés and written by Hans Brennert and Hanns Kräly,[11] the film tells the story of a young woman taken in by a Jewish family after her despairing mother had committed suicide. Pola Negri played the young woman fascinated by science whose deepest wish was to study medicine in St. Petersburg. However, this wish collided with the tsarist regulation that Jewish women could only reside in the city if they had a 'yellow ticket' – which was tantamount to being a prostitute. Lea could not find any accommodation because of her passport which proclaimed her Jewish background and finally applies for the stigmatising certificate. By chance, however, she finds in a book the identification papers of her professor's dead sister and takes on her identity. Her studies proceed well, but her landlady repeatedly demands the outstanding rent and threatens to force her into prostitution. The drama contains several reversals, and although there is finally a happy ending, the heroine's fate up to that point is harsh enough, even including an unsuccessful suicide attempt, to make quite clear to the public the harsh and unjust conditions in Russia. The ending of the story is also not unambiguous, since Lea is revealed to be an abandoned orphan of Russian blood and the daughter of her professor. Typically, although one would have thought anti-semitism was the obvious starting-point for criticising the despotic regime in Russia, the film engineers the improbable turn of events presumably because it did not trust its public to accept a Jewess as the heroine.

Janson's film contains many moments of theatricality, with scenes that look as if they are played on stage, but also amazes because of Negri's acting and the close-ups of her face. What makes it a technically impressive production is what makes it even better as a propaganda vehicle. Thus, it exemplifies the concept of good propaganda that the message must not be obvious with its entertaining treatment rather than explicit speeches. In this respect, DER GELBE SCHEIN accords with the goals the BuFA had set for itself, coming up to the (aesthetic) standards of not only the frequently mentioned MÈRES FRANÇAISES, but also such American films as those of Thomas Ince, which were considered a most potent threat.[12] In the area of documentary films, it was, of course, THE BATTLE OF THE SOMME (1916), which pushed the German side to similar efforts.[13] As a matter of fact, the first film made under the BuFA regime was a direct response to the British model. It was called BEI UNSEREN HELDEN AN DER SOMME and was first shown publicly in Berlin on 19 January 1917. For the first time a film was released bearing the explicit characterisation 'amtlich-militärisch' - or 'official military business.' Never before had a film presenting pictures of actual battle been shown in Germany – this film was advertised as doing so. And never before had a propaganda film been given a festival premiere. A journalist reported:

> One was invited to the first private performance preceding the public performances in one of the modern Berlin movie palaces. Mostly gentlemen in black, only occasional ladies, numerous officers – a solemn, seriously expectant audience as had scarcely been assembled so densely at any other time in a film theater. Subdued conversations here and there, otherwise silence. Darkness drifts

through the hall, music begins, the velvet curtain is parted and on the white shimmering screen letters engrave themselves, like words from a sacred text: 'Bei unsern Helden an der Somme.'[14]

One may doubt if the atmosphere in the then brand-new 'Tauentzien-Palast' was quite that ceremonious, but the performance was without a doubt an event. It was well prepared (two days earlier a newspaper published a preliminary report[15]), well attended and appreciated, at least as far as the press reaction was concerned.

The film consists of three clearly distinct parts. The first shows the daily life behind the western front. Reinforcements and supplies are brought to the lines, the inhabitants are evacuated because of the bombardment, etc. And, the main point: views of villages and towns destroyed by English, and sometimes French, artillery. These efforts represented so to speak the German answer to films such as LES MONUMENTS HISTORIQUES D'ARRAS, VICTIMES DE LA BARBARIE ALLEMANDE or L'OEUVRE DE LA 'KULTUR' – DEUX VILLES OUVERTES ET SANS DEFENSE.[16] As in the French films, extensive panning shots were used in BEI UNSEREN HELDEN AN DER SOMME to show the destruction. This is not surprising when one looks at other, earlier, non-fiction films since camera mobility had been utilized considerably earlier in actualities than in fiction films. Camera movement can be found not only in the countless and extremely popular 'phantom rides,' in which the camera's view was fixed in the direction of movement, usually along railway lines through (as exotic as possible) landscapes, or a journey over the Brooklyn Bridge, or a ride on the Wuppertal suspension railway. Pan shots were needed early on to capture particular happenings or places. For example, in 1900 Guido Seeber in the AUSFAHRT DER SÄCHSISCHEN CHINAKRIEGER followed the character at the end with a short and still clumsy pan. However, an event such as the great fire at the World Fair was portrayed under rather poor direction in INCENDIE DE L'EXPOSITION DE BRUXELLES (1910) with the climax at the end consisting of numerous pans that circled 360° around the burned-out English pavilion.

In this respect, then, the use of pans, preferably extended, to portray the destruction is nothing new in world cinema, even though one finds them only incidentally in German films. In the French films mentioned above, the movements of the characters are incorporated, and the pan begins with them, while a similar motivation is lacking in German films. However, I think it would be wrong to regard this as aesthetic backwardness. After all, in UNSERE STÄDTE ALS OPFER DER FRANZÖSISCHEN ARTILLERIE (1917), a remarkable horizontal pan in a ruined church ends on the statue of the Madonna, and a vertical pan stops just as it views the sky through the damaged roof. This closing movement leaves a strong impression and stresses the outrage over the damage visited upon 'defenceless' cities (which in this version are coincidentally situated outside Germany, though theoretically defended by German soldiers!).

The Embassy complaints mentioned earlier in fact do not touch on the technical quality of these 'war films' – always strictly distinguished from propaganda feature films –

but stress other disadvantages, notably that compared with the English product, convincing battle scenes are missing and the films are too short to offer spectators an evening-long programme. Battle scenes similar to the English films are indeed not found in German films – even when they resort to stock shots of troop manoeuvres claiming to be authentic images from the frontlines. The attempt was therefore made with BEI UNSEREN HELDEN AN DER SOMME, but only staged scenes appear, notably in the second and third parts, which may have detracted from its effect. For although the press were willing (against their better judgement?) to consider the film accomplished, revealingly treating it as actuality, it was not a success. But only in the light of their willingness to recognize the (propagandist) intention is it possible to understand the comment that these were 'historical document(s) of inestimable worth.'[17]

Even the declining attraction of the entente's full-length 'war films' by the end of 1917 provided BuFA with little consolation, considering the continuing ineffectiveness of German films. The news that THE BATTLE OF THE ANCRE was not as well received as its predecessor[18] said more about the public's weariness with images from the war in general[19] than about any successes on the part of German propaganda, which appeared to have no strategy for using 'documentary images' to counteract the public's aversion to seeing the same pictures of destruction over and over again.

The amazing element of the BuFA's work is the discrepancy between the quasi-theoretically formulated goals and the filmic results. The films were not innovative, although there is a distinct improvement in the filmic articulation over the war period. The German film industry had rather limited resources at its disposal, and its staff may have been relatively inexperienced. In those terms the propaganda films, which were only a small part of the total film production, slowly 'improved,' but they never matched the level of theoretical reflection on the nature and uses of film propaganda.

The men in charge at BuFA, then, were obviously not as obtuse as Goebbels made them out to be: they had the right ideas and had no hesitations about passing off faked or staged scenes as authentic. But above all, they recognized the core of effective media manipulation:

> The psychological momentum is the ruling one (...). The propaganda film will only be successful if it is aimed towards the latent instincts. They should be awakened, strengthened, kindled and stirred up in the desired way in order to attain the chosen end. The propaganda film can only be a success if it not only persuades and takes by surprise, but also convinces. (...) Domestic propaganda, too, has to take care to support or awaken only such favourable elements, which are still slumbering in the spectators' unconciousness.[20]

Instead of haranging them, Goebbels might just as well have taken his hat off to the men from the BuFA memorandum: they were his predecessors, pointing the way to his own propaganda policy. Whether this made his own efforts 'superior' as film propaganda or more successful as an antidote to 'total military breakdown' is, of course, another matter.

The Reason and Magic of Steel: Industrial and Urban Discourses in DIE POLDIHÜTTE

Kimberly O'Quinn

The factory became one of the initial cinematic landscapes when the Lumière Brothers opened the gates and filmed LA SORTIE DES USINES LUMIÈRE in 1895. In 1916, a German documentary toured a steel factory in another innovative exploration of this working class locale. In the twenty-one years from LA SORTIE DES USINES LUMIÈRE to DAS STAHLWERK DER POLDIHÜTTE WÄHREND DES WELTKRIEGES ('The Poldihütte Steelworks During the World War'), the cinema, technology and city life continued to mesh and transform as well depict the changing visual perception of time and space. With these transformations in mind, this essay will try to unfold around THE POLDIHÜTTE STEELWORKS three interweaving discourses: the immediate story of steel production during war-time, the representation of the steelworks as a technological spectacle and the deeper, underlying narrative of urbanism and the enigma of the city. An analysis of this almost unknown film may help identify some of the multiple histories that intersected with film form in 1916, not only in Wilhelmine Germany, but internationally.

Industrial Publicity Cinema

POLDIHÜTTE is divided into three parts, each introduced by the inter-title 'The Poldihütte Steelworks, during the World War - Important Scientific Record.'[1] This division by inter-title is the starting point for unravelling the surface narrative of the progress from coal to iron to steel products. The 'First Series' covers the preparatory stages, beginning with a panoramic shot of the factory yard, introducing the overall setting and triggering the symbolic awakening of factory life and thus of the film. The argumentative progression is signalled by a movement from outside to inside the factory walls where the initial sequence shows how fire softens and transforms the raw material. Crude iron casings take on shape by the intensity of the ovens' molten heat. In these images, the large iron chunks and the raw coal are manoeuvered by mechanical devices, such as cranes and conveyor belts. Workers, at this point, act as monitors by taking specimens of the fluid steel and operating the machinery.

The 'Second Series,' although still concerned with the 'growth' of steel into tubes, marks a narrative break. The pieces of steel become smaller and are shaved down into their final form, grenades. Instead of heat, tools like drills and hammers are now applied, sculpting the steel towards its final form, while workers have a more hands-on role in cutting and testing individual grenade bodies. The next to the last shot of this series is the loading of weapons onto a train car, and this production phase then executes a structural closure by returning to the panoramas of the POLDIHÜTTE 'factoryscape.'

The 'Third Series' introduces the production of crankshafts for airplanes and automobiles. In its preparation phase, the crude steel blocks are even larger and must be manoeuvered by both man and machine in their softening and shaping procedures. Similar to the grenades, they, too, are run through rotation tests on lathes. Both crankshafts and grenades are finally depicted piled in neat rows, the result of a completion process in mass production as well as a visual device of closure: from the mounds of raw material in the factory yards to the shining stacks of a refined, man-made product. The Series continues with what is actually a distinct fourth or final part, outlining the infrastructure of the steel factory: the transportation network, electrical system, laboratories and engineering division.

The film closes as the day shift leaves the factory, echoing the Lumière workers who also departed from the front gates towards the camera and exited diagonally off-frame. For factory gates are an entrance and an exit, a place which marks the beginning of work and the end of work. The film adapts this visual signifier in order to frame its own beginning and ending and to suggest the temporal structure of a day's labor. Regarding POLDIHÜTTE's overall shape, it would be appropriate to recall Marshall Deutelbaum's remark about the Lumière films: 'The event depicted is not discovered but created, not recorded but acted, the whole a unified design.'[2]

As has often been pointed out, this 'design' of LA SORTIE DES USINES LUMIÈRE is part of its larger purpose as 'the first example of a notable non-fiction sub-genre, the industrial publicity film.'[3] The Lumières were entrepreneur filmmakers, able to market their factory name through an entertaining innovation. POLDIHÜTTE continues the tradition of this early sub-genre, not only in its factory setting, but by returning to the 'selling' of science and industry through the cinematic machine. In Germany, however, it was the institutional context surrounding non-fiction filmmaking, particularly that of the *Kulturfilm* in war-time, which furthered such a strategy.

From 1907 onwards, *Kinoreformers* had advocated the creation of an alternative cinematic discourse. The core of their argument was that the German public, especially the young, were being overexposed to the corrupting environment of the cinema theaters – predominantly melodramatic narratives, also known as *Schundfilme* or 'trash' films. Educators, in their position as a cultural elite, pressured producers and the developing German film industry to consider film for the classroom, or more specifically to return to the example of the early actualities, which *Kulturfilm*-advocates felt reflected the cinema's potential for instruction rather than fantasy.[4]

The movement realized that in order to be a viable alternative, the *Kulturfilm* needed to compete with the commercial industry, and therefore to expand its distribution and exhibition network. Schools, the few 'scientific' cinemas and the 'Wanderkinos' were the most immediate exhibition sites, and new production companies began to organize based on this potential audience for *Kulturfilms*. The output, however, remained specialized, focused mainly in working-class areas, and marginal groups, unrepresentative of the proselytizing discourse that had given rise to it.[5] Although the *Kulturfilms* could compete with the

commercial industry in terms of production standards, it was obviously an impossible task to redirect the contemporary cinema industry towards this genre as the 'national ideal.'[6] The initiative might well have lost steam altogether, had it not been for World War I, when official bodies mobilized the ideology and practice of the *Kulturfilm*, except not necessarily for the classroom: 'The grassroots endeavors of educational reformers gave way at this junction to the interests of capitalism and the state.'[7]

The tactic of simultaneously promoting the German state and its international image via German products instigated a transformation in the *Kulturfilm* towards a more overt nationalist and promotional agenda.[8] Geography and biology as favourite topics of the educational *Kulturfilm* practically disappeared, making way for the films of DEULIG (Deutsche Lichtbild Gesellschaft, formed as a government organization in 1916), an essentially commercial venture that commissioned films endorsing German heavy industry, industrial plants and cityscapes.[9] This new *Kulturfilm* strengthened its competitiveness and profitability through the war-time centralization of DEULIG and also of BuFA (Bild und Film Amt), both of which were eventually consolidated into UFA (Universum Film AG) and becoming one of the pillars in the foundation of Germany's post-war film industry.[10]

The prestige of the war-time *Kulturfilm* also rose with the participation of professional filmmakers. The production of 'commercials' could already look back on a history of innovation and experiment,[11] to which must be added the exoticism and subsequent popularity of newsreels, a rather close relative of the *Kulturfilm*, especially when one remembers the pioneering role of Oskar Messter in making the newsreels an appealing spectacle, rather than horrifying.[12] Messter was a commercial producer, but equally an inventor who used the *Kulturfilm* as a welcome environment for cinematic experimentation and technical research,[13] part of his strategy of combining entertainment, warfare and education, and his belief in the cinema as 'weapon.' He spoke out for the power of moving images, criticizing the government for not developing their full potential in promoting national identity, both at home and abroad.[14] POLDIHÜTTE, a Messter-Film production, fits neatly into this strategy, making it singularly appropriate to consider the film as an example of aesthetic innovation in the service of a creative approach to industrial publicity, German national cinema, and war propaganda.

If the cinema was a contested territory in Wilhelmine Germany, where controlling it meant encountering 'the internal and external enemy – the rising working class and other nations,'[15] POLDIHÜTTE's eclecticism is also strategic, seeing how it advertises the working-class to itself and to the other, by way of a double containment: representing workers within a productive public sphere, it also gives of them an image in contrast to that of the Reform Movement which implicitly saw them being 'corrupted' by the cinema theaters. At the same time, in its professional and sophisticated visuals, it becomes an elaborate and ambitious advertisement for the German steel industry, a clue to its intention beyond the audience of the classroom and even beyond Germany's borders.

William Uricchio, who speaks of the genre's 'war-time transformations,'[16] has

suggested that the political consequences for the new *Kulturfilm* limited its potential and message. It would be my argument, however, that POLDIHÜTTE exposes the very artificiality of dividing the *Kulturfilm* between instruction and narrative, or to uphold a strict separation of non-fiction and fiction film. Rather than an example of a war-time *Kulturfilm* that 'constrains the range of effective discourse'[17] POLDIHÜTTE pioneers an innovative way of recognizing cinema's modernity and potential within a political space. Returning to the example of the Lumière films, it should be remembered that their selling of industry was perceived neither as realistic nor propagandistic, but as a kind of magic.[18] Similarly, the story of how steel and its applications are mass produced is merely the facade of POLDIHÜTTE's story construction. The visual symmetry and compositions for effect that structure the segments both internally and in relation to each other cross the boundary from informing about the process to a fascination with the process. POLDIHÜTTE may have been intended as a demonstration of German industry and the war effort, but an equally strong undercurrent seems to reflect an attraction for the machine style as such, or as Tom Gunning has termed it, 'the primal power of the attraction run[s] beneath the armature of narrative regulation.'[19]

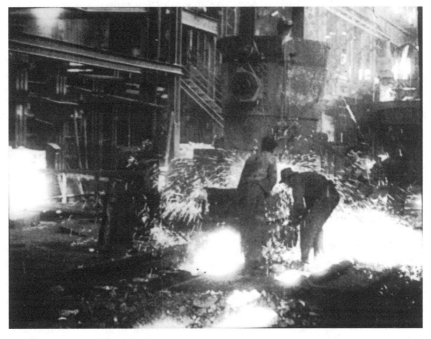

DAS STAHLWERK DER POLDIHÜTTE (1916)

Technology as Spectacle

Halfway through the 'Third Series' of POLDIHÜTTE a sequence demonstrates how springs are tested for railroad wagons. Two miniature rail carts roll slowly onto the screen, balancing the frame on either side by transporting and supporting a bowed strip of steel and placing it under a hydraulic press. The peculiar geometry is an immediate visual curiosity. A

factory worker adds plates on top of the strip to increase the weight and to achieve a balance. He then backs out of the frame, cuing the viewer that the machine's performance will soon begin. The press gradually bends the strip in the opposite direction and then releases. The effect of this procedure is not a greater knowledge of the engineering involved, but rather a sense of wonder as the three players, press, carts and steel achieve a kind of harmonic intercourse. The demonstration, one of the lengthiest shots in the film, is a presentational space of magical theater in the overall diegesis.

Central to the visual pleasure of the Poldihütte factory productions are these seductive transformation processes taking place in the steelworks, watching how machines and workers together sculpt the raw materials into shapes, resolving the contradiction between steel as solidly impenetrable and its fluidity and grace. Trying to interpret the unfamiliarity and strangeness of the performance encourages various human and animal analogies, with the huge steel blocks in the Third Series reminding one of untamed beasts or prehistoric creatures. They sway within their chains, positioned by the workers' prongs, until they must submit to the mechanical press or the oven fires. In addition, the camera follows individual pieces, a cast iron shell for example, as it gradually assumes its final form and is eventually loaded on a train, symbolic of characters maturing and leaving home.

It is my position that POLDIHÜTTE's excessiveness and its machines of otherness are part of a history of industrial amusement, part of the technological entertainments which belong to the convergence of the discourses of education, entertainment and science at the turn of the century. Reflected in places like Coney Island, where electricity and the X-ray machine were displayed as new sensations, this exchange between leisure and science found its ideal expression in World Fairs, universal expositions and large-scale amusement parks.

Tom Gunning has cited the example of the St. Louis Fair in 1904 to argue that 'the visual effect of the World Exposition teeters between the rational and classifying knowledge of the object lesson and an experience of bewilderment before the intensity of technology and cultural and sensual variety.'[20] He compares the spectacles as a trip through an encyclopedia, from restagings of the Galveston Flood, the Boer War and the explosion of the Battleship Maine to Philippine villages and the streets of Seville.[21] At the World Expositions, visitors could walk through exhibits displaying the transformation from raw materials to refined objects. A trip through the fairground was a replacement for travelling the world, or a tour through a factory.[22] It diminished time by trying to fit years of experience into an afternoon. As the educational reformers of the *Kulturfilm* would attempt a few years later, the Expositions and Fairs were stressing the visual, rather than verbal tools of instruction: 'scrutinizing the actual objects for the lessons, they contained,' rather than the texts.[23] As a consequence, an industrial-educational cinema, although a secondary attraction, was being incorporated into the Fairs' entertainments of modern mechanics. At St. Louis' Hall of Machinery, for example, the Westinghouse factory films played to sold-out audiences. A Fair history describes these early 'industrials,' which were shot by Billy Blitzer, as 'virtual voy-

ages': 'The novelty of sitting in a comfortable seat and literally taking a stroll through the different Westinghouse plants and seeing them in full operation was one that will be remembered with pleasure as long as memory lasts with those who saw the highest development of the photographer's art.'[24]

As Deniz Göktürk has shown, German travellers abroad were captivated by the fairgrounds, but also by another developing American phenomenon, the type of industrial organization represented by the Henry Ford car factory in Detroit, or the Chicago meat packing houses.[25] In other words, throughout the teens, the magic of industry continued beyond the fair to include the display of mass production at the assembly line, where human workers and engineering skills became integrated in the 'super-machine' that was the modern factory.[26] With Wilhelmine Germany convinced of its prowess as a leading industrial nation, POLDIHÜTTE is not only embodiment of a domestic agenda, but manifests an underlying desire to compete with the technological and industrial spectacles of the United States. It suggests that besides the need to define a territorial space during the War, Germany needed to define an image space, particularly that of modernity and progress.

But POLDIHÜTTE also celebrates a technology of method, by contemplating the efficiency of assemblage: cinema and factory were each evolving systems of 'montage' for component parts. Stephen Bottomore has argued that one of the essential lessons in early actualities was learning to make choices, that it was not necessary to include everything. The unpredictability of events, and the fact that one could not always restage them, encouraged innovative editing techniques.[27] Making a virtue out of necessity results in POLDIHÜTTE in a non-continuous style where the obvious breaks in the temporal and spatial action between edits are handled very creatively. Each shot and scene is designed around a single movement, either a machine operation or a machine and worker together. A shot becomes a micro-narrative about the completion of a motion along the assembly line: a crane picks up a pile of coal, a magnet transports cast iron shells, a cylinder pours molten fire onto coal or a worker positions a steel block under a grenade press. The macro-structure of the film then organizes these sequences into the coherent framework of the progress from raw to refined. The editing of the film can then suggest the simultaneous fragmentation and continuity of time, the itinerative motions and repeat actions exemplified in the Taylorism of factory production.[28] A sequential logic is still achieved by 'reproducing the event's (intensified) abstracted representation, as opposed to reproducing its (extensive) duration.'[29]

The temporality of movement is accelerated and intensified by mechanic bodies rather than human bodies. The workers are not made obsolete, but must refigure their motion in relation to motion economies controlled by machinery. Scientific management emphasized a 'stress-free' specialization where workers were given specific, predictable tasks. As POLDIHÜTTE shows, this mass organization of repeatable tasks can also become a technological spectacle. One expressive sequence features a factory hangar where 1500 people operate 500 lathes, each frantically busy rotating and cutting grenades with spinning tools and conveyor belts. The balanced and busy frame composition reflects the energetic and

engaged atmosphere of the workers. There is one worker at each table attending to a single grenade, the whole contained by a mechanical motion.

The only distraction in the composition is a female worker who enters the right foreground, looks up before starting her work and stares at the camera. Her look is an invitation for the camera to further investigate the individual lathes. The following two shots are close-ups of single grenades being cut and spun. In a symmetrical presentation, the camera returns to the initial starting point, centered on the technological reason of the assembly room, but with the same diverting gaze in the right foreground. Both the direct address and the close-up of the grenade have significance within POLDIHÜTTE's technological discourse. This diverting gaze anticipates the False Maria of METROPOLIS, a disturbance and a pleasure in the mass production rhythm. It is both a reminder of the new female labor in the public sphere of the factory, and a place of identification for the individual spectator in the cinema, figuring the woman as excess also in the cinematic system. Stacked, sorted and loaded by women, the grenades, too, become a place of spectacle and display within the technological rationale of mass production. In fact, the grenade, Poldihütte's Model T, is similar to Walter Benjamin's view of the cinema 'on the one hand, a mechanical copy and on the other, a diverting spectacle.'[30] When pulled from the pile, each weapon embodies an autonomous function as a distinct explosion, which becomes for both the worker and the spectator of POLDIHÜTTE, the nonrational, excessive or unstable moment within the order of the assembly room.

POLDIHÜTTE's technological discourse, however, manages to contain this instability within a magical theater of modernity and efficiency, just as the fairground space did, in contemplating the wonder of the battlefield from a seat at Coney Island's Luna Park. These mechanical histories are part of 'visual processing of modern life through the medium of spectacular attractions,'[31] simultaneously providing closer, exotic views, but with the experience of distancing and separation.[32]

City and Cinema

This illusion of knowledge is a significant element in a third narrative I want to explore in POLDIHÜTTE, a navigation knowledge of the modern city. I would like to begin with recalling Walter Benjamin's famous passage:

> Our taverns and our metropolitan streets, our offices and furnished rooms, our railroad stations and our factories appeared to have us locked up hopelessly. Then came the film and burst this prison-world asunder by the dynamite of the tenth of a second, so that now, in the midst of its far-flung ruins and debris, we calmly and adventurously go travelling.[33]

Benjamin's approximation of urban spaces and montage cinema, across the paradox of the silent explosion that frees us for calm adventures, opens up a perspective which allows one to consider the location of Poldihütte not only as that of a factory space, but as a city space,

as a contained and self-sufficient world. Another level of narrative thereby unfolds, one that intertwines visual modernism and the simultaneous familiarity and enigma of urbanism.

As part of its turn of the century continuum, POLDIHÜTTE alludes to the early travel cinema, which was prevalent between 1896 and 1906,[34] and particularly to the sub-genre of city topics. Cameras, mounted on some means of transportation, usually a carriage, gondola or train, transported the audience comfortably into another world. For those who could not afford to travel, it was the chance to see the world and bring back souvenirs as 'celluloid tourists.'[35] For those spectators who had never experienced it, the factory was at least as foreign a territory as any other location they did not have access to in their daily lives. The double movement of POLDIHÜTTE's opening reveals a great deal about the perception of charting a course. It begins with a panorama, from right to left, of the factory yard. This mapping tactic has always been a useful device to introduce and represent the spatial coherence of cityscapes. But here the pan is not a fixed site, but a camera mounted on a train. Gradually, the spectator is carried through the gates, as the shot tracks forward from the panorama movement. It is no accident that the train becomes the initial point of orientation in POLDIHÜTTE as it was in many early travel films, for the window of separation between observer and observed emphasizes the experience of vision, thereby modelling spectator positioning within the film theater.[36]

In his study of urban non-fiction films from 1895 to 1930, Uricchio cites that the tracking, vehicle-mounted shot was the most widely used view to introduce city scenery between 1896 and 1912.[37] 'The tracking shot with its exploration and penetration of space and event recorded an intensive set of relations, as opposed to the panorama which remained at a fixed distance and recorded an extensive set of relations.'[38] This transition from panorama to tracking is indicative of a transgression of boundaries from outside to inside, a cue to POLDIHÜTTE's agenda of 'making visible the truths hidden by the city's imposing facade.'[39]

Early cinema's predilection for investigating urban spaces highlights what James Donald has identified as one of the ambivalences of the modern metropolis. Donald contrasts the 'city as an object of knowledge and governable space, encompassing the diversity, randomness and dynamism of urban life in a rational blueprint, a neat collection of statistics, and a clear set of social norms' with its other side, the nonrational maze of city with its unpredictability of experiences.[40] Such a 'city is an overwhelming series of events and impressions, but above all it is the individual's psychic reaction as these events and impressions bear down on him.'[41] If Germans were fascinated by the functionalism of Taylor ethics and American modernity, they also keenly responded to urban America as a critical social experience, best represented perhaps by Upton Sinclair's *The Jungle*. When translated into German in 1906, the images of perversion in Sinclair's Chicago meat factory provoked national debate and became a symbol of the exploitation of the worker in capitalist society.[42] The factory was already part of a larger purification discourse about urbanity, based on slums, hunger and the dehumanization of technology, while the city was described as a place not only of disease, but of visual overstimulation.[43]

In its depiction of precision and harmony, the factory-city of POLDIHÜTTE seems like a response to this urban debate, a utopia of rationality as well as of liberation. Machines do not displace workers, but make their jobs easier. Concentrated animation everywhere. There is a sense of community among the workers as they load the trains or support steel blocks together. Train tracks are the modern roads of POLDIHÜTTE, connecting the various steel products and stages of production with each other and with the front lines. In several scenes, this transportation network is presented as a choreography of carts. Everything has a purpose and is in constant motion. The mounds of coal, eventually become shining stacks of grenades, imitating skyscraper-like structures in their arrangement.

At the same time that POLDIHÜTTE is making the factory transparent and rescuing the image of mechanization, it is investigating behind the symbolic gates of the Lumière factory, or rather, exploring the prospects for visual pleasure within urban architecture. Considering the cinema and the growing cities were both visual spectacles, the cinema, as Donald suggests in his commentary on the Benjamin passage quoted above, becomes the perfect compass through the urban myth.[44] Such a compass is POLDIHÜTTE, recording the liberating consequences for the camera, while making room, within its rationalist ideology, for an expressivity of fascination, based on techniques such as deep staging, dramatic lighting, long takes and the visualization of sound. Two stylistic devices I would like to highlight in particular are mise-en-scène and depth of field.

By climbing higher and wider, one of the first effects of this urban architecture was the shrinkage of the human figure. From a cinematic perspective, the architecture demanded a more complex spatial and compositional framing. Within the Poldihütte world, cranes, ceilings and train tracks define frame limits as replacements for the human scale. The heights of the buildings motivate the camera to tilt or pan to adequately articulate the space. In addition, no distinction is made in the spatial expanse between inside and outside scenes, for when the camera records within the factory walls, it often portrays a kind of landscape of the interior. Train tracks can penetrate buildings and particularly in the scene of the lathe room, where the tracks converge towards a vanishing point, they organize the perspective and suggest a continuum with the distant war machine. The megastructures of the Poldihütte steelworks are also not contained within the frame, such as the overhead crane, which due to its constant movement transgresses frame boundaries. This off-frame space encourages a visual curiosity and suspense about the course of the equipment's manoeuvres.

In addition, the film rarely conveys information by fragmenting the space. Rather, the autonomy of a shot 'insists upon an experienced continuum through movement.'[45] Uricchio has noted that scene dissection, occurring in fictional cinema between 1907 and 1908, is in non-fiction film omitted in favor of self-sufficiency. 'Rather than cutting to some distant portion or detail of an initial image, non-fiction representation [from 1895 to 1920] required that the complete fabric of relations from the initial image to the detail, be experienced through a continuous and unbroken movement.'[46] The worker, the steel works and the

machine are more often than not represented in the same shot. This depth of field is not an aid for comprehending the actual mechanics, but rather conveys an impression of the new space or territory it occupies. It is as if the spatial homogeneity attempted to establish a representational mode that gives human vision a new scale within the factory/city.

Kristin Thompson has identified these expressive devices as a distinct international current in fiction films between 1913 and 1919, seeing them as the background for the avant-garde cinema of the twenties. Despite the breaks in circulation, these elements of expressivity were simultaneously evident in several countries before and during the war.[47] 'The point here is that generic and stylistic developments of the 1910's prepared the way for expressionism, and CALIGARI, however great its stylistic challenges were, did not appear in a vacuum.'[48] If POLDIHÜTTE does indeed contribute to international expressivity in Thompson's sense, then it is a reminder of how urgent it is to soften the divide between fiction and non-fiction: 'Devices and techniques which may have owned their existence to the contingencies of filming a real event, became in turn, after being adopted by filmmakers intent on exploiting the topical value of the subject matter, the very conventions of the fiction film.'[49] The real event and given geography of steel production encourages the spontaneity in location shooting and determines distinctive compositions or depths of space. But the uses to which it puts the 'real event' makes POLDIHÜTTE an excellent reminder that it is necessary to look beyond commercial cinema for some of the transformations in film history. The quality of urban observation, penetration and surveillance underlying this 'non-fiction' factory film would become the very gateway through which different kinds of modernism in the twenties would continue to probe. MAN WITH A MOVIE CAMERA, METROPOLIS and BERLIN: SYMPHONY OF A BIG CITY, to name but a few, all explore the duality of fantasy and function within modern urban spheres and elaborate on the consequences for the community and individual.

The cinema of the teens existed within a context of upheavals and of refiguring borders and identities. Benjamin's dictum about the 'prison-world' reflects a violence of perception ('ruins and debris') while pointing to the cinema as its simultaneous liberation. POLDIHÜTTE is situated precariously on such a boundary: utilizing an explosive medium to turn a factory inside out, it also functions as a container for sensibilities that yearn for social and technological order. Visual fascination and rational visibility are ambiguous impulses connecting the discourses of war, technology and the city, but they have shaped the history of early cinema. POLDIHÜTTE's simultaneous reflections back and forward, from the Lumières to METROPOLIS, are indicative of multiplicities and non-synchronicities, disturbing any ordered hierarchy of linear progression from performance or 'attraction' to fiction or 'narrative.' The story of the Poldihütte steelworks, then, cannot be exclusively read as the progress from coal to iron to steel, but must be followed also through its transformations as a grenade, as an exhibition at Coney Island or as a skyscraper which in turn become points of entrance into POLDIHÜTTE's own multiple histories or house of mirrors.

From a Pinschewer trick film (ca.1920)

Section III

Film Style and Intertexts:
Authors, Films and Authors' Films

Max Mack:
The Invisible Author

Michael Wedel

Between Author and Audience

Looking back in 1920, at the end of what indeed was to remain the most productive decade of his career, Max Mack was convinced that future historians would acknowledge the significance of his films for the development of German cinema.[1] By then he had directed nearly 100 films of all conceivable genres, among them some of the most successful and popular films the German cinema of the teens had produced. Ironically, however, when critical or trade attention was paid to these films, it often happened without his name being mentioned at all. Mack's DER ANDERE, the first *Autorenfilm*, based on a play by the then famous author Paul Lindau and bringing, with Albert Bassermann, onto the screen for the first time one of Germany's most renowned stage actors, derived for most historians its lasting significance more from its cultural references to the literary and theatrical establishment than from any particular stylistic elements attributable to the director. In its reference to motifs from modern psychology and literature, DER ANDERE figured, for Siegfried Kracauer, for instance, as an exemplary foreboding of German cinema's symptomatic obsession with the double, from which other film historians extrapolated the crisis of the male bourgeois identity.[2] Paradoxically, it might have been the very notoriety of DER ANDERE for

Max Mack and Franz von Schönman in WO IST COLETTI? (1913)

WO IST COLETTI?
(1913)

all subsequent retrospective histories of the German cinema which blanked out the name of
its director and blocked off any closer attention given to the work of one of the most versa-
tile, prolific but also enigmatic directors of the teens.

In this sense, the still photograph which opens the film and shows Lindau,
Bassermann and Mack assembled around the writer's massive writing desk became em-
blematic for the cinema's cultural transition into the 'bourgeois' sphere of traditional cultur-
al production. But already a variation of this opening in another of Mack's so-called *Au-
torenfilme* problematizes this notion: in WO IST COLETTI? the author of the treatment, Franz
von Schönthan, witnesses how Mack conjures up the actors in a series of trick shots which
set up the action-packed scenes that follow, a mise-en-abyme that culminates in a repetition
of this opening in front of a cinema audience within the film at the very end. The trajectory
from the author to the audience which is described in WO IST COLETTI? is indicative for the
transformation of the literary source material into the performative space of cinema. The all
too often neglected agent of these complex processes of transformation is, of course, the
film director. Max Mack himself has repeatedly defined his role as a 'mediator between the
author and the audience.'[3] According to Mack, the early teens were

> an epoch when each film was an experiment, and when there was no authority in
> power to tell what the public wanted; when the problem had to be solved of
> expressing intelligibly to a new audience a vision of a story in terms of a lan-
> guage which was silent, and in pictures which were moving pictures, without
> having any examples of this kind in the past to point the way.[4]

In solving this practical problem, the primary requirement of a film director consisted in an
'optical sensibility'[5] that could convey narrative information by visual means such as fram-
ing[6] and character movement.[7] In what follows I shall take my cue from the first of Mack's

films made in collaboration with a literary author, Heinrich Lautensack, to trace some of the stylistic strategies and experimentations aimed at rendering basic narrative information in a comprehensible manner to a cinema audience – an audience which ZWEIMAL GELEBT, due to censorship restrictions, has apparently never seen in Wilhelmine Germany.

Visual Codification of Narrative Oppositions in ZWEIMAL GELEBT

Released as one of the first 'art-films' of the newly founded Continental-Kunstfilm GmbH, ZWEIMAL GELEBT ('Lived Twice') begins with a happy nuclear family – father, mother and daughter – whose happiness is destroyed when, on her parents' wedding-anniversary,[8] the little girl only narrowly escapes being hit by a car, and her mother suffers a nervous break-down necessitating her committal to a sanatorium. During the mother's stay there, the doctor in charge falls in love with her. Shortly after he notifies her husband in a telephone call about the need to keep her in the sanatorium for further observation, the mother suffers a serious relapse. She loses consciousness and is declared dead by the doctor, who informs her desperate family via a telegramme. Two days later the doctor visits the chapel where her body awaits burial. The woman suddenly rises from her coffin, apparently recovered but suffering total amnesia. The doctor immediately seizes his chance to keep the love object to himself, and without informing her family of the turn of events, takes her abroad. Six months later, the bereaved father takes his daughter on holidays, and as fate would have it, their paths cross. Observing the playing child, the woman suddenly regains her memory and with it, an awareness of her intolerable situation. Torn between the two men, she commits suicide by jumping from a bridge.[9]

As already indicated in the title, it is clear from the story-line that the film's narrative works on a set of oppositions derived from the main one between the woman's 'two lives': before and after her apparent death. However, the basic split not only generates several different female roles (mother/wife vs. patient/lover), but also motivates different roles for the husband – who now has to replace wife and mother –, as well as for the doctor who turns into lover, while even the daughter is split, by taking over, to a certain degree at least, the role of the mother in relation to the father. These broad oppositions are prepared by the division of the story space into the two different action spaces, home vs. sanatorium/chapel, each ascribed to one of the men and juxtaposed by parallel editing, in turn diegetically motivated by different forms of communication between the two men (telephone, telegramme).

This spatial split on the story level is established in two shots (9 and 10) when the mother is left in the sanatorium by her family. Their particular spatial articulation can be regarded as the centre of the film also on several formal levels. Both shots, by using a diegetically impossible camera view, show two rooms at once by panning 'through' a wall which appears in the middle of the frame.[10] At first glance the two shots have the same spatial structure, but closer inspection reveals that all characters – with the exception of the female protagonist – are substituted in their placement within this structure *after* the cut: the doctor is substituted by his assistant at the side of the patient's couch; in the place of the

assistant now stands the nurse, and instead of a third man in the frame, it is the father who holds the child; in the centre, exactly where the father was just about to reappear from behind the wall, the doctor now emerges in his stead. Although this peculiar pattern of substitution might conceivably be due to a continuity error during the shooting, it instantiates a structural strategy of character substitution which fulfills a dominant narrative function throughout the film. The wall renders visible a spatial narrative code of left/right screen division, which has been at work from the outset, and which in the further course of the narrative continues to constitute the film's key area of narrative articulation. This division ascribes the right side of the screen to the mother, while the left side is associated with the two men, respectively. It is through this spatial organization that desire and loss, as the two foremost narrative concerns, are codified.

Narrative and Psychological Space I: Desire

The female protagonist appears almost exclusively on the right half of the screen, be it as the loving wife and mother of the opening shot, be it as the patient in the sanatorium (shots 13 and 14, 23 and 24), or as the apparent corpse in the chapel (29, 31, 33). The left half of the screen space is in a first instance alternatively shared by the two men, and the visualization of their desire leaves the right space 'empty' in terms of character density, most visibly in the sequence after the doctor's love for the patient is revealed, and in which he informs the husband via telephone about the necessity of her extended stay in the sanatorium (shots 15-21). Compared to the opening shot of the film, shot 15 (the first of this sequence and the first to return to the location of the family living room) sets up a strong pattern of repetition, variation, and substitution in terms of who occupies whose initial space. This time, we find the daughter already on the right side of the screen, a space that was exclusively occupied by her mother in shot 1. After a few seconds, the father enters the shot through the door in the background centre (as did the mother in the opening shot), whereupon the daughter stands up and runs towards him. Both sit down on the chair in the foreground left, exactly where they had been when the film began, except that now the mother's absence is doubly marked by the armchair on the right half of the screen remaining empty. The father, then, picks up the phone and dials. Shot 16 cuts back to the mother's room in the hospital, where the doctor is told by a nurse to answer the call. In shot 17 we see the doctor already in his office at the phone on the left side of the screen. Parallel to the spatial organization of the domestic scene in shot 15, in the hospital the right half of the frame is codified as that of the absent love object signified by the now empty couch, where the doctor first encountered her when she was brought in as a patient (shot 9). This parallelism is further pronounced by a cut back to the disappointed father and daughter who are still in the same position on screen. The father then kisses his daughter with a vehemence and passion hovering between desire and despair, in the very space on screen where he had kissed his wife in shot 1. Finally, both, now knowing that the wife/mother would stay away a longer period, move over to the sofa on the right side of the screen, thus occupying 'her' space for the first time.

It would seem, therefore, that the spatial codification of desire works on a specific division of the screen, which runs the emotional states of the two male protagonists in tandem, thanks to a strong 'visual rhyme' created through the interaction of story space (location), shot space (left/right division), and continuity/contiguity space (parallel editing). The use of parallel editing for character psychology had been explored in the American cinema since 1908/9, most notably in the melodramas shot by D.W. Griffith,[11] familiar to German audiences from at least 1910 onwards.[12] In ZWEIMAL GELEBT, however, the editing pattern deviates in emphasis from Griffith's psychological editing in its much more elaborated visual composition of the noncentered shot space. It is on this level that the narration articulates the sequence's psychological substance most visibly, creating significant analogies and variations in relation to earlier shots in both the doctor's and the father's sphere. The organization of the shot space moreover reveals several important sub-structures connected to the characters' psychology. As indicated, shot 15 reveals the father's tendency to replace his wife by penetrating the spaces she had previously filled, and to displace his (sexual) desire onto his daughter. The doctor's desire, on the other hand, causes no such displacing activity, since it is he who is now 'in possession' of the desired woman. In his sphere, the right screen space is still reserved for her, her absence being only temporary – a hypothesis which is underlined by the metaphorical placement of a huge wall clock in the background right. While the father's desire is thus already infiltrated with the negative signs of loss and substitution, the doctor's desire as it is visually represented can still hope for fulfillment.

Narrative and Psychological Space II: Loss
Analogous to the sequence just described, the characters' experience of what they assume to be the definite loss of the desired woman (the reaction of the two men faced with the heroine's death) is expressed equally by parallel editing and left/right division of the screen, whereby several motifs are reverted, confirmed and strengthened. Early in shot 25, the longest shot of the whole film,[13] we see how the daughter is put to bed in her room by a maid who is introduced here for the first time, thus reinforcing the notion of replacement of the mother. Once more, the father, who enters the shot through a door on the right, and the maid, who then exits by the same door, pass through the right space and create a spatial balance which clearly contrasts with the earlier unstable shot composition articulated in order to create a sense of desire. The maid briefly reappears again from the right to deliver the telegramme with the news of his wife's death. The film's only insert communicates the news to the spectator ('We herewith comply with our sad duty to inform you about the demise of your wife. The Sanatorium'). The father, who read the telegramme while standing centre frame, now sinks into a chair placed foreground left in front of the daughter's bed, reestablishing the familiar spatial division of the previous shot. As before, he takes his daughter in his arms and hugs her intensely. Though the right shot space is now deserted again, the connotation with the mother is much weaker since the space has been kept busy by the maid and the

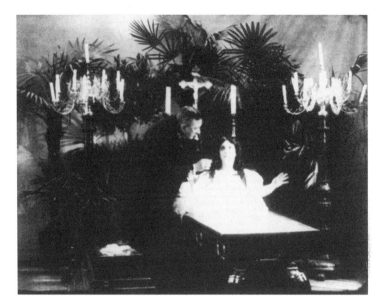

ZWEIMAL
GELEBT (1912)

father just before. The loss of the heroine seems accepted, her maternal and sexual roles filled by other females.

The visual composition of the shots in which the doctor assimilates the feeling of loss reveals a variation which is most crucial for the psychological motivation of the further narrative outcome. Although the doctor is present at the moment of her relapse, the film delays showing his psychological reaction, giving us that of the father instead. But following the sequence in the daughter's bedroom and, as we are told by an intertitle, two days later in diegetic time, a shot visualises the doctor's desire: he sits at his desk in his office in the left half of the shot, with the wall clock and the couch on the right. Immediately, a strong sense of contrast is established with the spatial organization of the shots located in the daughter's bedroom, where this visual imbalance was constantly transformed. We then cut to the mother lying in state in the chapel, before an intertitle describes the doctor's feelings ('His thoughts are still with the beloved dead woman') and returns us to the doctor's office. Still in the same position, his look is kept off-screen, while the image of the mother is superimposed on the right half of the screen between the couch in the foreground and the wall clock at the rear. Only after her visualisation has disappeared does the doctor move over to the couch on the right.

In both cases, then, the space of the mother is not left unoccupied as it was almost without exception throughout the previous part which articulated the desire of the two male protagonists. Now, as she is assumed to be irretrievably lost to both, the space attributed to her is filled, but differently for each of the men. Against the mobility and interchangeability of roles in the domestic space, the compositions signifying the doctor's psychological state 'recreate' the woman in her space with no trace of replacement, connoting the constancy and duration of grief through the repetition of the spatial structure. When, in

the next shots, the woman re-awakens in his presence, the same textual operation of visual structure and narrative psychology is at work, once more 'resurrecting' her in her space. In this sense, the visual codification of the shot space functions in a first instance to clarify the narrative's psychological motivation and thus supports the intelligibility of the narrative development, but it also provides a rationale by which the audience can accept as justified an action otherwise morally reprehensible and professionally criminal.

Narrative under Erasure: The Heroine's Suicide
The narrative's outcome, the heroine's suicide, results from the final conversion of the different narrative spheres – the sphere of the doctor and the sphere of the father. In shot 47, we see the heroine by the seaside, still not aware of her daughter's and former husband's presence, appearing diagonally from behind a tree and moving from background right to foreground centre. After a cut we then see her daughter at another point on the shoreline, occupying the same shot space foreground centre, a visual 'substitution' additionally underscored by the fact that behind her to the right we find a small tree, whose branches frame the upper space of the shot, just as those of the big tree did in the previous shot with the mother. In shot 49 the daughter appears from behind the tree in the right background and moves diagonally to foreground left, now face to face with her mother, who stands up and looks alternately at her and offscreen right.[14] As the following intertitle reveals, it is the moment she regains her memory.

The daughter rushes offscreen background right, with the mother following her to the tree, behind which she hides when the daughter reappears with her father crossing the space to the foreground of the shot (the mother gliding around the tree to remain hidden, but visible for the viewer). Not finding her, father and daughter leave the shot foreground left, allowing the mother to regain her initial position foreground centre, giving vent to her despair. While indebted to the proscenium space of the theatre, with entrances and exits, and the tree standing in for stage props, the sequence works through the very codes – lateral screen division, spatial substitution and visual rhymes, diagonal character movement, camera movement, framing – by which the characters have been granted psychological profile throughout the different stages of the action. At the end of the sequence, the woman is positioned centre frame, not only by general consent the weakest point on screen for a character to be, but through the specific codification in this film, a position which cannot be correlated to any of her former roles as mother, wife, patient or lover. The final sequence keeps her in the centre of the shot, while – reminiscent of the spatial overcoding in shots 9 and 10 – a line of trees distinctly segments the space around her. And, just as the wall signified the split between the two spheres of the male protagonists, shot 52 superimposes the two men in front of the two nearest trees on either side of her. In the next shot she climbs over the railings of the bridge, just visible in the background of the previous shots, and jumps. The line of her fall symmetrically splits the screen in two, at once closing the narrative and literally 'erasing' its visual articulation.

Flickering Screens

In devising critical paradigms for cinematic narration, subjectivity and character psychology most of film theory has been conceived around the visual system of classical continuity cinema. Among film theorists, it is commonly held that filmic narration works primarily through a set of textual operations by means of interlocking shots, which are sometimes seen as the equivalent of syntactic relationships in linguistic discourse. Classical devices of continuity editing and cinematic suture, such as scene dissection, shot/reverse shot patterns and point-of-view editing, have traditionally been privileged over the composition of the individual shot, rarely explored for its function and value in conveying narrative information and character psychology. In turn, early cinema's different articulation of time, space, and causality – often essentially based on the internal organization of the single shot – is generally regarded as 'ab-(sic!)psychological at its most characteristic.'[15]

The example of ZWEIMAL GELEBT, however, clearly suggests that with the advent of the industrial mode of the 'Monopolfilm' and the transition to longer films conveying narrative information did not mean a switch to unilinear 'literarisation' of film,[16] but a dialectical process whereby narrative codes became transposed into the visual space of the cinema. Max Mack's coherent – and thus apparently conscious – deployment of visual rhymes and spatial codes in ZWEIMAL GELEBT further problematizes the assumption that the internationally so uneven transitions to narrative filmmaking can be measured by the yardstick of a historical master-narrative told from the retro-perspective of the 'dominant,' the industrial mode of continuity cinema as it might have been the norm in American filmmaking of the mid-teens.[17] As the brief comparison to Griffith's early melodramas suggests, international influences are all too often subject to culturally specific redefinitions and appropriations. Such refigurations as can be observed in ZWEIMAL GELEBT point to the larger cultural field of force within which the German cinema in particular was seeking legitimacy, and therefore its public, for whom the theatre experience, for instance, constituted a significant intermediary reference point. In this sense, the triangularity of emblematic openings in later films, showing author, star and director, only seems to epitomize the different spaces folded into this process: the story space of the narrative, the filmic space of the screen, the performative space of the acting, and the imaginary space that results for the audience in the cinema.[18] This double- and triple-coding inherent in the articulations of cinematic space must make us wary of any direct reading of filmic patterns or motifs in the essentially literary terms of 'influence' or 'authorship.' Mack's simultaneous presence in and absence from the films he directed is thus symptomatic: given the many references in his writings to contemporary stage practices, painting, landscape photography, and music hall variety culture, the very stylistic simplicity or apparent backwardness of a film like ZWEIMAL GELEBT could well reveal itself to be the palimpsest whose code is no longer in our hands. Historically speaking, however, the very professionalism with which Mack was able to bind together different textual authorities and cultural frames within one cinematic space, while clearly in tune with the sensibilities of contemporary audiences, spells out the logic that made him one of the German cinema's most popular directors of the teens.

From Peripetia to Plot Point: Heinrich Lautensack and ZWEIMAL GELEBT (1912)

Jürgen Kasten

In German cinema history 1912 was to be the year of the two-acter. Films of over 600 metres in length were marketed as blockbusters, and in the selections of films sent for exhibition in provincial cinemas, it was stressed that they included a two-acter.[1] It was also the year in which Gerhard Lamprecht's index of German silent films first made any real reference to scriptwriters. Lamprecht lists nine film writers for 1912. Although this almost certainly underestimates the numbers for 1912 and the preceding years, the advent of the two-acter at least helped acknowledge the existence of qualified scriptwriters in the industry. The two-acter called for a different kind of dramaturgy: the extension of story length demanded a development of the story's continuity, causality and complexity. There was therefore a demand for writers who could take on the dramaturgy, reduction of genre, character and plot which had already been developed (and which characterised the one-acter) and expand this in a systematic way. To well-known writers this would have constituted unappealing, exacting work, and the task fell instead to authors prepared to meet the demands of a functional narrative and dramaturgical development.[2]

Heinrich Lautensack

By 1913, the famous *Autorenfilm* year, authors had already infiltrated the German film industry. These were not prominent literary figures such as Arthur Schnitzler, Gerhart Hauptmann or Hugo von Hofmannsthal, but belletrists, journalists and those authors who were not often published or performed, and who approached film in a professional manner and changed the thematic and dramaturgical nature of the medium. Authors like Walter Schmidthässler, Walter Turszinsky and Heinrich Lautensack not only came up with scripts, they also joined film companies, around 1911/12, as permanent employees. The films that they scripted, however, were not as a rule marketed under the effective label of *Autorenfilm*. Turszinsky was working for Messter until 1915, while Schmidthässler co-founded Continental Kunstfilm in 1911. In 1912/13 this company appointed the dramatist Heinrich Lautensack, a financial victim of censorship, as dramaturg and head of advertising. He had been similarly employed before at Deutsche Bioscop.[3] Lautensack's first project as scriptwriter for Continental – at least the first that we are aware of today – was the drama DIE MACHT DER JUGEND. At 605 metres it counted as a two-acter and had its premiere on 25 May 1912. What remains of his work today is the treatment for DAS IST DER KRIEG from 1913, a complete script for ZWISCHEN HIMMEL UND ERDE (1913),[4] and his third film for Continental, ZWEIMAL GELEBT (1912).[5]

Parallel Plots and Conflict Development

Although there is no statistical material on hand to support this claim, it is fairly safe to say that a large proportion of the conflicts in German silent films of the early teens developed out of threats to the familial way of life. This is how ZWEIMAL GELEBT opens. In an extremely cut-down exposition, framed by the intertitle 'Happiness' and 'An unhappy turn of events,' Lautensack presents us with the early silent film's most popular theme – the happy family. When the daughter is run over by a car,[6] the mother suffers a nervous breakdown. It is no accident that she is conveyed to a nearby sanatorium in an 'antiquated' means of transport – a horse-drawn carriage.[7] It comes as something of a surprise that the husband is much more concerned for his daughter (who looks as fit as a fiddle) than for his wife. The somewhat unnecessary 'filler' scene showing father and daughter leaving the sanatorium is also quite astounding. Its significance becomes apparent, however, when one recalls the scenes in which various characters leave rooms. The senior doctor had just asked the husband to go to the waiting room. Now he sends a nurse out of the ward where the woman lies unconscious. Alone with her at last, he gives the woman a long look and fleetingly takes her hand in his. Then comes an intertitle to explain what the apparently inept narrative build up was hinting at: 'The doctor has fallen in love with his patient.'

There is no indication that Max Mack, the director of the film, made either scenic, spatial or gestural directions for this incident, which, in the moral and hierarchical climate of the day, could be judged nothing short of scandalous. Solely the dramaturgy of entrances – which aims at bringing woman and doctor together in a spatial sense – hints at the actual field of conflict: the desire of a man in love with a married woman who is now 'delivered' to him

in a relationship of physical dependency. In kissing the unconscious woman, the doctor is violating the doctor-patient relationship. The way in which this head doctor of a sanatorium treats this wife and mother anticipates the conduct of the director of the institution towards the somnambulist Cesare in DAS CABINET DES DR. CALIGARI (1919/20). Although ZWEIMAL GELEBT for the most part avoids a passionate physical relationship between the doctor and the woman (and also her husband), the sexual tension between the characters provides the film's real dramatic core. This becomes particularly clear if we look at the narrative mode.

In ZWEIMAL GELEBT, as in many of his dramas – *Hahnenkampf* (1908), *Die Pfarrhauskomödie* (1911) or *Das Gelübde* (1916, presumably written in 1914) as well as the film ENTSAGUNGEN – it is an outsider who sets the genuine dramatic action in motion. He disturbs the equilibrium within the family (the car accident being a mere external stimulus) and thereby also upsets the wider social order. At first the doctor is integrated into the family drama. The camera is intent on keeping both him and the husband and the two spaces of the surgery and the waiting room in the frame, through the use of a panning shot. The dramatic panning shot, and the realistic use of space have a completely negative effect, but serve also to develop the story on two parallel levels.[8] Initially, this is motivated by the plot, since it is logical that the husband cannot remain in the sanatorium. And it is once again based on causality and time when the husband, in the next scene, telephones the doctor to find out how his wife is progressing. At this point the doctor has already left the family plot. He has been given his own storyline, which now also includes the wife. Lautensack makes very clever use of narrative technique, managing to provide narrative space for the conflict which up until that point could only be explained indirectly, by splitting up the plot into two.

This is most clearly evidenced in the way that the parallel scenes are placed in relation to each other. Once the doctor has kissed the wife, the physical tension appears to be passed on to the husband as well: In the following sequence he kisses and caresses his daughter with rare intensity, before telephoning the doctor about his wife. Another unusual factor is the parallel matching of the fight against death with a scene in which the father and an attractive maid put the daughter to bed. The father's physical demeanour towards his daughter and the spatial positioning of the maid indicates that the wife has been supplanted.[9] In the filmic discontinuity of the parallel plot, a narrative space is formed beyond the events shown, despite the close association of time and plot. It is in this space that the conflict develops and the counter-plot is prepared. This counter-plot takes centre stage in a radical manner at the end of the sequence, marking a turning point in the film.

The Dramatic Power of the Turning Point (Plot Point)
The author has the indignity not to show us the family grieving in their home or give us a farewell to the deceased loved one in the chapel, open coffin and all. What we do get is a radical change in perspective. It is no longer the family, in its joy or sorrow, that takes centre stage, as seemed to have been the case. It is the doctor, slumped over his desk, abandoned to his obsession – made visible with the presentation of the woman in double expo-

sure. The doctor's innermost desires are laid bare, and at an extremely inappropriate moment.[10] This marks a radical discontinuity at the level of what the spectator anticipates from the storyline.

One-acters had also been known to present sudden turning points. The Aristotelian concept of peripeteia was characteristic of a dramaturgy of tension, and a story often closed with a surprise happy ending or a tragedy. Early German scriptwriters were aware of the need for peripeteia somewhere in the middle of the plot.[11] The American school of scriptwriting, which regards the turning points as the principal elements of the story (plot points), was not widely esteemed in Germany.[12] And yet Heinrich Lautensack uses them in ZWEIMAL GELEBT as the central dramatic cornerstones, switching points and motivating forces of the plot. They not only provide the narrative space for the second act, but also provide the conflict with a direct formulation, depth and a considerable 'dying fall.' As a result, the characters and causal connections between the two main characters become more transparent, and tension is increased. Such a use of turning points, with such a dynamic effect upon the story, is unusual for a film of this period.

Also noteworthy is the way in which Lautensack uses odd moments of fantasy to carve out psychological dimensions in the characters, for example, by providing visual projections of their obsessions and psychological states by blending in characters who are not actually present, or in horror-filmesque incidents such as the transportation of the woman's corpse out of the morgue. With the aid of motivic and filmic excess, we are shown flashes of fantasy and introspection unusual for 1912, but which were to infiltrate German cinema more generally with the two artistically ambitious films DER ANDERE (1912/13) and DER STUDENT VON PRAG (1913). Films such as ZWEIMAL GELEBT or the Henny Porten film DER SCHATTEN DES MEERES (1912) indicate that this tendency was already discernible in films which were less ambitious in terms of production budget and target audience.[13]

The doctor takes the wife abroad, to marry and – by implication – to possess her. Six months pass. Then, during a walk in the woods, a new turning point (plot point 2) looms. Like the admission scene in the sanatorium, where two spaces and character levels were compressed into one image, the film once again brings a second level into the picture, in the shape of the husband and the daughter. As the woman takes a breather on a bench, the camera pans, bringing into view the forking path along which the husband and daughter are walking. They pass her, separated by only a few metres. An intertitle is considered necessary to verbalise the extraordinary spatial and dramatic tension, which is achieved once again by compressing two actually parallel plot lines into one image in the story: 'They come impossibly close to one another.' This time the ensuing parallel plot is not organised through spatially disparate and temporally analogous scenes, divided by cuts, but through a minimal temporal sequence of action brought into the same frame. The woman reaches a jetty where she climbs into a boat and rows off. A barely visible cut to the husband and daughter doing the same. In a long take of the lake, first one boat, then the other, enter the frame. Their paths

cross, without meeting directly, indicating a type of parallel editing within the image. But alongside this filmic continuity, an associative space develops, which goes far beyond the motif we are shown.

This is followed by a brief time lapse, and the two parallel plot strands, so closely driven together, collide into one another both spatially and temporally. The collision is outlined by a beautiful framing concept – the pine cones which the child is collecting on the shore and which lead her inevitably to the mother that she thought was dead. The mother's psychological reaction as she recognises the child is depicted very precisely, but she only takes in the truth after a double take: 'Seeing her child again brings back her memory' announces the intertitle. The collision with the husband is dragged out even longer, elevating the tension to new heights, as the confused, cowering woman hides behind a tree. She watches husband and daughter look for her and then leave. This is the last shot the film devotes to those around her. From this point on, the film concentrates solely on the fate of the woman, in yet another change of perspective.

A Recurring Theme: The Battle between Social Norms and Emotions
The distressed woman follows one of the paths that skirt the shore of the lake until she comes to a bridge, which marks the edge of the frame. Once again, a double exposure is used to render visible, in a fantastic way, the essence of her dilemma and her emotional state: She is standing between two trees when the two men appear, each of them leaning against a tree. She perceives the conflict. But at the same time her internalised moral code is activated. She is forced to recognise that she has committed adultery, abandoned her child, and is probably guilty of bigamy.[14] Both men reach out to her. She presses her hands to her head, and the double exposure – and the two men – disappear. Not a moment's thought is devoted to the fact that the woman bears no responsibility for the course events have taken or even that she followed her true feelings. The bridge, standing in solitary splendour in the background, is not only the vanishing point of the image but also of her destiny. With rigorous consistency the melodrama demands that women atone for not following the path of virtue, whatever reasons they might have for doing so.

Heinrich Lautensack is familiar with such a tragic pattern of conflict. In the dramas *Hahnenkampf, Das Gelübde* or the one-acter *Lena,*[15] he demonstrates the irreconcilable tension between the wish to act out one's sexual desires and the religious, social and moral norms which stand in the way of such behaviour. Admittedly, Lautensack does promote a radical humanisation of dogmatic religious and moral codes, particularly when it comes to sexuality, but he does not fundamentally question the order of the catholic, middle-class, rural way of life. The acting out of strong emotions and sexuality only seem conceivable to him within this social order.[16] This prompts the failure of the woman in ZWEIMAL GELEBT, who feels tied to two men, as well as of the doctor, who attempts to act outside the accepted behaviourial norms.

Only rarely does Lautensack allow his characters, immersed in a battle between

the norms of middle-class life and the driving force of intense emotions or intense sexual desires, to withstand this conflict. In the film DIE MACHT DER JUGEND (1912), an ageing industrial magnate who has been leading a double life for years departs this life when he realises that he is losing his young beloved to his nephew. ENTSAGUNGEN (1913) is a variation on this theme, this time involving an ophthalmologist who has saved a dancer from blindness and who commits suicide when he realises that she is actually in love with his nephew. In SO IST DER KRIEG (1913) a cripple turned traitor in order to possess the woman he loves delivers himself into the hands of death when he cannot fulfil his wish. In these films[17] the social pressure on the characters to realise the relationship that they so long for or have already initiated – a relationship that goes against all society's moral codes – is not given such prominence as in the dramas. However, the suicides with which Lautensack concludes the almost insoluble conflicts in these films can be interpreted not only as the consequence of the despair over a failed love affair but also of resignation based on social pressures to conform.

ZWEIMAL GELEBT was the object of an intensive advertising campaign, launched on 15 June 1912. Shortly before the premiere was due to take place, however, the film was banned by the Berlin censor. There is no record of the film ever being shown in Germany. The grounds for banning the film are indicated in a peculiar list of motifs: 'a woman's nervous breakdown, illness, crisis, death, laying out. Waking from a feigned death, loss of memory, the regaining of memory, a leap into the water.'[18] Reading this, one might be tempted to classify ZWEIMAL GELEBT as a fantasy or horror film. The grounds given for banning the film conceal the social and psychological foundations of the melodramatic turn of events, which is certainly not there merely for sensation or as an end in itself. These incriminating motifs must have featured in other German films: Illness, crisis and a woman's death are all familiar set pieces of tragic melodrama. Anguish and the final suicide by drowning, when a woman had overstepped the mark of the social moral code in carrying on with a man outside the bond of marriage, form a well-established topos. How, then, do these themes in ZWEIMAL GELEBT justify the film being banned? Alongside the ruthlessly pursued sexual desires of the doctor – together with his obsessive masculine craving for possession – comes the scandal of the woman's second life. The apparent legitimation of the adultery through a tender bigamistic relationship constitutes an attack on the bourgeois family ideal. Once again, in ZWEIMAL GELEBT Heinrich Lautensack has drastically illustrated the theme of all his dramas: the tense relationship of a given social order to the vital emotional and sexual demands of mankind. This central – if often latent – conflict is one of the characteristics of the German cinema in the period 1910-14.

Giuseppe Becce and RICHARD WAGNER: Paradoxes of the First German Film Score

Ennio Simeon

> The subject, the music, the lecture and the acting of the principal characters hold
> out great hopes for the success of this feature. There are flashes of superb beauty
> in it.

Such was the praise of the film RICHARD WAGNER[1] in the *Moving Picture World* of November 29th, 1913, by the American critic Stephen W. Bush. In Germany, on the other hand, opinions were more divided: while the trade press judged rather positively, the daily press and the journals of the cinema reformers were more laconic or sceptical, if not altogether malicious. In the *Frankfurter Zeitung* of September 3rd, 1913, Leopold Schwarzschild, for example, emphasized the moments of unintentional humour: Wagner's father is on his deathbed and 'doesn't pass away silently but instead seems to die a horrible death, suffocated by his family who trample all over him.'[2] Stephen Bush, too, mentions absurdities but explains them by pointing out the cinema industry's lack of maturity: 'This feature shows vast improvement, but it is not wholly free from jarring traces of that amateurishness which characterizes so many German film productions. The "early bad manner" is especially evident in the first and in parts of the second reel.'

In view of the topic's enormous cultural importance, these deficiencies did not overly worry the American critic. The New York performance of RICHARD WAGNER in the New Amsterdam Theater to which Stephen Bush refers was accompanied by a special commentary, written and delivered by R.S. Piggot, a noted musicologist. Bush was an enthusiastic Wagnerian and considered the composer's work as model for film music (which was indeed to become the inevitable principle for Hollywood's practice in the thirties and forties). Bush was also one of the first to reflect theoretically about film as a realization of the 'word-sound-drama' and wished there was a complete series of film productions of Wagner operas: 'What manufacturer in alliance with musical skill and genius, will give us the first example of the possibilities of instrumental synchronization of Wagnerian opera?'[3]

Although there had been quite a few films, especially German 'Tonbilder' ('sound pictures') based on excerpts of Wagner operas,[4] RICHARD WAGNER is without a doubt the first filmed biography of the master. The Messter production, directed by William Wauer and Carl Froelich, contains a few extracts from the composer's work which had never before been used for the screen. At any event, even putting aside Bush's personal preference, reception in Germany and the USA was instructively different: the cinematically sophisticated, but culturally more naive America is interested in the film, despite the

technical defects, because one values its artistically serious subject matter. Germany, while cinematically more retarded, has reservations about the Wagner film, because of its own, highly developed music culture. Simplifying a little, one might say: 'in Germany considered cultural sacrilege, the film is a success in the United States.'[5]

For the Messter Film GmbH RICHARD WAGNER signified a move into new territory. On the occasion of the composer's 100th birthday, Oskar Messter offered the bourgeois public an ambitious cinematographic tribute to its favourite musical figure, while also daring to take a great step towards a 'new film genre.'[6] By producing one of the first biographical films ever, Messter attempts, in the year 1913 – the year of the *Autorenfilm* – to break into the traditional area of literature. Without false modesty, RICHARD WAGNER is advertised in the trade press as 'one of the most interesting films of the year.' Apart from questions of film marketing strategies and questions of genre, this film biography is interesting also as a source for the Wagner cult of the teens. A number of inaccuracies, omissions and distortions illustrate the intention to purge the film biography of any details that might adversely affect the image of the composer. Wagner's relationship with Mathilde Wesendonk, for instance, is shown as purely platonic, and Cosima enters Wagner's life only once she is officially separated from her husband Hans von Bülow. Thus, RICHARD WAGNER is best not judged by how accurate its content is, but as a manifestation of the Wagner cult in Wilhelmine Germany after the turn of the century, which the film both promotes and reflects.

In this context, the music used plays a special role. Initially, the film biography was to have a score of original Wagner music, but according to Messter 'negotiations with the parties concerned broke down, due to the extraordinarily high financial demands, reaching a sum close to half a million mark.'[7] Apparently, Wagner's heirs insisted on such an outrageous sum because they were anxious not to have the master's sacred music associated with the notoriety of cinematography, and thus perhaps damage Wagner's reputation. Because of the physical likeness, Messter had already engaged the Italian composer Giuseppe Becce for the main part of Wagner, in addition to Becce's experience as a conductor. When it became clear that no Wagner music could be used, the producer commissioned his main actor also to act as the film's composer. The music for RICHARD WAGNER is not in fact a wholly original score. Messter Film GmbH's published piano score of the film is precise on this: 'RICHARD WAGNER. A film biography. Accompanying music arranged and partially composed by Dr. G. Becce.'[8]

That many so-called original film music scores were not entirely original is obvious when reading the *General Handbook of Film Music*, edited by Hans Erdmann (responsible for the theoretical section) and Giuseppe Becce (the practical examples) in 1927. About original scores, called 'Authors' Illustrations,' they add by way of a commentary that 'it is difficult to determine exactly the extent to which "really new compositions" were created, and how much was "half and half."' [9]

Usually, historians of film music are mostly interested in scores that were newly composed throughout. But in order to understand the development of film music dramaturgy

and film-specific musical language, it is imperative to include compilations and works of 'half and half' in the analysis. From the vantage point of original film music, two other pieces of Becce's work, created for Messter productions, might appear more rewarding: the score for COMTESSE URSEL by Hans Oberländer (1913) and SCHULDIG by Curt A. Stark (1914) are autonomous compositions. And yet, Becce's score for RICHARD WAGNER is especially revealing for music historians because it contains, apart from Becce's own work, a number of musical themes and motifs taken from the already extant repertoire.

It may sound paradoxical, but the parts of the score where Becce uses arrangements are more interesting than the pieces specially composed by him. The peculiarity of the arrangements used for RICHARD WAGNER lies in the choice of composers whose music is deemed to accompany the stations of Wagner's musical life history. The apprentice years of the master, in particular, are mostly accompanied by Haydn and Mozart and eventually Beethoven; furthermore, there are pieces chosen for their geographical and ethnic connotations (the Polish hymn during a Polish banquet) or because they evoke a political situation (the Marseillaise when Wagner is escaping the uprisings in Dresden). The latter is entirely in keeping with international arranging practices of the time. Viennese classics, on the other hand, were not popular and rarely used for silent movies. The *Handbook* contains a 'thematical register of scales' which systematizes a method of musical illustrations. For the most diverse film subjects it suggests hundreds of pieces to the film musician, yet it contains only three Beethoven compositions, four by Haydn and about twenty by Mozart. From other preserved compilations for silent movie music, one can similarly conclude that film musicians rarely fell back on the Viennese Classics. Becce's score for RICHARD WAGNER is thus not only the first film music for a German production, which mixes compilation and original compositions, but one that constitutes – at the very beginning of German film music – a unique phenomenon that significantly deviates from the subsequent developments in film music practice.

What might have motivated the Italian composer to call upon the Viennese classics for RICHARD WAGNER? Becce's choice evidently had to do with the film's overall aim of glorifying Wagner unconditionally. Entirely in line with Richard Wagner's own teleological perspective, Becce suggests to the audience a history of German music where the Viennese classics lead directly to Bayreuth. Even Giacomo Rossini, whom Wagner, in his writings, considered one of his main adversaries, is used by Becce to underscore this perspective: at the beginning of the film's second act, one sees young Wagner conduct, and Becce places the overture of the *Barber of Seville* on the conductor's stand, with a note in the score indicating the music should be 'adapted closely to Wagner.' Becce's choice is motivated, since, during his time in Riga, Wagner did indeed primarily conduct Italian opera. In act four, Rossini is used differently: here the *Wilhelm Tell* overture matches the rhythmical movements of the people's uprising. The *General Handbook* recommends this overture for 'crowd scenes,' 'society events,' 'hunting trips.'[10]

Becce's compilation score thus constructs a musical equivalent of the Wagner

film itself, including all of the latter's pretensions, presumptions and naiveties. The choice of musical pieces targets a new, educated audience, whom Messter and his competitors were keen to attract to the cinema. Meanwhile, German reactions were much divided over the intentions of the music in the Wagner film and its effects. To quote once more Leopold Schwarzschild: 'The music plays the minuet from *Don Giovanni*, after disfiguring the G Minor Symphony,' and he mocks Becce's new compositions, written self-evidently and at length 'à la manière de Wagner': Becce 'makes desperate efforts to imitate the Senta-ballad.'[11] Schwarzschild's unfavourable review of the film's score might be due to personal animus or occasioned by a bad performance from the cinema orchestra, for the *Kinematograph* explicitly praises the orchestra's rendition during the Frankfurt première.[12] Similarly, for the critic O. T. Stein, it was Becce's music, and not least the orchestra's performance, which saved the film:

> If it had not been for the highly tasteful musical arrangement, done by Dr. Becce in Berlin, well-played by a good orchestra – as was the case in the Union-Theater Dresden, which reminded the listener of the magic of Wagnerian art and coincided beautifully with the screen images – one's interest in the film, because of its obvious faults, would not have been sustained. Here the music becomes a glorious helper, an artistic co-creator, just as it should be and will have to be in the cinema.[13]

Contemporary comments about the performance practice are rare. The idea must have been for the film's score to be available for small as well as larger orchestras, since both kinds were for rental from the music publisher. The premiere of RICHARD WAGNER took place May 31st, 1913, in the Berlin Union Theater in the Bavaria House. Most likely, a cinema orchestra would have been employed, but sources remain vague as far as the music was concerned: the advertisement for the opening of this cinema palace in the in-house *Union-Theater-Zeitung* does not mention Becce's film music[14]; a later advertisement only mentions the conductor Fritz Riecke[15]; a review of the opening in the *Kinematograph* briefly writes about the film but does not comment on the music at all.[16] Leopold Schwarzschild, in his review of the Frankfurt performance, points out the harmonium, but no other instruments. The Frankfurt correspondent of the *Kinematograph*, on the other hand, praises the 'wonderful orchestra, increased to 18 players.'[17] In *Moving Picture World* of November 29th, 1913, Stephen Bush praises the film music, but mentions only an organ: 'The music was rendered with great skill. An organ is much to be preferred if a man can be found who handles it as well as the performer at the New Amsterdam.' Does it follow that Becce's film music was not even used during the New York performance? This would be typical for contemporary practices: various obstacles created a large gap between an ideal and actual performances, and most fully composed scores were rarely used to accompany the films in question.

In Becce's score, echoes and memories of Wagner's original music accumulate in direct proportion to the master's intellectual and musical development, until he can cele-

Excerpt from Giuseppe Becce's score for RICHARD WAGNER (1913)

brate his first public success. Only with great difficulty did Becce accept the restrictions regarding the use of Wagner's original music. The published score points to this sacrifice a number of times: 'It would be more appropriate here to play the first 64 bars of the overtures of the *Fliegende Holländer*' (when Wagner first conceives of the idea for this opera during a sea voyage from Riga to London); or: 'It would be more effective here to play one part of the last act of the opera *Rienzi*, i.e. from the words "Throw fire into..." until the sign ... (when *Rienzi* is finally being performed).' These comments resemble the 'music scenarios' as they were commonly prepared for performances of silent films, rather than the instructions given for the rather more infrequent, specially commissioned film music. The fact that Becce prescribes already extant musical pieces, instead of composing original scores, is a further paradox of this first German film score: it was highly unusual to include repertory pieces in commissioned work. Instead, it was the custom to use these as stand-ins only for those film projects which, for financial reasons, could not afford original scores.

Becce's new compositions for RICHARD WAGNER are mostly unpretentious and project very little of the filmic pertinence which famously characterized his later *Kinothek*. And yet, they manage to fulfil functional tasks for a variety of film situations, even if these solutions appear naive: he introduces 'bridges' between compilation pieces from other composers, has segments suffused with atmospheric music, and writes rhythmically stirring parts. When composing 'à la manière de Wagner' Becce had to take into account possible infringements of copyright law. Still, a few very short original citations appear, as well as free adaptations of Wagner themes. Mostly, the musical accompaniment of the film is a mixture of general chromatic exercises and lyrical melody, testifying to the Italian composer's romantic bent. For Wagner's film death, Becce made a concession to compilation practice by indicating the funeral march from Beethoven's *Third Symphony*.

In terms of film dramaturgy, the score for RICHARD WAGNER illustrates the hesitancy around the idea of incidental music as film accompaniment, then a practice still very much in its beginnings. In the teens and twenties, Giuseppe Becce made an enormous creative contribution to the development of a truly cinematographic musical language, and, therefore, to the creation of autonomous film music dramaturgy: music which is conceived as accompaniment, adapted formally as well as thematically to the context of the filmic narrative. The cinematically congenial spirit of Becce's music developed gradually, closely correlated with his 'routine' work as 'Illustrator' in cinemas on the one hand, and his work

as composer of atmospheric pieces and, finally, original music on the other. It is only in the twenties that Becce's importance came to be recognized. And yet, even the first commissioned piece already contained the whole spectrum of film musical activities.

Perhaps one can indeed reproach the film for a degree of arrogance, and RICHARD WAGNER has been justifiably categorized as one of the many films exploiting the fashion for authors' films.[18] For film history, however, the film is an extraordinary case, worth a closer look, not just as the starting point of German film music, but as a intriguing episode in its own right.[19]

RICHARD WAGNER (1913)

Early German Film:
The Stylistics in Comparative Context

Barry Salt [1]

Far more American films than German films were shown in Germany in 1912, as can be seen on page 10 of Emilie Altenloh's *Zur Soziologie des Kino*.[2] This was not the case in France in the same year, for instance, though that was about to change. So why did German audiences in 1912 watch more American films than German films, and indeed more than those from any other European country? Of course, there were more American films available, but I think that there were other reasons as well. I think American films were already more attractive to audiences, even before World War I. There were certainly some marked differences between American films and European films, as can be shown objectively by a stylistic analysis of the kind I introduced long ago.[3]

The Method and the Sample

The correct basis for the formal analysis of any art work, including films, is to use the analytical terms that the makers used in creating them. For films, this starts with the components of the script, with scenes forming the basic unit, and then extends through the variables about which decisions have to be made during filming, such as camera placement, type of staging within the shot, control of the nature of the actor's performances, and then on to the lengths of shots and the use of intertitles in the finished film.

Although I have seen scores of German films made before 1917, only nine multi-reel films were immediately available for close analysis. This is a rather small sample, but the indications from these samples accord with my subjective memories of a much larger number of films of all lengths.

Shot Length

This is the most obvious stylistic variable, and I am not the first to investigate it. One of my predecessors is Herbert Birett, and he gives a list of even earlier investigations.[4] The first person to look into this matter was the Reverend Dr. Stockton in 1912, whose investigations are reported in an article on page 542 of *The Moving Picture World* of August 10, 1912, which has been republished in George Pratt's *Spellbound in Darkness*.[5] The figures Dr. Stockton gives are for the number of shots, intertitles and inserts in a series of one-reel films. Since most of the films on his list are now lost, and their exact lengths unknown, it is impossible to derive exact figures for their Average Shot Lengths (ASL). However, I myself have gathered a number of figures for this period, and typical examples from 1913 are 81 shots in 1737 feet in the French Gaumont film PANTHER'S PREY, while the American

Thanhouser Company's JUST A SHABBY DOLL includes 60 shots in 871 feet. But in the same year D.W. Griffith's THE COMING OF ANGELO has 116 shots in 967 feet. These figures, and a number of others like them, show clearly that the move towards faster cutting was led from the United States, and within the American film industry it was undoubtedly led by D.W. Griffith from 1908 onwards.

As far as long feature films are concerned, the state of things for the products of the major industries are indicated by the samples below showing the various ASLs.

TITLE	*DIRECTOR*	*YEAR*	*ASL*
DANISH FILMS			
Fire Djaevle, De	Dinesen, R. & Lind, A	1911	21.0
Ekspeditricen	Blom, August	1911	43.0
Dodspringet til Hest fra Cirkuskuplen	Schnedler-Sorensen, E.	1912	17.0
Mystike Fremmende, Den	Holger-Madsen	1914	17.0
Hemmelighedsfulde X, Det	Christensen, Benjamin	1914	12.0
Fremmende, Den	Gluckstadt, Vilhelm	1914	16.0
Ekspressens Mysterium	Davidsen, Hjalmar	1914	21.0
Verdens Undergang	Blom, August	1916	13.0
Klovnen	Sandberg, Anders W.	1917	18.0
FRENCH FILMS			
Zigomar – Peau de Anguille	Jasset, Victorin	1913	13.0
1793	Capellani, Albert	1914	12.5
Alsace	Pouctal, Henri	1916	18.5
Barberousse	Gance, Abel	1916	13.5
GERMAN FILMS			
Zweimal gelebt	Mack, Max	1912	27.0
Sumpfblume, die	Larsen, Viggo	1913	27.5
Schwarze Kugel, die	Hofer, Franz	1913	16.0
Geheimnis von Château Richmond	Zeyn, Willy	1913	26.5
Dämonit	?	1914	19.4
Und das Licht erlosch	Bernhardt, Fritz	1914	25.0
Kinder des Majors, die	?	1914	23.5
Tirol in Waffen	Froelich, Carl	1914	27.8
Stolz der Firma, Der	Wilhelm, Carl	1914	14.0
Schuhpalast Pinkus	Lubitsch, Ernst	1916	13.0
Wenn Vier dasselbe tun	Lubitsch, Ernst	1917	8.5
ITALIAN FILMS			
Pellegrino, Il	Caserini, Mario	1912	27.5

Ma l'amor mio non muore	Caserini, Mario	1913	67.0
Tragedia alla corte di Spagna	Negroni, Baldassare	1914	22.0
Tigre Reale	Pastrone, Giovanni	1916	13.0
Fuoco, Il	Pastrone, Giovanni	1916	18.0

SWEDISH FILMS

Trägardmästaren	Sjöström, Victor	1912	24.0
Havsgamar	Sjöström, Victor	1915	14.0
Karleken Segrar	Klercker, Georg af	1916	18.0
Ministerpresidenten	Klercker, Georg af	1916	17.0
Minnenans Band	Klercker, Georg af	1916	14.0
Revelj	Klercker, Georg af	1917	11.5
Thomas Graals bästa Film	Stiller, Mauritz	1917	9.0
Vingarna	Stiller, Mauritz	1917	13.0
For hjem och hard	Klercker, Georg af	1917	11.0
Forstadsprästen	Klercker, Georg af	1917	15.0
Mysteriet Natten till den 25e	Klercker, Georg af	1917	13.0
I Moerkrets Bojor	Klercker, Georg af	1917	13.0
Allt hamnar sig	Tallroth, Konrad	1917	13.0
Tösen fra Stormyrtorpet	Sjöström, Victor	1917	6.0
Vem sköt?	Tallroth, Konrad	1917	14.0

AMERICAN FILMS

Traffic In Souls	Tucker, George L.	1913	7.0
Italian, The	Barker, Reginald	1914	7.5
Florida Enchantment, A	Drew, Sidney	1914	8.0
Wishing Ring, The	Tourneur, Maurice	1914	11.5
Avenging Conscience, The	Griffith, D.W.	1914	7.5
Spoilers, The	Campbell, Colin	1914	13.0
Squaw Man, The	DeMille, C.B. Apfel, O.	1914	11.5
What's-His-Name	DeMille, Cecil B.	1914	24.0
Italian, The	Barker, Reginald	1915	10.0
Cheat, The	De Mille, Cecil B.	1915	12.5
Martyrs of the Alamo	Cabanne, W.C.	1915	6.0
Hypocrites	Weber, Lois	1915	16.5
Birth of a Nation	Griffith, D.W.	1915	7.0
Madame Butterfly	Olcott, Sidney	1915	16.0
David Harum	Dwan, Allan	1915	20.0
Royal Family, The	Frohman, Charles	1915	7.2
Carmen	DeMille, Cecil B.	1915	11.5
Playing Dead	Drew, Sidney	1915	9.0

Young Romance	Melford, George	1915	15.0
Coward, The	Barker, Reginald	1915	11.0
Ghosts	Nicholls, G.	1915	12.0
Crisis, The	Campbell, Colin	1916	8.5
Argonauts of Cailfornia, The	Kabierske, Henry	1916	6.9
Child of the Streets, A	Ingraham, Lloyd	1916	7.5
Vie de Bohéme, La	Capellani, A.	1916	8.5
Happiness	Barker, Reginald	1916	5.8
Going Straight	Franklin, C. & S.	1916	7.5
Poor Little Peppina	Olcott, Sidney	1916	9.6
Vagabond, The	Chaplin, Charles	1916	14.0
Apple Tree Girl, The	Crosland, Alan	1917	4.0
Girl without a Soul, The	Collins, John H.	1917	5.3
Romance of the Redwoods	De Mille, Cecil B.	1917	10.0
Iced Bullet, The	Barker, Reginald	1917	6.4
Narrow Trail, The	Hillyer, Lambert	1917	4.5
Until They Get Me	Borzage, Frank	1917	6.8
Rebecca of Sunnybrook Farm	Neilan, Marshall	1917	5.0
Poor Little Rich Girl	Tourneur, Maurice	1917	10.0
Whip, The	Tourneur, Maurice	1917	6.0
Modern Musketeer, A	Dwan, Allan	1917	4.0

You might ask what is the point of all these figures. Well, the cutting rate (or ASL) is generally fairly closely connected with the apparent speed of the film narrative. This happens in various ways. The most obvious of these is that the more scenes there are within a given length, the more cuts there will be from one scene to the next, and hence the shorter the ASL. And in general, the faster the plot advances, the more scenes there will be. A greater number of scenes is also connected with the use of cross-cutting technique between parallel actions. This was particularly developed by D.W. Griffith in the United States, though he did not invent it in the first place. By 1913 a number of other American film-makers were starting to take up this idea, and it is a feature of TRAFFIC IN SOULS, the 90-minute American feature film tabulated above. However, amongst more than 2000 European films made before 1914, none use fully developed cross-cutting in the Griffith manner, and only a dozen or so use it in order to show both sides of a telephone conversation, or action inside and outside a house.

Despite the fact that there are some German films from this period, particularly thrillers, which contain a situation that could have been developed into a cross-cut race to the rescue, the only German example I have seen that even begins to use the device is Urban Gad's DIE VERRÄTERIN (1912), where there are a couple of cuts between the hero hurrying to save the heroine from execution, and the execution itself. But this kind of embryonic

cross-cutting dates back to 1907, before Griffith fully developed the notion.

By 1914 it was widely held in the American film industry that cross-cutting was most generally useful because it made possible the elimination of uninteresting parts of the action that play no part in advancing the drama, even if no suspense was involved. The introduction of cross-cutting into a film requires special thought at the script stage, and this of course requires special training of the writers, which was far from being the norm in Europe, and especially in Germany.

The other technique that introduces more cuts into a given length of film is the use of cutting within a scene, and in particular cutting in to a closer shot of the actors, and then back again. Like all noticeable cuts, I believe this has some sort of dynamic psychological effect, and in any case the introduction of closer shots in themselves can act to produce intensification of the dramatic situation. Although there was not vastly more cutting to closer shots in American than in European film up to 1914, when such cuts *were* used in American films, they tended to be from a general shot of the scene that was already closer to the actors than its European equivalent, and the close shot itself was likely to be closer, too. But during the war years there certainly was more scene dissection in American films than European films, and this is brought out in the statistics for scale or closeness of shot given later in this article.

A German film that illustrates the effect of lack of cutting, combined with very poor staging of the action, is ZWEIMAL GELEBT (1912). The plot of this film revolves around a doctor who falls in love with a seriously ill woman whom he is treating in hospital. After she apparently dies in hospital, he pays a last visit to see her body in an open coffin lying in a church before burial, with no one else present. He discovers that she is not actually dead, and picks her up and carries her to his car outside the church. Every foot of his travel during this process is shown in its complete detail in three shots, one inside the church, the next showing him taking her out the door, and the third taken from the street showing him carrying her about 20 metres from the side of the church out to his car and dragging her passive form into it. All this has taken the better part of a minute, and then we are taken all the way back through the same series of shots as the doctor goes back to the church to get his top hat, which he left behind, and to put the lid on the coffin. Now this is an extreme case, but nearly all other German films of the period have at least a little of this kind of failure to think out how the simple progress of the action could be easily speeded up with better selection of shots, and more cuts between them. This is a great pity, because a very interesting situation is now set up in this film, but the director fails completely to exploit it. The doctor takes the revived woman away to another country and lives with her there, but the woman's little daughter turns up in the same town, and the woman sees her. The inevitable scene in which the woman spies on her daughter without daring to approach her is also staged in an surprisingly crude way, with the woman lurking behind a tree at one side of the scene, in such a way that she would be clearly visible to anyone glancing her way. It is done like a bad nineteenth century melodrama on the stage.

In European cinema, I have found no films with an ASL shorter than 11 seconds before 1917, by which date a few clever and perceptive directors had finally begun to understand the new American methods of film construction. In Sweden, Victor Sjöström had all the devices of continuity cinema working properly in TÖSEN FRA STORMYRTORPET (1917), with an ASL of 6 seconds. (His other films of this time, in which he acted as well as directed, unlike the one just mentioned, are slightly more retarded stylistically.) Mauritz Stiller also went some of the way down the same path in THOMAS GRAALS BÄSTA FILM (ASL = 9 seconds), but this was not typical for the Nordic region, as figures for films made by Georg af Klerker and others show. The long scenes and very slow cutting in German films is clearly indicated in the figures given above. Ernst Lubitsch seems to have been the first to get a grip on American methods, as is indicated by the ASL for WENN VIER DASSELBE TUN (1917) of 8.5 seconds, while his DIE PUPPE of 1919 has an ASL of 5.5 seconds, not to mention the fact that he was already using a lot of reverse-angle shots by this date. His CARMEN of 1918 has 14% of such cuts, and DIE PUPPE includes 19% reverse-angle cuts. On the other hand, there are many American films with an ASL shorter than 10 seconds before 1915.

Scale or Closeness of Shot

Another filmic variable about which conscious decisions have to be made when a film is being shot is Scale (or Closeness) of Shot, and even before 1919 distinctions were already being drawn by American film-makers between the categories of 'Bust' or Close Up, American Foreground, French Foreground, Long Shot, and Distance Shot. Although there was already a small amount of disagreement about precisely what shot scale corresponded to each of these descriptive terms, it is sufficient for the purposes of analysis to define carefully what one means by each category, and then stick to it. I will in fact use categories of Scale of Shot more like those used in the forties and later, as follows: Big Close Up (BCU) shows head only, Close Up (CU) shows head and shoulders, Medium Close Up (MCU) includes body from the waist up, Medium Shot (MS) includes from just below the hip to above the head of upright actors, Medium Long Shot (MLS) shows the body from the knee upwards, Long Shot (LS) shows at least the full height of the body, and Very Long Shot (VLS) shows the actor small in the frame. It must be appreciated that the closer categories of shot are understood to allow only a fairly small amount of space above the actor's head, so that the kind of situation where just the head and shoulders of a distant actor are sticking up into the bottom of the frame with vast amounts of space above him would *not* be classed as a Close Up. Although all the analyses in this article are done with the above categories, it might be preferable for future work to subdivide the category of Long Shot into Full Shot, which just shows the full height of the actor, and Long Shot showing the actor so distant that the frame height is two or three times the actor height, and still reserving Very Long Shot for those shots in which the actors are very small in the frame.

Since there is very little camera movement in the films made in this period, and since the actors also tend to stay mostly at the same distance from the camera in them, it is

not difficult to assign the shots to the appropriate category. However, if a shot does include extensive actor movement towards, or away from, the camera, it is always possible to carry out an averaging process for actor closeness within the length of the shot to any desired degree of accuracy, if one takes enough time and care over it. Also, it should be noted that since we are considering films with 200 or more shots in them, there is a tendency for occasional errors in the assignments of shots to their correct category to cancel out.

The exact scales of shot that lie at the centre of the categories I have been using up to now in my work are not entirely satisfactory for films made up to the end of World War I, because two of the standardized distances that were fairly strictly used during this period both lie within one of my categories of Scale of Shot. The usual working distance for European films up to World War I was the four metre line, and if actors play at this distance from the camera they are cut off at the shins when photographed with a standard 50 mm lens, so giving what was called 'the French foreground' in the USA. On the other hand, the usual shooting distance in America was the 'nine foot line,' with the actors working right up to a line laid on the floor at that distance from the camera. Under these conditions this cut the actors off just below the hips when they were framed with their heads a reasonable distance from the top of the frame. This was called the 'American foreground.' Although the 'American foreground' corresponds with the centre of the later standard category, the Medium Shot, that I use, the 'French foreground' falls towards the point where Medium Shot changes into Full Shot. It would be possible to introduce a new category for this, but for consistency with my earlier work, I have included French foreground shots under Medium Shot in these new figures. In any case, they are closer to being a Medium shot (as it is nowadays understood) than to being a Full Shot, let alone a Long Shot.

The Technique

Although in the first place I record the total number of Close Ups, etc. in a film, for the purpose of the comparison between one particular film and other films which will include different numbers of shots in total, it is preferable to multiply the number of shots in each category by 500 divided by the total number of shots in the film, so that one then has the number of each type of shot per 500 shots. This 'standardization' or 'normalization' not only enables one to easily compare one film with another, but also gives a direct measure of the relative probability of a director choosing any particular closeness of shot.

A broad summary of the results for the purposes of comparison can be given by quoting the percentages of shots closer than Medium Long Shot for the groups of American and German films.

ZWEIMAL GELEBT	(1912)	0%
DIE SUMPFBLUME	(1913)	9%
DIE SCHWARZE KUGEL	(1913)	28%
DAS GEHEIMNIS VON CHÂTEAU RICHMOND	(1913)	10%
DÄMONIT	(1914)	11%

DIE KINDER DES MAJORS	(1914)	1%	
TIROL IN WAFFEN	(1914)	3%	
UND DAS LICHT ERLOSCH	(1914)	3%	
DIE SÜHNE	(1917)	7%	
TRAFFIC IN SOULS	(1913)	8%	
IVANHOE	(1913)	9%	
WHAT'S-HIS-NAME	(1914)	13%	
THE SPOILERS	(1914)	16%	
THE AVENGING CONSCIENCE	(1914)	30%	

The most striking thing about these results is the high proportion of close shots in Franz Hofer's DIE SCHWARZE KUGEL. This reaches a Griffith-like level. All the BCUs and CUs in this film are insert shots of objects, more or less relevant to the action. Taking this together with other features of this film, it looks to me as though Hofer had noticed some features of contemporary American film-making, without completely realizing their significance. The situations in which they are used would not bring forth such inserts in American films of this period or later, for they do not add extra clarity or force to what can already be clearly seen in the preceding shots in the film. The same is true of Hofer's use of masked Point of View shots (see below). Unfortunately, I have not been able to analyse any German films from 1915 and 1916 in detail, but DIE SÜHNE, made in 1917, though not released until the following year, gives an indication of what is visible in other films I have seen, but not listed here. This is that there seems to have been very little progressive stylistic development in German films during the war years.

Reverse Angle Shots

As in the rest of Europe, it was not until after the war that German film-makers took the use of the fully developed technique of reverse-angle cutting which had begun to appear in American films from 1911. The one exception to this was the use of cuts to the opposite angle to show the audience watching a stage show, as well as the show itself seen in Long Shot from the audience's direction and point of view. It seems that many film-makers all over the world had difficulty generalizing from this situation to the general one. In fact, even in theatrical scenes many European film-makers were unable to get their heads around this idea, even though they must have seen it in other people's films. For instance, Franz Hofer in DIE SCHWARZE KUGEL repeatedly tries to include the spectators of the stage show central to his plot in the foreground of the same shot as what they are watching. Unfortunately, his cameraman does not have sufficient depth of field to cover the audience, and either they or the show are badly out of focus in successive shots. This is an extreme case of the technical ineptitude generally visible to some extent in all German films of the period.

Point of View Shots

The only true examples of Point of View (POV) shots in German films made before 1918 are the masked variety, where the scene looked at is shown inside a vignette shaped to represent the aperture of whatever is being looked through by the character in the film - telescope, keyhole, or whatever, e.g. DIE SUMPFBLUME and DER SCHIRM MIT DEM SCHWAN (1916).

The true Point of View shot, which shows what a character in the film is looking at without any mask, and *from a camera position along his line of sight*, began to appear in some quantities in American films from 1912. There are one or two examples of what might appear to be POV shots in German films made before 1918, such as DIE SUFFRAGETTE (1913), but closer inspection shows that the scene that the characters are looking at is not actually taken in the direction they are looking, but from a quite different direction. Indeed,

such was the mental difficulty that German film-makers seem to have had with the concept of the true POV shot that a shot of an important object that one character is looking at in Joseph Delmont's AUF EINSAMER INSEL is shown inside a circular mask, even though neither he nor anyone else in the scene is using a telescope.

Staging within the Shot

Given the length of the takes in German films, there is inevitably a fair amount of staging with the actors moving between positions up near the 4 metre line and deeper in the set, and for the same reason the actors tend to face towards the 'front' in a fairly obvious way. It was possible to stage scenes in one long take and avoid direct frontality, as most Danish film dramas of the period show, and it was possible to go beyond this, as in Sjöström's INGEBORG HOLM (1913), and use great subtlety in the placing of the actors with respect to each other, but one does not find anything like that in German films of the same date.

There is also a certain amount of use of deep sets including a space behind visible through a doorway or arch, in which parts of the action can take place. This is something that appears occasionally in European films made in the teens, but more rarely in American films, where action moves to adjoining spaces and back with a cut and a change of camera position.

Lighting

The lighting in German films of the period before 1918 is in general like that in other European films of the period, though the amount of lighting applied from arc floodlights on floor stands to the front and sides of the sets is a little heavier than the European average. In this respect, it approaches the lighting in French Gaumont films, which used an exceptionally large number of arc floodlights. Combining this with the sort of staging used, I have been struck by the way that many German films, such as DAS GEHEIMNIS VON CHÂTEAU RICHMOND, do indeed look like Gaumont films. Apart from the fact that French films were probably the principal models for German films, the somewhat lower light levels of the sunlight through the studio roofs at Berlin's more northerly latitude may have had something to do with this. As in the rest of Europe, the old style glass studios continued to be used until after the war, whereas the Americans moved over to shooting solely with artificial light in dark studios during the war. Similarly, there is no backlighting of the figures with spotlights in studio scenes. However, none of the German films made before 1917 that I have seen have the subtlety of the lighting of the best Gaumont films, impressive by the precision with which the light is applied to the figures and particular areas of the scene. Indeed, the lighting can be downright crude, as in the attempts at low-key lighting in UND DAS LICHT ERLOSCH and HOMUNCULUS. Things began to change a little after the war, a harbinger being the lighting in DIE LIEBE DER MARIA BONDE (1918), which does interesting things with available light in an artist's studio.

A staging including a 'scene behind' in UND DAS LICHT ERLOSCH (1914)

Scene with low key lighting from available light filmed in a real artist's studio in
DIE LIEBE DER MARIA BONDE (1918)

Gaumont style lighting in DAS GEHEIMNIS VON CHÂTEAU RICHMOND (1913). The foreground figure is almost up to the nine foot line, or 'American foreground'

Script Construction

The basic problem with German films stems from their poor scripting, and this can be illustrated in its most extreme form by DIE SUMPFBLUME (1913), where it takes the film fully ten minutes for the hero to get to know the heroine and the story of the film to start at all, and another seven minutes to get the other components of the plot into place, so that something interesting can happen at last! In more action-oriented films, there are chases that have no goal, and indeed even return to the point of origin, via utterly irrelevant pieces of action, as in DIE SCHWARZE KUGEL. Here much is made of the mechanism of a secret entrance through a staircase to a cellar, but this reputed cellar plays no part in the plot, and we never even see it. Even the best German films from before the war, which are undoubtedly the Asta Nielsen films directed by Urban Gad, are not always free from these kinds of defects.

Conclusion

In Germany, as elsewhere, audiences preferred American films when they were put before them. And this was because American films were in general more exciting, gripping, and entertaining, to the reasons indicated above.

Self-Referentiality in Early German Cinema

Sabine Hake

The Wilhelmine cinema, simply because so little is known about it, is frequently described as technically inferior and formally undeveloped.[1] Siegfried Kracauer's dictum that the cinema before World War I must be seen as 'prehistory, an archaic period insignificant in itself'[2] has done much to contribute to this impression. It is the purpose of this essay to challenge such perceptions and draw attention to one particular trait of this 'other' early German cinema, its disposition toward a self-referentiality that draws attention to the cinema and foregrounds its stylistic means and emotional effects. The re-presentations of cinema, for instance in the form of stories about filmmaking and through images of images, imitate the aesthetics of the store-front window. Their primary purpose is to advertise the many goods this new mass entertainment has to offer. While the films create critical distance through the scenarios of duplication and display, they skilfully apply the rules of advertising, namely to make the product look appealing and to seduce prospective buyers into their realm of new sensations and new pleasures.[3]

The interest in self-mirroring and self-promotion belongs to a cinema that, to evoke Tom Gunning's distinction between the classical voyeurist cinema and an earlier 'cinema of attractions,' is spectacular, sensationalist, and unabashedly self-involved.[4] This cinema prefers the aesthetics of presentation and flaunts its skills with little regard for narrative or spatial continuity.[5] Tableau-like frame compositions, long takes, and frontal play with direct glances at the cinema are its main characteristics. With the early cinema thus likened to a kind of institutional exhibitionism, the preference for theatrical mise-en-scène in German films of the early teens appears in a new light. It becomes associated with a discourse on the apparatus that foregrounds the cinema's technological and institutional aspects. This self-referential quality does not necessarily imply a critique of dominant practices in the way that the modernist novel rejects the underlying assumptions of realism or the epic theatre of Brecht introduces the alienation effect to provoke critical thinking. In the context of cinema culture and consumerism, these instances of self-referentiality serve largely affirmative functions; they belong to a new industry promoting its products. The hallucinations of cinema, whether in the form of narrative structures or special effects, represent a form of advertisement, a showcase for technical accomplishments as well as the technological imagination. Their impact can be studied in a number of films that are at once playful and didactic, exploratory and prescriptive – qualities typical of any cinema in transition. As 'transitional objects,' these films show audiences how to appreciate the cinema and its increasingly sophisticated products, how to deal with feelings of astonishment and disbe-

lief, and how to gain satisfaction from the playful awareness of the apparatus and the simultaneous denial of its presence. Such emphasis on questions of spectatorship seems at once essential and excessive: a sign of instability and strength. The resultant circulation of means and meanings gives rise to what Thomas Elsaesser describes as one of the unique qualities of early German cinema, namely 'its mastery over the cinematic process and narrativation.'[6] It is with similar implications that I propose to discuss the narrative and discursive references to the cinematic apparatus: as a self-presentation of the cinema and domestication of its forces, that is: as another act of mastery indeed.

The cinema's desire to draw attention to its possibilities, to show its nicks and display its achievements, finds expression in visual and narrative terms. The desire for duplication stands behind the self-referential use of special effects as well as the many stories about filmmaking and film professionals. The fascination with cinema as a production is most apparent in films that are set in the world of film and that feature film stars or cameramen in the leading roles. In these examples of diegetic self-referentiality, the process of filmmaking is invariably portrayed as a challenge and an adventure. Funny and grotesque situations abound, art infringes upon life, and life models itself on art, but in the end, even the greatest organizational problems are resolved through the protagonists' sheer ingenuity, and the multiple layers of deception only affirm the power of the cinematic apparatus. The resourcefulness of the characters becomes a measure of the resourcefulness of cinema.

Playing with these implications, DER STELLUNGSLOSE PHOTOGRAPH ('The Unemployed Photographer'), a Max Mack film from 1912, presents the typical day in the life of a cameraman as a series of comic adventures. His professional identity is developed through two central elements, women and technology. On his way to a job interview, the young man makes the acquaintance of an attractive woman on the bus. Introducing himself as the member of a young and still disreputable profession, he uses to his advantage the secret wishes of women everywhere. 'I want to be filmed,' confesses the woman and, in so doing, offers herself to the objectifying gaze of the camera. Her wish gives rise to a paradigmatic configuration of cinema, but it also betrays a legitimate need for self-representation. The woman, who has entered the public sphere, is confident enough to express her desires and to ignore suggestions of impropriety. This potentially liberating moment, however, is contained within a narrative structure that organizes access to the cinematic apparatus along the lines of gender and places the man as the bearer and the woman as the object of the look.[7] Moreover, the request is made in an erotically charged atmosphere which defines, in a fundamental way, the relationship between femininity and technology as one of exclusion and fetishization.

The emphasis on film production as a narrative device carries over into the next scene, the job interview, which offers insight into the difficulties of filmmaking. Borrowing from slapstick comedy, Mack plays extensively with the analogies between man and machine. The cameraman's struggle with the tripod exploits a standard comic motif, the animation of the inanimate world, in order to draw attention to the skills required by those

working in the film industry. Because of its delicate mechanisms and lack of stability, the tripod must be handled with care, just as the cinema needs professionals to control its possibilities. The analogies between the equipment and the entire industry are extended to the human participants when the cameraman's excursions into the streets prove that crowd control must take place not only on the screen but on location as well. The unruly behaviour of the passers-by and their curious glances toward the camera confirm the need for the controlled environment of the film studio. Given these adverse conditions, and the implicit suggestion that only artificiality can produce an illusion of reality, it is not surprising that the encounter with the real world ends with the cameraman's involuntary jump into the water. Behind the comic effects stands a more serious interest in self-promotion that becomes evident in the conscious appeal to the spectator's expectations, including their need for perfect illusionism, and to standards of quality that can only be achieved through the professionalization and institutionalization of cinema. What is referred to as the 'difficulties of the profession' thus draws attention to the achievement that this particular film represents. Obviously, Mack and his collaborators have followed all the necessary steps in the making of a film; obviously, they have solved all problems with creativity and expertise. It is in this spirit of technical and creative accomplishment that the travelling shot at the end, which is almost experimental in the use of camera movement, gives a preview of attractions still to come. Whereas the narrative of THE UNEMPLOYED PHOTOGRAPHER is loosely structured around the man behind the (movie)camera, DIE FILMPRIMADONNA ('The Film Primadonna,' 1913) introduces a set of competing positions and perspectives. The Urban Gad film with Asta Nielsen in the title role shows a film star who leaves her place in front of the camera and takes control of the process of image production. In the first reel – the others are unfortunately lost – the film's self-referential qualities manifest themselves on two levels, through the protagonists and through extradiegetic references. The story of a production establishes the dramatic constellations in which the famous Ruth Breton is called upon to prove her screen appeal and her leadership skills. Supervising the making of her screen persona, she exhibits the confidence of someone in complete control; the provocative gesture of smoking in public is a measure of her appropriation of male privilege. More important still, the 'film primadonna' is well aware of the pleasures to be gained once the images of women are no longer exclusively in the hands of men. The film's spectators are invited to watch as she negotiates with the director, promotes an aspiring screenwriter, examines the first contact print, and suggests better camera angles to her cameraman. These different settings show the woman at ease with the technical side of cinema. Whether in the studio, the printing lab, or the producer's office, every encounter underscores her expertise. To prove her independence, the star in the film repeatedly takes advantage of the commingling of screen persona and public persona, for instance when she uses sexual allure to consolidate her position in a predominantly male world.

This kind of behavior has an equivalent in 'real life.' As an example of art imitating life, the casting of Asta Nielsen superimposes a web of extradiegetic references onto a

Asta Nielsen
and Urban Gad
on the set
(1913)

rare example of female empowerment. The circular construction of the star playing herself promotes an appreciation of cinema that requires familiarity with the dream factory and its self-fabricated myths. Nielsen was one of the first real stars of the German cinema, adored by the masses and the intellectuals alike; the many essays and articles devoted to the 'immortal Asta' bear witness to an almost religious cult that developed around her screen persona. She participated actively in all aspects of film production, supported by her husband and collaborator, the Danish director Urban Gad. Both aspects of the Nielsen phenomenon, her tremendous popularity and her authorial control, enter into the Ruth Breton character and instill a sense of complicity in the audience that goes beyond self-indulgent celebrations of cinema. By following the stages in a production and by privileging the woman's perspective, the film draws attention to the circumstances under which sexual difference comes to structure the cinematic gaze. At the same time, the figure of the glamorous star affirms the association of woman and cinema from the side of production – an approach that is both enlightening and mystifying, given her double role as a character and a celebrity. The vacillation between critical analysis and objectification bears witness to the very contradictions through which the cinema introduces itself as an alternative to bourgeois culture and its different notions of authorship and production, while at the same time aligning itself with consumer culture and its exhibitionist practices.

The most astonishing case of a cinema reflecting upon itself can be found in WIE SICH DAS KINO RÄCHT ('How the Cinema Takes Revenge,' 1912). Made by Gustav Trautschold for Eiko Film, the film takes aim at the cinema reformers and their fanatic campaigns against trash and smut. Its explicit purpose is to expose the hypocrisy behind the reformist arguments and, through a less obvious, but equally significant scheme, to bestow on the cinema an aura of moral rectitude. The discourse about cinema is doubly present, in the

narrative and as a film-inside-the-film; the spectators experience the conditions of production as well as the final product. Opening with a session of the 'Association for the Fight Against Cinematography,' the film takes its cues directly from reality, both in the cast of characters and the references to reformist discourse. When the main protagonist, Professor Moralski, speaks of 'muddy streams of immorality,' the phrase might very well be taken from one of the countless pamphlets against the 'movie plague' published during the early teens. Faced with such arguments, the producers in the film make it their foremost mission to expose the enemies of cinema to public ridicule. On the surface concerned with cultural legitimation, their project has clear economic motives. The expansionist ambitions of early cinema, after all, cannot be threatened by questions of morality. Thus 'Filmfabrikant Flimmer' (whose name already betrays the industrial nature of his business) hires an attractive young actress to seduce Moralski. She follows the professor to a 'Conference for the Fight Against Cinematography' at a seaside resort appropriately called Dummstadt (Stupidtown). A chance encounter on the beach turns into a lively conversation, with two cameramen documenting the scene from a distance. They record on film how the professor clandestinely takes off his wedding ring and joins the attractive stranger for a stroll. Later, the privacy of a wicker beach chair allows for more intimate caresses and inspires a convincing performance for the camera that completes the professor's moral downfall. The use of a binocular mask underscores the voyeuristic perspective which implicates the cinema, as well as its enemies, in the perverse pleasures of looking without being seen.

The close link between rigid morality and barely concealed lechery becomes glaringly obvious when Professor Moralski returns to his desk at home to write yet another speech against the cinema. His recollections of the encounter are still too vivid, and his desires too strong, to remain without adequate representation. They materialize in the ghost-like female figure which, through stop motion, appears in the door frame. The moment he tries to embrace the uncanny apparition, she turns into his matronly wife. Guilt and shame have once again triumphed as enemies of the imagination. Following the suggestion of an alleged supporter, Moralski decides to conclude his next public lecture with the screening of a 'trash film,' 'The Paragon of Virtue at the Spa.' Much to the shock and amusement of the audience, the film recounts the details of his own yielding to temptation. The film-inside-the-film shows the scenes at the beach for a second time, but now processed through the cinematic apparatus. According to the logic of the diegesis, the repetition of the scene underscores the difference between reality and representation. Through the means of framing and editing, the staged encounter on the beach has been transformed into a drama of eroticism; such is the meaning of the fiction effect. The reaction of the spectators to the film takes a different direction. Confronted with the revealing images, they experience a reality effect, so to speak. The shock of recognition forces the audience, including the professor's wife, to see the glaring discrepancies between theory and practice in the rhetoric of cinema reform. After that, only the cinema seems to be able to provide a place where morality, profitability, and eroticism can peacefully exist side by side. While the professor flees from

the scene, the announcement 'From tomorrow on daily: "The Paragon of Virtue at the Spa." Sensational hit. Amusing, educational!' celebrates the superior reality of cinematic fiction.[8]

The detective film WO IST COLETTI? ('Where is Coletti?', 1913), carries further this playful investigation of different levels of representation. The recognition of cinema as a production begins in the credit sequence where the participants are introduced in a way not uncommon for the early teens. Standing in front of a dark backdrop reminiscent of a theatre curtain, director Max Mack and scenarist Franz von Schönthan discuss the film script and then, as if in a magic trick, pull down the names of the actors (Magde Lessing, Hans Junkermann, etc.) in large white letters. Storytelling in the cinema, the opening implies, requires a close collaboration between director and scenarist and must be seen as a construction, not a reflection of reality. The credit sequence prepares the ground for the film's narrative project, a demonstration of how modern mass media influences the perception of reality. Irony and travesty provide the main strategies of self-doubling. In its use of generic conventions, Mack's film offers an interesting variation on the detective film. The detective no longer looks for suspects, gathers evidence, and tries to reconstruct the crime. Instead, he becomes the focus of the investigation, initiating a frantic search and reversing the genre's epistemological objectives in the process. Provoked by an open letter, Coletti decides to prove the impossibility of finding a particular person in Berlin, the city of millions. His strategy: to distribute 'wanted'- posters all over town, to offer a reward of 100 000 marks for information leading to his capture, and then to disappear for 48 hours. Committed to elegance and style, Coletti goes to a portrait photographer to have his picture taken. And obsessed with accuracy, he seeks the help of a quack physician to take his body measures according to the Bertillon system. However, behind the parody of the detective genre, a more far-reaching project takes shape. It concerns the dissemination of mass-produced images into all areas of modern life. The traditional notion of what constitutes reality is supplanted by a more precarious relationship between the simulated and the real that demands constant attention from the audience. As Coletti shows in his use of photography and film, any attempt to reconstruct a particular series of events is doomed to fail in the context of modern mass media. A chain of endless deferrals is set into motion through one initial act of re-presentation, here to be understood in the sense of making present that which is absent. Aware of the consequences, Coletti carries the process of simulation to its logical conclusion and asks his hairdresser to act as a stand-in. The fact that the double is soon afterwards recognized by passers-by only underscores the detective's claim that the 'fake' can be more authentic than the 'original.' A wild chase through the streets of Berlin follows which involves a growing number of participants and several means of transportation, including a double-decker bus and a zeppelin, and which illustrates the increasingly futile search for a reality based on physical presence. With this recognition, the participants and eyewitnesses return to the site of their own construction as spectators, the movie theatre, where highlights from the chase appear in a newsreel. Amidst the audience a delighted Coletti watches the performance of his double on the screen and enjoys the success of this little experiment.

Shooting WO
IST COLETTI?
(1913)

Again, a staged event has been endowed with the qualities of the real; again, imagination and desire have triumphed over the laws of probability. As WHERE IS COLETTI? sets out to prove, both processes are the work of the cinematic apparatus and its most eager collaborator, the audience.

Despite their differences, HOW THE CINEMA TAKES REVENGE and WHERE IS COLETTI? rely on similar strategies in foregrounding the cinema as a production. In both films, protagonists become protagonists in a film-inside-the-film: Professor Moralski without his knowledge and against his will, Coletti in an act of wilful deception and to his own amusement. Both films comment on the conditions of spectatorship by using the movie theatre as the setting of their most revealing moments. Time and again, the reaction shots of spectators give an indication of the diversity of audience responses (laughter, outrage, repulsion) and show the awareness of the difference between reality (i.e., the diegesis) and representation (i.e., the film in the diegesis) as a precondition for the enjoyment of cinema. Reflecting on their own status as public spectacle, both films tell a story and demonstrate how this story is told through the means of cinema. This self-referential quality develops almost naturally and with much playfulness, and it makes learning an integral part of the viewing experience. The aim is not to shatter the cinematic illusion but rather to increase its appeal. For it is precisely through the vacillation between critical distance and visual pleasure, between knowing and not knowing, that the cinema establishes itself as a powerful cultural and representational practice.

In the previous examples, the films-inside-the-films have a decisive effect on the narrative. The public screening confronts the diegesis with its own effects and, in so doing, draws attention to the politics of representation. Those in control of the new technologies overcome all adversities and emerge victoriously in the end. By contrast, those opposing technological progress for moral or political reasons are subjected to mockery. The positive

attitudes toward the new media find an almost programmatic expression in ZAPATAS BANDE ('Zapata's Gang,' 1914), another Asta Nielsen film directed by Urban Gad.[9] Announced as a 'film joke,' the film almost reverses the hierarchies between fiction and reality and offers a surprisingly modern perspective on the old problem of life imitating art. A motley group employed by the Nordland Film arrives in Italy for on-location shooting. Though the area has been terrorized by bandits, the film team is determined to finish another 'sensational hit.' They dress up as wild robbers and initiate a series of dramatic reversals that jeopardize their shooting schedule and fundamentally put into question the very definitions of role-playing.

Extradiegetic and metadiscursive references inform visual and narrative strategies from the very beginning. The company's name recalls the Nordisk company where Gad and Nielsen produced their greatest hits. The glamorous star of Nordland not only exudes the same liberated eroticism associated with Nordisk's main asset, Asta Nielsen, but is in fact played by the actress herself. When Nielsen points to her high leather boots, the essential piece of clothing for a convincing robber, she consciously displays her slender body as the site of an androgynous sexuality and, through this suggestive play with sexual difference, initiates a more complicated process of doubling. Its implications are spelled out as soon as the film team begins on-location shooting. On one level, the rustic setting inspires many humorous touches. The actors' search for privacy in their makeshift dressing rooms is depicted in all its absurdity, a comment also on the theatre and its stiff formality. Their theatrical gestures appear completely out of place in the serene Italian countryside and indirectly confirm the higher reality associated with the film world. On another level, the similarities between bandits and actors provide the basis on which the drama of mistaken identity unfolds. While the real robbers leave the area, the film actors apprehend a coach, thereby showing off their acting skills and confirming the almost uncanny realism of screen acting. The passengers, a countess and her pretty daughter Elena, return to the village in horror. News of the robbers' most recent attack spread like wildfire, and the panic reaches new heights when seven hotel guests – the film crew – are reported missing. Defenceless against these rumours, the actors decide to play their parts rather than resist the power of the imagination. These events are complicated by Elena's growing infatuation with the handsome young man played by Nielsen. While the *Hosenrolle* (i.e., a woman playing a man's part) introduces the possibility of female homosexuality, its association with an act of misrecognition disperses any possible fears of sexual transgression; rejected, the young countess simply turns to the next 'man.' The flirtation with role-playing comes to an end once the false robbers are arrested by the local carabinieri and face severe punishment for deeds they have not committed. Only the arrival of the Scandinavian consul (as the *deus ex machina*) resolves the situation, and the crew returns back home: 'Without a film but rich in experience,' as the intertitle notes.

The films discussed in this essay show a surprising willingness to experiment with the cinema's formal and narrative possibilities. As they explore the difference between

Ernst Lubitsch

fiction and reality and as they test the powers of simulation, they prove their ability to distinguish between the two and make the awareness of this difference integral to the pleasures of cinema. While generic conventions, cultural traditions, and sociosexual stereotypes define the conditions under which this kind of self-referentiality takes place, the sheer enjoyment of the apparatus generates enough momentum for an exploration of cinema on its own terms.[10] The breaking of the illusionist conventions draws attention to the constructed nature of narrative and invites the spectator's active collaboration; this process has affirmative and critical functions. Evidence of the need to define the parameters of production and reception can also be found in other national cinemas; however, I suspect that the Wilhelmine cinema had a special interest in the affirmative, if not educational, aspects of self-referentiality.[11] Confronted with the relentless attacks by cinema reformers and literary critics, the cinema used the references to filmmaking in order to facilitate critical analysis, thereby almost imitating modernist forms of self-reflexivity, and to provide the cultural legitimation that justified its integration into middle-class culture. The high degree of self-awareness that characterizes these films contradicts widespread notions about the early German cinema as being primitive and not worthy of close analysis. Instead of limiting film to the aesthetics of the theatre, the strong emphasis on mise-en-scène provides – quite literally, as the preoccupation with staging and screening suggest – a framework in which self-referential qualities continue to flourish despite the growing emphasis on narrative continuity and cinematic illusionism. The emergence of the feature film around 1910 led to a further standardization of filmic means; so did the controversy surrounding the film drama which thematized the tension between spectacle and narrative in unambiguous terms. The concomitant process of economic concentration and specialization in the film industry necessitated the creation of a positive image of the industry and transformed the cinema into an object of pleasurable and critical appreciation.[12] Within these configurations, the duplication of the cinematic apparatus made possible the re-presentation of film production and spectatorship in narrative terms and gave rise to the cinema's emergent discourse about itself.

Of Artists and Tourists: 'Locating' Holland in Two Early German Films

Ivo Blom

In the Desmet collection of the Nederlands Filmmuseum, two remarkable German fiction films can be found, DES MEERES UND DER LIEBE WELLEN (1912) and AUF EINSAMER INSEL (1913). Each was shot in a well-known Dutch tourist attraction: Volendam, where Christoph Mülleneisen filmed DES MEERES UND DER LIEBE WELLEN for Dekage, and the Island of Marken, where Joseph Delmont did location work for AUF EINSAMER INSEL, an Eiko production. These two German 'adventures' in the Netherlands are no isolated cases, for they are part of larger trends: the emergence of artists' colonies at sites of outstanding beauty, and the simultaneous expansion of cross-border tourism at the turn of the century. What this essay sets out to do is to evaluate this conjuncture in the context of another emergent expansion, that of the cinema, hungry ever since its beginnings for new locations and exotic places. The argument will be that artists and tourists, but also the international film industry, all 'discovered' the pictorial qualities of 'unspoiled' locations like Volendam and Marken, each institution or industry creating a discourse, and each discourse sustaining the values and status of the others, in a process that has remained typical for the triad art-tourism-cinema ever since, helping to define both European cinema and 'Europe' for the cinema. In the specific case of DES MEERES UND DER LIEBE WELLEN and AUF EINSAMER INSEL, one not only can recover the traces of the gaze of the tourist and that of the artist, but also observe a crucial definition of 'Holland' taking shape.

The Discovery of Volendam and Marken

When Mülleneisen and Delmont arrived in Volendam and Marken, these little towns had already become tourist resorts, and a specific image existed of these places and their inhabitants. The French art historian Henry Havard can be considered the discoverer of the little towns at the former Zuiderzee (nowadays the IJsselmeer). Already in 1874, he characterised the fishermen of the Zuiderzee in his travel account *La Hollande pittoresque, voyage aux villes mortes du Zuyderzee*:

> The way they are squatting down, oriental-like, smoking their pipes taciturn, immobile and indifferently, and their gaze wandering around aimlessly, they possess rather the appearance of Turkish fatalists, instead of Dutch fishermen. Everything in their looks contributes to this illusion, certainly in the first place their wide trousers, their slippers, which they place in front of them when squatting down this way, and their caps which mostly look like turbans.[1]

Havard's travel account became immensely popular. A Dutch translation appeared in 1876, a German one in 1882, and an English one in 1885. His book gave the starting signal for making the cities around the Zuiderzee a complex symbol of the Zeitgeist, combining nostalgia for obsolete crafts and places that time forgot with a taste for the exotic, colourful and unknown, as signalled by the reference to orientalism.

In the beginning this discovery was one made by artists. As early as 1875 the Englishman George Clausen visited Volendam and Marken with Havard's travel book in his hand, and a little later, partly due to exhibitions of work by Dutch and foreign artists, the upcoming tourist industry seized on such places. Volendam in particular became an obligatory excursion for each foreign tourist visiting the Netherlands. At the same time, in Volendam, as in other Dutch locations like Laren, Domburg and Bergen, a true artists' colony sprang up and stayed there until the outbreak of World War I.[2]

Spaander
The discovery of Volendam, however, did not happen solely on the basis of travel accounts and views of the town painted or sketched by artists. Leendert Spaander, a local entrepreneur, played an important role by providing bed and board for the first foreign artists who had come to Volendam, still lacking suitable hotel accommodation. Opening his house to visitors, which got the nickname 'De toevlucht' (the refuge), Spaander proved himself not only an amateur of the arts but also a shrewd business man with a good instinct for public relations. In 1881 he bought a local bar, converting it into the Hotel Spaander, which is still in existence today. In 1895 Spaander took his daughters to the opening of an exhibition of the Dutch artist Nico Jungman at an art gallery in London. For this occasion he dressed the two girls in the typical costumes of Volendam. This stunt caused a stir. He had postcards printed of Volendam and of his hotel and had them sent to all the foreign art academies. He also ran ads for his hotel with the Holland-America shipping line. At the hotel, Spaander put typically Volendam interiors at the disposal of the artists and, also for a fee, organized artist models. His own daughters would often pose for artists, and as a result, three of them married foreign painters. Spaander bought land at the back of his hotel in order to build studios for artists who might want to stay in Volendam for longer periods. The majority, however, only came on a passing visit, especially during the summer months. Unpaid accounts were occasionally settled in exchange for paintings, giving Spaander a chance to amass an enormous art collection. In turn, these paintings – along with the sights – attracted the tourists, and his hotel became crowded by guests from all continents. From Spaander's visitors' books one can deduct that even millionaires like Carnegie and members of the royal family stayed there. Filmmakers, too, show up in these visitors' books.[3]

Accessibility and Attraction of Volendam and Marken
For a long time, Volendam remained a remote fishermen's town and Marken, being an island, was almost totally inaccessible. In 1873 Havard had to navigate the coast of the

Zuiderzee on a tjalk (barge), a mode of transport in use until the end of the 19th century. From 1888 on a steam tram from the Noordhollandsche Tramwegmaatschappij travelled from Amsterdam to Edam and back. From Edam one took the old tow-boat to Volendam. In 1905 a special service was installed for the tourists, called from 1906 onwards the 'Marken-express,' which provided a roundtrip from Amsterdam via Marken and Volendam. All manner of transport was used en route. By steamboat the tourists crossed the IJ behind Central Station at Amsterdam. There, at the Tolhuis (toll-house) station, one took the steam tram to Monnickendam. At Monnickendam the motor boat of the Markerveer (Marken ferry) would be waiting. From Marken one sailed by botter (fishing boat) to Volendam, where a quick lunch was ready at Hotel Spaander. The tour continued with the tow-boat to Edam, from whence the steam tram took one back to Amsterdam, completing a day trip in the American tempo.

Due to the diminishing returns from fishing and the threat of the Afsluitdijk, the dyke being built to close the Zuiderzee off from the open sea, the villages and towns came, by the turn of the century, to resemble dead cities. Yet it was precisely this dilemma which created the anachronistic popular culture of Volendam and Marken to which artists were mainly attracted, seeing how the life there contrasted with the industrialisation and modernisation of major Dutch cities like Rotterdam and Amsterdam, and of foreign capitals. The untouched character of the Zuiderzee villages was praised. The gaudy colors of the costumes of the inhabitants and the wooden houses with their doll's house interiors, especially in Marken crammed with decorative plates and knick-knack, spoke to the imagination of the foreigners.

Typical for this period is the determining way in which these surroundings were associated by artists, writers and tourists alike with an idealized image of humanity. The people from Volendam were thought of as pious, honest, healthy and happy, satisfied with little and mercifully ignorant of social problems such as alcoholism, which plagued big city inhabitants (in the films of Delmont and Mülleneisen, the fishermen are not portrayed in such a positive light). One preferred to pass over the poverty and the poor housing of the fishermen, and the artists who worked on Volendam's and Marken's nostalgic image had to do some retouching of social reality, in order to associate these places credibly with a past, that of the Dutch seventeenth century painting. The trend for painting in the open air and thus the need to visit the locations and the skies of the old Dutch masters, had driven foreign artists to Amsterdam and the North Sea. But when coastal locations like Scheveningen and Katwijk became too fashionable, the gaze inevitably turned to the unspoiled places at the Zuiderzee.[4]

The Cinema and Couleur Locale
Because of the improved infrastructure alluded to above, it had become feasible and attractive for camera crews to reach Volendam and Marken. Already in August 1900, the Dutch production company Nöggerath took pictures of a naval review on the Zuiderzee, attended

by Queen Wilhelmina, and in 1901 Nöggerath released a film about 'the island of Marken.' In 1906 American Bio-Tableaux, a successor to the Dutch branch of the American Mutoscope & Biograph Co., took footage of Volendam and Marken. Before long, other Dutch companies like Alberts Frères and Hollandia followed. Furthermore, Dutch crews were not the only ones present at Volendam and Marken. Between 1909 and 1914 the Netherlands as a whole were a favoured subject for travel films made by foreign production companies, with French (Raleigh & Robert, Eclipse), British (Cricks & Martin, Kineto) and Italians (Pasquali en Comerio) also filming the Zuiderzee towns. As usual, its was Pathé Frères that took the lead, finding here inspiration for several documentaries: UNE JOURNÉE À L'ÎLE DE MARKEN, EN HOLLANDE – LE PORT DE VOLENDAM, COIFFURES ET TYPES DE L'HOLLANDE and ENFANTS DE HOLLANDE, the last two partly shot at Volendam, and all of them released in 1910.[5]

These documentaries were probably shot by the French filmmaker Alfred Machin, who is known to have stayed in Volendam in September 1909. His signature has been discovered with that date in the visitor's book of Hotel Spaander. Machin returned to Holland during the autumn of 1911, where he used the history, the culture and the landscape of the Netherlands for a series of short fiction films. At Volendam he shot, partly in an open air studio behind the Hotel Spaander, several fishermen's dramas. The first to be released (though not the first to be shot) was HET VERVLOEKTE GELD (L'OR QUI BRÛLE, 'The Cursed Money'), with the famous Dutch theatre actor Louis Bouwmeester in the leading part. For the other films only foreigners were employed, with actors and the crew coming partly from Belgium but mainly from France. Two painters, the Belgian Henri Cassiers and the Frenchman Augustin Hanicotte, were present during the shooting. Possibly they advised Machin on the authenticity of the pictures to take, as they were both residents of Volendam and had made it their main artistic subject matter. Machin's films added a dimension to Volendam as a film subject because he made it the setting for fiction films shot on location.[6]

DES MEERES UND DER LIEBE WELLEN *and* AUF EINSAMER INSEL

A year after Machin had shot his films at Volendam, a second film crew appeared on the doorstep of Hotel Spaander with the intention of shooting a film. In Spaander's visitors' books one finds that from 16 to 20 November 1912, a certain Christoph Mülleneisen from Cologne was in residence in order to take pictures for DES MEERES UND DER LIEBE WELLEN, a film begun in Italy.[7]

According to the intertitles in the film copy, however, the story is initially set in Spain and not in Italy. The actual locations of the opening scenes on the other hand, remind one of Italy, however. The discrepancy can be explained by briefly summarizing the plot. DES MEERES UND DER LIEBE WELLEN is the story of Venila, the daughter of a Spanish captain, who falls in love with sailor Pietro. The captain illegally transports gunpowder to Scotland and conceals this fact from the insurance company. A jealous first mate sets the boat on fire and steals the insurance policy. The captain commits suicide, his daughter escapes with

the sailor on a raft. They are washed ashore at what the intertitles indicate is the Dutch isle of Urk (but is in fact Volendam). The first mate is also washed ashore. Fishermen rescue them and put Venila in the traditional costume of Urk (in reality a typical Volendam outfit). On his deathbed, the first mate repents and hands over the policy to Venila, who is now financially able to marry Pietro. After a wedding in typical folkloristic style, the couple sets sail for Spain again, waving goodbye to the locals.[8]

A year after the 'expedition' to the Netherlands by Mülleneisen, the German director Joseph Delmont came to Holland to shoot two films. These were the crime story DER GEHEIMNISVOLLE KLUB, shot at Rotterdam, Scheveningen and possibly Amsterdam, and the fishermen's drama AUF EINSAMER INSEL, shot on Marken. Delmont was a specialist in exotic films. According to his autobiography, he had, as early as 1902, taken part in travels around the world to take pictures. For his films he always looked for authenticity, getting irritated by the way others were faking it in Africa:

> In particular with regard to the festivities and dances of native tribes the most impossible fakes have been foisted on the cinema public. (...) To portray the people, the fauna and the flora of a strange country on the films one needs time, more time and still more time. No producer or cameraman ought to attempt such a film without the help of an expert, if he wants to obtain a picture of real cultural value.[9]

It is not known where exactly Delmont stayed at Marken. At the time, there was only one hotel on the island, Hotel De Jong, but no visitors' book or other sources have remained. But if he did not stay on the island and went ashore each night, there is nevertheless no signature by his hand in the visitors' book of Hotel Spaander. Possibly he stayed at another Volendam hotel, given that since 1905 a second one was managed by Frits Veldhuizen.[10] Delmont must have been at Marken for quite some time, because his film was a three-acter, a feature-length film in those days. Mülleneisen's film was also longer than the films Machin shot at Volendam, averaging less than 350 metres, the maximum length of a one-act 'one-reeler.' If Mülleneisen's film (of which only the scond part was set in Volendam) needed four to five days' location work, then Delmont must have been filming at Marken for close to two weeks, since his picture is entirely set there, with many outdoor shots. The interiors were done in the studio, as was probably the case with Mülleneisen's film. We know that Delmont used the Komet Film studio in Berlin.

AUF EINSAMER INSEL, just like DES MEERES UND DER LIEBE WELLEN, is a love triangle. The rich fisherman Pieter (Fred Sauer) is after the beautiful and equally rich Sijtje (Mia Cordes), but she only has eyes for his mate, the poor fisherman Dirk (played by Delmont himself). Her father, of course, prefers Pieter, who sabotages the boat on the high seas, leaving Dirk to drift out of control, until he reaches a desert island. Claiming an accident, Pieter pretends Dirk has perished and marries Sijtje. Dirk is saved by a foreign ship, just as he is about to kill his loyal dog for food. Years later, he returns to his village, in time to

defend Sijtje and her little daughter against Pieter, now an alcoholic and a wife-abuser. In a drunken fit, Pieter sets his own boat on fire while at sea. Dirk tries to save him, but in vain, so that after the funeral, Sijtje and Dirk can be together at last.

Class Distinctions

At first sight AUF EINSAMER INSEL and DES MEERES UND DER LIEBE WELLEN have much in common. Both have a 'good guy,' a 'bad guy' and 'the woman in the middle,' and in both, good triumphs over evil, and evil is punished by death. The rival disappears, so the hero gets the woman. However, besides the rival, other elements function as obstacles blocking the relationship. In AUF EINSAMER INSEL, class distinctions thwart the course of love: Sijtje's rich parents try to match her with another rich fisherman, with the hero compensating class by a doubly selfless act, defending a woman and child against a brutal husband, and trying to save the life of a man who was his deadly enemy. In DES MEERES UND DER LIEBE WELLEN the difference in rank or class is still there: the 'bad guy' is first mate, the 'good guy' is merely a hired hand. Venila's father dies during the shipwreck and is thus spared having views about a captain's daughter being in love with an ordinary sailor, who – as in AUF EINSAMER INSEL – defends the woman against unwanted advances and saves her, showing himself worthy by virtue of his strength and dedication.

If class distinctions can be bridged by moral heroism, differences in wealth are resolved by melodramatic solutions. Venila cannot marry her sailor for lack of money, a problem the film solves by the rival turning up with the valuable insurance policy and conveniently showing remorse before dying. In AUF EINSAMER INSEL Dirk's years away in the United States and his fancy clothes suggest a man of means, thus removing the financial barrier. In this respect, both films are typical examples of early German cinema, where conflicts of class and social status are frequently either the dominant or subsidiary cause of melodrama.[11]

Authentic Setting and Deep Staging

What distinguishes the two films under discussion is the role played by the location. The Dutch version of DES MEERES UND DER LIEBE WELLEN, for instance, was called EEN SCHIPBREUK OP DE HOLLANDSCHE KUST ('A Shipwreck on the Dutch Coast'). On the other hand, since 'Urk' was the name of the island in the German release version, it would indicate that no clearly identifiable location was intended. Rather, a more general image of 'Dutchness' prevails, with 'couleur locale' rather than documentary truth being the usual way the Zuiderzee culture was represented. Already in 1875 George Clausen caused a stir at the Royal Academy in London with his painting *High Mass at a fishing village on the Zuyderzee*, which depicts Volendam fishermen in front of the church of Monnickendam.

In AUF EINSAMER INSEL the location of Marken is nowhere mentioned in the intertitles, nor does the German trade press give a specific location.[12] Nonetheless, the un-

mistakeably Dutch names of the characters must have given German audiences enough of a hint that the film was set in Holland, and in some trade papers the subtitle 'A drama in 3 acts from modern Holland' gave added confirmation.[13]

Location

In both films, therefore, great pains have been taken over the authenticity of locations and props, evident from the interior scenes, shot in German studios. As was the habit of passing artists as well, the two film crews probably bought souvenirs on the spot in order to dress the studio sets later, giving the interiors their rather credible look. In DES MEERES UND DER LIEBE WELLEN the first interior scene once the protagonists arrive in Holland is almost emblematic. On the back wall hang: a clock, a poker, a mirror, small paintings with genre images (among which a picture with a little girl followed by a cockerel and one with a boy followed by a goose) next to a sideboard filled with decorative plates. On the floor are two kitchen chairs with rush-bottomed seats and a chest with an imitation of the famous *L'Angelus* by Jean François Millets painted on it.[14] The people present are in typical Volendam costumes. The man smokes a stone pipe and wears the characteristic cap. In the interior scene with the dying first mate, the two small paintings just mentioned return in the setting. Decorative plates are again visible above the alcove where the man is lying. Landscape scenes cover the wall, next to an oil lamp and a candle on a stick. The interiors are modest and reflect the limited means of the little houses of Volendam.

The interior of the living room of Sijtje's family in AUF EINSAMER INSEL is much larger, connoting a wealthy family. The room is filled to the brim with ornamental plates and is generally bulging with objects, furniture and bric-à-brac, thus conveying the super-abundance and 'horror vacui' typical for Marken, where people cover the walls up to the ceiling with plates, paintings and prints, and place buffets and etagères against the walls to

Historical Dutch interior, ca. 1910

De ... Visscher

AUF EINSAMER INSEL
(1913)

show off their knick-knacks. The Marken interiors, however, are all extremely small in size, in contrast to Delmont's film, which wants to suggest wealth by size. Here, too, the persons wear the typical Marken costume, such as the richly embroidered jackets and the small bonnets.

The feeling for space recurs in Delmont's film also in the exterior scenes. It can be related to his style. While Mülleneisen's film has modest, small sets that look quite flat due to frontal staging, Delmont always seeks out diagonals in his compositions. This gives the exterior scenes the impression that Marken must have been quite a large fishermen's town (which it was not), echoing the interiors where actors navigate space without bumping into the furniture, something which could be a problem in an authentic Marken interior. It suggests that one of the major contributions of Delmont's style is his feeling for staging in depth, helping to demolish the barrier between the films of the teens and the spectator of today.

The tight and simple sets in DES MEERES UND DER LIEBE WELLEN are probably closer to the reality of Volendam than AUF EINSAMER INSEL's handling of space is to the reality of Marken. The former's sets, however, give the impression of having been made cheaper and faster, and hint at a more traditional production. Delmonts' sets and camera angles indicate a change in style and mise-en-scène that is all the more remarkable considering that AUF EINSAMER INSEL was produced only one year after DES MEERES UND DER LIEBE WELLEN.

Space and perspective stand primarily in function of the film and help to create a reality on its own. But the many location shots and deep staging in the interior scenes also refer to a second reality, that of a Dutch fishermen's island as fixed by foreign artists and the tourist industry, and bearing only a tenuous relation to life on Marken in the year 1913. AUF EINSAMER INSEL and DES MEERES UND DER LIEBE WELLEN thus invite comparison with the Zuiderzee iconography from the plastic arts.

Representation of the Zuiderzee in Germany

From the 1880s onward, Holland was fashionable among German artists. They commended the Dutch light, the Dutch skies, the locations of the old Dutch masters, responding to the urge for 'plein air' painting. The village of Katwijk on the North Sea coast was not only popular with Dutch artists like Jozef Israëls, but also with German painters like Hans von Bartels, the epoch-making German impressionist, who toured the Netherlands from Katwijk and spent ten weeks in Volendam in 1893. Max Lieberman stayed at Katwijk also, but painted little of the Zuiderzee except at Edam. He preferred Amsterdam and the places by the North Sea: Zandvoort, Katwijk and Noordwijk, depicting scenes of the elegant life on the beaches of Scheveningen. Nonetheless, in tracking the iconography of 'Dutchness' in AUF EINSAMER INSEL, Heide Schlüpmann rightly refers to Liebermann.[15] Even if he never painted either Volendam or Marken, Liebermann may have inspired Delmont in more than just the use of light and spaciousness. Think of the oils and watercolors by Liebermann like the painting The Menders of Nets (1887-1889) and a gouache with the same title (1898), both showing women at work in Katwijk.[16] More solid evidence for a history of this iconography might be the fact that well before the German translation of Havard's travel journal appeared in 1882, the German painter Rudolf Jordan had visited the island of Marken in 1844, where he was overwhelmed by the colourful costumes: 'The costumes, the costumes, the costumes O! Ah! Hurrah! Heavenly! I'll paint heads. Ah, the costumes! Ah, my good folk! They'll give me everything I need.' Jordan took costumes or accessories home in order to put them on models, who would pose for his paintings. This gave rise to some fantastical ensembles, including errors in authenticity like bonnets worn back to front.[17]

With the rise of tourism to the Dutch North Sea resorts and villages in the 1880s, numerous German artists looked to the Zuiderzee for 'virgin territory' and moved to Volendam and Marken. They were by no means the most insignificant ones. Hans von Bartels and Carl Jacoby showed their Zuiderzee pictures at the great annual exhibitions in Brussels, London, Paris, Berlin and Vienna, winning several medals with them. Their work received positive reviews and sold well, especially to private collectors. Another famous painter was Georg Hering, a pupil of Lovis Corinth, who established himself in Volendam in 1910 and married one of Spaander's daughters, Pauline. Many of these artists worked in a style that was halfway between romantic realism and an impressionism related to the Haagse School. At the beginning of this century, this style became a cliché for lack of renewal, but continued to find a ready market until the outbreak of the World War I, thus providing a 'common knowledge' base for German audiences about these Zuiderzee villages. Delmont and Mülleneisen must have been influenced by this representation, considering how clearly certain images of their films refer to late nineteenth and early twentieth century genre painting. Even at the time, the Austrian film magazine *Die Filmwoche* noted:

> So it was an excellent idea to leave for once our Fatherland and make a trip to
> Holland whose picturesque landscapes and magnificent costumes provide a col-

ourful context for the events of the drama, which greatly adds to its attraction. This is another proof that Joseph Delmont is not only a versatile director but also possesses much sensitivity for pictorial effects. He has succeeded in creating some attractive genre pictures and recorded on film some of the most interesting national customs.[18]

Both Mülleneisen and Delmont create an image of the Zuiderzee as something archetypical, underlined by neither indicating an exact location: the classical Dutch fishermen's village, where everybody is dressed in costume and the men wear clogs, drink Dutch gin and suck on a pipe, while the women wait patiently at the harbor quay, with their sons or husbands out on the perilous high seas. A similarly archetypical image of the Netherlands could be found in the films of Alfred Machin, so much so that the Dutch popular magazine *Het Leven* featured an article in 1911 fiercely protesting against these foreign 'windmills and clogs films' which created the impression Holland had nothing more to offer than folkloristic types and surroundings. On the other hand, these foreign productions exercised an important influence on the young Dutch fiction film industry. When the film company Hollandia started producing fiction films from 1912 on, these were indeed mainly fishermen and millers' dramas, reproducing the same folkloristic image of the Netherlands (DE LEVENDE LADDER ['The Living Ladder'], 1913, OP HOOP VAN ZEGEN ['The Good Hope'], 1918] or was even parodied (TWEE ZEEUWSCHE MEISJES IN ZANDVOORT ['Two Girls from Zeeland at Zandvoort'], 1913).[19]

Yet it is important not to project the overfamiliarity of the Zuiderzee iconography today on DES MEERES UND DER LIEBE WELLEN and AUF EINSAMER INSEL. These films are representative for a period of iconographic innovation, where places like Volendam and Marken were still exotic locations, before becoming typical, even stereotypical for the Netherlands, partly due to the very popularity of such films and their close alliance with tourism and the mass consumption of cliché or myth. With the outbreak of the war, the stream of foreign artists, filmmakers and tourists stagnated, and the Zuiderzee iconography lost favour with the cinema and the plastic arts after the war. As a reaction to the mass-tourist image, Dutch cinema made the villages at the Zuiderzee once more an 'issue' in the thirties, now focussing on the social cost of the closing of the Zuiderzee and the forced shift to agriculture, at a time of agricultural crisis. Losing much of their careless exotic and idyllic character, the villages became the settings of social dramas like Gerard Rutten's TERRA NOVA (1932) and DOOD WATER ('Dead Water,' 1934) and social documentaries like Joris Ivens' NIEUWE GRONDEN ('New Land,' 1934). Yet internationally, the images which Mülleneisen and Delmont helped to consolidate have survived, obliging these places to 'live up' to their own myth, and thus proving the strength of the cinema in putting into circulation its own versions of reality, even in the face of reality.

Stylistic Expressivity in DIE LANDSTRASSE

Kristin Thompson

Expressivity in the Teens

Over the past decade, historians have begun to find the teens an extraordinarily rich field for exploration by film historians.[1] A decade previously summed up by CABIRIA, THE BIRTH OF A NATION, Thomas Ince, Charlie Chaplin, and the early Swedish cinema has now revealed an enormous international variety previously little suspected.

Older histories also treated the teens simply as the period in which the cinema gained an ability to tell a clear story, primarily through continuity editing. During this era, films supposedly went from being theatrical to being 'cinematic' through an increasing use of editing and camera movement. Yet these two techniques have been privileged only in retrospect. At the time, filmmakers presumably felt free to explore all cinematic techniques, including acting, the long take, and depth staging in their quest to tell stories more clearly and expressively.

It is that expressivity upon which I wish to focus here. It is one thing to tell a story clearly, and no doubt most of the filmmakers' efforts were concentrated on that task, at least during the first half of the teens. But a filmmaker may aspire to go further, enhancing the impact of his/her presentation of events. I have argued elsewhere[2] that from about 1912 onwards, there was an increasing move by filmmakers in many countries to investigate all the expressive possibilities of the new art form.

For some reason, that move seems to have gained a sudden intensity in 1913, a year in which an extraordinary number of rich and inventive films appeared. Among them was Paul von Worringen's early German feature, DIE LANDSTRASSE, which vividly exemplifies the search for expressive filmic style. The film was long lost and eventually rediscovered in the Desmet collection of the Nederlands Filmmuseum. It was perhaps the most important revelation of the pre-1920 German retrospective at the 1990 festival, Le Giornate del Cinema Muto, in Pordenone, Italy. In this essay, I propose to analyze two aspects of the film's style that seem to me unusual for the cinema of the early to mid-teens: first, how similar framings are used to create parallels between the murderous escaped convict and the wandering tramp mistakenly accused of his crime, and second, how long takes of a type completely atypical for American (and most other) films of the era are used to create a slow rhythm for certain stretches of the film. Frank Kessler has previously commented on the film's narrative structure and some aspects of its style.[3] I shall try not to duplicate his excellent analysis but rather make some additional points about DIE LANDSTRASSE.

I should note before setting out upon my analysis that the only surviving ver-

Fig. 1 Fig. 2

sion of DIE LANDSTRASSE is an original Dutch distribution print in the Desmet collection of the Nederlands Filmmuseum. It is difficult to say how closely it conforms to the original German version. Indeed, there seem to be at least two portions in which significant footage is missing. The nightclub scene during which the police attempt to arrest the convict is most confusing – something that is not typical of the rest of the film – and probably there were some shots at the beginning setting up the presence of the police and convict. Similarly, immediately after the convict first walks along the main road in the village, he is seen sitting eating in the woods (Fig. 1). Then abruptly, he is back in the village. In the original print, the latter shot is tinted in blue, indicating a time lapse to night. Basically, it would seem that after the convict finds some coins in the farmer's purloined suit, he goes into town, and buys (or perhaps steals) some victuals in a missing bit of footage. He then returns to the countryside in order to eat it. The next shot represents his return to the village that night in order to find a place to sleep (the hay-loft of the farm). Fortunately, such lacunae seem relatively limited, and hence it is still possible to make some observations about the film's style.

Spatial Motifs

DIE LANDSTRASSE works largely through parallelism, introducing two characters of roughly equal importance who do not actually meet until the very last scene. (The exceptions are only apparent: Unnoticed by the tramp, the convict watches him through a window as he climbs down from the loft, and at that point the two do appear briefly in the same shot. But even at the trial of the tramp, the presence of the convict among the spectators is not revealed until after the tramp is already out of the room.) Yet once the tramp is introduced, the two men's actions are systematically compared, not only because they often behave in comparable ways (both limp, for example), but also because the framings, camera angles, directions of movement, and so on are often remarkably similar.

This notion of using motifs based on the camera's spatial orientation on the action was a sophisticated and fairly novel one. D.W. Griffith had used simple versions of it in some of his Biograph shorts. The first and last shots of THE COUNTRY DOCTOR (1909), for

example, consist of 'bookend' pans in reverse directions across the same bucolic landscape - a suggestion of life continuing despite the events of the plot. More famously, THE MUSKETEERS OF PIG ALLEY (1913) uses a motif of offscreen space at several key moments. Directors in other countries were also occasionally exploring filmic motifs. Victor Sjöström plays on variations of depth in scenes of characters standing on a ferry landing or on the ferry approaching the landing in TRÄDGÅRDSMÄSTAREN ('THE BROKEN SPRING ROSE,' 1912).[4]

Such motifs, however, remained rare indeed in an era when filmmakers were still working out ways of keeping the spatial and temporal relations between shots clear while telling a comprehensible story. Today, when this sort of visual echoing has become a staple of the art cinema, such films can look remarkably 'modern' in comparison with other works of their day.[5] This is certainly the case with DIE LANDSTRASSE, whose methodical repetitions and occasional long takes almost seem to look forward to the work of Bresson, Angelopoulos, or Kiarostami.

DIE LANDSTRASSE creates parallels between its two main characters, a vicious escaped convict and an apparently simple-minded tramp who is accused of a murder committed by the former. The reason for these parallels is less clear, since the traits of the two men are quite different: the convict is a cold-blooded killer who allows another man to take the blame for his crime; the tramp is a harmless man trying to scrape out a living. I suspect that the parallels are evoked in order to create precisely this ironic contrast between the two and to suggest how easily a simple, unpretentious life can be disrupted. If so, DIE LANDSTRASSE falls easily into the early phases of what was to emerge as the 'art cinema' in the post-war period. Certainly, such thematic material would fit into the short-lived but prestigious *Autorenfilm* of the German cinema of the early teens.

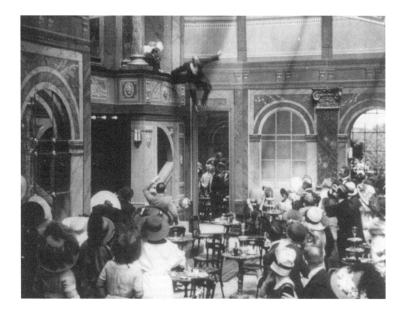

Fig. 3

Fig. 4 Fig. 5

Kessler has pointed out parallelisms created by repetitions of setting and action, as when the tramp and the convict both climb into the loft of the house where the murder occurs:

> The *mise-en-scène*, too, constantly refers one storyline to the other and is supported by the construction of a homogeneous diegetic space. Thus, when the tramp breaks in, he follows the same path as the prisoner before him, and the scenes are repeated to a certain extent, which creates a stronger impression of *déjà vu*. The same is generally true for the way in which the same locations appear and reappear throughout Acts II and III: the barn, the farmyard, the loft, etc.[6]

For Kessler, these parallelisms are important because they result from the crosscutting that characterizes the first three acts of the film but disappears in the last two.

Such repetitions are quite insistent in the first three reels of the film. For example, the tramp's departure from the village takes him past the same pump where the convict had earlier taken a drink in a similar framing (Fig. 2). But even when the locations are different, the framing can set up an echo of an earlier scene. This happens most notably during the shot in which the tramp walks from the background to sit by a bush in the foreground; he hides the stolen meat under the bush and eats a bit of the loaf he has bought. His position, slightly to the right of center and in the lower part of the frame strongly recalls the similar framing of the convict eating a bit of food earlier on (see Fig. 1).

In addition to the straightforward parallelisms between characters created by this sort of repetition, there is another spatial motif that furnishes a contrast. The convict is associated with vertical descents from heights. The second shot of the story proper is a low angle that shows a sheet dangling from an unseen window above the frame. The escapee shinnies down along it and drops to the ground. Later, he climbs up into the attic of the farmhouse and sneaks down the steps to commit the robbery and murder with which the tramp will be charged. Finally, during the scene of his arrest, the convict leaps from the balcony of a nightclub (Fig. 3) and receives the fatal injury that will lead to his deathbed confession.

Fig. 6 Fig. 7

These descents are juxtaposed to the tramp's slow, limping progress along the eponymous country road, as well as to the farmers' back-and-forth daily visits to the fields along the same road (Fig. 4). The flat, blank road may suggest the normalcy of everyday routine, which the convict's eruptions from above disturb. (It is perhaps noteworthy that while both the convict and the tramp climb the ladder into the farmhouse loft, the tramp does not go down the interior staircase, but retreats as he had come.) Certainly, the final shot (Fig. 5), in which the tramp leaves jail to set out once more upon the road, suggests that the tedious routine of his life is beginning again. This byplay between vertical movements down from the top of the screen and horizontal movements across the screen constitutes an unusual motif for a film of 1913.

Long Takes

Kessler has argued quite convincingly that what he considers the first three acts of a five-act film are dominated by relatively frequent cuts, especially during the passage of intercutting between the convict and the tramp during the murder/robbery scene. He suggests that the very long take showing the deathbed confession (Fig. 6, roughly six minutes in length[7]) strongly contrasts with that earlier editing pattern. I would agree with this with one proviso. While on average the cutting is faster earlier in the film, there are several relatively lengthy takes in this same portion that create another stylistic motif and set up for the impressive climactic scene. Again, to a traditional historian, such shots might seem evidence of the backward staginess of DIE LANDSTRASSE. Yet they little resemble the single-shot scenes of earlier films of the pre-classical period.

The first such lengthy take occurs in the farmhouse and shows a young woman helping an elderly man (her father or grandfather?) off with his outer clothes (Fig. 7); presumably he has fallen ill in the field. We wait through this slow process, which is extended by his panting and feeble gestures. The shot would last roughly two and three-quarter minutes at silent speed. Its main function is to establish quite redundantly that the old man is an easy target for the convict, who later murders him. It also perhaps helps to establish the slow pace associated with everyday life in this film – slow even in comparison with the notoriously

leisurely paced German cinema of the post-war era. Certainly, a Hollywood film would dispose of this action in a small fraction of the time.

Perhaps the most impressive of the long takes prior to the confession scene is the one in which the tramp has a meal in the forest. It begins as he moves from the distance (Fig. 8) into the foreground; he cuts his bread and meat, eats, drinks, hides the remainder of the meat, and continues eating and gazing vacantly around to the end of the shot, which again lasts about two and three-quarter minutes (Fig. 9). Here the long take seems simply to respect the rhythm of a series of mundane actions, again in a fashion that suggests post-World War II art cinema. True, the tramp's meal is a cutaway that covers the time of the gathering of a large group of townspeople at the farm where the murder has been committed. But other films of this period would use a much briefer cutaway for that purpose. This long take resolutely refuses to offer the spectator any drama, any significant new narrative information. I do not recall anything comparable in other silent films, and if nothing else qualified DIE LANDSTRASSE as worthy of our attention, these few minutes would.

Fig. 8

Fig. 9

Fig. 10

The motif of extended takes continues when the tramp is dragged back for in-
terrogation and arrest. The shot of witnesses accusing him and him feebly denying anything
but the theft of the meat (Fig. 10) once again takes about two and three-quarter minutes. The
confusing long-shot of the nightclub in which the convict is pursued and fatally injures
himself in trying to flee (see Fig. 3) lasts about two minutes, including an insert photograph
of the convict (apparently held by police present in the shot).

The notion that the long take could be a positive, constructive component of an
early feature seems remote and implausible. Ordinarily, we think of rapid crosscutting or
shot/reverse-shot editing as constituting the leading edge of innovation in the mid-teens. Yet
DIE LANDSTRASSE moves in the opposite direction, extending scenes not simply by adding
shots, but by prolonging some of them considerably. They surely represent a testing of
cinematic possibilities fully as much as do the rapid editing and flashy camera movements
of other films of the era. Expressivity, in addition to clarity, is thus served.

Conclusions: An Amalgam of Stylistic Possibilities
Kessler has suggested that DIE LANDSTRASSE mixes techniques from various stylistic para-
digms of the day. The long-take confession scene, he argues, is a theatrical moment com-
parable to the end of LA REINE ELISABETH, while the opening is more like the crime dramas
of the day.[8] This is not surprising, since in the pre-war period, films were still circulating
internationally with little impediment, and influences passed easily from country to country.

Yet DIE LANDSTRASSE does not have an eclectic or disunified feel about it, be-
cause these techniques have been modified, always toward the same basic end. The con-
vict's confession (see Fig. 6) is staged quite differently from the end of LA REINE ELISA-
BETH. There we watch a virtuosic display of acting from Sarah Bernhardt, seen in long shot
and definitely the center of attention. In DIE LANDSTRASSE, the action is much closer to the

camera, people come and go, and in the early portion of the scene, there is depth staging as the patients in a row of beds at the rear listen agitatedly to the convict's confession; during the confession and the repetition of it to the nurse and doctors, our eye is likely to shuttle between the convict and the tramp.

Similarly, the slow pace and relative lack of dynamic action of the opening scene of the convict's escape from prison would seem to set it apart from something like the comparable scene that begins the Danish crime film, GAR EL HAMA III, SLANGEØNEN (Robert Dinesen, 1914). Even the most rapidly edited section of DIE LANDSTRASSE, the crosscutting between the convict murdering the old farmer and the tramp arriving in the village, mutes rather than enhances the violence of the crime. It also generates little of the suspense conventionally associated with crosscutting (the last-minute rescue), since we do not yet have any idea how the tramp's actions will relate causally to those of the convict.

Thus, while von Worringen draws upon a variety of norms of the era, he has done so for unusual ends. Despite its few moments of intense action, DIE LANDSTRASSE is essentially an atmospheric film, lacking characters with focused goals. The convict, of course, wants to elude capture and steal whatever he can, but this is hardly a specific goal; the tramp is essentially passive and even appears to feel happier in the prison infirmary than at any other point. The result is a very simple plot which lingers over individual actions and psychological reactions. This simplicity in turn permits the plot to progress with virtually no intertitles - a rare feat for a feature film of the era, though one which of course would become a self-proclaimed goal for many German filmmakers of the twenties.

DIE LANDSTRASSE demonstrates one reason why historians have come to regard 1913 as such a turning point in film history. While owing much to early cinema, it already seems at least as close, if not closer to the tradition of the art film that would be recognized and discussed after the war. That is, it offers a significant alternative vision of filmmaking to that of Hollywood, even at a period when the norms of classical filmmaking were still in the formative stage.

Two 'Stylists' of the Teens:
Franz Hofer and Yevgenii Bauer

Yuri Tsivian

As far as the European cinema is concerned, I see the teens as a relatively unknown period squeezed between relatively well-known ones: the cinema of the twenties (the various avantgardes) and the pioneers' decade (of the Lumières, Gaumont and Pathé in France, Paul, Hepworth and Williamson in Britain, and Messter in Germany).

In comparison with these, films of the teens are often considered less interesting (which is unfair) and unoriginal (which is not true). Only because the cinema of the teens was trying to reach middle-class audiences and, in order to achieve this, wanted to look as respectable as it could, we tend to define it as 'derivative' and 'enslaved' to other arts, notably the theatre; this prejudice is particularly strong in respect to early Russian cinema, which came later to be overshadowed so completely by such titanic figures as Vertov or Eisenstein.

I want to show that, first, there is nothing wrong with being derivative and, second, that if we look at films from the (only slightly) hypothetical vantage point of 'the period itself,' instead of our conveniently (and deceptively) omniscient hindsight that takes our present preferences as the norm, then contemporary cinematic imitations or borrowings from high art can reveal themselves to have been highly innovative – even experimental – ways of handling images.

To support the first argument, I will consider one image from Yevgenii Bauer's THE DYING SWAN (1917) and use it to relate this Russian film to an extracinematic tradition reaching back to artistic Bohemia in Berlin of the 1890s; for the second point I will refer to such staging devices as shooting into mirrors and 'precision' blocking (using examples from Bauer's and Franz Hofer films for the latter) in order to show that what to the modern observer may appear as a purely 'theatrical' technique was in fact cinema's early claim to originality, or, as we would put it today, the filmmakers' search for 'cinematic' specificity.

That we are not always able to recognize at a glance the 'cinematic' quality of the teens' cinema is largely because our notion of what is and what is not part of the 'nature' of cinema is somewhat different from the ideas held by the filmmakers of the teens. As film historians we understand how much one ought to be wary of essentialist statements, realizing that notions like 'cinematic,' 'nature' or 'medium' are merely cultural and aesthetic configurations which, for all the power that they may have over critics and filmmakers, live and die together with their epoch. Yet, being at the same time the children of the 20th century and sharing its cultural doxa, even the most rigorous film historians sometimes find it hard to resist the spell of the essentialist discourse coined in the twenties, the period dominated by avant-garde sensibilities. Deep inside, many of us still believe that the medium of

cinema has a 'nature' or 'essence,' that, whatever it may be, the specificity of the medium is 'inherent' in (and can be 'distilled' from) its basic technology (be it cinema's 'photographic' quality, its 'dynamism,' or other) and that this nature or essence is something that the art of cinema must always be true to. For all the respect that we may have for intertextuality, we also tacitly agree that 'being true to the nature of the medium' entails 'not being like any other art.' I want to argue that all these things become less axiomatic from the point of view of the teens' cinema. I do not claim that the filmmakers of the teens were completely free of any such tenets, but rather that the way in which they imagined the specific nature of the medium they worked within was different, maybe only slightly so, yet enough to blunt the edge of novelty of the period in the eyes of those whose very sense of novelty and innovation was imbibed from the cinema of the twenties, still the big mother of us all.

In particular, it seems that for directors like Bauer and Hofer, 'being original' did not automatically entail 'being independent,' at least not from high arts other than stage theatre which, as I will argue later, European filmmakers of the teens strove to dissociate themselves from rather than identify with (a fully reciprocated tendency, of course, judging by the many hate essays about the cinema to be found in theatre periodicals of the teens, both in Germany and Russia). If I were sure I could avoid Freudian associations, I would say that in the family of the arts the teenage art of cinema felt hostile towards its closest parent, live theatre, while at the same time trying to look like painting, a more distant, yet equally 'aristocratic' relative. Looking at the cinema of Yevgenii Bauer, one feels that for this director the most welcome (in fact, often consciously provoked) compliment would be that his films look like 'paintings in motion' - not a rare definition of the 'nature of the medium' in film-related literature of the teens.[1] In 1915 the Russian poet Sergei Gorodetsky went as far as to propose a new term for 'cinema,' 'zhiznopis' ('life-writing'), coined by analogy with 'zhivopis' ('live-writing'), a standard Russian word for 'painting.'[2] While, in theory, this 'painting-in-motion' concept was presented as an ideal marriage, in practice, particularly in Russian films, the 'painting' constituent often prevailed over the factor of 'motion.' The tendency was so salient that in Russian film literature of that decade you often discover that 'the principle of immobility' is declared central for the new (national) film aesthetics.[3] Here we find another distinction between the essentialist discourse of the teens and that of the twenties: while major film theories of the later decade formulated the essence of film art in terms of its technical data, such as 'speed,' 'motion,' or 'montage,' the theorists of pre-Kuleshovian Russia insisted that film becomes art not in keeping with but in spite of cinema's 'mechanical nature.'

In this respect, Bauer (a former theatre set designer, involved in film production from 1913 to 1917) should be seen as one of the most consistent proponents of this perverse aesthetics according to which the 'true nature' of film art is defined 'by proxy' from older arts, and the mastery of the film medium is understood in defiance of what, on the face of it, looks like the medium's prime technical advantages. Kevin Brownlow once said that Bauer's films had only two speeds: 'slow' and 'stop,' which is perfectly true, but I would like to

add that looking at some of Bauer's best films, you sometimes feel he probably preferred the 'stops': the actors pause for four or five seconds, and the moving image turns into a still picture. At these moments one can actually see Bauer the film director turn into Bauer the painter (as far as we know, he never became one; when a student, he was expelled from the Moscow College of Painting, Sculpture and Architecture).

Bauer's favourite pretext for parking the film's narrative were characters' dreams and visions, and THE DYING SWAN contains a particularly vivid example: a melancholy young woman, abandoned by her fiancé, meets a decadent painter obsessed with the image of Death, and the young woman agrees to sit as a model for his painting called 'Death.' Halfway through, however, the fiancé returns, and the girl is once more happy, so that the painter has to strangle her in order to be able to finish his work of art. At one point, the girl has a dream (Fig. 1). This dream has already acquired its own history of readings. At the 1992 *Domitor* conference in Lausanne, Paolo Cherchi Usai, in the context of discussing the (art historical) concept of 'influence' in early cinema, made the point that a number of images comparable to those of Bauer were current in international cinema well before 1917, specifically, in ASPETTANDO IL DIRETTO DE MEZZANOTTE (1911) (Fig. 2). Similar visions of hands, but with one arm stretching into the frame from off-screen space could also be found in CABIRIA and in Lois Webers's SHOES.[4] After Paolo Cherchi Usai's paper, Ivo Blom intervened to say that he recalled an even earlier example from LA POULE AUX EUFS D'OR, made by Pathé in 1908 (Fig. 3). In the discussion that followed, everyone (including Paolo, Ivo and myself) agreed that there must be a non-cinematic parallel as well, most probably coming from turn-of-the-century Symbolist Art. I kept on looking, and what I found was the frontispiece to Peladan's 'Femmes honnêtes' (Fig. 4), painted by the Belgian Symbolist Artist Fernand Khnopff, symbolizing woman as the object of man's lust. This composition has no textual counterpart in Peladan's book, but art historians have pointed out a similar image which even earlier (in 1895) was used by Edvard Munch for a lithograph (Fig. 5), and to me, Munch's picture looks quite similar to Bauer's shot, both iconologically and in terms of what it refers to.[5]

In addition (and this is my own discovery, unless someone whose work I do not know had discovered it before me), this image has a contemporary literary parallel in the work of Munch's friend, the Polish decadent writer Stanislaw Przybyszewsky. In this case, moreover, there was a love story hidden behind the intertextuality of the symbol. The fact is that in 1895, when living in Berlin, Munch fell in love with Prybyszewsky's wife, an extraordinary Norwegian redhead by the name of Dagnia (Przybyszewska) who, so the rumour went, never wore a corset. An emancipated, true turn-of-the-century character, Dagnia was also courted by August Strindberg, at about the same time as Munch was after her. Thus, it was an open secret that the figure depicted in the centre of this Munch lithograph called 'Lust' was Dagnia. Her exacting high-life eventually extracted its price, for legend has it that, years later, she died at the hands of a jealous Russian army officer in Morocco.

To return to Bauer's visual motif in THE DYING SWAN. In the novel *Homo Sapi-*

Fig.1

Fig.2

Fig.3

Fig.4

Fig.5

ens, written in the same year 1895 by Dagnia's husband Stanislaw Przybyszewsky, I found a passage which looks to me like a literary riposte to Munch's offensive image. The novel features one Mikita, a misunderstood artist who kills himself for a femme fatale whom he had chosen as a sitter for a painting he conceived. This is how Przybyszewsky describes Mikita's design for this fictional painting which the poor suicidee never came to realizing:

> In the middle of the picture there will be a woman, a fascinating, lovely woman.
> Thousands of hands will be stretching towards her from all sides: from above,
> from below. Thousands of frenzied hands, quarrelling, shouting at each other.
> Artists' hands, thin and narrow; stock-jobbers' hands, fat and fleshy, with rings

Fig. 6

Fig. 7

on the fingers, thousands of different hands, orgies and orgies of lascivious greedy hands.[6]

If after hearing this passage someone still has doubts whether it relates to Munch's picture, these should be dissipated by the following lines from Przybyszewsky's letter to Edvard Munch of July 1896 concerning a Swedish critic's suggestion that Munch could have served as prototype for the figure of Mikita:

> Regarding this ludicrous nonsense they told you that I depicted you [in my novel], I do not want as much as discuss it. Such talk is stupid and childish. Oh those Swedes, those Swedes, aren't they an uncouth race [wstretna rasa]!'[7]

My next argument in favour of the specific interest in fine arts-related compositions on the part of the teens' filmmakers is shooting into mirrors. This predominantly European craze has been discussed recently by Kristin Thompson, John Fullerton, and in an article of mine,[8] so let me mention only a few examples supporting my point about the European cinema of the teens, struggling to change the identity of the film medium, part of this strategy being to suggest that the space of the screen is more like that of the artist's canvas than that of the stage. Take, for example, the mirrors positioned frontally vis-à-vis the viewer. With a few exceptions, such frontally positioned mirrors came into regular use around 1911, which roughly coincides with the period when film designers in Europe became increasingly determined to give up theatrical conventions of interior space in favour of those used by realist paintings. This change involved a different conception of 'backspace' (or the imaginary space positioned 'behind' the viewer inscribed in the diegetic space): instead of ignoring it (as was customary on stage), film people were now determined to bring it in, activate it, make it visible (as was customary in realist paintings). In live theatre, there was little sense in positioning mirrors so that they face the audience: the risk of frontal mirrors incidentally reflecting footlights, or space behind the scenes, or the audience itself was higher than whatever effects could be gained from them: because of the multiple spectators' viewpoints scattered in the auditorium, reflections were impossible to position with precision. Sometimes, blind mirrors would be used on stage. One rare example of a blind mirror used on a film set occurs in Emile Coutard's THE STREET ARAB OF PARIS, made by Eclair in 1910 (Fig. 6), but because this was a film version of a stage melodrama (with stage actors in principal roles), it may happen that the blind mirror was borrowed from its stage production as well.

Generally, it looks as if, because of their restricted use on stage, filmmakers of the teens seized the opportunity to appropriate real mirrors. Precisely by using them in ways that could not be deployed on stage, directors made mirrors send a message to the viewer: 'This is film, not a stage.' Typically, a reflected fragment of the space 'behind the viewer' would appear in these cinematic mirrors, in order to inscribe the viewer into the space of action, imbue him with the same sense of 'being there' as painters were used to doing. To make the reflective space more functional or even dramatic, an off-screen door would often

appear reflected in this cinematic mirror, motivating exits and entrances past the camera (another element impossible on stage). Evidently, such use of doors-within-the-mirrors was clearly non-theatrical and innovative in relation to earlier modes of filmmaking, when doors were made either in lateral walls or in the front wall opposite the camera (or both) - a ready-made solution borrowed from theatre stage design as in the Russian film KRETCHINSKI'S WEDDING from 1908 (Fig. 7). The dramatic possibilities opened by this door-in-the-mirror alliance, too, were difficult to imagine on stage. Let me give some examples from Danish and Italian productions of the early teens. In the Danish film by August Blom VED FAENG-LETS PORT (1911), the main space of action is shown from an angle (Fig. 8), and the door in the mirror is carefully cued by entrances and exits (Fig. 9), till it finally pays off dramatically: the protagonist steals his mother's money from a drawer, and as the mother enters at just this point (Fig. 10), thanks to the angled mirror, we see her seeing him without him seeing her, an excellent example of narrative economy and narrational skill. To us, raised on dynamic conceptions of cinematic space whereby heightened dramatic effects are associated with the increase in scene dissections, such shots may appear rather uncinematic, even theatrical. However, from the point of view of the teens, shooting into mirrors must have looked perfectly film-specific, if only for the reason that none of these mirror effects could be produced on stage.

The same can be observed about blocking. The inventiveness and precision with which some filmmakers of the teens grouped and moved human figures in space shows how excited they must have been about the new expressive possibilities opened for blocking within the medium of cinema. Two examples from Bauer's and Hofer's films illustrate their use of blocking in what in the teens looked like specifically cinematic ways. Franz Hofer's DIE SCHWARZE KUGEL ('The Black Ball, or, The Mysterious Sisters,' 1913) is a story of two sisters – music hall jugglers taking vengeance on the seducer of the third sister who is already dead when the film begins. From the start, we are left with two mysterious sisters, perhaps twins (despite the fact that one of them is blonde, and the other black-haired), who take advantage of their family likeness to almost drive the villain mad. The very story is thus grounded in symmetry, and part of the reason why the film is visually compelling is that Hofer converts the story symmetry into the symmetry of space. Each time the two sisters are seen together in the shot, they are symmetrically positioned with respect to the centre of the frame; this symmetry is strictly lateral (rather than staged in depth); Hofer reinforces it by way of making the two sisters mirror each other's gestures and wear (always!) identical costumes which both actresses change from scene to scene as if to refresh this sense of symmetry.

Take the following series of shots from the opening sequence of DIE SCHWARZE KUGEL. After the suicide letter appears on the screen as an insert, we see the two sisters reading it; they are sitting side by side (framing: 'American foreground'), facing the camera; each sister holds the letter with one hand, the one on the left from us with her right hand, the one on the right with her left hand. The letter is positioned exactly in the middle of the frame (a bit below its geometrical centre), right on the axis of symmetry formed by the sisters'

Fig. 8

Fig. 9

Fig. 10

figures. Almost immediately the sisters are told to react, and looking at their carefully synchronized movement one can almost hear Hofer's off-screen voice prompting: 'Look at each other in mute amazement – now drop the letter – put your hands to your foreheads and pause in grief.' All this is performed with the exactitude and symmetry of a mirror gag in a Max Linder movie, except of course that the scene does not look funny. This remarkable shot cues symmetry as a leitmotif of the whole film, both visually and in terms of narrative: visually, the synchrony and symmetry of acting will pay off when we see the mysterious sisters as music hall jugglers perform a double turn; the narrative pay-off comes later when Hofer makes us realize (slowly!) the perfectly timed revenge plot (based, of course, on confused identities) devised in order to juggle the villain into confessing the crime of seduction.

In the next shot the symmetry is reinforced by showing Edith and Voletta mourning at something looking like a family altar: first, we see them, their backs turned to the camera ('American foreground' again), looking at the suicide's photograph positioned, predictably, in the middle of the frame, a trifle above its exact geometrical centre; compositionally, the shot is so faithful to the one previous to it that, were it not for an intertitle between them, they would form an exact graphic match. Needless to say, as the sisters look at each other and join hands in an oath of revenge, they move perfectly in synch.

Another intertitle, another 'American foreground,' and a new exercise in symmetry: the sisters are shown sitting facing the camera in the dressing room of a music hall (the shot is tinted in ominous red); slowly, they put black masks over their eyes. Suddenly, their heads turn back abruptly (both heads are turned inwards to the frame, in keeping with the law of symmetry), and we see the manager coming in through the door behind, positioned exactly in the middle of the frame, between the two sisters. The plot is triggered. The sisters are summoned to the stage.

The next scene takes place in the auditorium of the vaudeville theatre. The unsuspecting villain and his boyfriend are ushered into the box, and the show begins (Fig. 11). Here the symmetry is quadrupled: not only does Hofer position the villain and his friend symmetrically in relation to the stage they are looking at (compositionally, this shot repeats the one with the sisters mourning at the family altar), but also locates the actresses on a swing (not our sisters yet) so that their figures form a symmetry in relation to the tiny figure of the conductor (whose head, like those of the villains, is turned with its back to us). Look again at the frame enlargement: despite the fact that the whole composition is slightly off-centre (obviously, the result of misframing on the part of the photographer), you feel that the head of the conductor coincides with the geometrical centre of the frame. Draw an imaginary line combining the two figures in the foreground, the two figures in the background, and the conductor's head in the centre, and you will get an X-shaped composition, a classical figure of central quadruple symmetry. An amazing shot, indeed!

As Hofer cuts in closer to the stage, the number of actors doubles, indicating, perhaps, that the director-in-fabula who had staged the show was as obsessed with symmetry as Hofer himself (Fig. 12). Finally, the mysterious sisters come out on the stage and engage in

a symmetrically choreographed double act which culminates in a conjugate juggling turn with burning torches. Then, without any re-establishing shots (at least, no such shots survive in the Nederlands Filmmuseum print) to mediate the transition, we jump into another exquisite specimen of quadruple symmetry: the juggling sisters are shown through the symmetrical binoculars of the seducer (Fig. 13). Framed! – but, in reality, who has framed whom? A model case of narrative economy and narrative ambiguity.

Clearly, this is a pictorialist strategy even though the juggling act and the tableau vivant with the swings in the previous shot are part of a variety show. Lateral symmetry flattens space – and so does the technique of foreground framing: here the space of action is sandwiched between the frontal background and the foreground mask. Later in the film Hofer will shoot a scene through a glazed door (Fig. 14). Contrary to the opera glass vignette, this foreground frame is not used as an indicator of a character's point of view; rather, it is purely ornamental and probably meant to situate the picture within the context of the fine arts (I recall having seen a similar grated foreground in a painting by Gustave Caillebotte) and in pictorialist photography. Yevgenii Bauer had his favourite glazed door, too (Fig. 15), which he must have spotted somewhere in Moscow around 1914, since he used it in at least three of the films he shot that year.

Dissimilar as they may look in terms of architectural design, in the context of cinematic style Bauer's door seconds Hofer's, in the same sense that mirrors in Italian cinema duplicated those found in Danish films: both Hofer and Bauer responded to the general tendency of European films of the teens to make filmic space look different from the space of live theatre and, in doing so, sought for alternative aesthetic alliances in the area of fine arts. In the history of the film medium's 'struggle for autonomy' the teens were thus the period when independence did not mean being self-sufficient, but signalled the search for a better sovereign among the established arts than the theatre or the stage crafts generally. This does not imply that Bauer's films have a similar look to Hofer's. On the contrary, within the current of pictorialism common to both, Bauer's method of negotiating space seems almost the opposite to that of Hofer. Not only the lateral symmetry of DIE SCHWARZE KUGEL, but also the density of objects (props, figures) found in every frame (even more remarkably and consciously explored in WEIHNACHTSGLOCKEN, 1914) makes Hofer's shots look compressed, depthless, almost spaceless.

Bauer's shots are different: in contrast to Hofer, he prefers to expand rather than compress, and he favours empty spaces over densely packed images. To illustrate this difference in approach to space, let us look at Bauer's A LIFE FOR A LIFE (1916), yet another story about two sisters. In Bauer's film the sisters get married on the same day, each to the wrong man: Musia marries the man loved by Nata, and Nata marries the man she hates, in order to spite the man she loves. So, in its own way, this, too, is a drama of family symmetries, and it seems that Bauer, like Hofer, in DIE SCHWARZE KUGEL, felt tempted to visualise the idea. However, only once did he attempt translating the symmetry of narrative situation into the type of symmetry dominant in DIE SCHWARZE KUGEL, in a shot that comes after the intertitle

'The Double Wedding' (Fig. 16). The sisters are positioned on both sides of their mother, with their respective fiancés flanking the happy group. On the whole, however, lateral (or axial) symmetry is not typical for Bauer's film: more often, one finds symmetrical arrangement along diagonal lines, as in the scene where two more or less identical desk busts (one looking off frame – either by negligence or for some compositional reason) duplicate the main diagonal formed by the figures of Nata and her unloved husband (Fig. 17). Another shot taken from the same camera setup but somewhat 'longer' with regard to its framing (this time both busts are looking inwards), explores the opposite diagonal, formed by the dejected husband talking to his mother-in-law, Musia and her husband in the middle, and the lonesome Nata at the foremost point of the axis (Fig.18). According to the contemporary doctrine of stage directions stemming from the times of François Delsarte, the side-to-side dimension of the stage expresses volition, movements directly toward or directly away from the audience signify passion and (again, according to Delsarte) diagonals, because arrived at by the opposition of two directions, have an element of conflict in them.[9]

To us, all this may look fairly theatrical, but I suspect that things looked differently from the perspective of the teens. Refining the geometry of pro-filmic space to the extent that Hofer and Bauer did for their films would be hardly worth the trouble unless the results were secured by the fixed point of view thanks to which every overlapping and every compositional detail could be balanced with utmost care, the facility all the more alluring for film directors because it was not provided on the stage. In a sense, what filmmakers of the teens were trying to achieve through staging and composition can be seen as an attempt to out-theatre theatre. Why was it possible? On the one hand, for a number of reasons (the lack of spoken text, for example, due to which blocking had to purvey a good deal of narrative information), silent film was more dependent on blocking than a theatre performance. On the other hand, the medium of cinema provided more favourable conditions for blocking to become a flexible tool of expressivity than stage, where the position occupied by an actor at any given moment was dictated, besides other factors, by considerations of optimal audibility. In other words, for the cinema of the teens, high precision blocking was an article of both necessity and pride, as clear a token of the film medium as montage would become for the next decade. Shooting into mirrors, building 'human diagonals,' or compressing space to the degree that all the objects filling the frame appear to be on the same plane (the method perfected by Hofer, probably influenced by Art Nouveau painting): such techniques in the teens must have looked as state-of-the-art and medium-specific as, say, digital special effects today.

To conclude: although we often define good films as those that are 'true to the nature of the medium,' this by itself is an arbitrary doxa inherited from the aesthetic preferences coined in the twenties. But even if we agree to accept this as an axiom of historical criticism, we must be wary not to extend 'the nature of the medium' as understood in the twenties to what was felt to be 'the nature of the medium' in the teens, particularly in European films. As film historians know only too well, value judgements just do not stretch all

Fig. 11

Fig. 12

Fig.13

275

that far and have a short shelf-life. If we look back at Bauer's or Hofer's films through the imaginary prism of what, say, early Eisenstein would think about them, we probably perceive them as being very theatrical; however, in Eisenstein's later theory there exists a term that helps to highlight the medium-specific quality of Bauer, Hofer, Caserini, Maurice Tourneur and other pioneers of cinematic staging of the teens. The term is 'mise-en-cadre' as opposed to 'mise-en-scene,' the aim of which distinction is to emphasize that staging and blocking of characters is itself a cinematic technique par excellence. Each historic period, as Leopold Ranke used to say, has its own direct access to God – in this case, to the 'true nature' of cinema.

Fig. 14

Fig. 15

Fig. 16

Fig. 17

Fig. 18

The Voyeur at Wilhelm's Court: Franz Hofer

Elena Dagrada

If it is true that the *Giornate del cinema muto* at Pordenone often give their audience the joy of discovering an unrecognized talent, then 1990 honored the tradition with a new, discreetly presented gift. After Yevgenii Bauer, the 'little big genius' of Russian cinematography which Pordenone 'discovered' the year before, another unrecognized director has taken up his rightful place in the early cinema's pantheon: Franz Hofer, six of whose films were shown at Pordenone, in the retrospective dedicated to the German cinema before CALIGARI.

Born in Germany but educated in Vienna, little or nothing seems to be known about Hofer. A catalogue entry for the Pordenone event[1] says that he had a passion for the theatre, where he worked as both author and actor, and that he was a scriptwriter from 1910 onwards, who in 1913 directed his first film, DES ALTERS ERSTE SPUREN. Between 1913 and 1914, before World War I, he shot about 25 films for Luna Film GmbH. In the years that followed, he passed to different production companies, among which Messter Film GmbH, before venturing himself into production, founding Hofer Film GmbH,[2] which was active after the war.

It is also known that, to judge by the titles of his films, he practised different genres and that the actors he liked to work with, notably Dorrit Weixler and Franz Schwaiger, were well-known stars. Finally, we know that in 1913 he took part in one of the many public initiatives designed to promote the social status of the film director, in the context of what has come to be known as the *Autorenfilm* movement. His name in fact figures next to directors like Stellan Rye (DER STUDENT VON PRAG), among others, in an advertisement featured in a special issue of *Die Lichtbild-Bühne* entirely dedicated to the role of the film director.[3]

If the biographical information on Hofer is, at this point, still meagre, the same is fortunately not true about his art: after seeing some of the films that have survived, mostly belonging to the period of Luna Film, a precise shaft of light has now fallen on Franz Hofer, opening up rather like one of those peepholes through which the characters of his numerous and beautiful point-of-view shots like to gaze. Because – let's say it right away – it is this that strikes one most forcefully in Hofer: the fascinating but never gratuitous virtuosity with which he constructs the visual space of his characters, depicting their perception within elegant geometrical coordinates. And equally striking is the equilibrium that in these point-of-view shots is achieved between visual fascination and narrative pertinence, between ocular magic and story sense.

Hofer always tells of a world seen by an intimate point-of-view, as if standing above things. A point-of-view more often 'of a feminine kind,' as Heide Schlüpmann has pointed out. In contrast to the Russian Bauer (more stereoscopic), Hofer is a creator of monoscopic visions and knows how to enrich even the most commonplace intrigues with the depth of an individualized psychological dimension. But, again in contrast with Bauer, who is interested in organizing space in architectonic ways, Hofer seems more interested in the composition of the frame, more in filling in the space than in designing it in determined ways. In Hofer's films the camera movements are rare. Often the frames are static, pictorial. And yet, the figurative care with which they are conceived is profoundly cinematographic: their elegance derives from conscious visual arrangements, well-timed optical effects, scenographic point-of-view shots and apparitions bodying forth in discreetly, but deliberately arranged large black spaces.

Hofer seems to place himself perfectly half-way between the spectacle-attraction tradition of pre-cinema and the linearizing and narrative innovations brought into the German cinema of the teens with the *Autorenfilm* movement. If it is in fact true that the German cinema before CALIGARI owes to the *Autorenfilm* an active process of breaking with the theatrical heritage and the involvement with the expressive components specific to cinema,[4] then the films of Hofer seem to testify to the reality of this positive influence. From one side, in fact, they are 'quality' productions, which enrich the market with new genres and proliferate the expressive means typical of the new film language. From the other side, however, they preserve between the lines the nostalgia for the theatre and the fascination of cinema still lived as magic, as the first bewilderment experienced in the face of these luminous images in motion.

It is also thanks to the mixing of these components that the films of Hofer, independent of the genre they belong to, appear somehow with an undercurrent of profound lyricism, whether it is a *Sensationsfilm* (the 'sensational' film) with its crime story background (like DIE SCHWARZE NATTER and DIE SCHWARZE KUGEL), a witty comedy (HURRAH! EINQUARTIERUNG! and FRÄULEIN PICCOLO), a *Heimatfrontfilm* (like the marvellous WEIHNACHTSGLOCKEN), or – more naturally – a melodrama (like KAMMERMUSIK). Often, it is exactly the gaze of the characters, through numerous point-of-view shots, that carries the transfer of the lyrical impact from the figurative level to the emotional and narrative one, even when the atmosphere is choral or multi-voiced, as in WEIHNACHTSGLOCKEN, or when it is concentrated on the action, as in the *Sensationsfilm*. Into the center of this last genre, for instance, Hofer pushes 'the feminine power and the power of the feminine gaze.'[5] In DIE SCHWARZE NATTER (Luna Film, 1913) the protagonists are two women who fight for the same man: Ladya, the viper woman (or the black viper, the *schwarze Natter* of the title) and enchantress of snakes; and Blanche d'Estrée, amazone and proprietress of the circus where the story is set.

The plot in itself is little more than a gloomy amorous intrigue, staged half-way between a melodrama and a detective story. Hofer proceeds adroitly here, displaying great

care for details (in the clothes of the two women, for instance, to indicate their different personalities) and a rather dynamic use of space: the pursuit and the escape of Blanche by the police leads the camera through an arena, onto rooftops, through the booths and among the merry-go-rounds of a Luna Park. But the perspective of the characters also leads to some remarkable visual strokes of genius: we are taken through holes in the wall, see a mirror hidden in a hat (which in the final scene the evil Ladya will smash, with suggestive scenographic effect, for the terror of seeing reflected in it the image of the good Blanche) and we are even merging with the form of a hand that has melted down the ice on a windowpane.

In DIE SCHWARZE KUGEL (Luna Film, 1913), too, the protagonists are two women. They decide to avenge their sister, who committed suicide out of love, by killing the seducer who had jilted her. Another *Sensationsfilm* in short, set this time in the world of the theatre. And another torrid intrigue, where two sisters, instead of fighting for the same man, become allies in order to combat him. Again, however, Hofer does not limit himself to burdening the plot with the treatment of tormented souls. What interests him above all is to entrust the task of expressing the sentiments of these souls in the composition of the frames, here invariably very theatrical.

The still vivid ties of Hofer to the theatre, in fact, can be felt in this film more than in most of the others.[6] Not only in the recurring motif (perhaps a little obvious) of the theatre chosen as preferred action space, or by the curtains doubling as theatre curtain (for instance, at the end, in the castle of the count, when like a bolt from the blue, the murderous sister appears in front of her victim lifting a heavy velvet curtain that suddenly opens up). It can be noticed especially in the use of the space of the action as a stage, as a three-dimensional place observed in silence through an invisible fourth wall. But careful: we are dealing with a theatre within cinema, where emblematic spectators point out with their fingers details in the titles of the printed programme (as they do at the beginning of the film). And the silent gaze that observes the events through the fourth wall reveals itself often as a diegetic gaze. A trapped gaze, as if peering through the keyhole.

The gaze here belongs to the man, a seductive and voyeurist count. Morbidly attracted to the feminine world, he spies upon the sisters both in private (their house, their room adorned with lace and flowers) and at their workplace, the theatre (in the dressing room and on the stage). It concerns a rather intimate theatre, the sort customarily frequented by seducers. The two women perform an act entitled 'Die geheimnisvollen Schwestern' ('The mysterious sisters': the title of the act serves as subtitle of Hofer's film) in which they show themselves masked in black, and covered in large cloaks that they swirl around them like ominous dark wings. Then there is a sudden cut, however, followed immediately by the same image of the cloaked sisters, now encircled by a matte with a double lens. It is the gaze of the voyeur, in the auditorium, who observes the spectacle through a pair of binoculars. When the same pair of binoculars are directed towards the stage, we see him aim at them, from a balcony, in the following shot.

This is not the only 'theatrical' point-of-view shot in the film: others follow,

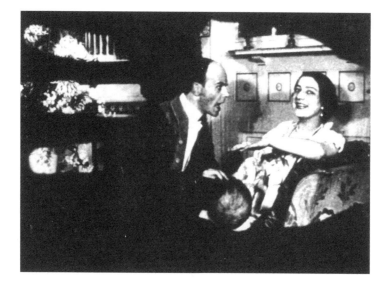

through mattes similar to picture frames, by the arched windows of the castle. But the most beautiful – and also the most erotic – must surely be the one where the man steals the intimacy of the two women, on the stage of the action. The two sisters are at home and moving about in their room; they first attentively close the window's outer shutters, then lower a white curtain, stretched taut like a screen. Cut to the outside, where the count arrives and approaches the window. Carefully, he prizes apart the slats of the shutters, leans forward to spy through the opening, only to be once more frustrated in his desire to look: the white curtain blocks his gaze. He opens the shutters completely, revealing the stylized profiles of the two sisters projected against the white of the curtain, two-dimensional like an ancient shadow play. The count, taking a pair of scissors from his waistcoat, makes a slight incision in the cloth in order to open a passage for his gaze. Cut to a triangle framing a black background simulating the gash opened by the count in the curtain cloth; beyond it, the two sisters go about their business, unaware of being observed. Later on, when a reverse shot shows us the room once more from the inside, in the background of the frame, one distinctly recognizes the dark stain of the hole in the white curtain.

This fascinating mixture of old and new, here uniting the traditional magic of the shadow-play with its modern use in an expressive as well as narrative context, seems to find in the representation of the gaze its most fertile territory. The point-of-view shot, in Hofer, consents to presenting the viewer with visual and scenographic effects that are striking above all for their immediate beauty. Yet at the same time, they are always used to perfectly mesh with the story. Recall the final point-of-view shot of DIE SCHWARZE NATTER, when Ladya discovers the figure of Blanche reflected in the hidden mirror: highlighting an object of an undeniable visual fascination, the point-of-view shot here nevertheless unites itself with its other use, modern and specifically cinematic: the exchange of glances between characters, used here to unblock the course of the plot with a miraculous stage effect.

WEIHNACHTSGLOCKEN (1914)

In Hofer's point-of-view shots, very often the look into the camera relies on the – cinematically speaking – somewhat backward technique of 'direct address.' The characters indulge in it, squandering themselves in grins and bows towards the camera as if acknowledging the audience in the auditorium (of the theatre). But this always concerns characters solidly 'chaperoned' by other persons, who on screen fully perform their dramatic

role of the (cinematographic) emblematical audience. One thinks of the ending of the comedy HURRAH! EINQUARTIERUNG! (Luna Film, 1913), where all kinds of virtuosities of the look as pure attraction are very much in evidence (bubbles that reflect the faces of the characters in close up, heart-shaped masks, etc.). This is a deliciously impertinent final scene, in which the two lovers, discovered making love behind a curtain (the umpteenth simulacrum of a theatre curtain), hide behind a paravent screen to kiss each other in order not to be seen even by the camera.

A similarly ambiguous final scene recurs in WEIHNACHTSGLOCKEN (Luna Film, 1914). Two lovers kiss each other in the dark; in the background, behind a large glass door lit up from behind, some characters approach, slide the door open, and drive the two young people out of their hideaway.(see illustr., p. 10). A rapid reverse shot then shows the couple framed through an oval mask, which after a slight bow towards the camera catches a curtain on both sides of the frame (just like the one under which the voyeurist photographer in THE BIG SWALLOW is hiding) and subtract themselves from our indiscreet gaze.

WEIHNACHTSGLOCKEN is a small masterpiece, and undoubtedly the most original and complete of Hofer's still extant films. It has the additional advantage of offering a delicate portrait of the prewar German bourgeoisie, so prominent in the literature of that period. The main title is followed by a significant subtitle that reads: HEIMGEKEHRT. EINE KRIEGSGESCHICHTE. Significant, because this truly extraordinary film is really a *Kriegsgeschichte*, a 'war story,' but it tells about the war without showing it. Or better, by showing it (for once) from another angle. From the opposite angle. The perspective of those who stayed at home and patiently await the mail, the leave, the return of those who went away to fight.[7] It's Christmas day during the Great War. But instead of battlefields, uniforms, trenches, mud and dust, we see padded and illuminated bourgeois interiors, inhabited by elegantly dressed women and children, or aged parents anxious for their sons at the front. Everything is measured on the level of sentiments. There is no trace of material discomfort; the Christmas preparations go ahead without privations, amidst the muted joy of anticipation aroused by the announcement of the soldiers' being granted leave. People even find time to fall in love and to get engaged. The only image of the front is an imaginary one, produced by the fantasy of the parents of a young soldier: it appears in superimposition on the right half of the screen (while the parents complete the frame at the left side) and shows a group of soldiers in uniform. But not even here do violence and brutality flourish. The soldiers are in cheerful and carefree mood, warming themselves by an open fire. Just as carefree is the (mental) image of a young soldier on leave evoked by his new beloved, without a trace of the grief about the next and inevitable separation, the fear of moving on, or even loss (see illustr., p. 11).

In short, there is something noble and gentleman-like in this distanced view on the war. Something that has to do with the same noble and gentleman-like view that pervades LA GRANDE ILLUSION (1937) by Jean Renoir. It represents the domestic version of war, the feminine version. Here the familiar-family sentiment stands above all other things,

the aristocracy of affection, of the amorous and domestic sensibility. Christmas dinner is being served in the living room. The children spy on the occasion through a large glass door (the same in the final scene) which is suddenly lit by a yellow light and becomes the screen for a new theatre of shadow-plays. Brighter are the shadows beyond the door that adorn the tree; darker are the shadows of the children in front. The frame is beautiful, of great compositional delicacy. Again it unites the old visual fascination of moving shadows with a wise and modern use of the definition of depth. A refined photography raises the clair-obscur and gives the same representation of the movement a fascinatingly stylized cadenza. Hofer knows this and indulges in it. The finely etched figures of the children seem at one and the same time to comply with a geometric and a lyric taste: they are a visual attraction, while still inhabiting the very essence of the world of the film.

The same thing happens in the flashbacks and the mental visions of the last film Hofer realized for Luna Film: KAMMERMUSIK (shot in 1914, but released not before March 1915). Here the plot does not present the thematic originality of WEIHNACHTSGLOCKEN, but possesses the same lyricism. Its mise-en-scène is so full of narrative originality, so strong in its composition that the results are no less interesting or successful. From a thematic point-of-view, KAMMERMUSIK is, on the face of it, merely a patchwork of melodramatic situations, typical of the most decadent romanticism: it is the unhappy story of a woman who sacrifices her youth and her entire life by marrying a sick man who leaves her a widow when still in childbed. Yet it is told with remarkable inventiveness and the use of extremely modern narative techniques. It begins with the protagonist as an old woman, who feels her end is nigh and who decides to tell the story of her life to the young daughter-in-law. The point of departure is a small box containing tokens of memories; every memory is materialized by a flashback and is tied to the following one by the image of the two women and the little box. At the end, the story is interrupted by the arrival of the son, now a musician, who returns home after a triumphal concert. The mother receives the message with joy, because she is now granted one last wish before dying: to hear her son play her favorite piece of music (a chorale by Bach). This happens in the final scene, at a subsequent concert, during which, one after the other, the crucial moments of her existence pass before her mind's eye as she passes away. The final shot is composed (or we should rather say, filled in) in an extraordinary way. Because it concerns only one frame: a frame that knows to unite statics and dynamics with extreme naturalness. The old woman is seated in an easy chair, the daughter-in-law is present at her side, and the bodies of the two women accurately fill out the left part of the frame; on the other half, the memories evoked during the film in flashback (which the spectator recognizes and relives just as so many attractions) run in sequence, in rhythmic cadence with the music.

Little is known about what Hofer did with this talent of his after World War I, whether the grace by which he knew how to let magic and story live together in his films stayed with him. What can no longer pass into oblivion is the trace he has left on the German cinema of the early teens.

DIE SCHWARZE NATTER (1913)

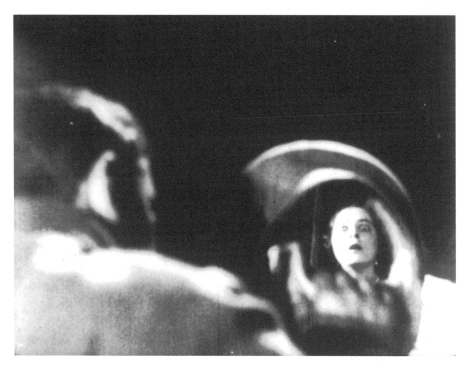

Notes

Preface

1. See Martin Loiperdinger, below.
2. Leon Hunt, 'THE STUDENT OF PRAGUE: Division and Codification of Space,' in Thomas Elsaesser (ed.), *Early Cinema: Space, Frame, Narrative*, London: BFI Publishing, 1990, pp. 389-400.
3. As argued by Peter Lähn, below.
4. See Loiperdinger below for some of the reasons why early German cinema has become a 'lost continent.'
5. See also the title of the book edited for the occasion by Paolo Cherchi Usai and Lorenzo Codelli, *Prima di Caligari / Before Caligari: German Cinema, 1895-1920*, Pordenone: Edizioni Biblioteca dell'Imagine, 1990.
6. Another Italian festival should be mentioned here, the 'Cinema tedesco dalle origini al Terzo Reich' which under the direction of Vito Zagarrio and Riccardo Redi took place in Pesaro in October 1993.
7. Leon Hunt's essay mentioned in note 2, and John Fullerton 'Spatial and Temporal Articulation in Pre-Classical Swedish Film,' in Elsaesser (ed)., *Early Cinema*, op. cit., pp. 375-388.
8. Michael Wedel (ed.) *German Cinema, 1895-1917: A Checklist of Extant Films in International Archives*, University of Amsterdam, 1995, obtainable on request in electronic form (MS-DOS diskette) from Amsterdam University Press.

Early German Cinema: A Second Life?

1. On some of the difficulties, both archival and conceptual, of researching the German cinema between 1895 and 1917, Thomas Elsaesser, 'Early German Cinema: Audiences, Style and Paradigms,' *Screen*, vol. 33, no. 2, Summer 1992, p. 205-6.
2. Barry Salt in this volume.
3. One of the most assiduous historians to have combed through the print sources for early German cinema is Herbert Birett (see bibliography).
4. Essays by these authors are to be found in Thomas Elsaesser (ed.), *Early Cinema: Space, Frame, Narrative*, London: BFI Publishing, 1990.
5. David Bordwell, Janet Staiger, Kristin Thompson, *Classical Hollywood Cinema: Film Style and Mode of Production to 1960*, London: Routledge and Kegan Paul, 1985.
6. For instance, the essays by Tilo Knops, Kimberly O'Quinn, Kristin Thompson, Barry

Salt and Yuri Tsivian, below.

7. Hence the emphasis in the present volume on the film relations with Denmark (the essays by Evelyn Hampicke, Peter Lähn and Caspar Tybjerg), with France (Frank Kessler/ Sabine Lenk) and the United States (Deniz Göktürk), not forgetting Rainer Rother's article on the 'international' and 'comparative' dimension of German propaganda films during World War I.

8. Thomas Elsaesser, 'The New Film History,' *Sight & Sound*, vol. 55, no. 4, Autumn 1986, pp. 246-251.

9. Robert C. Allen and Douglas Gomery, *Film History: Theory and Practice*, New York: Alfred A. Knopf, 1985, p. 38.

10. 'In Germany we have great factories for making cameras and projectors, and also for producing first-rate film stock. But our country makes the worst films one can find anywhere on the globe. Putting aside their lack of aesthetic sense and taste, German films are distinguished by errors in focus, overexposure, fuzziness, unintentional shadows, developing flaws and bad copies. Such are the details by which, after only a few seconds, one can tell a German production.' Wolf Szapel, *Union Theater* (house magazine), 1912, quoted by G. Sadoul, *Histoire générale du cinéma*, vol 2, Paris: Denoël, 1973, p. 361.

11. Emilie Altenloh, *Zur Soziologie des Kino: Die Kinounternehmung und die sozialen Schichten ihrer Besucher*, Jena: Diederichs, 1914, gives an indication of how many films in German cinemas were foreign imports.

12. Since 1990, there have been, among others, anniversary volumes for Ufa and Babelsberg, for Reinhold Schünzel, Joe May, Erich Pommer and E.A. Dupont, more than a dozen regional studies, and of course, the publications associated with the centenary of the cinema itself. For an indication of the manifold ways in which the regional dimension intersects with the international, see the essays by Frank Kessler and Sabine Lenk, Evelyn Hampicke (Berlin/Denmark), Peter Lähn (Frankfurt/Denmark), Jan-Christopher Horak (Munich-Berlin/France) and Deniz Göktürk (Berlin/USA).

13. Heide Schlüpmann, *Unheimlichkeit des Blicks: Das Drama des frühen deutschen Kinos*, Frankfurt and Basel: Stroemfeld/Roter Stern, 1990.

14. *Ibid.*, p. 97.

15. Tom Gunning, 'The Cinema of Attractions: Early Film, its Spectator and the Avantgarde,' in Elsaesser (ed.), *Early Cinema*, op. cit., pp. 56-62.

16. Corinna Müller, *Frühe deutsche Kinematographie: Formale, wirtschaftliche und kulturelle Entwicklungen 1907-1912*, Stuttgart and Weimar: Metzler, 1994.

17. One valuable source of evidence for both the structure of a normal cinema programme and the constitution of a typical audience comes perhaps from a somewhat unexpected quarter: the Report of the Hamburg cinema commission of 1907, part of the reform movement combatting the rise of the feature film (see note 35). For a book-length study of the conditions of reception in the period in which the numbers principle dominated,

see Yuri Tsivian, *Early Cinema in Russia and its Cultural Reception*, London: Routledge, 1994.

18. Apart from the November opening programme, consisting of nine short sketches, including a boxing kangaroo number, a view of the Copenhagen Tivoli Gardens, and a direct address to the audience by his brother Emil, Skladanowsky put together a second programme in 1896/97, mainly of Berlin city views which was successfully shown all over Germany, though mostly on the (technically superior) Lumière cinématographe. The last time the cumbersome Bioskop machine was used was on 30 March 1897, the day Max Skladanowsky's trading license expired.

19. Martin Loiperdinger, 'Ludwig Stollwerck: Wie der Film nach Deutschland kam,' *KINtop 1*, 1992, pp. 115-119 and 'Ludwig Stollwerck, Birt Acres and the Distribution of the Lumière Cinématographe in Germany,' in Roland Cosandey and François Albéra (eds.), *Images Across Borders, 1896-1918. Internationality in World Cinema: Representations, Markets, Influences and Reception*, Lausanne/Quebec: Editions Payot/Nuit Blanche Editeur, 1995, pp. 167-177.

20. Martin Loiperdinger and Roland Cosandey, 'L'introduction du Cinématographe en Allemagne,' *Archives* 51, Institut Jean Vigo, Nov. 1992, pp. 13-14.

21. Among a number of studies of the cinematograph in its first years, one particularly detailed is Guido Convents, 'L'apparition du cinéma en Belgique (1895-1918),' in *Les Cahiers de la Cinématèque*, Perpignan, no. 41, April 1984, pp. 12-26. See also the papers given at the 'Hondert Jaar Film - het begin' conference, University of Amsterdam, March 22-23, 1996.

22. Messter was not the first to try out sound-on-disk synchronisation. Edison had developed the kinetoscope originally in order to 'illustrate' his phonographic cylinders, and Gaumont had also patented a synchronized sound-film system. Since amplification and sound reproduction remained poor, these efforts were abandoned as soon as cinemas expanded their auditorium size. Why Messter persisted is not quite clear, but it may have had to do with his inventor-bricoleur mentality, a mixture of the practical and the playful.

23. See Martin Koerber, below.

24. This is one of the distinctions made by Noël Burch, in 'A Paranthesis on Film History,' in *To the Distant Observer: Form and Meaning in Japanese Cinema*, London: Scolar Press, 1979, pp. 61-66.

25. The information comes from his autobiography *Mein Weg mit dem Film,* Berlin: Verlag Max Hesse, 1936, but is also summarized in Friedrich v. Zglinicki, *Der Weg des Films: Die Geschichte der Kinematographie und ihrer Vorläufer*, Hildesheim: Olms, 1956.

26. Noël Burch, *To the Distant Observer*, op. cit., pp. 61-63.

27. As Jeanpaul Goergen shows in his essay below, a similar inventiveness in finding new applications and exploring new markets for the cinema was revealed by Julius Pinschewer, the pioneer of the industrial advertisement film. See also Kimberly O'Quinn's

essay for the links between *Kulturfilm*, propagada and newsreel-documentary in Messter.

28. An invaluable near-contemporary source for German variety is Signor Saltarino, *Das Artistentum und seine Geschichte*, Leipzig: Willi Backhaus, 1910.

29. Martin Loiperdinger and Harald Pulch, DER FILMPIONIER OSKAR MESSTER, Filmproduktion Harald Pulch, 1995, 58 mins.

30. Jakob von Hoddis, 'Der Kinematograph' (1911), quoted in Ludwig Greve, Margot Pehle, Heidi Westhoff (eds.), *Hätte ich das Kino! Die Schriftsteller und der Stummfilm*, Munich: Kösel, 1976, p. 15.

31. Alfred Döblin, 'Das Theater der kleinen Leute' (1909), reprinted in Anton Kaes (ed.), *Kino-Debatte: Texte zum Verhältnis von Literatur und Film 1909-1929*, Tübingen/Munich: Niemeyer/dtv, 1978, p. 38.

32. *Ibid*. See Martin Loiperdinger's essay 'The Kaiser's Cinema,' below.

33. Egon Friedell, 'Prolog vor dem Film' (1913), reprinted in Jörg Schweinitz, *Prolog vor dem Film: Nachdenken über ein neues Medium 1909-1914*, Leipzig: Reclam, 1992, p. 204.

34. Victor Noack, 'Der Kintopp,' *Die Aktion*, no. 29, 17 July 1912, p. 907.

35. One of the best-known is the Hamburg report by C.H. Dannmeyer, *Bericht der Kommission für 'Lebende Photographien'* (1907), reprint, ed. Hans-Michael Bock, Hamburg: Fläschner Druck, 1980.

36. Alfred Döblin, *op. cit.*, pp. 37-8.

37. *Ibid*. See also Corinna Müller's argument about children as spectators in *Frühe deutsche Kinematographie*, op. cit.

38. Altenloh's argument is taken up by Heide Schlüpmann, 'Cinema as Anti-Theater: Actresses and Female Audiences in Wilhelmine Germany,' *Iris*, no. 11, Summer 1990, pp. 77-93.

39. Georges Sadoul, *op. cit.*, p. 365.

40. For information about early German production companies, see Michael Esser (ed.), *In Berlin Produziert: 24 Firmengeschichten*, Berlin: Stiftung Deutsche Kinemathek, 1987.

41. According to Thomas Saunders, in 1912/13 the native share of the market still reached only 13 percent. See his *Hollywood in Berlin: American Cinema and Weimar Germany*, Berkeley et al.: University of California Press, 1994.

42. Kristin Thompson, *Exporting Entertainment: America in the World Film Market 1907-1934*, London: BFI Publishing, 1985, p. 37.

43. Hermann Wollenberg, *Fifty Years of German Film*, London: Falcon Press, 1948, p. 11, but see also Sadoul, *op. cit.*, p. 364, who attributes this calculation to the 'pangermanist lobby' in the Black Forest, and thus as part of the anti-French propaganda war on the eve of the 1914 'hot' war.

44. Enno Patalas et al., *Bilddokumente zur Geschichte des Films*, Munich, n.d., vol. 1, pp. 12-15.

45. Most historians (e.g. Jürgen Spiker, *Film und Kapital*, Berlin: Verlag Volker Spiess, 1975) have taken their figures from Altenloh, where perhaps not enough distinction is made between different types of cinema theatres. But it is Corinna Müller who challenges these assertions most decisively, providing the figures that lead to her quite different argument, for in this question above all, the regional and local studies have shed new light.

46. Sadoul, *op. cit.*, p. 361, and Dieter Prokop, *Soziologie des Films*, 2nd ed., Frankfurt: Fischer Taschenbuchverlag, 1982.

47. For some of the desperate measures employed, see Karen Pehla, 'Joe May und seine Detektive,' in Hans-Michael Bock and Claudia Lenssen (eds.), *Joe May: Regisseur und Produzent*, Munich: edition text & kritik, 1991, pp. 61-72.

48. On the Monopolfilm and its repercussions for both exhibition and production, see Corinna Müller, *Frühe deutsche Kinematographie*, op. cit., esp. chapters 4 and 5.

49. '[Asta Nielsen's] coming characterized the break-through to art in German film production, which so far had been entirely guided by the ever-growing business possibilities. Today it seems almost grotesque to think that those forces which were aiming at the artistic development of the film in Germany were at first opposed by difficulties almost too great to overcome. These difficulties were caused by the lack of interest in the popular new entertainment-medium shown by the ruling classes, by educated and official circles, who had so far completely overlooked its cultural and educational possibilities.' H.H. Wollenberg, *op. cit.*, p. 9.

50. Barry Salt, 'The World Inside Lubitsch,' first given as a paper at the 'Space Frame Narrative Conference' at the University of East Anglia, 1983.

51. Salt has unearthed the operetta pretext and prototype for many of Lubitsch's most successful films, from MADAME DUBARRY and DIE PUPPE, to THE OYSTER PRINCESS and THE MOUNTAIN CAT. One should add that the sexual comedy of errors and substitutions, of gender-bending cross-dressing are also conventionalized - and by their audiences much prized - aspects of operetta subjects.

52. Ennio Simeon has made a suggestion along these lines in his essay 'Music in German cinema before 1918,' in Cherchi Usai and Codelli (eds.), *Before Caligari*, op. cit., p. 80.

53. See Ivo Blom on the Messter-Desmet correspondence in 'Filmvertrieb in Europa 1910-1915: Jean Desmet und die Messter-Film GmbH,' *KINtop 3*, 1994, pp. 73-91, esp. pp. 83-4.

54. 'It was the war which spawned an independent German cinema, partly because it provided existing producers with new opportunities, and more essentially because it finally mobilized the financial forces required to sustain large-scale production. In the first instance, declining output in France and Italy gave a crucial fillip to native production. This was accompanied in 1915 by a ban on import of foreign (chiefly French, British and Italian) films made since the outbreak of war. Then in February 1916 a comprehensive ban was imposed as part of a general tightening of import/export regulations, leav-

ing import permission to a federal commissioner.' Saunders, *op. cit.*, pp. 21-22.

55. Kimberly O'Quinn, below, discusses Bill Uricchio's argument in respect of the *Kulturfilm* and 'Kinoreform.'

56. Tom Saunders has pointed out that 'restriction of import provided a precondition but not a guarantee for the ascendancy of domestic producers.' Saunders explains: 'By 1916 German films outnumbered imports by somewhat less than 2:1. Admittedly, this ratio concealed anomalies. Chief of these was the fact that the foremost "German" producer was still a foreign company. The Danish concern, Nordisk, largely filled the void left by the French and Americans and enjoyed a commanding position on the German market. Nordisk not only distributed in Germany but had its own production facilities and owned the largest chain of German theatres. So powerful was its position that it gained exemption from the import ban.' Saunders, *Hollywood in Berlin*, op. cit., pp. 21-22. See also Hampicke, below.

57. Kristin Thompson, *Exporting Entertainment*, op. cit., pp. 104-111.

58. For formal analyses of Scandinavian films, see John Fullerton's and Kristin Thompson's contributions in Karel Dibbets and Bert Hogenkamp (eds.), *Film and the First World War*, Amsterdam: Amsterdam University Press, 1995, as well as the examples cited by Yuri Tsivian, below.

59. The fact that ZWEIMAL GELEBT, by all accounts, was censored and never publicly shown adds a further level of irony both to the film title and my emblematic use of it as the book title.

60. For a convenient account of 'apparatus theory,' see Phil Rosen, (ed.), *Narrative, Apparatus, Ideology*, New York: Columbia University Press, 1986.

61. Charles Musser, *The Emergence of Cinema: The American Screen to 1907*, New York: Scribner, 1990, ch. 1.

62. The honours of having 'rediscovered' Franz Hofer in Germany are shared by Heide Schlüpmann ('The Sinister Gaze: Three Films by Franz Hofer from 1913,' in Cherchi Usai and Codelli [eds.], *Before Caligari*, op. cit., pp. 452-473) and Fritz Güttinger ('Franz Hofer: Ausgrabung des Jahres?' In *Köpfen Sie mal ein Ei in Zeitlupe! Streifzüge durch die Welt des Stummfilms*, Zurich: NZZ Verlag, 1992, pp. 215-226).

63. RICHARD WAGNER was made to coincide with the composer's centenary. The project gained wide publicity because of a well-known figure of Berlin musical life, Giuseppe Becce, played the lead. Notoriety was added by the outrageous financial demands made for the music rights by the Bayreuth Wagner estate, which necessitated that the film be performed with a Wagner-ish score. For a fuller discussion of the music in RICHARD WAGNER, see Ennio Simeon, below.

64. As to the reaction of the critics, see Julius Hart, 'Der Atlantis Film,' *Der Tag*, 24 December 1913. Reprinted in Fritz Güttinger (ed.), *Kein Tag ohne Kino: Die Schriftsteller über den Stummfilm*, Frankfurt: Deutsches Filmmuseum, 1984, pp. 292ff. My thanks to Martin Loiperdinger for drawing attention to this passage.

65. The references to its popularity - over 150 copies sold and one of the rare German export successes of the time - are in George Sadoul, *op. cit.,* p. 368.

66. DIE KINDER DES MAJORS maintains a very complex distribution of knowledge among the character at the same time as it elaborates an involuted temporal structure, again indicative of the efforts made to involve the spectator in an 'inner' drama, as opposed to employing what Noël Burch has called 'external narration' and André Gaudreault has defined as 'monstration.'

67. The situation of the heroine is more convoluted still: one not only imagines the silent cry of Henny Porten on the organ loft, before she collapses, but actually 'hears' it, thanks to the prominence of huge organ pipes framing her tormented look.

The Kaiser's Cinema:
An Archeology of Attitudes and Audiences

1. See in this context, Thomas Elsaesser, 'Early Cinema: From Linear History to Mass Media Archeology' in *Early Cinema: Frame Space Narrative,* London: BFI Publishing, 1990, pp. 1-10.

2. Heinrich Fraenkel, *Unsterblicher Film. Die grosse Chronik: Von der Laterna Magica bis zum Tonfilm,* Munich: Kindler, 1956.

3. Siegfried Kracauer, *From Caligari to Hitler: A Psychological History of the German Film,* Princeton: Princeton University Press, 1947, p. 16.

4. Dieter Prokop, *Soziologie des Films,* Opladen: Luchterhand, 1970, p. 33.

5. Anton Kaes, 'Mass Culture and Modernity: Notes Toward a Social History of Early American and German Cinema,' in Frank Trommler / Joseph McVeigh (eds.), *America and the Germans: An Assessment of a Three-Hundred Year History,* vol. 2, Philadelphia: University of Pennsilvania Press, 1985, p. 320.

6. Emilie Altenloh, *Zur Soziologie des Kino: Die Kinounternehmung und die sozialen Schichten ihrer Besucher,* Jena: Diederichs, 1914.

7. See Jürgen Kinter, *Arbeiterbewegung und Film (1895-1933): Ein Beitrag zur Geschichte der Arbeiter- und Alltagskultur und der gewerkschaftlichen und sozialdemokratischen Kultur- und Medienarbeit,* Hamburg: Medienpädagogik Zentrum, 1985.

8. Cf. Altenloh, *Zur Soziologie des Kino,* op. cit., p. 78: 'While the men are at an election meeting, the women go to the picture palace next door, and after the performance they collect their men. In the course of time, this stopgap measure turned into a significant part of their existence. Little by little they were seized by real enthusiasm for it, and more than half of them managed to indulge this enjoyment one or more times a week.'

9. *Ibid.,* pp. 91-2.

10. Prokop, *Soziologie des Kinos,* op. cit., p. 33.

11. Bruno Fischli, 'Das goldene Zeitalter der Kölner Kinematographie (1896-1918),' in Fischli (ed.), *Vom Sehen im Dunkeln: Kinogeschichten einer Stadt,* Cologne: Prometh,

1990, p. 30.

12. Heide Schlüpmann, *Unheimlichkeit des Blicks: Das Drama des frühen deutschen Kinos*, Basel, Frankfurt: Stroemfeld/Roter Stern, 1990.

13. See 'Lebende Flottenbilder, vorgeführt durch den Biographen', in *Die Flotte*, vol. 4, no. 5, May 1901, section 'Vereinsnachrichten', pp 75-6. Excerpts form this report are appended to my essay 'Kino in der Kaiserzeit', in Uli Jung (ed.), *Der deutsche Film. Aspekte seiner Geschichte*, Trier: Wissenschaftlicher Verlag, 1993, pp. 47-50.

14. No footage featuring the German navy before 1908 has so far been found in German film archives.

15. See 'Der Deutsche Flottenverein als Schausteller', *Der Komet* no. 927, 27.12.1902, and 'Die Kinematographen-Theater und der Deutsche Flotten-Verein, *Der Kinematograph* no. 60, 19.2.1908.

16. See *Die Flotte*, Annual Report for 1903, p. 4.

17. The *Monopolfilm* distribution practice meant that in each area only one cinema received a copy for exhibition and could thus take exclusive advantage of the première value of the film. The first film to be treated in this manner, Asta Nielsen's AFGRUNDEN, reached the German cinemas via the Düsseldorf distributor Ludwig Gottschalk. See Peter Lähn's essay in this volume and especially Corinna Müller, *Frühe deutsche Kinemato–graphie*, Stuttgart: Metzler, 1994.

18. See Paul Klebinder, *Der deutsche Kaiser im Film*, Berlin: Verlag Paul Klebinder, 1912.

19. *Ibid.*, the first citation is from the preface (neither marked nor paginated), the second from the unmarked article, 'Hermelin und Lichtspielkunst' (p. 16).

20. See Herbert Birett, *Das Filmangebot in Deutschland 1895-1911*, Munich: Winterberg; I am grateful to Herbert Birett for valuable suggestive information.

21. See Hans Magnus Enzensberger, 'Scherbenwelt: Anatomie einer Wochenschau,' in Enzensberger, *Einzelheiten I: Bewusstseins-Industrie*, Frankfurt: Suhrkamp, 1964, pp. 106-133.

22. Paul Klebinder, *Kronprinzens im Film*, Berlin: Verlag Paul Klebinder, 1913, p. 9.

23. *Der Kinematograph*, no. 99, 18 November 1908.

24. Cf. Werner K. Blessing, 'Der monarchische Kult, politische Loyalität und die Arbeiterbewegung im deutschen Kaiserreich,' in Gerhard A. Ritter (ed.), *Arbeiterkultur*, Königstein/Ts.: Athenäum, 1979, pp. 185-208.

25. George L. Mosse, *Die Nationalisierung der Massen: Politische Symbolik und Massenbewegung in Deutschland von den Napoleonischen Kriegen bis zum Dritten Reich*, Frankfurt: Fischer, 1986.

26. For an overview see Thomas Elsaesser (ed.), *Early Cinema: Space, Frame, Narrative*, London: BFI Publishing, 1990, and Thomas Elsaesser, 'The New Film History,' *Sight & Sound*, vol. 55, no. 4, Autumn 1986, pp. 246-251; see also the more recent contributions to the DOMITOR-conference, held from 29 June to 4 July 1992 at the University of Lausanne, collected in Roland Cosandey and François Albera (eds.), *Cinéma sans fron-*

tière/Images across Borders, 1896-1918. Internationality in World Cinema: Representations, Markets, Influences and Reception, Lausanne/Quebec: Editions Payot/Nuit Blanche Editeur, 1995.

Oskar Messter, Film Pioneer:
Early Cinema between Science, Spectacle, and Commerce

1. See Oskar Messter, 'Erinnerungen an die Anfänge der Kinematographie in Deutschland,' *Die Kinotechnik*, no. 23, 1927, p. 613. See also an earlier, more detailed draft of this article in the Messter Collection, *Bundesarchiv (BA) N 1275*, file 471. (It should be noted that the file numbers of the Messter Collection given here are no longer current, as the collection has been re-arranged in 1994. Please consult the new catalogue of the collection, *Findbücher zu Beständen des Bundesarchivs*, vol. 48.)
2. See Letter Robert W. Paul to Oskar Messter, 5 August 1932, *BA N 1275*, file 43.
3. See Letter Max Gliewe to Oskar Messter, 18 June 1922, *BA N 1275*, file 352.
4. See Albert Narath, *Oskar Messter: Der Begründer der deutschen Kino- und Filmindustrie*, Berlin: Deutsche Kinemathek, 1966, p. 12.
5. See 'Kassenbuch der Firma Ed. Messter 1892-1896,' *BA N 1275*, file 315.
6. *Special-Catalog Nr. 32 der Fa. Ed. Messter*, Berlin 1898; reprint, ed. Martin Loiperdinger, Basel and Frankfurt: Stroemfeld/Roter Stern, 1995, p. 80.
7. *Ibid*, p. 75.
8. One metre of sound picture cost 2.50 marks, in addition to the cost of the record. The price of 'silent' film at the time lay between 60 pfennigs and 1.20 marks per metre, depending on whether it was black and white or colour, and whether it was a so-called 'art film.' Older programmes could be had for lower rates. See Heinrich Putzo, 'Aus den Kindertagen des Tonfilms,' *Lichtbildbühne*, no. 277/278, 20 September 1929.
9. See Corinna Müller, *Frühe deutsche Kinematographie: Formale, wirtschaftliche und kulturelle Entwicklungen 1907-1912*, Stuttgart and Weimar: Metzler, 1994, p. 80.
10. See Guido Seeber, 'Trick und Ton,' *Photographische Industrie*, no. 40, 1930; reprinted in Norbert Jochum (ed.), *Das wandernde Bild: Der Filmpionier Guido Seeber*, Berlin: Stiftung Deutsche Kinemathek/Elephanten Press, 1979, pp. 125-6.
11. See Harald Jossé, *Die Entstehung des Tonfilms: Beitrag zu einer faktenorientierten Mediengeschichtsschreibung*, Freiburg and Munich: Alber, 1984, p. 82.
12. See exposé about Messters-Projektion, *BA N 1275*, file 355.
13. See Corinna Müller, *Frühe deutsche Kinematographie*, op. cit., p. 83.
14. Messter, *Mein Weg mit dem Film*, Berlin: Verlag Max Hesse, 1936, pp. 98-99.
15. Letter Maxim Galitzenstein to Oskar Messter, 20 September 1922, *BA N 1275*, file 355.
16. Letter Leo Mandl to Oskar Messter, 14 October 1924, *BA N 1275*, file 342.
17. Robert Heymann, *Der Film in der Karikatur*, Berlin 1929, p. 47.
18. This reconstruction of the career of Henny Porten follows mainly Corinna Müller's ac-

count in *Frühe deutsche Kinematographie*, op. cit., pp. 170ff.

19. Letter Maxim Galitzenstein to Oskar Messter, 20 September 1922, *BA N 1275*, file 355.

20. *Ibid.* See also Ivo Blom, 'Filmvertrieb in Europa 1910-1915: Jean Desmet und die Messter-Film GmbH,' *KINtop 3*, 1994, pp. 73ff.

21. See Corinna Müller, *Frühe deutsche Kinematographie*, op. cit., pp. 126ff.

22. See *ibid.*, pp. 166ff.

23. Its subjects alternated between anti-Russian propaganda, individual military heroism, and patriotic home front efforts by popular artists and members of the royal family.

24. 'Messters Kriegskinos,' *Der Kinematograph*, no. 437, 12 May 1915.

25. The special value of the equipment was first successfully put to the test during the Battle of the Somme in 1916, see 'Der Reihenbildner. Seine Anwendung und seine Vorteile,' (typescript, undated), *BA N 1275*, file 446.

26. Aerial warfare and film technology combined in another of Oskar Messter's inventions, the machine-gun camera which 'required exactly the same trigger movement and had the same sighting mechanism, but instead of a cartridge belt it had rolls of film. Instead of providing 600 rounds per minute it made 600 shots of film per minute. Each shot displayed the enemy plane and a crosshair. The pilot could see where he had aimed and whether he had 'aimed' too high or too low, and could correct his next flight accordingly. (...) It became the rule that pilots were not sent into battle until they had proved themselves competent shots with the machine-gun camera.' Messter, *Mein Weg mit dem Film*, op. cit., p. 88.

27. A reprint of Messter's memorandum can also be found in *KINtop 3*, pp. 93ff. See also Wolfgang Mühl-Benninghaus, 'Oskar Messters Beitrag zum Ersten Weltkrieg,' *ibid.*, p. 113.

28. This is only the nominal price for the goldmark; because of money devaluation and re-valuation, the costs for Ufa were reduced to ca. 3.8 milllion marks. This still considerable amount also included the payments to Messter's companions. See *BA R109 I*, file 138.

The French Connection:
Franco-German Film Relations before World War I

1. This essay is a reworked and shortened version of a paper presented in German at the 1995 CineGraph conference in Hamburg, dedicated to Franco-German film relations. While collecting primary materials we were greatly helped and supported by Youen Bernard, the Deutsches Institut für Filmkunde (DIF), and Martin Loiperdinger. Special thanks are also due to Herbert Birett and Evelyn Hampicke, both of whom generously offered us access to their research and source material.

2. Cf. Martin Loiperdinger 'Wie der Film nach Deutschland kam,' *KINtop 1: Früher Film in Deutschland*, Basel/Frankfurt: Stromfeld/Roter Stern, 1993, S.115-118 as well as Martin Loiperdinger, Roland Cosandey (eds.), *L'Introduction du cinématographe en*

Allemagne. De la case Demeny à la case Lumière: Stollwerck, Lavanchy-Clarke et al., 1892-1896 (= *Archives* 51, November 1992).

3. Cf. Friedrich von Zglinicki, *Der Weg des Films*, Hildesheim, New York: Olms Presse, 1979, p. 246-247 (his claims and conclusions are not, however, documented with references to sources). Currently, this question is being investigated by, among others, Evelyn Hampicke and Deac Rossell. See also Laurent Mannoni, *Le grand art de la lumière et de l'ombre: Archéologie du cinéma*, Paris: Nathan, 1994, p. 421. From Carpentière's letter to Lumière on p. 421, it becomes evident that Lumière was aware of the German competition.

4. Herbert Birett, *Das Filmangebot in Deutschland 1895-1911*, Munich: Winterberg, 1991. Herbert Birett researched these numbers for us.

5. See in this context Helmut H. Diederichs, 'Die Anfänge der deutschen Filmpublizistik 1895-1909,' *Publizistik*, vol. 30, no. 1, 1985, pp. 55-71, and also Herbert Birett, 'Standortverzeichnis früher deutscher Filmzeitschriften', *KINtop 1*, op. cit., pp. 136-144.

6. 'Our trade is sighing under the French yoke, and even the last German film would have remained unborn in Germany if the war had not arrived,' Arthur Mellini, 'Die Politik und der Film,' *Licht-Bild-Bühne*, vol. 7, no. 56, 29 August 1914, p. 2.

7. *Ibid.*

8. See Youen Bernard, *L'Eclipse. L'histoire d'une maison de production et de distribution cinématographique en France, de 1906 à 1923*, Maîtrise d'Etudes Cinématographiques et Audiovisuelles, Paris VII, 1992/1993, p. 15.

9. About Theophile Pathé compare Thierry Lefebvre and Laurent Mannoni, 'Annuaire du commerce et de l'industrie cinématographiques (France - 1913)' in: Lefebvre and Mannoni (eds.), *L'Année 1913 en France* (= *1895*, numéro hors série), October 1993, pp. 11-65. See also Youen Bernard, *Les petites maisons de production cinématographique françaises de 1906 à 1914*, DEA d'Etudes Cinématographiques et Audiovisuelles, Paris III, 1993/94, pp. 55-65.

10. For a detailed analysis consult Sabine Lenk, 'Lichtblitze: Prolegomena zur Geschichte der französischen Filmproduktionsgesellschaft Eclair im Deutschen Reich und in der K.u.K. Monarchie Österreich-Ungarn,' *KINtop 1*, op. cit., pp. 29-57 as well as 'Licht–blitze: Die Produktionsgesellschaft Eclair - ein Nachtrag,' *KINtop 4: Anfänge des dokumentarischen Films*, Basel/Frankfurt am Main: Stroemfeld/Roter Stern, 1995, pp. 163-167.

11. Founded in 1906, Lux opened a Berlin office on April 10th, 1908, headed by one Gertrud Grünspan. See note in *Erste Internationale Film-Zeitung*, vol. 3, no. 16, 15 April 1909.

12. See Corinna Müller, *Frühe deutsche Kinematographie: Formale, wirtschaftliche und kulturelle Entwicklungen*, Stuttgart, Weimar: Metzler, 1994, pp. 106-107, and endnote no. 21.

13. See Youen Bernard, *Les petites maisons...*, op. cit., p. 69.

14. See Evelyn Hampicke, 'Vive la Concurrence! Oder was sich über Pathé finden liess. Der

Versuch einer Rekonstruktion,' in Corinna Müller and Harro Segeberg (eds.), *Medienge-schichte des Films*, vol. 2, Munich: Wilhelm Fink, forthcoming.

15. See Heinrich Auer, 'Zur Kinofrage,' *Soziale Revue*, vol. XIII, no. 1, 1913, pp. 19-36 ('...Pathé Frères is supposed to have had 90% dividends in the year before last and employs 5000 people.')

16. Thierry Lefebre / Laurent Mannoni, 'Annuaire du commerce et de l'industrie cinémato-graphiques (France-1913),' in Lefebre / Mannoni (eds.), *l' Année 1913 en France* (=*1895*, numéro hors série), October 1993, pp. 11-65.

17. See Martin Koerber, 'Filmfabrikant Oskar Messter - Stationen einer Karriere,' in Martin Loiperdinger (ed.), *Oskar Messter: Filmpionier der Kaiserzeit*, Basel/Frankfurt: Stroemfeld/Roter Stern, 1994, p. 58.

18. See *Le Cinéma* from 14 Feb 1913 (Nielsen), 8 Aug 1913 (Porten), 21 Nov 1913 (Kay-ssler), 28 Nov 1913 (Hofer), 3 Feb 1914 (Nielsen), 27 Feb 1914 (Morena), 6 Mar 1914 (May) and 10 Mar 1914 (Neumann, Treptow, Orla).

19. See 'Die Konvention,' *Erste Internationale Film-Zeitung*, vol. 3, no. 11, 11 March 1909.

20. See *Erste Internationale Film-Zeitung*, vol. 3, no. 13, 15 March 1909.

21. See *Erste Internationale Film-Zeitung*, vol. 3, no. 25, 17 June 1909.

22. See *Licht-Bild-Bühne*, 25 May 1912.

23. See Martin Loiperdinger's essay in this volume.

24. Helmut H. Diederichs, *Der Student von Prag: Einführung und Protokoll*, Stuttgart: Fo-cus, 1985, p. 6.

25. Hampicke, 'Vive la concurrence!' *op. cit.*

26. These papers are held at the Geheimes Staatsarchiv Preußischer Kulturbesitz, Abt. Merseburg (today Berlin-Dahlem) and have been researched by Herbert Birett.

27. Hampicke, 'Vive la concurrence!' *op. cit.*

28. Oskar Messter, 'Exposé über die neue Sensation der sprechenden, lebenden Photogra-phie zum Zweck einer Gesellschaftsgründung,' quoted after Harald Jossé, *Die Entste-hung des Tonfilms: Beitrag zu einer faktenorientierten Mediengeschichtsschreibung*, Freiburg/Munich: Verlag Karl Alber, 1984, p. 79.

29. See Jossé, *Die Entstehung des Tonfilms*, op. cit., p. 79-8, also Müller, *Frühe deutsche Kinematographie*, op. cit., p. 80. An advertisement of their joint system is published in Koerber, 'Oskar Messter,' *op. cit.*, p. 50.

30. See the counter statements by Pathé in *Erste Internationale Film-Zeitung*, vol. 3, no. 49, 2 December 1909 and no. 50, 9 December 1909.

31. *Erste Internationale Film-Zeitung*, vol. 3, no. 20, 13 May 1909.

32. Julius Becker, 'Der Kampf gegen die ausländischen Films,' *Licht-Bild-Bühne*, no. 62, 19 September 1914, on Gaumont also see Herbert Birett/Sabine Lenk, 'Die Behandlung ausländischer Filmfirmen während des ersten Weltkriegs,' in *1895-1995: Positionen deutscher Filmgeschichte*, Munich: diskurs film (= Münchner Beiträge zur Filmphilolo-gie 8), forthcoming.

33. See Lenk, 'Lichtblitze: Prolegomena...,' *op. cit.*, p. 37.

34. Becker, 'Der Kampf gegen die ausländischen Films,' *op. cit.*

35. For a detailed analysis of how foreign firms in general, and French firms in particular were 'administered' or expropriated during the war, see Herbert Birett/Sabine Lenk, *op. cit.*

36. 'Der Einzug der Deutschen in Paris,' *Licht-Bild-Bühne*, no. 58, 5 September 1914.

37. See Becker, *op. cit.*, who even states that 'Pathé was always cheap and real, more real than many of the German firms.'

38. Arthur Mellini, 'Die Politik und der Film,', *op. cit.*

39. Stefan Wronski (=Ferdinand Hardekopf), 'Der Kinematograph,' *Nord und Süd*, vol. XXXIV, no. 412, 1910, pp. 326-328. Quoted from the reprint in Jörg Schweinitz (ed.), *Prolog vor dem Film: Nachdenken über ein neues Medium 1909-1914*, Leipzig: Reclam, 1992, p. 157.

40. *Erste Internationale Film-Zeitung*, vol. 3, no. 31, 29 June 1909.

41. See, for instance, the Pathé and Gaumont titles of the Joye collection, in Roland Cosandey (ed.), *Wecome Home Joye: Film um 1910*, Frankfurt/Basel: Stroemfeld/Roter Stern (= KINtop Schriften 1), 1993.

42. See 'Vom Kino-Deutsch,' *Erste Internationale Film-Zeitung*, vol. 3, no. 52, 23 December 1909, see also Assessor H.F., 'Die Verdeutschung fremdsprachiger Titel,' *Erste Internationale Film-Zeitung*, vol. 3, no. 41, 7 October 1909.

43. Willy Rath, 'Emporkömmling Kino,' *Der Kunstwart*, no. 24, 1912/13, pp. 415-424. Quoted from the reprint in Schweinitz, *Prolog vor dem Film*, op.cit., p. 79.

44. 'Kinematographische Vorführungen,' *Ostasiatischer Lloyd-Shanghaier Nachrichten*, 26 July 1907.

45. 'Kinematograph New Point Hotel,' *Ostasiatischer Lloyd-Shanghaier Nachrichten*, 11 August 1911.

46. 'Die Verrohung des Kinos,' *Ostasiatischer Lloyd-Shanghaier Nachrichten*, no. 17, 25 April 1913, p. 1 (part 1); no. 19, 9 May 1913, p. 154 (part 2); no. 20, 16 May 1913, p. 163 (part 3).

47. See Walter Thielemann, 'Die Nutzbarmachung der Kinematographie für Schule, Jugendpflege und Volksbildung,' *Die Hochwacht*, vol. IV, no. 10, pp. 244-5; and 'Kinematographie und Jugendpflege,' *ibid.*, pp. 270-1.

The Danish Influence: David Oliver and Nordisk in Germany

1. *Der Kinematograph*, no. 450, 11 August 1915.

2. *Bild & Film*, vol. 4, no. 12, 1914 / 15.

3. See *Der Kinematograph*, no. 576, 16 January 1918.

4. See Wolfgang Jacobsen, *Erich Pommer: Ein Produzent macht Filmgeschichte*. Berlin:

Argon, 1989, p. 48.

5. After leaving his post as general director at Ufa, Oliver worked as a free-lance project manager, building new cinema palaces, especially for the Phoebus Co. At this point he had already built large cinemas in Dresden, Munich and Nuremberg. In 1928 he writes: 'As founder and manager of the Oliver concern, and later of the Universum Film AG, I have initiated and supervised a number of great building projects in the last 25 years. This has been a great success, as every expert in the field can tell you...' In the summer of 1927 Oliver, who was general manager of the real estate investors' group 'Grundwert AG' at the time, and realizing how profitable such a venture could be, decided to erect a cinema palace in Hamburg, which was meant to be larger than all the existing movie houses in the city, as well as offering an extensive variety programme, far surpassing those of other cinemas in scope and quality. The movie palace was built in the American style with 2700 seats - the largest cinema in Europe. This information is taken from Roland Jaeger, *Block & Kochfeld: Die Architekten des 'Deutschlandhauses,'* PhD Hamburg, 1995.

Paul Davidson, the Frankfurt Film Scene and AFGRUNDEN in Germany

1. Karl Zimmerschied, *Die deutsche Filmindustrie: Ihre Entwicklung, Organisation und Stellung im deutschen Staats- und Wirtschaftsleben*, Erlangen, 1922, p. 49.
2. Kurt Mühsam and Egon Jacobsohn, *Lexikon des Films*, Berlin: Verlag der Lichtbild-bühne, 1926, p. 38. The sections on Paul Davidson are based on a questionnaire sent to Davidson by the publisher, which he filled out extensively.
3. The brief biographical information on Wronker, Wiesbader and Bauer was supplied by the Jewish Museum, Frankfurt am Main.
4. The founding of each of the cinemas are published, along with place and date, in a 'Stammbaum der U.T.,' which is illustrated in a PAGU advertising brochure from 1913.
5. Zimmerschied, *op. cit.*, p. 49.
6. *Ibid.*
7. *Ibid.*
8. For a brief account of the history of sound pictures and their significance for the development of cinematography in Germany in this period (1903-1913), see Martin Koerber's essay in this volume.
9. On 29 August in the Varieté Apollo Theatre in Berlin. The numerous reports of this event indicate a fascination for 'the subtle correspondence between movement and sound' that it contained.
10. C. Borger, 'Das "Tonfilmtheater," ein neues kinematographisches Unternehmen,' *Der Kinematograph*, no. 24, 12 June 1907.
11. See the essays by Martin Loiperdinger and Martin Koerber elsewhere in this volume.

12. C. Borger, *op. cit.*

13. b. (= C. Borger), 'Bericht über die Entwicklung des Tonbild-Theaters Zeil 54,' *Der Ki–nematograph*, no. 37, 11 September 1907.

14. C. Borger, 'Tonbild-Theater...,' *Der Kinematograph*, no. 48, 27 November 1907.

15. Th. M., 'Wie singende Bilder (Tonbilder) entstehen,' *Der Kinematograph*, no. 65, 25 March 1907. Reprinted in Martin Koerber, *op. cit.*, pp. 50-52. This atmospheric description of a recording in a Messter studio reports about four-figure royalty payments which were paid to top workers.

16. *Der Kinematograph*, no. 76, 10 June 1908.

17. Report on the economical situation of the Deutsche Tonbild-Theater-Gesellschaft m.b.H. in *Der Kinematograph*, no. 223, 5 April 1911.

18. Zimmerschied, *op. cit.*, p. 49.

19. Viktor Happrich, 'Das Union-Theater,' *Der Kinematograph*, no. 140, 1 September 1909.

20. *Frankfurter Adressbuch*, 1909, p. 24.

21. Corinna Müller, *op. cit.*, p. 37.

22. Dr Arthur Spamer, 'Zur Krisis in der Filmindustrie. I. Wesen der Filmindustrie und ihre gegenwärtige Lage,' *Erste Internationale Film-Zeitung*, no. 30, 22 July 1909. Two further installments of this article appeared in no. 31, 29 July 1909 and no. 33, 12 August 1909.

23. *Ibid.*, no. 33, 12 August 1909.

24. *Der Kinematograph*, no. 172, 13 April 1910.

25. *Ibid.*

26. *Ibid.*

27. *Der Kinematograph*, no. 283, 29 May 1912.

28. *Der Kinematograph*, no. 181, 15 June 1910.

29. These figures were taken from a commemorative publication by PAGU on the opening of the 'U.T.' theatre in the 'Bavariahaus' on Berlin's Friedrichstrasse on 30 May 1913.

30. *Kleine Presse*, 23 July 1910.

31. C. Borger in *Der Kinematograph*, no. 215, 8 February 1911.

32. See Peter Lähn, 'AFGRUNDEN und die deutsche Filmindustrie. Zur Entstehung des Monpolfilms,' in Manfred Behn (ed.), *Schwarzer Traum und weisse Sklavin: Deutsch-dänische Filmbeziehungen 1910-1930*, Munich: edition text & kritik, pp. 15-22, and Corinna Müller, *op. cit.*, pp. 126-7.

33. *Ibid.*

34. Paul Davidson in P. Diaz, *Asta Nielsen: Eine Biographie unserer populären Künstlerin*, Berlin: Verlag der Lichtbild-Bühne, n.d.; reprinted in Renate Seydel and Allan Hagedorff (eds.), *Asta Nielsen: Ihr Leben in Fotodokumenten, Selbstzeugnissen und zeitgenössischen Betrachtungen*, Berlin: Henschel, 1981, p. 50.

35. *Der Kinematograph*, no. 315, 8 January 1913.

Munich's First Fiction Feature:
DIE WAHRHEIT

1. See Sylvia Wolf and Ulrich Kurowski, *Das Münchner Film und Kino Buch*, Munich: Edition 8 1/2, 1988, pp. 11ff.
2. The film has been preserved by the Munich Filmmuseum. A nitrate print is held by the estate of Peter Ostermayr.
3. See Uta Berg-Ganschow and Wolfgang Jacobsen, *...Film...Stadt...Kino...Berlin...*, Berlin: Argon Verlag, 1987.
4. See Corinna Müller, *Frühe deutsche Kinematographie: Formale, wirtschaftliche und kulturelle Entwicklungen*, Stuttgart and Weimar: Verlag J.B. Metzler, 1994, p. 74.
5. Peter Ostermayr, *Wie es begann... und wurde! ERZÄHLTES vom MÜNCHNER FILM. 50 Jahre Erinnerungen und Erfahrungen. 1907 bis 1957*, unpublished manuscript. Translated from the German by the author. Thanks to Andreas Mardersteig GmbH for making an excerpt available to me.
6. Even more primitive was Karl Valentin's first film, KARL VALENTINS HOCHZEIT (1912). Produced by Munich's other film pioneer, Martin Kopp, the film was obviously shot on an open air set. See Jan-Christopher Horak, 'Ridere da Sentirsi male. Il Cinema comico Tedesco e Karl Valentin / Laughing Until it Hurts: Karl Valentin and German Film Comedy,' in Paolo Cherchi Usai and Lorenzo Codelli (eds.), *Prima di Caligari: Cinema tedesco, 1895-1920 / Before Caligari: German Cinema, 1895-1920*, Pordenone: Ed. Biblioteca dell'Immagine, 1990, pp. 202-229.
7. Corinna Müller notes that the cost of raw film stock at 42 pfennings a meter forced all German producers to produce at shooting ratios of 2.5 to 1 or lower. See *Frühe deutsche Kinematographie*, op. cit., pp. 85-6.
8. See Gerhardt Lamprecht, *Deutsche Stummfilme 1903-1912*, Berlin: Deutsche Kinemathek e.V., 1969, pp. 17-8.
9. An abridged version of Ostermayr's narrative was published in a Munich newspaper as 'Mit der WAHRHEIT fing der Schwindel an. Mein erster Spielfilm / Eine Plauderei von Peter Ostermeyer,' n.d., reprinted in Wolf/Kurowski, *Das Münchner Film und Kino Buch*, op. cit., pp. 17-8.
10. Müller, *Frühe deutsche Kinematographie*, op. cit., p. 74. Quote is from 'Monopolisierung oder Zentralisierung,' in *Die Lichtbild-Bühne*, no. 31 5 August 1911.
11. *Ibid.*
12. See Wolf/Kurowski, *Das Münchner Film und Kino Buch*, op. cit., p. 20.
13. *Ibid.*, p. 21.

Moving Images of America in Early German Cinema

1. George Grosz, *Ein kleines Ja und ein grosses Nein*, Reinbek: Rowohlt, 1986 (1st ed. 1955), pp. 220-1. My translation.

2. Incidentally, 'apaches' was a common term for urban criminals and semi-criminals, revealing how elements from the urban underworld and the American West were merged into one sphere of adventurous imagination which had its home in cinema.

3. George Grosz, 'Gesang der Goldgräber,' *Neue Jugend*, vol. 1, no. 11/12, February/ March 1917, p. 242.

4. Walter Hasenclever, 'Der Kintopp als Erzieher. Eine Apologie,' (1913) in Anton Kaes (ed.), *Kino-Debatte: Texte zum Verhältnis von Literatur und Film 1909-1929*, Munich/ Tübingen: dtv/Niemeyer, 1978, p. 48. My translation.

5. Karl Hans Strobl, 'Der Kinematograph,' (1911) in Fritz Güttinger, *Kein Tag ohne Kino: Die Schriftsteller und der Stummfilm*, Frankfurt: Deutsches Filmmuseum, 1984, p. 52.

6. Kristin Thompson, *Exporting Entertainent: America in the World Film Market 1907-1934*, London: BFI Publishing, 1985, p. 37.

7. Emilie Altenloh, *Zur Soziologie des Kinos: Die Kino-Unternehmung und die sozialen Schichten ihrer Besucher*, Jena: Eugen Diederichs, 1914, p. 10.

8. In November 1914, the Organisation for Protecting the Interests of Cinematography (Verein zur Wahrung der Interessen der Kinematographie und verwandter Branchen) advised cinema owners not to show films during the war from enemy countries or produced by companies working with capital investments from enemy countries.

9. Cf. Herbert Birett (ed.), *Verzeichnis in Deutschland gelaufener Filme: Entscheidungen der Filmzensur 1911-1920,* Berlin etc.: K.G. Saur, 1980.

10. Cf. Peter Stanfield, 'The Western 1909-14: A Cast of Villains,' *Film History*, vol. 1., 1987, pp. 97-112. Also Jon Tuska, *The Filming of the West*, Garden City, New York: Doubleday, 1976.

11. Cf. G. Edward White, *The Eastern Establishment and the Western Experience: The West of Frederic Remington, Theodore Roosevelt, and Owen Wister*, New Haven: Yale University Press, 1968.

12. Cf. Charles Musser, *Before the Nickelodeon: Edwin S. Porter and the Edison Manufacturing Company*, Berkeley, Los Angeles, Oxford: California University Press, 1991.

13. Lewis Jacobs, *The Rise of the American Film*, New York: Harcourt, Brace & Co., 1939, p. 43. Cf. also Charles Musser, *The Emergence of Cinema: The American Screen to 1907* (History of the American Cinema, vol. 1), New York: Charles Scribener's Sons, 1990, 'The Transition to Story Film: 1903-1904,' pp. 337-369.

14. For a filmography cf. Edward Buscombe (ed.), *The BFI-Companion to the Western*, London: André Deutsch/BFI, 1988.

15. Cf. Birett, *Verzeichnis gelaufener Filme*, op. cit.

16. Cf. Herbert Birett, *Das Filmangebot in Deutschland 1895-1911*, Munich: Winterberg, 1991, lists 109 films directed by D.W. Griffith. Cf. also Helmut H. Diederichs, *Frühgeschichte deutscher Filmtheorie: Ihre Entstehung und Entwicklung bis zum Ersten Weltkrieg*, Appendix: 'Griffith' Biograph-Filme in Deutschland,' Habil. (Manuscript), Universität Münster, 1991, pp. 626-631.

17. Cf. Diederichs, *Frühgeschichte*, op. cit., p. 626.

18. Cf. *Der Kinematograph*, no. 348, 1913.

19. Willi Bierbaum, 'Heimat und Fremde,' in Güttinger (ed.), *Kein Tag ohne Kino*, op. cit., p. 180.

20. Karl Hans Strobl, 'Die Tochter der Rothaut,' *Lichtbild-Bühne*, vol. 8, no. 8, 25 Feb 1911, p. 4. The title and description might refer to several contemporary films. In *Lichtbild-Bühne* of 24 Feb 1912 DIE TOCHTER DES INDIANERSTAMMES (Nestor) is mentioned, a film titled DIE TOCHTER DER ROTHÄUTE (Bison) was censored in Berlin in 1913 as 'not suitable for children,' and another film titled DIE TOCHTER DER ROTHAUT was partly banned in 1915 in Munich.

21. Arthur Holitscher, *Amerika: Heute und Morgen*, Berlin: S. Fischer, 1913, pp. 266-69.

22. See Altenloh, *op. cit.*, pp. 11-12.

23. Konrad Lange, *Das Kino in Gegenwart und Zukunft*, Stuttgart: Enke, 1920, p. 41.

Early German Film Comedy, 1895-1917

1. *Lichtbild-Bühne*, 13 December 1913.

2. Martin Loiperdinger (ed.), *Special-Catalog No. 32 von Ed. Messter* (Berlin 1898), re-print, Frankfurt and Basel: Stroemfeld/Roter Stern, 1995 (KINtop-Schriften 3), p. 76.

3. Heide Schlüpmann, *Unheimlichkeit des Blicks: Das Drama des frühen deutschen Kinos*. Frankfurt/Basel: Stroemfeld/Roter Stern, 1990, p. 51.

4. The films were also available on the German market, with titles such as FRICOT MACHT DIE ROSSKUR and CALINO HAT PFERDEFLEISCH GEGESSEN.

5. See Schlüpmann *Unheimlichkeit des Blicks*, op.cit., pp. 50-58.

6. See Thomas Brandlmeier, 'Fin de siècle Comedy Culture,' in: Helga Belach and Wolfgang Jacobsen (eds.), *Slapstick & Co.: Early Comedies*, Berlin: Argon, 1995, pp. 17-72.

7. See Volker Klotz, *Bürgerliches Lachtheater*, Reinbek: Rowohlt, 1987.

8. See Thomas Brandlmeier, *Filmkomiker: Die Errettung des Grotesken*, Frankfurt/Main: Fischer Taschenbuchverlag, 1983.

9. Adequately praised in Heide Schlüpmann, *Die Unheimlichkeit des Blicks*, op. cit.

10. *Ibid.*, p. 126.

11. In 1926, with SO THIS IS PARIS, Lubitsch and Kräly used the same operetta material again.

12. Lubitsch's work can generally also be interpreted as a cinema of crisis, see Thomas Brandlmeier, 'Anmerkungen zu Ernst Lubitsch,' *epd-Film* 2/1984.

Asta Nielsen and Female Narration: The Early Films

1. On Habermas' term of 'self-thematization' see Jürgen Habermas, *Strukturwandel der Öffentlichkeit: Untersuchung zu einer Kategorie der bürgerlichen Gesellschaft* (1962),

Frankfurt: Luchterhand, 1969, p. 56.

2. André Bazin, *Qu'est-ce que le cinéma?* Paris: Cerf, 1975.

Melodrama and Narrative Space:
Franz Hofer's HEIDENRÖSLEIN

1. See Tom Gunning, 'Non-Continuity, Continuity, Discontinuity: A Theory of Genres in Early Film,' *Iris,* vol. 2, no.1, 1984, pp. 100-112 and his 'The Cinema of Attractions: Early Film, Its Spectator and the Avant Garde,' in: Thomas Elsaesser (ed.), *Early Cinema: Space, Frame, Narrative,* London: BFI Publishing, 1990, pp. 56-62.

2. For bio-filmographical information about Hofer, see Elena Dagrada's essay in this volume; Fritz Güttinger, 'Franz Hofer: Ausgrabung des Jahres?' In: *Köpfen Sie mal ein Ei in Zeitlupe! Streifzüge durch die Welt des Stummfilms,* Zurich: NZZ Verlag, 1992, pp. 215-226; and my brief entry in Ginette Vincendeau (ed.), *Encyclopedia of European Cinema,* London: BFI Publishing, 1995, p. 207.

3. Heide Schlüpmann, 'Cinema as Anti-Theater: Actresses and Female Audiences in Wilhelminian Germany,' *Iris* 11, Summer 1990, p. 90. See also Schlüpmann's essay in this volume. With similar implications, Janet Bergstrom ('Asta Nielsen's Early German Films,' in: Paolo Cherchi Usai/Lorenzo Codelli (eds.), *Before Caligari: German Cinema, 1895-1920,* Pordenone: Edizioni Biblioteca dell'Immagine, 1990, pp. 178-180) has desribed Asta Nielsen: `If one looks at the story structure, Nielsen's female characters are punished for their transgressive behavior, or punish themselves, or move back within social norms in the final scenes. In many of her melodramatic parts, she is a victim at the end. Yet, she is never a conventional victim. The very naturalness with which she endows so many actions deemed unusual for women, her integrity, her depth of feeling, her active sense of intelligence, her particular kind of sensuality, mark her female roles with an individuality that resists the reduction to types that will become common during the 1920s in Germany. In Asta Nielsen's films of the pre-Weimar period, she creates characters based on familiar melodramatic types, but who are nevertheless individualized by a strong sense of self-identity and self-definition through their expression of interiority and the way they assert their presence within the environment.'

4. Heide Schlüpmann, 'Melodrama and Social Drama in Early German Cinema,' *Camera Obscura* 22, January 1990, pp. 75-6.

5. *Ibid.,* p. 76.

6. *Ibid,* p. 78.

7. *Ibid.,* pp. 86-7.

8. *Ibid.,* p. 85.

9. Peter Brooks, *The Melodramatic Imagination: Balzac, Henry James, Melodrama and the Mode of Excess* (1976), New York: Columbia University Press, 1985, p. 62.

10. Emilie Altenloh, *Zur Soziologie des Kino: Die Kinounternehmung und die sozialen*

Schichten ihrer Besucher, Jena: Diederichs, 1914.

11. *Ibid.*, p. 58.

12. *Ibid.*

13. Heide Schlüpmann, 'The Sinister Gaze: Three Films by Franz Hofer from 1913,' in *Before Caligari*, op. cit., p. 452.

14. For the latter series, see Fritz Güttinger, 'Franz Hofer: Ausgrabung des Jahres?' *Op. cit.*

15. HEIDENRÖSLEIN. Ein dramatischer Kunstfilm in 3 Akten. Apollo-Film-Gesellschaft m.b.H.; dir./aut: Franz Hofer; cam: Ernst Krohn; act: Lya Ley, Fritz Achterberg, A. von Horn. See *Die Lichtbildbühne*, vol. 9, no. 38, 23 September 1916, p. 41.

16. This was suggested by Heide Schlüpmann at the workshop 'Rot für Gefahr, Feuer und Liebe: Early German Cinema, 1911-1919,' Nederlands Filmmuseum, Amsterdam, 28 October 1995.

17. Siegfried Kracauer, 'Über Arbeitsnachweise: Konstruktion eines Raumes' (1930), in: *Schriften 5.2*, ed. Inka Mülder-Bach, Frankfurt: Suhrkamp, 1990, p. 186; transl. quoted from Miriam Hansen, 'Mass Culture as Hieroglyphic Writing: Adorno, Derrida, Kracauer,' *New German Critique* 56, Spring/Summer 1992, p. 66.

18. See *Die Lichtbildbühne*, vol. 9, no. 35, 2 September 1916, p. 34.

19. See e.g. Jürgen Kasten, 'Dramatik und Leidenschaft. Das Melodram der frühen zehner Jahre: Von ABGRÜNDE (1910) bis VORDERTREPPE UND HINTERTREPPE (1915),' in: Werner Faulstich/Helmut Korte (eds.), *Fischer Filmgeschichte*, vol. 1: *Von den Anfängen bis zum etablierten Medium 1895-1924*, Frankfurt: Fischer Taschenbuchverlag, 1994, pp. 243-4.

20. 'What Franz Hofer actually delivers here is proof of the training for effect ["Dressur zur Wirkung"].' *Die Lichtbildbühne*, vol. 9, no. 35, 2 September 1916, p. 28.

Cinema from the Writing Desk: Detective Films in Imperial Germany

1. Siegfried Kracauer, *From Caligari to Hitler: A Psychological History of the German Film*, Princeton: Princeton University Press, 1947, p. 19.

2. See the contributions of Heide Schlüpmann, Karen Pehla and Thomas Elsaesser in Hans-Michel Bock/Claudia Lenssen (eds.), *Joe May: Regisseur und Produzent*, Munich: edition text & kritik, 1991, and the essay by Sebastian Hesse, below.

3. Heide Schlüpmann, 'Wahrheit und Lüge im Zeitalter der technischen Reproduzierbarkeit: Detektiv und Heroine bei Joe May,' in Bock/Lenssen (eds.), *Joe May*, op. cit, 1991, p. 45.

4. *Ibid.*

5. *Ibid.*, p. 49. For a more extended discussion of the problem of ideology in the new film history, see Tilo R. Knops, 'Eingefrorene Leiblichkeit: Anmerkungen zu einer feministischen Geschichte des frühen deutschen Films, '*Neue Zürcher Zeitung* (foreign edi-

tion), 25 April 1991; reprint in *Film- und Fernsehwissenschaft*, report no. 2/1991, Gesellschaft für Film- und Fernsehwissenschaft, Berlin.

6. See Thomas Elsaesser, 'Early German Cinema: audiences, style and paradigms,' *Screen* 33/2, Summer 1992, pp. 205-214.

7. See Miriam Hansen, 'Early Cinema - Whose Public Sphere?' In Elsaesser (ed.), *Early Cinema: Space, Frame, Narrative*, London: BFI Publishing, 1990, pp. 228-246.

8. Although until the beginning of 1916 American films still entered the country through Scandinavia, despite the blockade. See Kristin Thompson, *Exporting Entertainment: America in the World Film Market, 1907-1934*, London: BFI Publishing, 1985, p. 53.

9. Still HOFFMANNS ERZÄHLUNGEN (1916) begins with the director Oswald staring into the camera with a look demanding respect, in front of a stone clearly inscribed 'Here Schiller wrote his Wallenstein.'

10. In DER MANN IM KELLER the fake business card of the disguised Detective Webbs bears the company insignia 'Continental,' and Fritz Lang showed much later in KÄMPFENDE HERZEN (1920) a background scene of a studio street with a cinema called 'Decla Cinema.'

11. Narrative indecisions of the transitional phase are also recognisable here, as in DIE JAGD NACH DER 100-PFUND-NOTE (1913) or DAS GEHEIMNIS VON CHÂTEAU RICHMOND (1913) by Willy Zeyn. What these feature-length films about a mysterious treasure hunted by not only the main character as the lucky heir but also the conspiratorial male organisation and the German serial detective 'Nobody' lack is primarily an economy of information transmission. Instead of a logical stringency of the investigative solution of a suspenseful, conflict-ridden puzzle, confusion reigns over the roles and the meanings of the main characters as well as the sense of the whole. For example, Miss Nobody appears in the beginning to be spying on the hero half-heartedly, while in the second half we learn that she is a detective. Instead of making deductions, she checks the legality of the inheritance like a policewoman. In total, the criminal case seems to present just an excuse for sensational chase scenes over rooftops and storehouses, bridges and steamboats.

12. See Karen Pehla, 'Joe May und seine Detektive: Der Serienfilm als Kinoerlebnis,' in Hans-Michael Bock/Claudia Lenssen (eds.), *Joe May*, op. cit., pp. 61-72.

13. Also May and Reicher himself, who took responsibility for the book, obviously had difficulties with the logic of the treatment development: to Webbs telegraphic request for permission to enter the lord's villa the answer arrives that he left on holiday on the 15th. The decisive clue for the crime, the lord's letter forged by Ganovan and found on the bride by the disguised Webbs, is dated the 20th: it states that the holiday is over, and he is returning to arrange the wedding which is due to take place soon afterwards. Why should the lord want to come after his holiday, doesn't he then have to take a second holiday, or does he intend to end his service in the colonies?

14. Fritz Bleibtreu wrote a mocking review after the Zürich premiere in 1913: 'DER MANN

IM KELLER haunts the Radium. In a dark cellar, as the improbabilities are sufficiently murky themselves. The cinema is filled with a joie-de-vivre...for the detective, who is in the land of milk and honey. However, Jung-Reicher does a good job, and suspense there must be, says the man from Berlin.' Quoted after Fritz Güttinger, *Kein Tag ohne Kino: Schriftsteller über den Stummfilm*. Frankfurt am Main: Filmmuseum, 1984, p. 278.

15. Karl Bleibtreu, 'Theater und Kino,' *Kinema*, vol. 3, nos. 14-18, 1913.

16. See Herbert Birett (ed.), *Verzeichnis in Deutschland gelaufener Filme: Entscheidungen der Filmzensur 1911-1920*. Munich et al.: K.G. Saur, 1980.

17. *Ibid.*, pp. 15, 16, 20, 23, 536, 304.

18. *Ibid.* p. 64.

19. When Jean-Luc Godard held a long TV interview with Fritz Lang for *Le Dinosaur et le Bébé* in November 1964, the two directors discussed the build-up of a scene and how they differently value a fixed meaning that a director has before shooting a scene. 'Let's assume,' said Fritz Lang, the experienced crime thriller and detective director who had been working since the silent era, to his younger colleague, while drawing a rectangle on a piece of paper, 'we have this room here. Then the writing desk will be placed there.'

20. See Schlüpmann, 'Wahrheit und Lüge,' *op. cit.*, p. 49.

Ernst Reicher alias Stuart Webbs: King of the German Film Detectives

1. *Licht-Bild-Bühne*, no. 10, 1914, p. 61.

2. DIE GEHEIMNISVOLLE VILLA, dir. Joe May; script Ernst Reicher; camera Max Fassbender; cast Ernst Reicher, Sabine Impekoven, Julius Falkenstein; prod. Continental-Kunstfilm, Berlin; premiere 13 March 1914, Berlin, Kammerlichtspiele.

3. The exact figure is difficult to discern, since contemporary programmes and information in the trade press were often contradictory.

4. Ernst Reicher was born on 19 September 1985, the son of theatre actor Emanuel Reicher. At the age of 18 he entered the theatre, working in Berlin, London, Munich and Frankfurt. In 1912 he embarked on a film career, and his first project with Joe May was in the same year with VORGLUTEN DES BALKANBRANDES.

5. Siegfried Kracauer, *From Caligari to Hitler: A Psychological History of the German Film*, Princeton, NJ: Princeton University Press, 1947, p. 19.

6. *Ibid.*, p. 20.

7. *Ibid.*, p. 19.

8. *Ibid.*

9. Contemporary censorship reports indicate that detective films were prohibited to children, and that in some cases violent or suicide scenes had to be cut, but that only very rarely was a whole film banned.

10. *Licht-Bild-Bühne*, no. 5, 1914, p. 69.

11. *Licht-Bild-Bühne*, no. 21, 1915, p. 26.

12. *Der Kinematograph*, no. 374, 1914.

13. 'Tension and interest are not roused by the plot (we are long familiar with the stock situations from crime fiction), but our keen interest in Webbs' fate is kept alive by the use of scenery, both from the point of view of the director and of the actors.' *Licht-Bild-Bühne*, no. 14, 1914, p. 37.

14. *Licht-Bild-Bühne*, no. 34, 1915, p. 32.

15. *Ibid.*

16. In Jörg Schweinitz (ed.), *Prolog vor dem Film: Nachdenken über ein neues Medium, 1909-1914*, Leipzig: Reclam, 1992, p. 66.

17. *Ibid.*, p. 86.

18. *Ibid.*, pp. 128ff.

19. Emilie Altenloh, *Zur Soziologie des Kino: Die Kino-Unternehmung und die sozialen Schichten ihrer Besucher*, Jena: Diederichs, 1914, p. 98.

20. *Ibid.*, pp. 82-3.

21. *Licht-Bild-Bühne*, no. 3, 1916, p. 36.

22. This bears a striking resemblance to a contemporary call for women's emancipation, as Heide Schlüpmann points out in her *Unheimlichkeit des Blicks: Das Drama des frühen deutschen Kinos*, Frankfurt/Basel: Stroemfeld/Roter Stern, 1990.

23. Heide Schlüpmann, 'Wahrheit und Lüge im Zeitalter der technischen Reproduzier-barkeit: Detektiv in Heroine bei Joe May,' in Hans-Michael Bock and Claudia Lenssen (eds.), *Joe May: Regisseur und Produzent*, Munich: edition text & kritik, 1991, p. 47.

24. Programme in the *Ernst Reicher File*, Stiftung Deutsche Kinemathek, Berlin.

25. *Ibid.*

26. Schlüpmann, 'Wahrheit und Lüge,' *op. cit.*, p. 45.

27. A similar argument is put forward in Thomas Elsaesser, 'Filmgeschichte-Firmenge–schichte-Familiengeschichte: Der Übergang vom Wilhelminischen zum Weimarer Film,' in Hans-Michael Bock and Claudia Lenssen (eds.), *Joe May*, op.cit., 1991, pp.11-30

28. *Ibid.*, p. 49.

29. *Licht-Bild-Bühne*, no. 12, 1914, p. 15.

30. *Licht-Bild-Bühne*, no. 34, 1914, p. 37.

31. This motif is also found in the detective film DER BÄR VON BASKERVILLE, also made in 1915.

32. Lupu Pick probably met Ernst Reicher during the shooting of the Webbs film DIE PA-GODE (1916/17), in which he played the supporting role of Dr Tomari.

33. This motif obviously belonged to the most popular Webbs films, and it was shown again after the war in March 1919.

The Faces of Stellan Rye

1. Anders W. Holm, 'Dagmarteatrets Forsæson,' *Verdensspejlet* 4, no. 52, 1906, p. 824.
2. Olaf Fønss, *Fra Dagmarteatres Glansperiode: Erindringer*, Copenhagen: Chr. Erichsen, 1949, p. 24.
3. Holm, 'Dagmarteatres Forsæson,' *op. cit.*, p. 825.
4. Clara Pontoppidan, *Eet Liv - Mange Liv: Erindringer*, vol. 1: *Barndom og første Ungdom*, Copenhagen: Westermann, 1949, pp. 197-8.
5. See C.H. [= Christian Houmark], 'Johannes Poulsen om Stellan Rye,' *København*, 4 September 1906.
6. See Stellan Rye, *Løgnens Ansigter: En Symfoni*, Copenhagen: Gyldendal, p. 34.
7. Herman Bang, '[Review of] *Løgnens Ansigter*,' *København*, 6 September 1906, p. 1.
8. Stellan Rye, 'En Prøve,' *Hver* 8, day 12, no. 15, pp. 236-237.
9. Harry Jacobsen, *Den tragiske Herman Bang*, Copenhagen: Hagerup, 1966, p. 149.
10. See Herman Bang, *Denied A Country*, transl. Marie Bush and A.C. Chaler, London: Knopf, 1927.
11. Oscar Petersen, 'Løgnens Ansigter,' *Middagsposten*, 24 August 1906.
12. See Wilhelm von Rosen, *Månens Kulør: Studier i dansk bøssehistorie 1628-1912*, vol. 2, Copenhagen: Rhodos, 1993, pp. 729-30, 650 (n423).
13. Karl Kruse, 'Sædeligheds-Skandalen: Mandfolkeelskere paa vore Kaserner,' *Middagsposten*, 27 November 1906.
14. See Rosen, *Månens Kulør*, op. cit., pp. 653-4.
15. See *ibid.*, pp. 702, 750.
16. Clara Pontoppidan, *Een Liv - Mange Liv: Erindringer*, vol. 2: *1910-1925*, Copenhagen: Westermann, 1950, pp. 16-7.
17. Pontoppidan, *Een Liv...*, vol. 1, op. cit., p. 202.
18. *Lichtbildbühne*, no. 23, 7 June 1913; emphasis in the original.
19. 'Stellan Rye,' *ibid.*, p. 121.
20. Helmut H. Diederichs, *Der Student von Prag: Einführung und Protokoll*, Stuttgart: Focus, 1985, p. 15.
21. Vivian Greene-Gantzberg, *Herman Bang og det fremmede*, Copenhagen: Gyldendal, 1992, p. 82.
22. Kai Möller (ed.), *Paul Wegener - Sein Leben und seine Rollen: Ein Buch von ihm und über ihn*, Reinbek: Rowohlt, 1954, p. 34.
23. Diederichs, *Der Student von Prag*, op. cit., p. 11.
24. Stellan Rye, 'Teatrum mundi,' *Verdenspejlet* 3, no. 35, p. 550; emphasis in the original.
25. See Georges Sadoul, *Histoire Génerale du Cinéma*, 2nd ed., vol. 3, Paris: Denoël, 1974, p. 371.
26. Reinhold Keiner, *Hanns Heinz Ewers und der phantastische Film*, Hildesheim: Olms, 1988, p. 34.

27. Reprinted in Ludwig Greve, Margot Pehle, Heidi Westhoff (eds.), *Hätte ich das Kino! Die Schriftsteller und der Stummfilm*, Munich: Kösel, 1976, p. 112.

28. Quoted in Keiner, *Hanns Heinz Ewers*, op. cit., pp. 33-4.

29. See Marguerite Engberg, 'Den gådefulde Stellan Rye,' *Sekvens*, 1982, p. 162.

30. Keiner, *Hanns Heinz Ewers*, op. cit., pp. 20, 28.

31. See *ibid.*, pp. 29-30.

32. *Erste Internationale Film-Zeitung*, no. 3, 17 January 1914.

33. *Lichtbild-Bühne*, no. 3, 17 January 1914.

34. See letter by Octavia Rye to Ove Brusendorff, Collection of the Danish Film Museum, file Stellan Rye.

35. *Ibid.*

36. Lotte Eisner, *The Haunted Screen: Expressionism in the German Cinema and the Influence of Max Reinhardt*, Berkeley and Los Angeles: University of California Press, 1973, p. 45.

37. *Lichtbild-Bühne*, no. 80, 21 November 1914.

38. Letter by Poul Engelstoft to Ove Brusendorff, 7 July 1950, Collection of the Danish Film Museum, file Stellan Rye.

HOMUNCULUS: A Project for a Modern Cinema

1. From a press advertisment of the Deutsche Bioscop, *Lichtbild-Bühne*, no. 42, 1915.

2. *Film-Kurier*, no. 183, 19 August 1920.

3. This is an adventure that would merit to be completed. As I am writing this text, I have come to know of the existence of a nitrate copy of the first part of the film in the film archive in Prague, with a length of 1126 m, in comparison to the 1588 m of the original copy; I am grateful to Vladimir Opela for this valuable information.

4. *Illustrierter Film-Kurier*, no. 19, 1920. From the available cinema program notes I want to mention in particular those in the collection of the Stiftung Deutsche Kinemathek, Berlin.

5. For the figure of the superhuman in the feuilleton (and for the mentioned periodization of its evolution) I refer to Umberto Eco and Cesare Sughi (eds.), *Cent'anni dopo: Il ritorno dell'intreccio*, Milano: Almanacco Bompiani, 1971 and Umberto Eco, *Il superuomo di massa*, Milano: Cooperativa Scrittori, 1976.

6. It is well known how Gramsci, in some of his famous reflections on the popular novel, saw not only the 'Nietzschean,' but Nietzsche himself, indebted to the romanesque hero: 'Wouldn't Nietzsche be influenced by French popular novels? (...) In any case, it seems that it can be confirmed that much of Nietzsche's so-called "superhumanity" has as its origin and doctrinal model not only Zarathustra, but also the Count of Monte Christo of A. Dumas.' Antonio Gramsci, 'Origine popolaresca del 'superuomo,' in *Quaderni del carcere*, critical edition, ed. Valentino Gerratana, Torino: Einaudi, 1975, vol. 3, p. 1879.

7. At least according to the program of the film (part 3) of the Lichtspielhaus in Giessen, preserved in the archive of the Stiftung Deutsche Kinemathek, Berlin.

8. This quote is to be found in the film program (Lichtspielhaus Giessen, part II) as well as in *Illustrierter Film-Kurier*, op. cit.

9. The Frankenstein of Mary Shelley is in fact the essential point of reference by Reinert: he takes from it also the motif of the hatred towards its creator who has condemned it to unhappiness (because his affection cannot be returned - in HOMUNCULUS because the protagonist cannot experience sentiments), and, in short, towards the whole of humanity.

10. This quote is again from the above cited program notes and refers to part II of the film.

11. The doubling is even clearer in the 4th episode where the character acts at the same time in the clothes of a government leader (the intertitles literally speak of a 'Körperschaft') and those a peoples' agitator who infuriates the masses against its alter ego, only to lead them directly into their ruin.

12. *Illustrierter Film-Kurier*, op. cit.

13. Gr., 'HOMUNCULUS, III. Teil,' *Der Film*, no. 37, 1920, p. 37.

14. Jean Tortel, 'Il romanzo popolare,' in Eco and Sughi (eds.), *Cent'anni dopo*, op. cit., p. 34.

15. 'HOMUNCULUS, Teil II,' *Der Film*, no. 36, 1920, p. 38. The reviewer notes only one unique exception to this rule.

16. The film, 'Parodistischer Scherz in 2 Akten,' was presented by the Österreichisch-Ungarische Kino-Industrie; an article published in *Die Filmwoche* (no. 185, 1916, p. 46) announced its release for 29 December 1916; the reprinted dates are taken from the same source.

17. The whole story is in effect obsessively packed with rocks, caverns that give refuge to the protagonist. It concerns again a rather favourite place in the popular adventurous imagination. Here it seems to become at the same time an efficient symbolical configuration of alienation of Homunculus from the human species, of its original diversity (a bit like the ice in *Frankenstein*).

18. See Fritz Güttinger, *Der Stummfilm im Zitat der Zeit*, Frankfurt: Deutsches Filmmuseum, 1984, p. 153.

19. It is the aspect emphasised most often by those who have studied the film, and Eisner above all.

20. Here we understand that the dark of the other half of the frame is in effect also the indispensable support to host the visions of the character...

21. A sequence to which probably mention is made in an interview with Reinert: 'Thus, the scene called "Homunculus as Death the Knight visiting the Battlefield" was to have a devastating impact.' 'Der Dichter des HOMUNCULUS in Wien,' *Die Filmwoche*, no. 175, 1916, p 50.

22. See the program of the Lichtspielhaus Giessen, *op. cit.*

23. 'HOMUNCULUS, II. Teil,' *Lichtbild-Bühne*, no. 38, 1916, p. 36.

24. 'HOMUNKULUS, II. Teil,' *Die Filmwoche*, no. 175, 1916, p. 50.

25. Gr., 'HOMUNCULUS (III. Teil),' *op. cit.*, p. 38.

26. In this sense the excellent work of Kristin Thompson in respect to the relations between German fantasy film of the teens and twenties must be mentioned for its attribution attributes of a central place to HOMUNCULUS in this overview, see '"Im Anfang war..."': Some Links between German Fantasy Films of the Teens and the Twenties,' in Paolo Cherchi Usai and Lorenzo Codelli (eds.), *Before Caligari: German Cinema, 1895-1920*, Pordenone: Edizioni Biblioteca dell'Immagine, 1990, pp. 142-148. Just as much, as we will see later on, the film holds a possible tie with theatrical tendencies of contemporary expressionism.

27. See 'HOMUNCULUS,' *Lichtbild-Bühne*, no. 18, 1916, p. 26; 'HOMUNCULUS!' *Lichtbild-Bühne*, no. 25, 1916, p. 21; 'Die HOMUNCULUS-Idee,' *Die Filmwoche*, no. 157, 1916.

28. 'HOMUNCULUS!' *Op. cit.*

29. F.O. (= Fritz Olimsky), 'Neue Filme,' *Berliner Börsen-Zeitung* (undated clipping in the Archive Stiftung Deutsche Kinemathek, Berlin).

30. See 'Der Dichter des HOMUNCULUS in Wien,' *op. cit.* In relation to such processes of involvement, the intervention contains in reality a devaluation of the role of the *Autorenfilm*. I have dealt with the complexity (and the contradiction) of the contemporary debate on the *Autorenfilm* (particularly of *Die Filmwoche*), in '"Dichter heraus!" The *Autorenfilm* and the German Cinema of the 1910s,' *Griffithiana*, no. 38/39, October 1990, pp. 101-126. 'Dieses Werk steht am Tore einer neuen Zeit der Lichtspielkunst,' writes the critic of the *B.Z.am Mittag* (in an article reprinted in *Lichtbild-Bühne*, no. 34, 1916, p. 36).

31. 'Here we find the art of film, so many times disputed, attacked, and declared impossible. (...) HOMUNCULUS shows cinematography climbing the heights we call 'Parnassus' [!],' 'HOMUNCULUS!' *Op cit.*, p. 24.

32. Efen., 'HOMUNCULUS,' *Der Drache*, no. 46, 11 August 1920, p. 9.

33. Max Prels, 'Der kommende Film,' *Vorwärts*, 14 September 1921.

34. F.O., 'Neue Filme,' *op. cit.*

35. 'HOMUNCULUS, Teil II,' *op. cit.*

36. The preceding expression is taken from *Illustrierter Film-Kurier* instead. All the subsequent spectators have remarked the affinity of this situation with that proposed 10 years later in METROPOLIS.

37. The episode is to be found in the beginning of the 5th part of the film.

38. Siegfried Kracauer, *From Caligari to Hitler*, Princeton, NJ: Princeton University Press, 1947, p. 33.

39. 'It is unlikely that one can find anywhere else in film history a nation at war making, at the height of the fiercest enemy action, a film of such decidedly pacifist tendencies,' is the

judgement of Ilona Brennicke and Joe Hembus in their *Klassiker des deutschen Stummfilms 1910-1930*, Munich: Goldmann, 1983, p. 194.

40. Hans Weissbach in *Illustrierter Film-Kurier*, op. cit.

41. M-l., 'HOMUNCULUS,' *Film und Presse*, no. 7, 1920, p. 174.

42. See 'Aus der Praxis,' *Der Kinematograph*, no. 505, 1916; 'Der Dichter des HOMUNKULUS in Wien,' *op. cit.*

43. See the review of the first part of the new version in *Der Film*, no. 35, 1920, and the already cited *Illustrierter Film-Kurier*, and *Film-Kurier*: 'The whole world was in awe at the sight of such a monumental achievement by the then still youthful art of film.'

44. A similar phenomenon occurred in the first version of DER GOLEM, accompanied (but only in 1917) by the parodistic variation DER GOLEM UND DIE TÄNZERIN, directed and interpreted - and thus 'authorized' - by Paul Wegener.

45. F.Iw. in *Der Tag*, 21 August 1920 (quoted from *Film und Presse*, no. 8, 1920, p. 202).

46. Christian Flüggen, 'HOMUNKULUS,' *Deutsche Lichtspiel-Zeitung*, no. 30, 1920, p. 3; fl. in *Berliner Börsen-Courier*, 22 August 1920 (quoted in *Film und Presse*, no. 8, op. cit.).

47. M.-l., 'HOMUNKULUS,' *op. cit.*

48. F.O., 'Neue Filme,' *op. cit.*

49. See Efen, 'HOMUNCULUS,' *op. cit.*; 'HOMUNCULUS,' *Der Drache*, no. 47, 18 August 1920, p. 12.

50. I have alluded to this question in 'Der Expressionismus als Filmgattung,' in Uli Jung and Walter Schatzberg (eds.), *Filmkultur zur Zeit der Weimarer Republik*, Munich etc.: K.G. Saur, 1992.

51. Robert Heymann, 'Der Film als Brücke zur Romantik,' *Der Film*, no. 52, 1917, pp. 21-22.

52. *Ibid.*

Julius Pinschewer: A Trade-mark Cinema

1. Heinz Gies, 'Gestaltungs- und Wirkungsweisen des Werbefilms,' in Walter Hagemann (ed.), *Filmstudien*, Emsdetten/Westf., 1957 (Beiträge des Filmseminars im Institut für Publizistik der westfälischen Wilhelms-Universität Münster 3), p. 87.

2. Ingrid Westbrock, *Der Werbefilm*, Hildesheim, Zurich, New York, 1983 (Studien zur Filmgeschichte 1), pp. 30ff.

3. Paul Effing, 'Der Kinematograph als Reklamemittel,' *Mitteilungen des Vereins Deutscher Reklamefachleute* (Berlin), no. 20, August 1911, p. 3.

4. See the advertisement, *ibid.*, p 25. See also nos. 21-23, September - November 1911.

5. Editorial comment to William Besel, 'Der Kinematograph als Reklamemittel,' *Mitteilungen des Vereins Deutscher Reklamefachleute*, no. 25, January 1912, pp. 16-18.

6. Julius Pinschewer, 'Zur Geschichte des Werbefilms,' *Der Markenartikel*, vol. 16, May 1954, special edition, Archive Stiftung Deutsche Kinemathek, Berlin.

7. *Mitteilungen des Vereins Deutscher Reklamefachleute*, no. 28, [April] 1912, p. 2 ('Neu-Anmeldungen').

8. *Mitteilungen des Vereins Deutscher Reklamefachleute*, no. 42, Juli 1913, after page 256. This advertisment was published in each issue until no. 47, December 1913, inclusively.

9. See Kurt Mühsam and Egon Jacobsohn (eds.), *Lexikon des Films*, Berlin: Verlag der Lichtbildbühne, 1926, p. 140.

10. Julius Pinschewer, 'Zur Geschichte des Werbefilms,' *op. cit.*

11. Julius Pinschewer, 'Von den Anfängen des Werbefilms,' *Die Reklame*, No. 2, June 1927, p. 408.

12. Julius Pinschewer, 'Filmreklame,' *Seidels Reklame*, no. 8, August 1913, pp. 243-246.

13. *Ibid.*

14. Handelsregistereintrag No. 11891, 26 March 1913; quoted from *Vossische Zeitung*, 30 March 1913. I am grateful to Herbert Birett for this piece of information.

15. ALT-HEIDELBERG, DU FEINE (1912), dir. Julius Pinschewer. See 'Harry Walden in Alt-Heidelberg,' *Lichtbild-Bühne*, No. 30, 27 Juli 1912, pp. 16f.

16. Julius Pinschewer, 'Vom Reklamefilm,' *Seidels Reklame*, no. 6, 15 June 1914, pp. 273-278 (with 8 illustrations).

17. *Ibid.*

18. *Ibid.*

19. 'But the true publicity film hasn't been achieved yet. What is currently presented to the audience under this label, at our cinemas the "Pintschewer[sic!]-films" by name, is not the right solution. They start off just like a little fiction film, only to burst out all too soon with the real punch line, namely to convey the publicity in the most penetrant way possible. This soon caused the anger of the grumpy audience which demanded to see something worth the high admission prices.' Hans-Ulrich Dörp, 'Reklame durch den Film,' *Kino-Börse*, no. 38, 24 September 1921.

20. William Besel, 'Der Kinematograph als Werbemittel', *op. cit.*

21. 'Der Film als Werbemittel. Stenografischer Bericht des Herrn Julius Pinschewer, Berlin, auf der Monatsversammlung des Vereins Deutscher Reklamefachleute, am 14. Mai 1916 im Union-Theater gehaltenen Vortrages,' *Mitteilungen des Vereins Deutscher Reklamefachleute*, nos. 5/6, May/June 1916, pp. 115-118; See also 'Der Film als Werbemittel,' *Der Kinematograph*, no. 490, 17 May 1916.

22. *Ibid.*

23. *Ibid.*

24. Julius Pinschewer, 'Aus meiner Werkstatt,' *Mitteilungen des Vereins Deutscher Reklamefachleute*, nos. 5/6, May/June 1916, supplement, 4 pages.

25. *Ibid.*

26. See Julius Pinschewer, 'Aus meiner Werkstatt,' *op. cit.*

27. This seems to have been a widespread pattern in the early publicity film, according to a description from early 1912 by William Besel of a publicity film for the 'Confection-

shaus Petersdorff' in Posen that was released in the Spring of 1911. See Besel, 'Der Kinematograph als Werbemittel,' *op. cit.* Besel presents himself here as 'founder and owner of a company which is especially concerned with the production of cinematographic publicity.'

28. Fritz Kempe, *Dokumente zur Geschichte des Werbefilms: Beiheft zum Film.* Munich: Inst. f. Film und Bild in Wissenschaft und Unterricht, 1965.

29. Julius Pinschewer, 'Politische Propaganda,' *Mitteilungen des Vereins Deutscher Reklamefachleute*, no. 2, February 1915, pp. 35-38.

30. *Ibid.*

31. Kempe, *op. cit.*, pp. 8f.

32. See *Reichs-Kino-Adressbuch*, Berlin 1918/19.

33. See also the events 'Deutsche Kriegsanleihe-Werbefilme des 1. Weltkriegs' (13 August 1994, Zeughaus-Kino, Berlin, and 'Die Macht der Bilder. Kriegsanleihe-Werbefilme 1916-18' (27 March 1995, Caligari-FilmBühne, Wiesbaden), as well as the information material issued at this occasion organized by the present author.

34. See advertisment of the Vaterländischer Filmvertrieb in *Der Film*, no. 10, 10 March 1917, pp. 6f.

35. For further information about these films, see the filmography of Jeanpaul Goergen, 'Julius Pinschewer,' in Hans-Michael Bock (ed.), *CineGraph: Lexikon zum deutschsprachigen Film*, Munich: text & kritik, 1984ff, Lg. 25, June 1995.

36. *Bundesarchiv* (Potsdam) A.A, Zentralstelle für Auslandsdienst, no. 942, p. 31.

37. *Der Kinematograph*, no. 590, 24 April 1918 ('Aus der Praxis').

38. *Reichs-Kino-Adressbuch*, Berlin, 1920/21.

39. Kempe, *op. cit.*, p. 14.

Newsreel Images of the Military and War, 1914-1918

1. Oskar Messter, *Mein Weg mit dem Film*, Berlin: Verlag Max Hesse, 1936, p. 128.

2. 'Offenhalten und Weiterspielen,' *Lichtbild-Bühne* (LBB), no. 52, 15 August 1914, p. 7. See also R. Flatz, *Krieg im Frieden: Das aktuelle Militärstück auf dem Theater des deutschen Kaiserreichs*, Frankfurt/Main, 1976, pp. 248ff.

3. 'Das Programm in Kriegszeiten,' *Der Kinematograph*, no. 405, 30 September 1914.

4. See for example G.A. Fritze, 'Die Kinematographie im Dienste der Industrie,' *Bild und Film*, vol. 3, no. 6, 1913/14, pp. 124ff.

5. Oefle 'Kinematographie für Heereszwecke,' *Frankfurter Zeitung*, no. 69, 10 March 1913, second morning issue.

6. 'Mehr Anschauung im militärischen Unterricht,' *Film und Lichtbild*, vol. 1, no. 2, 1912; pp. 9ff; Fritz Seitz, 'Die Schlacht von Austerlitz im Film,' *Film und Lichtbild*, vol. 1, no. 4, 1912, pp. 33ff.

7. See the essay by Martin Koerber elsewhere in this volume.

8. Ernst Jünger, 'Die totale Mobilmachung,' in: *Krieg und Krieger*, Berlin, 1930, pp. 9-30, here p. 14.

9. Franz Carl Endres, *Der Film als Mittel der politischen Berichterstattung*, Munich, 1915, p. 55f. See also Oefle, *op. cit.*.

10. A. Mellini, 'Deutschland im Kriegszustand!,' *LBB*, no. 48, 1 August 1914; 'Kino und Krieg. Mars regiert die Stunde,' *Der Kinematograph*, no. 397, 5 August 1914.

11. 'Aus dem Kampfe gegen französische Films,' *Projektion*, no. 32-3, 20 August 1914.

12. See for example Malwine Rennert, 'Nationale Filmkunst,' *Bild und Film*, vol. IV, no. 3, 1914/15; 'Film und neue deutsche Form,' *Der Kinematograph*, no. 452, 25 August 1915; 'Kinematographie und Krieg,' *Der Kinematograph*, no. 447, 21 June 1915.

13. *BA Militärarchiv (MA) Reichsmarineamt (RM3)*, no. 9873, pp. 32ff. 60f.

14. 'Kinos Offenbarung,' *Vorwärts*, no. 258, 21 September 1914; 'Was die L.B.B. erzählt,' *LBB*, no. 50, 8 August 1914.

15. Walter Nicolai, *Nachrichtendienst, Presse und Volksstimmung im Weltkrieg*, Berlin, 1920, pp. 51ff; Ludolf Gottschalk von dem Knesebeck, *Die Wahrheit über den Propagandafeldzug und Deutschlands Zusammenbruch: Der Kampf der Publizistik im Weltkriege*, Berlin, 1927, p. 44.

16. See for example 'Kinos Offenbarung,' *Vorwärts*, no. 258, 21 September 1914.

17. A. Mellini, 'Das Monopol der Kriegsaufnahmen (II),' *LBB*, no. 78, 14 November 14.

18. Gertraude Bub, *Der deutsche Film im Weltkrieg und sein publizistischer Einsatz*, Berlin, 1938, p. 94.

19. A. Mellini, 'Das Monopol der Kriegsaufnahmen,' in: *LBB*, no. 74, 31 October 1914; see also Gertraude Bub, *op. cit.*, p. 95.

20. 'Zeitgemässe Films in den Berliner Theatern,' *Der Kinematograph*, no. 408, 21 October 1914.

21. 'Mangel an Aktualitäten,' *Der Kinematograph*, no. 400, 26 August 1914; see also *Kriegs-Echo Wochenchronik*, nos. 1-9, Berlin: Ullstein & Co., 1914.

22. Hans-Joachim Giese, 'Die Film-Wochenschau im Dienste der Politik,' *Leipziger Beiträge zur Erforschung der Publizistik*, vol. 5, Dresden, 1940, p. 39.

23. Walter Thielemann, 'Der Kinematograph als Journalist,' *Der Kinematograph*, no. 312, 18 December 1912; Oths, 'Die kinematographische Zeitung,' *Der Kinematograph*, no. 366, 31 December 1913; O. Th. Stein, 'Der Kinematograph als moderne Zeitung,' *Bild und Film*, no. 2, 1913/14.

24. 'Der Mangel an Aktualitäten,' *Der Kinematograph*, no. 400, 26 August 1914; 'Die schwere Lage,' *LBB*, no. 60, 12 September 1914.

25. 'Der Krieg und der zeitgemässe Film,' *LBB*, no. 68, 10 October 1914.

26. For example: 'messter film berlin, 336 gr headquarters 887-1140 w. come back from front directly sent day before yesterday films made in most forward trenches under shrapnel fire further films and report today - happily,' *Der Kinematograph*, no. 70, 11 November 1914.

27. 'MESSTER WOCHE NR. 10. We have just received and viewed footage of the theatre of war which shows attacks from the trenches and the great advances of our brave troops in exceptional clarity for the first time. These pictures appear in our Messter newsreel and will arouse justified sensation.' *Projektion*, no. 49, 3 December 1914.

28. A. Mellini, 'Das Monopol der Kriegsaufnahmen,' *LBB*, no. 74, 31 October 1914.

29. A. Mellini, 'Das Monopol der Kriegsaufnahmen (II),' *LBB*, no. 70, 14 November 14.

30. 'Der moderne Bilder-Nachrichtendienst. Das Kriegsbilder-Archiv,' *Der Kinematograph*, no. 409, 28 October 14.

31. 'Neujahrs-Gedanken,' *LBB*, no. 1, 2 January 1915.

32. 'Streifzüge durch die Branche,' *LBB*, no. 6, 6 December 1915.

33. 'Mehr Operateure an die Schlachtenfronten,' *LBB*, no. 9, 27 January 1915.

34. 'Mehr Kino-Operateure an die Schlachtenfronten,' *LBB*, no. 11, 13 March 1915.

35. F. Felix, 'Kinematograph und Krieg,' *Bild und Film*, no. 4/5, 1914/15.

36. Stefan Grossmann, 'Das bitterste Kriegsbuch,' *Vossische Zeitung*, no. 413, 15 August 1917.

37. 'Das Ende der Kriegsaufnahmen,' *LBB*, no. 12, 20 March 1915.

38. O. Th. Stein, 'Lebendige Kriegsdokumente,' *Bild und Film*, no. 7/8, 1914/15.

39. E.W., 'Das Filmarchiv des Grossen Generalstabs. Was ein Kinooperateur erzählt,' *Berliner Tageblatt*, no. 168, 1 April 1915, evening edition.

40. *BA MA RM 5*, no. 3798, 50ff.

41. William Kahn, 'Von friedlichen "Kriegsfilms" und anderen Films,' *Deutsche Kinorundschau im Weltkrieg*, no. 13, 1915.

42. *Ibid.* In general, however, even the most meaningless of film images from the war bear a striking resemblance to the combat or battle scene illustrations found in the press. At least there the lack of photographs caused by the censors could be partly compensated for by drawings or paintings.

43. Wolfgang Filzinger, 'Etwas über Kino-Aufnahmen im Felde,' *LBB*, no. 31, 1 July 1915.

44. *BA Reichsministerium des Innern (RMdI)*, no. 14033, p. 110.

45. 'As large as the battlefields may be, they have little to offer the viewer. There is nothing to see in this wasteland. If it weren't for the thunder of shots deafening you, only the weak fire of guns betrays the presence of the artillery.' Alfred von Schlieffen, 'Der Krieg in der Gegenwart,' in *Gesammelte Schriften*, vol. 1, Berlin, 1913, p. 15.

46. O. Th. Stein, 'Kinematographische Kriegsberichterstattung,' *Film und Lichtbild*, no. 3, 1914, pp. 42ff. 'Der deutsche Kaiser sieht zum ersten Male eine wirkliche Schlacht,' *Der Kinematograph*, no. 365, 24 December 1913.

47. 'Kieferverletzungen im Kriege und ihre Heilung,' *LBB*, no. 78, 14 November 14; 'Der Film als Lehrmittel für Kriegsbeschädigte,' *LBB*, no. 11, 13 March 1915; 'Film im Dienste der Fürsorge für Kriegskrüppel,' *LBB*, no. 4, 10 April 1915.

48. 'Der Kriegshund und seine Verwendung im Winterfeldzuge,' *LBB*, no. 4, 23 January 1915.

49. *BA RWM*, no. 8031, p. 18.

50. See for example descriptions of relevant advertising films: 'Das Kino im Dienste der Filmpropaganda für die Kriegsanleihe. Ein Hindenburgfilm,' *Der Film*, no. 35, 23 September 1916; *Zeichnet die Kriegsanleihe*, no. 38, 22 September 1917; 'Kriegsanleihe-filme,' *Der Kinematograph*, no. 562, 3 October 1917.

51. *BA AA ZfA*, no. 947, 317; W. Th., 'Der Film als Agitator,' *LBB*, no. 47, 25 November 1916.

52. 'Der deutsche Flottenverein und der Film,' *LBB*, no. 18, 5 May 1917.

53. *BA RPM*, no. 4727, 7ff.; Hans Barkhausen, *Filmpropaganda für Deutschland im Ersten und Zweiten Weltkrieg*, Hildesheim/Zürich/New York, 1982, p. 71.

54. 'Das Kino als Bindeglied zwischen Heimat und Front,' *Der Film*, no. 33, 9 September 1916.

55. *BA MA RM 3*, no. 9876, pp. 79f.

56. See Hans Joachim Giese, op. cit., p. 41.

57. *BA RMdI*, Nr. 14033, p. 156.

58. *BA Reichspostministerium*, no. 4727, pp. 2-3.

59. Wilhelm Deist (ed.), *Militär und Innenpolitik im Weltkrieg 1914-1918*, Düsseldorf: Droste, 1970, pp. XL-XLI.

60. See for example Nipperdey, *Deutsche Geschichte 1866-1918*, vol. 1: *Arbeitswelt und Bürgergeist*, Munich: C. H. Beck, 1991, pp. 814-5.

61. W. Fr., 'Das Beiprogramm,' *Der Film*, vol. 2, no. 17, 28 April 1917.

62. 'Das Kino im Dienste des vaterländischen Gedankens,' *Der Film*, vol. 2, no. no. 21, 26 May 1917.

63. *BA AA ZfA*, no. 948, p. 97.

64. kn., 'Echte Kriegsfilms. Aufnahmen der Militärischen Photo- und Filmabteilung,' *Vossische Zeitung*, no. 628, 8 December 1916.

65. See extensively Rainer Rother, 'BEI UNSEREN HELDEN AN DER SOMME: Eine deutsche Antwort auf die Entente-Propaganda,' *KINtop 4: Anfänge des dokumentarischen Films*, Basel/Frankfurt: Stroemfeld/Roter Stern, 1995, pp. 123ff.

66. *BA AA ZfA*, no. 1030, pp. 86ff; see also Barkhausen, op. cit., pp. 46ff.

67. *BA AA ZfA*, no. 973, p. 5, 13.

68. *BA AA ZfA*, no. 956, pp. 36f.

69. See 'Die Verwendung und Veredelung des Bewegungsbildes. Das Wandelbild im Heer,' *Illustrirte Zeitung* (Leipzig), vol. 150, no. 3889, 10 January 1918; see also O. Th. Stein, 'Lebendige Kriegsdokumente,' *Bild und Film*, vol. 4, no. 7/8, 1914/1915.

70. See Bernd Hüppauf, 'Kriegsfotografie,' in Wolfgang Michalka (ed.), *Der Erste Weltkrieg: Wirkung, Wahrnehmung, Analyse*, Munich/Zurich, 1994, pp. 883ff.

71. 'Der Isonzosieg im Film,' *Vossische Zeitung*, no. 575, 10 November 1917.

72. *BA AA ZfA*, no. 955, p. 146; *Reichswirtschaftsministerium*, no. 8031, p. 27.

73. 'Beratungen im Reichsministerium des Innern. Zur Frage des kurzen Films,' *LBB*, vol.

9, no. 49, 9 December 1916; see also Barkhausen, op. cit., p. 105.

74. *BA MA SA*, no. 12856, p. 91.

75. *BA AA ZfA*, no. 973, p. 5.

76. *BA AA ZfA*, no. 973, pp. 13ff.

77. 'Bilanz und Ausblick,' *Der Kinematograph*, no. 627, 8 January 1919.

Learning from the Enemy:
German Film Propaganda in World War I

1. Quoted in Gerd Albrecht, *Film im Dritten Reich: Eine Dokumentation*, Karlsruhe, 1979, pp. 72-3.

2. Ernst Collin, 'Aus anderen Blättern,' *Das Plakat*, vol. 10, no. 1 (1919) p. 70. This incidental remark corresponds to an essay published somewhat later by Hermine C. Schuetzinger, 'Angelsächsischer und deutscher Chauvinismus in der politischen Bildreklame,' *Das Plakat*, vol. 10, no. 2 (1919): 'There was absolutely no option left untried by the English or the Americans to sway the public through poster images. Whereas we had only near the end the Erdt'sche Hilfsdienstplakat which formed a limited and dull illustration for a thousand kinds of plain text posters, in England and America colourful sheets had long been plastered on the walls and pillars with sometimes rather good depictions of the duties of the new army.' (p. 145).

3. For the history of the founding of both institutions, see Hans Barkhausen, *Filmpropaganda in Deutschland im Ersten und Zweiten Weltkrieg*, Hildesheim: Olms, 1982.

4. *Potsdam Federal Archive*, item R 901, file 949 p. 45. The memorandum is dated 11 July 1917. Other embassy representatives, in addition to Kessler, expressed a wish for *better propaganda*; the corresponding files are filled with similar instances. The tenor does not vary much during the entire war; the reports suggest that foreign representatives of the German Reich either did not receive enough films or did not feel able to make particularly effective propaganda with what they did receive.

5. The discussion document can be found in the *Potsdam Federal Archive*, file 951, pp. 170ff. All following citations derive from this source.

6. Ibid., pp. 175-6.

7. It seems to be a clear exaggeration when Ramona Curry writes that Porten's image 'played a major role in promoting German nationalist politics in the conduct of the First World War, as did the German film industry as a whole.' Ramona Curry, 'How Early German Film Stars Helped Sell the War(es),' in Karel Dibbets and Bert Hogenkamp (eds.), *Film and the First World War*, Amsterdam: University of Amsterdam Press, 1995, p. 146. Curry overlooks in her interpretation of the symbolically (and in this case also factually) remarkable appearance of Henny Porten in film how small the contribution of the film industry to effective film propaganda really was. This contribution remained so small, less from reluctance (as willingness could be assumed) than from incompetence,

that the BuFA had an effectively negative output.

8. The film was first censored under the title DER FELDARZT, see Herbert Birett (ed.), *Verzeichnis in Deutschland gelaufener Filme*, Munich: K.G. Saur, 1980, pp. 409 and 421.

9. Argus in *Der Kinematograph*, no. 577, 23 January 1918; quoted from Hans-Michael Bock (ed.), *Paul Leni: Grafik, Theater, Film*, Frankfurt am Main: Deutsches Filmmuseum, 1986, p. 251.

10. Statements from Herbert Birett, *Verzeichnis in Deutschland gelaufener Filme*, op. cit., p. 441 and Hans-Michael Bock and Michael Töteberg (eds.), *Das Ufa-Buch*, Frankfurt am Main: Zweitausendeins, 1992, p. 34. The film is considered missing. Reconstruction was made possible by the discovery of a copy with Dutch intertitles saved in a private collection. The incomplete copy was restored by Kevin Brownlow, Photoplay Productions London, by the use of additional material from Gosfilmofond Moskau. The current copy (English intertitles) has a length of 1350 m.

11. Both of them had worked often on propaganda films. For example, Brennert had also written the screenplay for DAS TAGEBUCH DES DR. HART, on which Kräly worked as assistant director.

12. In particular, the film CIVILISATION (Thomas Ince, 1916) was considered as a dangerous, anti-German film. Cf. *Potsdam Federal Archive*, file 948, pp. 281ff.

13. The boundary between 'documentary films' and 'feature films' is necessarily problematic. During World War I, however, at least the form of the fictional film was stable, although with national differences. In addition, the public showed a wide-ranging interest in films which, without casting doubt on their plausibility, presented 'authentic' pictures from the frontline. As the characteristic which makes a film 'documentary' does not depend on its structure or the source of its images alone, but also on how the public attributes this quality, the 'birth' of the documentary film happened during World War I. Here the interest in authentic images played such a role that obviously staged pictures as well as those found to be too bare were rejected - to the advantage of films considered documentary, which however did not shrink in the least from fakery and staging.

14. A.B., 'Der deutsche Somme-Film,' *Der Reichsbote*, 23 January 1917.

15. The author was Hans Brennert, see *B.Z. am Mittag*, 17 January 1917. For a more extensive discussion of the film and its reception in the Berlin press, see Rainer Rother, 'BEI UNSEREN HELDEN AN DER SOMME (1917): The Creation of a "Social Event." ' *Historical Journal of Film, Radio and Television*, vol. 15, no. 4, October 1995, pp. 533-550.

16. Both films were shown in 1993 in Bologna as part of the festival 'Il Cinema Rittrovato.' The dating of the first one has not been confirmed, and the production company is unknown. The second was released by Pathé in 1915.

17. *Die Woche*, no. 6, 10 February 1916. The article 'Krieg und Film' was written by Felix Neumann ('Hauptmann im Kriegspresseamt'). His semi-official critique was, however, supported by independent journalists, as 'a document from the great and serious period

of the World War' (*8 Uhr Abendblatt*, 20 January 1917) or 'unadorned excerpts from a terrible reality' (*Tägliche Rundschau*, 20 January 1917).

18. Cf. *Potsdam Federal Archive*, file 949, p. 323, where the report from Copenhagen is reproduced, according to which THE BATTLE OF THE ANCRE had to be 'removed from the programme after just a few days.'

19. For the reception of the longer war films and their supposed propagandistic effect, see Nicholas Reeves, 'The Power of Film Propaganda - Myth or Reality?' *Historical Journal of Film, Radio and Television*, vol. 13, no. 2, 1993, pp. 181-201.

20. *BuFA memorandum*, 14 november 1917, op. cit., pp.170ff.

The Reason and Magic of Steel: Industrial and Urban Discourses in DIE POLDIHÜTTE

1. The only known print seems to be the one held at the Netherlands Filmmuseum, and in its present version probably dating from after the War, with Dutch intertitles: 'De staalgieterijen Poldihütte, tijdens den wereldoorlogg - Belangwekkende wetenschappelijke opnamen.' The credits are 'Germany (Messter-Film) 1916, dir: ?, length 1011,4 metres.

2. Marshall Deutelbaum, 'Structural Patterning in the Lumière Films,' *Wide Angle*, vol. 3, no. 1, 1979, p. 35.

3. Allan Williams, 'The Lumière Organization and "Documentary Realism,"' in John Fell (ed.), *Film Before Griffith*, Berkeley et al.: University of California Press, 1983, p. 155.

4. William Uricchio, 'The Kulturfilm: A Brief History of an Early Discursive Practice,' in Paolo Cherchi Usai and Lorenzo Codelli (eds.), *Before Caligari: German Cinema, 1895-1920*, Pordenone: Edizioni Biblioteca del'Immagine, 1990, pp. 358-360.

5. See Uricchio, *op. cit.*, pp. 364-366. The inclusion of Wanderkinos in the sites of exhibition is a contribution from an article by Scott Curtis, 'The Taste of a Nation: Training the Senses and Sensibility of Cinema Audiences in Imperial Germany,' *Film History*, vol. 6, no. 4, 1994, pp. 453-454.

6. Sabine Hake, *The Cinema's Third Machine: Writing on Film in Germany, 1907-1933*, Lincoln: Nebraska University Press, 1993, p. 31.

7. Uricchio, *op. cit.*, p. 366.

8. *Ibid.*, pp. 366-368.

9. Wolfgang Mühl-Benninghaus, 'Changes in German Cinematography during World War One,' unpublished paper given at the *Film and the First World War: International IAMHIST Conference*, Amsterdam, 5-11 July 1993, p. 9.

10. Uricchio, *op. cit.*, pp. 370-372.

11. On Julius Pinschewer, see Jeanpaul Goergen's essay above.

12. Hake, *op. cit.*, pp. 11-13.

13. *Ibid.*, p. 364.

14. See Mühl-Benninghaus, *op. cit.*, p. 7.

15. See Hake, *op. cit.*, p. 40.

16. Uricchio, *op. cit.*, p. 370.

17. *Ibid.*, p. 372.

18. Tom Gunning, 'The Cinema of Attractions: Early Film, Its Spectator and the Avant-Garde,' in Thomas Elsaesser (ed.), *Early Cinema: Space, Frame, Narrative*, London: BFI Publishing, 1990, pp. 57-59.

19. Gunning, *op. cit.*, p. 61.

20. Tom Gunning, 'The World as Object Lesson: Cinema Audiences, Visual Culture and the St. Louis World's Fair, 1904,' *Film History*, vol. 6, no. 4, 1994, p. 427.

21. Gunning, 'The World as Object Lesson,' *op. cit.*, pp. 433-434.

22. *Ibid.*, pp. 435-437.

23. *Ibid.*, p. 425.

24. *Ibid.*, p. 439.

25. See Deniz Göktürk's essay elsewhere in this volume and also her 'Market Globalization and Import Regulations in Imperial Germany,' in Karel Dibbets and Bert Hogenkamp (eds.), *Film and the First World War*, Amsterdam: Amsterdam University Press, 1995, p. 190.

26. Peter Wollen, 'Cinema/Americanism/the Robot,' in James Naremore and Patrick Brantlinger (eds.), *Modernity and Mass Culture*, Bloomington: Indiana University Press, 1991, p. 43.

27. See Stephen Bottomore, 'Shots in the Dark-The Real Origins of Film Editing,' in Elsaesser (ed.), *Early Cinema*, op. cit., pp. 104-110.

28. Frederick Taylor's *The Principles of Scientific Management*, published in 1911, was a labor study of exemplary gestures adjusting the worker to the efficiency and predictability of the machine. One of Taylor's followers, Frank B. Gilbreth, analyzed human movement through a special motion picture camera which took successive photographs or chronocyclegraphs. Gilbreth's resulting application of workers picking up and laying bricks was a direct descendant of Muybridge's motion study of a galloping horse. See Stephen Kern, *op. cit.*, pp. 116-117.

29. Thomas Elsaesser, 'Introduction - Early Film Form: Articulations of Space and Time,' in Elsaesser (ed.), *Early Cinema*, op. cit., p. 17.

30. Wollen, *op. cit.*, p. 53.

31. Gunning, 'The World as Object Lesson,' *op. cit.*, p. 427.

32. A similar 'Hall of Machinery' can be found in the contemporary instance of NASA's space performance, a magical science theater of its own, which also suppresses the shadow of an explosion.

33. Walter Benjamin, 'The Work of Art in the Age of Mechanical Reproduction,' reprinted in Gerald Mast and Marshall Cohen (eds.), *Film Theory and Criticism: Introductory Readings*, New York: Oxford University Press, 1974, p. 629.

34. Charles Musser, 'The Travel Genre in 1903-1904: Moving Towards Fictional Narrative,'

in Elsaesser, *Early Cinema*, op. cit., p. 123.

35. See Noël Burch, 'Narrative/Diegesis - Thresholds, Limits,' *Screen*, vol. 23, no. 2, July/ August 1982, p. 18.

36. Musser, *op. cit.*, pp. 127-128.

37. See William Uricchio, *Ruttman's 'Berlin Symphony' and the City Film to 1930*, Ann Arbor: UMI Research Press, 1982, p. 68.

38. *Ibid.*, p. 81.

39. James Donald, 'The City, The Cinema: Modern Spaces,' in Chris Jenks (ed.), *Visual Culture*, London: Routledge, 1995, p. 80.

40. *Ibid.*, p. 78.

41. *Ibid.*, p. 81.

42. Göktürk, 'Market Globalization,' *op. cit.*, p. 190.

43. Hake, *op. cit.*, pp. 91-95.

44. Donald, *op. cit.*, p. 85.

45. Uricchio, *Ruttman's Berlin*, op. cit., p. 88.

46. *Ibid.*

47. Kristin Thompson, 'The International Exploration of Cinematic Expressivity,' in Dibbets and Hogenkamp (eds.), *Film and the First World War*, op. cit., pp. 65-85.

48. Kristin Thompson, 'Im Anfang War... some links between German fantasy films of the Teens and the Twenties,' in Cherchi Usai and Codelli (eds.), *Before Caligari*, op. cit., p. 154.

49. Elsaesser, 'Introduction,' *op. cit.*, p. 17.

Max Mack:
The Invisible Author

1. Max Mack, 'Wie ich zum Film kam,' *Die Lichtbildbühne (LBB)*, no. 21, 24 May 1919, p. 24: 'If anybody should ever make the effort of writing a history of the German film, then a true expert of the matter will surely not want to pass by my first creations without notice.'

2. See Siegfried Kracauer, *From Caligari to Hitler: A Psychological History of the German Film*, Princeton, NJ: Princeton University Press, 1947, pp. 33-4. Also see Heide Schlüpmann, *Unheimlichkeit des Blicks: Das Drama des frühen deutschen Kinos*, Basel and Frankfurt: Stroemfeld/Roter Stern, 1990, pp. 108-113.

3. Max Mack, 'Moderne Filmregie,' *LBB*, no. 7, 1920, p. 13: 'Between the audience and the film author a tacit agreement exists about venturing ever more deeply into the innermost problems of mind, soul and the senses. Does it not therefore stand to reason that the director is doing his best to keep pace with them? More than that, would he not want to provide the appropriate platform on which these battles can take place? After all, the director is the born mediator between author and audience: only he can infuse with

blood the poets' dreams, loosen the actors' tongues - if this bold mataphor can be applied to a silent art - and turn the receptive auditorium into the ideal spectator, a process for which Greek tragedy required the chorus.'

4. Max Mack, *With a Sigh and a Smile: A Showman Looks Back*, London: Alliance Press, 1943, p. 35.

5. See 'Das Motiv. Fachwissenschaftliche Hinweise von Max Mack,' *LBB*, vol. 7, no. 6, 7 Feb 1914, p. 11: 'Among the many talents the modern cinematic director has to combine, pictorial vision is one of the most necessary and perhaps the one most often ignored. (...) Apart from an innate pictorial predisposition there must be a trained eye, a steady apprenticeship of the look (...).'

6. See *ibid.*, p. 12: 'In conclusion, I want to draw your attention to the eminent importance which framing has in film photography.' Also see Max Mack, *Wie komme ich zum Film?* Berlin: Reinhold Kühn, 1919, p. 21: '(F)ilm is above all a matter of photography. This means: it does not bring onto the screen the beautiful soul, but the material body, the exterior world. And the problem of material appearance is the first, the central question one has to answer in order to be successful in film at all.'

7. In his chapter on 'Film Direction' in *Wie komme ich zum Film*, Mack has described in great detail the importance of character movement for the transformation of a literary model into the performative space of the cinema: 'The director (...) has to make sure that the unity of the photoplay is preserved, that the transition between the individual scenes is continuous, that the pace of the film is kept flowing. It sounds so easy: keeping the pace flowing - but oh how difficult this is in actual practice. Let me single out just one of the many ball scenes. The script says: "Boisterous ball atmosphere. Lissy enters in excellent mood, when suddenly she spots her husband." That's all! The film author has done his job, however rudimentary. The general course of the action is defined - now it is a matter for the director to conjure a vivid image from these meager words. How this is done is probably best illustrated by illustrating my own practice. First of all, the director must have an idea of the overall course of the scene, of the individual events, but not necessarily in all the minor details. Then he contacts the 'artistic advisors.' Together with the art director he discusses the location and the different spaces. They have to be appropriate for the action he is about to film in them. A ballroom isn't just a square room with a couple of doors. Things are not that simple. What one wants to conjure up is not the sight of a few dancing couples, but the atmosphere, the magic of a ball. So I have an expansive ball staircase leading from a raised platform down into the hall. The orchestra plays in a spacious alcove. A gallery winds itself around the hall at a certain height, interrupted by a few lateral boxes. Exits to the right and to the left, which lead to brightly-lit side rooms. Once transformed like this, you can really do something with the space. I have several choices of entrances and exits. I have a big gallery which I can use for interrupting shots. And I have a couple of lateral boxes for making all sorts of connections.

Now I let thirty, forty couples dance. Then I choose a group of ladies and gentlemen who enter the hall when I call "one," join the exactly defined couples, mingle to blend with the line, disengage and exit through a side door. In the meantime my group "two" has entered, consisting of ten waiters, all symmetrically waving their napkins and holding out in front of them champagne bottles on their trays. On another command, more couples come dancing in, appearing from other entrances, rendered in long shot. On command "five," the couples who passed through the dancers on command "one" to disappear in the wings have reappeared on the gallery, disturbing the whispering couples there, and throwing confetti down on the crowd. At the same time, the boxes have filled up, the waiters are once more rushing in and pour the champagne. Below, in the hall a couple has in the meantime attracted broad admiration and applause with their step-dancing. People are standing in a circle around them, imitating the rhythm of every movement. The dance is coming to an end, the band is playing louder, and everyone joins for the last few steps. This is the appropriate moment to let the plot begin.' (pp. 68ff.)

8. A piece of information not given in the film as it has come down to us, but in a contemporary plot-synopsis; see *LBB*, no. 24, 15 June 1912, p. 36.

9. This spectacular variation of the suicide to end a melodramatic narrative was much in evidence in the German cinema of the early teens. Apart from numerous still extant films and/or plot synopses in the contemporary trade press, this is also illustrated by the fact that in 1912 a newly established site for location shooting meant to attract production companies by hinting at the fact that it included a bridge which would be 'wonderfully suited for depictions of suicide.' In *Das Lichtspieltheater*, 25 April 1912; quoted in Adolf Sellmann, *Der Kinematograph als Volkserzieher?* Langensalza: Hermann Beyer & Söhne, 1912, p. 19.

10. Edward Branigan has described such a gap between screen and story space as a visible marker of the narrational process that 'leads to degrees and kinds of "impossible" space; that is, to space which cannot be justified as existing wholly within the diegesis.' According to Branigan, 'impossible spaces' in turn lead to 'perceptual problems of a new kind that force the spectator to reconsider prior hypotheses about time and causality.' See his *Narrative Comprehension and Film*, London: Routledge, 1992, p. 44. For a similar terminological distinction between 'story space' and 'discourse space' see Seymour Chatman, *Story and Discourse: Narrative Structure and Film*, Ithaca: Cornell University Press, 1978, pp. 97-8.

11. See Tom Gunning, 'Weaving a Narrative: Style and Economic Background in Griffith's Biograph Films,' in Thomas Elsaesser with Adam Barker (eds.), *Early Cinema: Space, Frame, Narrative*, London: BFI Publishing, 1990, pp. 343-4. For an extensive discussion of early examples, see also Gunning, *D.W. Griffith and the Origins of American Narrative Film: The Early Years at Biograph*, Urbana and Chicago: University of Illinois Press, 1991, pp. 85-129.

12. According to Herbert Birett, between 1908 and 1911, 109 Griffith films were released (or at least submitted to the censorship board) in Germany, including Gunning's prime examples for 'psychological editing,' SUNSHINE SUE (1910) and ENOCH ARDEN (1911); see Birett, *Das Filmangebot in Deutschland 1895-1911*, Munich: Winterberg Verlag, 1991 (for the two mentioned titles, pp. 161 and 595).

13. This shot has a duration of 96 seconds. It is interesting to note the tendency of ZWEIMAL GELEBT to retain a coherent shot space in key moments of the narrative, which is reflected in the extreme duration of the opening shot (70 s), shot 9 (66 s), shot 24 (83 s; the depiction of the mother's crisis), shot 46 (69 s; the shot in which the female protagonist and her former family nearly meet while taking a boat trip), and shot 50 (the final encounter of the two parties). The long shot duration is always paired with medium long, long, or very long framing. The fact that the film's narration makes no use of closer framing to manipulate the viewer's attention for relevant actions and create the sense of suspense and character psychology, once more reinforces the impression of an 'alternative style.'

14. The activation of offscreen space by the look of a character here as throughout the film differs obviously from 'classical' modes of visual representation in the cinema, where an imaginary activity constantly refers it back to the screen in creation of a coherent diegesis; by contrast, and as an important element of the alternative spatial codification in ZWEIMAL GELEBT, off-screen space remains invisible and its activation by the gaze is to signify the characters' memories of an absent object or experience.

15. For Noël Burch 'the *autarky* and *unity* of each frame' and 'the *non-centered quality* of the image' are the primary reasons for his conclusion that 'The Primitive Cinema at its most characteristic is ab-psychological.' (emphasis in original) See his 'Primitivism and the Avant-Gardes: A Dialectical Approach,' in Phil Rosen (ed.), *Narrative, Apparatus, Ideology: A Film Theory Reader*, New York: Columbia University Press, 1986, p. 487.

16. Early German cinema's transition to the long narrative film has traditionally been described in terms of 'literarisation.' Apart from the huge amount of literature on the phenomenon of the *Autorenfilm*, see e.g. Anton Kaes, 'The Debate about Cinema: Charting a Controversy (1909-1929),' *New German Critique*, no. 40, Winter 1987, esp. p. 9 and Joachim Paech, *Literatur und Film*, Stuttgart: Metzler, 1988.

17. See the extremely instructive comparative table in Barry Salt's essay below.

18. 'The opening sequence is the visiting card of the film director. Before the colourful play begins, a gentleman bows and takes a call, smiling at the audience with friendly reservation, stroking his dog with napoleonic seriousness or agonizingly browsing through the manuskript. This is the film director who in this very unobtrusive manner hammers into the brains of the audience that he is the maker of this world. Usually the actors, too, follow with a sweet smile and sometimes, in the big hits, also the film author, deeply absorbed in his thoughts, bent over his writing desk. The opening sequence deals with everything in the film. Presentation, taking a call, making a bow: in short, all those

captivating vanities of the stage. And the audience is by now so used to it that popular directors are made welcome by a warm round of applause the very moment their faces appear on the screen.' Max Mack, 'Die Toilette des Films,' in Mack (ed.), *Die zappelnde Leinwand*, Berlin: Verlag von Dr Eysler & Co., 1916, pp. 124-5.

From Peripetia to Plot Point: Heinrich Lautensack and
ZWEIMAL GELEBT

1. See the poster from the Frankfurter Film-Compagnie in *Lichtbildbühne*, no. 25, 1912, p. 24, which expressively emphasizes that 'this programme (of a total length of approximately 1,600 metres) [contains] a two-acter.' See also Corinna Müller, *Frühe deutsche Kinematographie*, Stuttgart and Weimar: Metzler, 1994, pp. 161-2, who notes that, as far as Messter's production is concerned, the 'drama' in particular - the main product of narrative cinema at the time - 'was often a two-acter' in 1912. We are sorely lacking a precise indication of length for a two- or three-act film. The available statistics of German film production until 1919 give production figures in 'acts' as units of length.

2. On the early history of scriptwriting in Germany see Jürgen Kasten, *Film Schreiben: Eine Geschichte des Drehbuches*, Vienna: Hora Verlag, 1990, pp. 14-46, and Alexander Schwarz, *Der geschriebene Film: Drehbücher des deutschen und russischen Stumm– films*, Munich: diskurs film, 1994, pp. 26-74.

3. This is claimed in Ludwig Greve, Margot Pehle, Heidi Westhoff (eds.), *Hätte ich das Kino! Die Schriftsteller und das Kino*, Munich: Kösel Verlag, 1976, p. 101.

4. Reprinted in Kurt Pinthus (ed.), *Das Kinobuch* (1914), Frankfurt: Fischer Taschenbuch-verlag, 1983, pp. 133-47. Pinthus changed the specific staging technique of the script, partly for the ease of the reader. Lautensack's handwritten manuscript is in Munich's city library (for details on these changes see Schwarz, *op. cit.*, pp. 117-20).

5. ZWEIMAL GELEBT, approximate length 672m, dir. Max Mack, cast: Eva Speyer-Stöckel (woman), Anton Ernst Rückert (her husband). Censored 12 June 1912. Complete ban. Premiere: unknown. The existing copy is in the collection of Jean Desmet, the international film distributor, in the Archive of the Nederlands Filmmuseum, Amsterdam, and is 560.9 m in length. The original script is apparently lost.

6. The family being threatened by a technical object comes up in other films. In WEIH-NACHTSTRÄUME (1910) a child is also run over by a car, turning the mother into an alcoholic. In TRAGÖDIE EINES STREIKS (1912) a strike cuts off the entire electricity supply, making it impossible for the hospital to perform any operations, with the tragic result that the child of one of the working-class couples dies.

7. In DIE ERZIEHERIN (1911) a horse and cart comes close to running over the young daughter of an upper-class family. The governess, who had been dismissed by the family after a liaison with their eldest son, saves the child and is re-employed by the family.

8. See Michael Wedel, '"Kino-Dramen": Narrative and Space in Early German Feature

Films, 1912-1919,' University of Amsterdam: unpubl. MA thesis, 1993, pp. 47-58. The fact that Lautensack had some experience of arranging linkages between temporal and plot elements in the narrative as early as 1912/13 is clear in ZWISCHEN HIMMEL UND ERDE, in which an interesting sequence shows the four main characters who may be separate, but all long for the climax (frame 21-24). In Pinthus, *op. cit.*, 1983, pp. 139-40). In DAS IST DER KRIEG the author combines scenes like the last-minute rescue sequence, involving the siege and the advancing liberation of a surrounded military company (see *Lichtbild-Bühne*, no. 19, 1913, p. 30).

9. On the substitution and spatial organization of characters in ZWEIMAL GELEBT see Michael Wedel's essay above.

10. Lautensack also uses a similar character and conflict construction in ZWISCHEN HIMMEL UND ERDE (frame 9, in Pinthus, *Das Kinobuch*, op. cit., p. 137). Here the revelation of an intense emotion at an inappropriate moment triggers the action-packed intrigue of a tale of jealousy. In this script Lautensack once again delineates the inner action in great detail.

11. See Urban Gad, *Der Film: Seine Mittel, seine Ziele*, Berlin, n.d. (1920, first Danish edition 1919), pp. 41-2.

12. The normative plot points principle held up in American scriptwriting manuals as the central dramaturgical mode of the classical narrative cinema was first questioned by German script-writing theorists. Peter Hant, in his *Das Drehbuch: Praktische Filmdramaturgie*, Waldeck, 1992, p. 20, describes precisely the method adopted by Lautensack in ZWEIMAL GELEBT: 'Plot point 1 leads to the confrontation in the second act. Plot point 2 leads to the climax and the resolution.'

13. In DER SCHATTEN DES MEERES Henny Porten follows, in the closing shot, the appearance of her dead loved one in the sea. Her longing for love and her dissatisfaction with the reality of her everyday existence are made very clear.

14. An association which was probably also essential to the censor's banning of the film. In the censor's summary a whole sentence is dedicated to this predicament, namely the endangering of the family through a bigamist relationship.

15. Published versions of these three plays are included in Heinrich Lautensack, *Das Verstörte Fest: Gesammelte Werke*, ed. W.L. Kristl, Munich: Hanser Verlag, 1967.

16. See Otto F. Best, 'Heinrich Lautensack und die Säkularisierung des Eros,' *Akzente*, no. 4, 1970, pp. 370-84. 'The goal of his love was to it (the catholic, middle-class, rural way of life) at the same time a provocation and a reproach' (p. 370).

17. On DIE MACHT DER JUGEND see the synopsis in *Lichtbildbühne*, no. 16, 1912, p. 36. On ENTSAGUNGEN see the programme of the Continental, quoted in W.L. Kristl, 'Ein Filmpionier aus Passau,' *Bayerische Staatszeitung*, no. 4, 1974, p. 30 (section 'Unser Bayern'). An original plot outline of DAS IST DER KRIEG is to be found in *Lichtbildbühne*, no. 19, 1913, pp. 25, 30, 32.

18. Quoted after Herbert Birett, *Verzeichnis in Deutschland gelaufener Filme: Entscheidungen der Filmzensur 1911-1920*, Munich et al.: K.G. Saur, 1980, p. 48.

Giuseppe Becce and RICHARD WAGNER

1. RICHARD WAGNER. Ein Kinematographischer Beitrag zu seinem Lebensbild, scr: William Wauer; dir: William Wauer and Carl Froelich; cam: Carl Froelich; mus: Giuseppe Becce; leading players: Giuseppe Becce (Richard Wagner), Olga Engl (Cosima), Manny Ziener (Minna Planer), Miriam Horowitz (Mathilde Wesendonk), Ernst Reicher (Ludwig II); prod: Messter-Film GmbH, Berlin; cens: Berlin, 8 May 1913, 2055m, restricted access; World Premiere: 31 May 1913, Berlin, Union-Theater Friedrichstrasse in the Bavaria House; for the Wagner year 1983 the film was projected with music by Armin Brunner and has been shown in this version on television several times.

2. Leopold Schwarzschild's review is reprinted in Ludwig Greve et al. (eds.), *Hätte ich das Kino! Die Schriftsteller und der Stummfilm*, Munich: Kösel, 1976, pp. 51-52.

3. Stephen Bush, quoted from Charles Merrel Berg, *An Investigation of the Motives for and Realization of Music to Accompany the American Silent Film, 1896-1927*, New York 1976, p. 76.

4. It would be a separate task to construct a Wagner filmography of the early years. It is not possible to even approximate the real number of early Wagner films at this moment. The following facts should therefore be considered with reservations. Wagner sound films of a few minutes' length are produced primarily between 1907-1919 by German companies: There are nine pictures with the title LOHENGRIN, among these two with Henny Porten; seven TANNHÄUSERS, two FLIEGENDE HOLLÄNDER as well as one MEISTERSINGER VON NÜRNBERG and one SIEGFRIED; Pathé Frères offered at least three Wagner sound pictures, the American Vitascope at least one, no other producers present in Germany are (as yet) known to have produced Wagner films (see Herbert Birett, *Das Filmangebot in Deutschland 1895-1911*, Munich: Filmbuchverlag Winterberg, 1991, pp. 200, 410, 439, 440, 601, 632). Already in 1904 there existed a PARSIFAL by Edwin Porter, in 1910 another PARSIFAL by the Edison Company; in Italy we know of I NIBELUNGHI by M. Bernacci (1910), TRISTANO E ISOTTA (1911), also PARSIFAL (1912) and SIEGFRIED (1912) by Mario Caserini.

5. See entry 'Carl Froelich,' in Hans-Michael Bock (ed.), *Cinegraph: Lexikon zum deutschsprachigen Film*, Munich: edition text + kritik, Lg. 7, D 1, 1986.

6. O. Th. Stein, 'Ein neues Filmgenre (Die Richard-Wagner-Biographie im Kino),' in *Das Lichtbild-Theater*, vol. 5., no. 23, 5 June 1913.

7. Oskar Messter, *Mein Weg mit dem Film*, Berlin: Verlag Max Hesse, 1936, p. 63.

8. Becce's score for RICHARD WAGNER is kept at the Library of Congress, Washington; see also Gillian Anderson, *Music for Silent Films: A Guide*, Washington: Library of Congress, 1988, LCM176, R5, Music 3212, item 113.

9. Hans Erdmann and Giuseppe Becce (with Ludwig Brav), *Allgemeines Handbuch der Filmmusik*, vol. 1, Berlin 1927, p. 6 (note in the margin).

10. *Ibid.*, vol. 2, p. 192.

11. Schwarzschild, *op. cit.*, p. 52.

12. *Der Kinematograph*, no. 349, 3 September 1913.

13. Stein, *op. cit.*

14. *Union-Theater-Zeitung*, no. 22, 1913.

15. *Ibid.*, no. 33, 1913.

16. 'Die Eröffnung des 6. Union-Theaters in Berlin,' *Der Kinematograph*, no. 336, 4 June 1913.

17. *Der Kinematograph*, no. 349, 3 September 1913.

18. See Helmut Diederichs, 'The Origins of the Autorenfilm,' in Paolo Cherchi Usai and Lorenzo Codelli (eds.), *Before Caligari: German Cinema, 1895-1920*, Pordenone: Edizioni Biblioteca dell'Immagine, 1990, p. 390.

19. I am grateful to Martin Loiperdinger for his assistance in preparing the German original of this essay for print.

Early German Film:
The Stylistics in Comparative Context

1. My thanks to the National Film Archive and National Film Theatre for their usual extensive cooperation in making films available for analysis, and this time the Goethe Institute also deserves a full share of my appreciation for their help.

2. Emilie Altenloh, *Zur Soziologie des Kino: Die Kinounternehmung und die sozialen Schichten ihrer Besucher*, Jena: Diederichs, 1914.

3. See the 2nd edition of Barry Salt, *Film Style and Technology: History and Analysis*, London: Starword, 1992.

4. See Herbert Birett, 'Alte Filme. Filmalter und Filmstil: Statistische Analyse von Stummfilmen,' in Elfriede Ledig (ed.), *Der Stummfilm: Konstruktion und Rekonstruktion*, Munich: diskurs film, 1988, pp. 69-88.

5. George Pratt, *Spellbound in Darkness*, New York: Graphic Society, 1973.

Self-Referentiality in Early German Cinema

1. This essay is an edited and slightly shortened version of 'Self-Referentiality in Early German Cinema,' *Cinema Journal*, vol. 31, no. 3, Spring 1992, pp. 37-55.

2. Siegfried Kracauer, *From Caligari to Hitler: A Psychological History of the German Film*, Princeton, N.J.: Princeton University Press, 1947, p. 15.

3. On a different tradition of self-reflexivity that emphasizes its critical aspects, see Robert Stam, *Reflexivity in Film and Literature: From Don Quixote to Jean-Luc Godard*, Ann Arbor, Mich.: UMI Research Press, 1985. Most scholarship on self-reflexivity in the cinema (Kawin, McCabe, Polan) has focused on the modernist tradition from Brecht to Godard, while more recent work on cinema, women, consumer culture (Gaines, Allen)

investigates its affinities with the self-celebratory mode of advertisement.

4. See Tom Gunning, 'The Cinema of Attractions: Early Film, Its Spectator and the Avant-Garde,' in Thomas Elsaesser with Adam Barker (eds.), *Early Cinema: Space, Frame, Narrative*, London: BFI Publishing, 1990, pp. 56-62. By the same author and in the same volume, also see 'Non-Continuity, Continuity, Discontinuity: A Theory of Genres in Early Films,' pp. 86-94 and "Primitive' Cinema: A Frame Up? Or, The Trick's on Us,' pp. 95-103.

5. See the work of André Gaudreault, especially 'Showing and Telling: Image and Word in Early Cinema,' *Early Cinema: Space, Frame, Narrative*, pp. 274-82.

6. Thomas Elsaesser, 'National Subjects, International Style: Navigating Early German Cinema,' in Paolo Cherchi Usai and Lorenzo Codelli (eds.), *Before Caligari: German Cinema, 1895-1920*, Pordenone: Edizioni Biblioteca dell'Immagine, 1990, p. 352.

7. The reference here is to Laura Mulvey's famous essay 'Visual Pleasure and Narrative Cinema,' *Screen,* vol. 16, no.3, Autumn 1975, pp. 6-18.

8. Compare Heide Schlüpmann, *Unheimlichkeit des Blicks: Das Drama des frühen deutschen Kinos*, Basel and Frankfurt am Main: Stroemfeld/Roter Stern, 1990, esp. pp. 59-61.

9. Beginning in the teens, the appearance of film crews in public places also emerges as a recurring theme in plays written for lay theatre groups. For examples, see Hans Fischer, *Filmaufnahme in Krähenwinkel*, Bonn: Anton Heidelmann, c. 1915, and Gustav Pfenning, *Der Filmautor*, Mühlhausen/Thüringen: G. Danner, 1928.

10. This configuration recalls Stephen Heath's call for a 'history of the cinema-machine that can include its developments, adaptations, transformations, realignments, the practices it derives, holding together the instrumental and the symbolic, the technological and the ideological, the current ambiguity of the term apparatus.' In 'The Cinematic Apparatus: Technology as Historical and Cultural Form,' *Questions of Cinema*, Bloomington: Indiana University Press, 1981, p. 227.

11. For instance, when Edwin Porter stages the perils of spectatorship in UNCLE JOSH AT THE MOVING PICTURE SHOW (1902), he emphasizes the proximity of cinema and delusion, a psychological configuration that still dominates the American cinema in Keaton's SHERLOCK JR. (1924). By contrast, the scenarios of spectatorship that take place in WHEN THE CINEMA TAKES REVENGE or WHERE IS COLETTI? imply that the cinema's deceptions can also involve a process of learning. When Chaplin disrupts the smooth functioning of the 'dream factory' in HIS NEW JOB (1915) and BEHIND THE SCREEN (1916), the apparatus is for a moment threatened - but only to prevail in the end. By contrast, the filmmakers in THE FILM PRIMADONNA and ZAPATA'S GANG appear as committed members of the film industry but abandon their projects for real-life experiences.

12. See Corinna Müller, 'Emergence of the Feature Film in Germany between 1910 and 1911,' in *Before Caligari*, pp. 94-114; Helmut H. Diederichs, 'The Origins of the Autorenfilm,' *Before Caligari*, pp. 380-401; and Anton Kaes, 'Literary Intellectuals and the

Cinema: Charting a Controversy (1909-1929),' trans. David J. Levin, *New German Critique* 40, Winter 1987, pp. 7-33.

Of Artists and Tourists:
'Locating' Holland in Two Early German films

1. For this article I owe gratitude to the following individuals and institutions: Jorien Jas (Zuiderzeemuseum Enkhuizen), Geoffrey Donaldson, Paul van Yperen, and the Nederlands Filmmuseum. For the relation between artists and Volendam, I refer to the exhibition catalogue by Gusta Reichwein, *Vreemde gasten. Kunstschilders in Volendam 1880-1914*, s.l.: Vereniging Vrienden van het Zuiderzeemuseum, 1986. The quote by Havard is from Henry Havard, *La Hollande pittoresque, voyage aux villes mortes au Zuyderzee*, 1874.

2. For Clausen see Reichwein, *Vreemde gasten*, op. cit., pp. 8-9.

3. For the names from the guestbooks of Spaander, I thank Geoffrey Donaldson.

4. The determining way of describing the inhabitants of the villages at the Zuiderzee can also be found in travel guides from the turn of the century. H. Maho writes in his travel guide *D'Amsterdam à l'île de Marken*, Brussel: A. Bieleveld, 1911, pp. 158-159: 'De ces pauvres masure de Marken, il ne sort ni vagabonds, ni femmes corompues; nul habitant n'a jamais deserté la mer, et aucune jeune fille n'a jamais dédainé la main d'un pêcheur.'

5. Apart from those films mentioned, Pathé shot at the same time COMMENT SE FAIT LE FROMAGE DE HOLLANDE (1910) at Alkmaar, not far from the Zuiderzee, and LES PORCELAINES DE DELFT (1909).

6. Geoffrey Donaldson, 'Het lijden van den scheepsjongen/le calvaire du mousse,' in the series 'Wie is wie in de Nederlandse film tot 1930,' *Skrien*, no.136, Summer 1984, pp. 36-37. In the Zuiderzeemuseum within the inheritance of Hanicotte, three setphotos of LE CALVAIRE DU MOUSSE are available, on which next to the filmcrew and the actors also Cassiers and Hanicotte are visible. See also Herbert Birett, *Das Filmangebot in Deutschland 1895-1911*, Munich: Filmbuchverlag Winterberg, 1991; Herbert Birett, *Verzeichnis in Deutschland gelaufener Filme 1911-1920*, Munich et al.: K.G. Saur, 1980. For Machin and his activities in the Netherlands see also Eric de Kuyper, *Alfred Machin Cinéaste/Film-maker*, Brussels: Cinémathèque Royale de Belgique, 1995. This book contains furthermore a detailed filmography of Machin's work, compiled by Sabine Lenk.

7. Apart from Mülleneisen the film crew consisted, according to Spaander's guestbook, of 'Fräulein Lissi Nebuschka' from Dresden (the protagonist of the film), 'Herr Fritz Stöve' from Garmisch, 'Herr Röttger' from Berlin and the cameraman 'Herr Fürkel' also from Berlin.

8. Meant here are the intertitles from the film copy within the Desmet collection of the

Nederlands Filmmuseum, the only original copy left of the film.

9. Joseph Delmont, *Wilde Tiere im Film: Erlebnisse aus meinen Filmaufnahmen in aller Welt*, Stuttgart: Died, 1925; see also Friedrich P. Kahlenberg, 'DER GEHEIMNISVOLLE KLUB and AUF EINSAMER INSEL: Two German feature films made by Eiko-Film in 1913,' in Paolo Cherchi Usai, Lorenzo Codelli (eds.), *Before Caligari: German Cinema, 1895-1920*, Pordenone: Edizioni Biblioteca dell'Immagine, 1990, pp. 326-336.

10. The present manager of the hotel told me that the actual building is the one from Delmont's time and has been there since 1905. A previous building by the same owners had been there until 1903, when it burned down.

11. See, for instance, the plot of a Henny Porten film such as DES PFARRERS TÖCHTERLEIN (1912).

12. See the review in *Die Lichtbildbühne*, 7 November 1913.

13. For George Clausen, see *Vreemde gasten*, pp. 8-9; *Lichtbildbühne*, 7 November 1913; the subtitle is mentioned in a review in *Die Filmwoche*, no. 32, 19 October 1913, pp. 10-14.

14. That *L'Angelus* should be on such a painted chest is most unlikely. However, every house at the time possessed such chests, though painted in naive, often abstract style, while Millet's painting could be found in many interiors in those days but in the form of a print, in particular in the Catholic town of Volendam.

15. 'The echoes of landscape painting and genre painting are hard to miss. Besides the allusions to Dutch paintings, one distinctly senses the proximity of the realist, but in its use of light impressionist tradition of [Max] Liebermann, [Wilhelm] Leibl, who rebelled against the stuffiness and clutter of 'Gründerzeit' aesthetics. It is as if the film wanted to show, how the cinema, in this respect, can go one better than painting.' Heide Schlüpmann, *Unheimlichkeit des Blicks: Das Drama des frühen deutschen Kinos*, Basel/Frankfurt: Stroemfeld/Roter Stern, 1990, p. 171.

16. John Sillevis et al., *Liebermann in Holland*, Den Haag: SDU, 1980 (exhibition catalogue Haags Gemeentemuseum). According to this catalogue there is no work known of Liebermann on which Volendam or Marken are depicted.

17. Hans Kraan, 'Als Holland Mode war: Deutsche Künstler und Holland im 19. Jahrhundert,' *Nachbarn* (Bonn), no. 31, 1985, pp. 16-17.

18. *Die Filmwoche*, op cit., pp. 10-14.

19. See Karel Dibbets and Ed Kerkman, 'Een zee van ruimte: Het beeld van de zee in de Nederlandse speelfilm tot 1940,' *Volkskundig Bulletin. Tijdschrift voor Nederlandse cultuurwetenschap* 16/2, June 1990, pp. 157-175. The cliché of the Volendam costume as symbolic for the Dutch people can be traced to, apart from Machin's Dutch films, also his Belgian production LA FILLE DE DELFT (1913), and one year earlier a Pathé production, LA LÉGENDE DES TULIPES D'OR (1912). Moreover, AUF EINSAMER INSEL and DES MEERES UND DER LIEBE WELLEN were not the first and the last German films to be shot on location in Volendam or Marken. In 1921 the film DER EWIGE KAMPF, starring Lotte

Neumann, was made, released in Holland as ANTJE VAN VOLENDAM. This Union production, directed by Paul Ludwig Stein, was shot in Volendam, too. See *Cinema & Theater* 35, 1921, p. 8.

Stylistic Expressivity in DIE LANDSTRASSE

1. This essay was helped by having access to the print of DIE LANDSTRASSE held at the Nederlands Filmmuseum, Amsterdam. My thanks to Mark-Paul Meyer and the staff of the Stichting Nederlands Filmmuseum for their kindness and hospitality during my visit.
2. Kristin Thompson, 'The International Exploration of Cinematic Expressivity,' in Karel Dibbets and Bert Hogenkamp (eds.), *Film and the First World War*, Amsterdam: Amsterdam University Press, 1995, pp. 65-85.
3. Frank Kessler, 'A Highway to Film Art?' In Paolo Cherchi Usai and Lorenzo Codelli (eds.), *Before Caligari: German Cinema, 1895-1920*, Pordenone: Edizioni Biblioteca dell'Immagine, 1990, pp. 438-451.
4. See John Fullerton, 'Spatial and Temporal Articulation in Pre-classical Swedish Film,' in Thomas Elsaesser (ed.), *Early Cinema: Space, Frame, Narrative*, London: BFI Publishing, 1990, pp. 375-388.
5. Kessler also comments that DIE LANDSTRASSE has 'quite a "modern" feel to it,' arising from the clarity of the spatial and temporal relations in the editing. See 'A Highway to Film Art?', p. 446.
6. *Ibid.*, p. 444.
7. I have seen DIE LANDSTRASSE under a number of different circumstances, but none which would allow me to make a reasonably precise measurement of individual shot lengths. Given the problems with silent-film projection speeds, my estimates here can be only approximate.
8. Kessler, 'A Highway to Film Art?', pp. 446, 448.

Two 'Stylists' of the Teens:
Franz Hofer and Yevgenii Bauer

1. The future Russian/German/French/American film director Fedor Otsep advocated this idea in his unpublished book of 1913 (outline for the book survives at RGALI [Russia's State Archive for Literature and Art], 2743/1/72.) See also G. Er. 'Dinamika Zhivopisi i kinematograf,' ('The Dynamics of Painting and Cinema'), *Sine-Fono*, 1914, no. 20, pp. 33-34.
2. Sergei Gorodetskii, 'Zhiznopis,' *Kinematograf*, 1915, no. 2, pp. 3-4.
3. More on this doctrine see my article 'Some Preparatory Remarks On Russian Cinema,' in Yuri Tsivian (research), Paolo Cherchi Usai e. a. (eds.), *Silent Witnesses: Russian Films,1908-1919*, Pordenone/London: British Film Institute & Edizioni dell'Immagine, 1989, pp. 26-34.

4. For the discussion and frame enlargements illustrating his point see Paolo Cherchi Usai, 'On the Concept of "Influence" in Early Cinema,' in Roland Cosandey and François Albera (eds.), *Cinema sans Frontieres / Images Across Borders, 1896-1918: Internationality in World Cinema: Representations, Markets, Influences and Reception*, Quebec/Lausanne: Nuit Blanche Editeur-Editions Payot, 1995, pp. 275-286.

5. Jeffery W. Howe, *The Symbolist Art of Fernand Khnopff*, Ann Arbor: UMI Reserarch Press, 1982, pp. 63-64.

6. Quoted from the Russian translation of Przybyszewsky's *Homo Sapiens*, Moscow, 1904, p. 45.

7. Quoted from Henryk Izydor Rogacki, *Zyvot Przybyszewskiego*, Warszawa: Panstwowo Institut Wydawniczy, n.d., p. 50.

8. See Kristin Thompson, 'The International Exploration of Cinema ic Expressivity,' in Karel Dibbets, Bert Hogenkamp (eds.), *Film and the First World War*, Amsterdam: Amsterdam University Press, 1995, pp. 70-75; John Fullerton, 'Contextualising the Innovation of Deep Staging in Swedish Films,' *ibid.*, pp. 86-96, and my own 'Portraits, Mirrors, Death: On Some Decadent Clichés in Early Russian Films,' *Iris*, no. 14-15, Autumn 1992, pp.67-83.

9. Ted Shawn, *Every Little Movement: A Book about François Delsarte*, New York: Dance Horizons 1963, pp. 28-59.

The Voyeur at Wilhelm's Court: Franz Hofer

1. Heide Schlüpmann, 'The Sinister Gaze: Three Films by Franz Hofer from 1913,' in Paolo Cherchi Usai and Lorenzo Codelli (eds.): *Before Caligari: German Cinema, 1895-1920*, Pordenone: Ed. Biblioteca dell'immagine, 1990, pp. 452.

2. Two titles produced by this company in 1921 are reported in Ludwig Greve, Margot Pehle, Heidi Westhoff (eds.), *Hätte ich das Kino! Die Schriftsteller und der Stummfilm*, Munich: Kösel Verlag, 1976.

3. See the 'Luxus-Ausgabe' of the *Lichtbild-Bühne*, no. 23, 1913. The supplement was edited by Arthur Mellini, and dedicated to 'Filmregie und Kinokunst. Unsere Regisseure in Wort und Bild'; the contribution by Hofer is indicated with the title 'Kunst und Literatur im Kino.' In 1923, the *Lichtbild-Bühne* published another contribution by Franz Hofer ('Kunst und Begeisterung beim Theater'), this time on the theatre, in a supplement dedicated to 'Der Kino Regisseur.' The 1913 supplement dedicated to the film director gave rise to a long debate that also involved other film magazines, like *Die Filmwoche* (no. 39, 1913).

4. On the contribution of the *Autorenfilm* to the evolution of a film language in German cinema, see Leonardo Quaresima, '"Dichter, heraus!" The Autorenfilm and the German Cinema of the 1910s,' *Griffithiana*, no. 38/39, 1990, pp. 101-126.

5. Heide Schlüpmann, *Unheimlichkeit des Blicks: Das Drama des frühen deutschen Ki-*

nos, Basel and Frankfurt: Stroemfeld/Roter Stern, 1990, p. 465.

6. Apart from, maybe, FRÄULEIN PICCOLO (Luna Film, 1914), a comedy that seems still tied to typically theatrical mise-en-scène, with transvestism, stage entrances and exits, and the use of the gaze into the camera according to the technique of 'direct address.' The film tells the story of a young girl who finds herself forced to work in a hotel as room maid and manservant. It boasts a fleeting appearance of Ernst Lubitsch. See also Leonardo Quaresima, 'Kunst im Kino,' in Antonio Costa (ed.), *La meccanica del visibile: Il cinema delle origini in Europa*, Firenze: La Casa Usher, 1983.

7. Also IHR UNTEROFFIZIER (dir. Alfred Halm, National-Film, 1915) offers a private and 'childish' view of the war: that of a young girl who writes to three soldiers and sends them food and warm socks. But the mood is decisively that of comedy and of military propaganda, directed towards the morale of soldiers at the front.

THE GERMAN CINEMA 1895-1917

A Classified Bibliography

GENERAL REFERENCE
(ENCYCLOPEDIAS, GENERAL HISTORIES, FILMOGRAPHIES...)

Birett, Herbert (ed.), *Verzeichnis der in Deutschland gelaufenen Filme: Entscheidungen der Filmzensur*. Berlin/Hamburg/Munich/Stuttgart: K.G. Saur, 1980.

--- *Das Filmangebot in Deutschland 1895-1911*. Munich: Winterberg, 1991.

Bock, Hans Michael (ed.), *CineGraph: Lexikon zum deutschsprachigen Film*. Munich: edition text & kritik, 1984ff.

Boussinot, Roger et al., *L'encyclopédie du cinéma*, 3 vols. Paris, 1984.

Bredow, Wilfried von / Rolf Zurek (eds.), *Film und Gesellschaft in Deutschland: Dokumente und Materialien*. Hamburg: Hoffman & Campe, 1975.

Bucher, Felix, *Screen Series: Germany*. London/New York: A. Swemmer Ltd./ AS. Barnes & Co., 1970.

Cherchi Usai, Paolo, 'German Fiction Films, 1895-1920: A Checklist of Surviving Material in FIAF Archives,' in *Before Caligari*, pp. 480-511.

Dahlke, Günther / Günther Karl (eds.), *Deutsche Spielfilme von den Anfängen bis 1933: Ein Filmführer*. Berlin/GDR: Henschel, 1986.

Deutsches Institut für Filmkunde / Stiftung der deutschen Kinemathek (ed.), *Verleihkatalog 1*. Frankfurt/Wiesbaden/Berlin, 1986.

Faulstich, Werner / Helmut Korte (eds.), *Fischer Filmgeschichte*. Vol. 1: *Von den Anfängen bis zum etablierten Medium 1895-1924*, Frankfurt/M.: Fischer TaschenbuchVerlag, 1994.

Fraenkel, Heinrich, *Unsterblicher Film: Die große Chronik – Von der Laterna Magica zum Tonfilm*. Munich: Kindler, 1956.

Frieden, Sandra et al., *Gender and German Cinema: Feminist Interventions*. Vol. 1, Providence / Oxford: Berg, 1993.

Gregor, Ulrich / Enno Patalas, *Geschichte des Films*. Gütersloh: Mohn, 1960.

Hake, Sabine and Katie Trumpener, *German National Cinema*. London: Routledge, 1995.

Holba, Herbert / Günter Knorr / Peter Spiegel, *Reclams deutsches Filmlexikon: Filmkünstler aus Deutschland, Österreich und der Schweiz*. Stuttgart: Reclam, 1984.

Jacobsen, Wolfgang / Anton Kaes / Hans Helmut Prinzler (eds.), *Geschichte des deutschen Films*. Stuttgart/Weimar: Metzler, 1993.

Jason, Alexander, *Der Film in Ziffern und Zahlen: Die Statistik der Lichtspielhäuser in Deutschland 1895-1925*, Berlin: Hackebeil, 1925.

Jung, Uli (ed.), *Der deutsche Film: Aspekte seiner Geschichte von den Anfängen bis zur*

Gegenwart. Trier: Wissenschaftlicher Verlag, 1993.

Lamprecht, Gerhard, *Deutsche Stummfilme 1903-1931*. 9+1 vols. Berlin: Deutsche Kinemathek, 1966-70.

Loiperdinger, Martin, 'Erhaltene Spielfilme aus der Messter-Produktion, 1909-1918,' in *KINtop 3*, 1994, pp. 209-212.

Magliozzi, Ronald S., *Treasures from the Film Archives: A Catalogue of Short Silent Fiction Films Held by FIAF Archives*, Metuchen,N.J./London: Scarecrow, 1988.

Mitry, Jean, *Histoire du Cinéma: Art et Industrie*. Vol. 1: *1895-1914*, Paris: Editions Universitaires, 1968.

Murray, Bruce A. / Christopher Wickham (eds.), *Framing the Past: The Historiography of German Cinema and Television*. Carbondale/Edwardsville: Southern Illinois University Press, 1992.

Ott, Frederick W., *The Great German Films: From Before World War I to the Present*. Secaucus: Citadel, 1986.

Prinzler, Hans Helmut, *Chronik des deutschen Films*. Stuttgart/Weimar: Metzler, 1995.

Prokop, Dieter, *Soziologie des Films*, Opladen: Luchterhand, 1970 (2nd ed. Frankfurt: Fischer, 1982)

Riess, Curt, *Das gab's nur einmal: Die große Zeit des deutschen Films*. 3 vols. Frankfurt/M. et al.: Ullstein, 1985.

Sadoul, Georges, *Histoire Géneral du Cinéma*. Vols. 2 and 3, Paris: Denoël, 1973.

Schneider, Roland, *Histoire du cinéma allemand*. Paris: Cerf, 1990.

Silberman, Marc, *German Cinema: Texts in Context*. Detroit: Wayne State University Press, 1995.

Tichy, Wolfram (ed.), *Buchers Enzyclopädie des Films*. Luzern/Frankfurt: Bucher, 1997.

Toeplitz, Jerzy, *Geschichte des Films*. Vol. 1, Berlin: Henschel, 1972.

Vincendeau, Ginette (ed.), *Encyclopedia of European Cinema*. London: BFI Publishing, 1995.

Werner, Paul, *Die Skandalchronik des deutschen Films 1: Von 1900 bis 1945*. Frankfurt: Fischer Taschenbuch Verlag, 1990.

Zglinicki, Friedrich von, *Der Weg des Films: Die Geschichte der Kinematographie und ihrer Vorläufer*, Hildesheim: Olms, 1956.

CONTEMPORARY SOURCES

Anthologies

Greve, Ludwig / Margot Pehle / Heidi Westhoff (eds.), *'Hätte ich das Kino!' Die Schriftsteller und der Stummfilm*. Munich: Kösel Verlag, 1976.

Güttinger, Fritz (ed.), *Kein Tag ohne Kino: Schriftsteller über den Stummfilm*. Frankfurt: Deutsches Filmmuseum, 1984.

Kaes, Anton (ed.), *Kino-Debatte: Texte zum Verhältnis von Literatur und Film 1909-1929*.

Tübingen/Munich: Niemeyer/Deutscher Taschenbuch Verlag, 1978.

Schweinitz, Jörg (ed.), *Prolog vor dem Film: Nachdenken über ein neues Medium 1909-1914*. Leipzig: Reclam, 1992.

Bibliographies

Birett, Herbert, 'Standortverzeichnis früher deutscher Filmzeitschriften,' *KINtop 1*, 1992, pp. 136-144.

Traub, Hans / Hanns Wilhelm Lavies (eds.), *Das deutsche Filmschrifttum: Eine Bibliographie der Bücher und Zeitschriften über das Filmwesen*. Leipzig: Hiersemann, 1940.

Periodicals

- *Bild und Film*, M.Gladbach (1912-1915).
- *Erste Internationale Filmzeitung*, Berlin (1907-1920).
- *Der Film*. Zeitschrift für die Gesamtinteressen der Kinematographie (1916-1943).
- *Filmkunst* (Eclair). Illustrierte Wochenschrift für moderne Kinematographie, Berlin (1912-1914).
- *Der Kinematograph*. Organ für die gesamte Projektionskunst, Berlin (1907-1935).
- *Kunst im Kino*. Zeitschrift für Lichtspielkunst, Berlin (1912-1913).
- *Lichtbildbühne*, Berlin (1908-1939).
- *Pathé-Woche*, Berlin (1910-1914).

Books

Adler, Wilhelm (1917), *Wie schreibe ich einen Film? Ein Lehr-und Hilfsbuch für Filmschriftsteller*. Weimar: Weimarer Schriftsteller Bund, 1917 (= Hilfsbücher für die Praxis des Schriftstellers, vol. 1), 1917.

Altenloh, Emilie, *Zur Soziologie des Kino: Die Kino-Unternehmung und die sozialen Schichten ihrer Besucher*. Jena: Diederichs, 1914 (= Schriften zur Soziologie der Kultur III; Diss. Heidelberg 1913; reprint Hamburg: Medienladen 1977).

Dannmeyer, C.H., *Bericht der Komission für 'Lebende Photographien'* (1907). Reprint, ed. by Hans-Michael Bock, Hamburg: Fläschner Druck, 1980.

Die Bedeutung des Films und Lichtbilds. Sieben Vorträge. Munich: Max Kellerer, 1917 (= 6. Flugschrift des Vereins für 'Deutsche Wacht').

Dupont, E.A., *Wie ein Film geschrieben wird und wie man ihn verwertet*. Berlin: G. Kühn, 1919. (2nd ed. 1926).

Ferdinand, Franz / Ferdinand Bielitz, *Wie werde ich Kinodarsteller? Praktische Anleitung zum Selbststudium in Original-Aufnahmen aus fertigen Filmen*. Vienna: Verlag H. Panner, 1916.

Forsten, Hans, *Wie wird man Kinoschauspielerin und Kinoschauspieler?* Leipzig: Deutscher Theaterverlag, 1918.

Frensdorff, Walter, *Kinostern*. Stuttgart: Fürstverlag, 1917.

Häfker, Hermann, *Kino und Kunst.* Munich: Volksvereinsverlag, 1913 (Lichtbühnen-Bibliothek Nr. 2).

Hellwig, Albert, *Schundfilms: Ihr Wesen, ihre Gefahren und ihre Bekämpfung.* Halle: Buchhandlung des Waisenhauses, 1911.

Hoppe, Hans, *Die Zukunft des Kinos.* Stettin: Hessenland, 1912.

Klebinder, Paul, *Der deutsche Kaiser im Film,* Berlin: Verlag P. Klebinder, 1912).

--- *Kronprinzens im Film,* Berlin: Verlag P. Klebinder, 1913.

Lange, Konrad, *Die Kunst des Kinematographen.* Korrespondenz des Dürer-Bundes, 1912.

--- *Nationale Kinoreform.* Mönchengladbach: Volksvereinsverlag, 1918.

--- *Das Kino in Gegenwart und Zukunft.* Stuttgart: Verlag von Ferdinand Enke, 1920.

Lemke, Hermann, *Die Kinematographie der Gegenwart, Vergangenheit und Zukunft.* Leipzig: E. Demme, 1910.

Liesegang, F. Paul, *Handbuch der praktischen Kinematographie.* Leipzig: Eger, 1908.

Mack, Max (ed.), *Die zappelnde Leinwand,* Berlin: Verlag von Dr Eysler & Co., 1916.

Messter, Oskar, *Special-Catalog Nr. 32 der Fa. Ed. Messter* (1898), reprint, ed. Martin Loiperdinger, Basel und Frankfurt: Stroemfeld/Roter Stern, 1994.

--- *Mein Weg mit dem Film,* Berlin: Verlag Max Hesse, 1936.

Pinthus, Kurt (ed.), *Das Kinobuch* [1913], Zurich: Arche, 1963.

Pordes, Viktor, *Das Lichtspielwesen: Dramaturgie, Regie.* Vienna: R. Lechner, 1919.

Pabst, Rudolf (ed.), *Das deutsche Lichtsspieltheater in Vergangenheit, Gegenwart und Zukunft.* Berlin: Prisma, 1926.

Schliepmann, Hans, *Lichtspieltheater: Eine Sammlung ausgeführter Kino-Häuser in Groß-Berlin.* Berlin: Ernst Wasmuth, 1914.

Sellmann, Adolf, *Der Kinematograph als Volkserzieher?* Langensalza: Hermann Beyer & Söhne, 1912.

Warncke, Hermann, *Anleitung zur Ausarbeitung von Lichtspielen für Kinotheater.* Mannheim: Selbstverlag, 1914.

Warstatt, W., *Allgemeine Aesthetik der photographischen Kunst auf psychologischer Grundlage.* Halle: Knopp, 1909.

Zimmerschied, Karl, *Die deutsche Filmindustrie: Ihre Entwicklung, Organisation und Stellung im deutschen Staats- und Wirtschaftsleben,* Erlangen, 1922.

BOOKS

Barkhausen, Hans, *Filmpropaganda in Deutschland im Ersten und Zweiten Weltkrieg,* Hildesheim: Olms, 1982.

Behn, Manfred (ed.), *Schwarzer Traum und weiße Sklavin: Deutsch-dänische Filmbeziehungen 1910-1930,* Munich: edition text & kritik, 1994.

Belach, Helga (ed.), *Henny Porten: Der erste deutsche Filmstar 1890-1960,* Berlin: Haude & Spener, 1986.

Birett, Herbert, *Lichtspiele: Der Kino in Deutschland bis 1914*, Munich: Q-Verlag, 1994.

Brennicke, Ilona, and Joe Hembus, *Klassiker des deutschen Stummfilms 1910-1930*, Munich: Goldmann, 1983.

Cherchi Usai, Paolo, and Lorenzo Codelli (eds.), *Before Caligari: German Cinema, 1895-1920*, Pordenone: Edizioni Biblioteca dell'Immagine, 1990.

Diederichs, Helmut H., *Anfänge deutscher Filmkritik*, Stuttgart: R.Fischer/Wiedleroither, 1986.

--- *Der Filmtheoretiker Herbert Tannenbaum*, Frankfurt: Deutsches Filmmuseum, 1987.

--- *Frühgeschichte deutscher Filmtheorie: Ihre Entstehung und Entwicklung bis zum Ersten Weltkrieg*, unpublished 'Habilschrift,' University of Münster, 1991.

Eisner, Lotte H., *The Haunted Screen: Expressionism in the German Cinema and the Influence of Max Reinhardt*, Berkeley: University of California Press, 1973 (originally published in French, 1952).

Güttinger, Fritz, *Köpfen Sie mal ein Ei in Zeitlupe! Streifzüge durch die Welt des Stummfilms*, Zurich: NZZ Verlag, 1992.

--- *Der Stummfilm in Zitat der Zeit*, Frankfurt: Film museum, 1984

Hake, Sabine, *The Cinema's Third Machine: Writing on Film in Germany 1907-1933*, Lincoln and London: University of Nebraska Press, 1993.

Hanisch, Michael, *Auf den Spuren der Filmgeschichte: Berliner Schauplätze*, Berlin: Henschel, 1991.

Heller, Heinz-B., *Literarische Intelligenz und Film: Zur Veränderung der ästhetischen Theorie und Praxis unter dem Eindruck des Films 1910-1930 in Deutschland*, Tübingen: Niemeyer, 1984.

Hennigsen, Wiltrud, *Die Enstehung des Kinos in Münster: Versuch einer Historiographie*, Münster: Hennigsen, 1990.

Hoffmann, Detlef, and Jens Thiele (eds.), *Lichtbilder, Lichtspiele: Anfänge der Photographie und des Kinos in Ostfriesland*, Marburg: Jonas, 1989.

Jochum, Norbert (ed.), *Das wandernde Bild: Der Filmpionier Guido Seeber*, Berlin: Stiftung Deutsche Kinemathek/Elephanten Press, 1979.

Jossé, Harald, *Die Entstehung des Tonfilms: Beitrag zu einer faktenorientierten Mediengeschichtsschreibung*, Freiburg and Munich: Alber, 1984.

Kalbus, Oskar, *Vom Werden Deutscher Filmkunst*, vol. 1: *Der stumme Film*, Altona-Bahrenfeld: Cigaretten-Bilderdienst, 1935.

Kinter, Jürgen, *Arbeiterbewegung und Film (1895-1933)*, Hamburg: Medienpädagogik-Zentrum, 1985.

KINtop: Jahrbuch zur Erforschung des frühen Films, eds. Frank Kessler, Sabine Lenk, and Martin Loiperdinger, vol. 1: *Wilhelminisches Kino*, Basel and Frankfurt: Stroemfeld/Roter Stern, 1992.

KINtop: Jahrbuch zur Erforschung des frühen Films, eds. Frank Kessler, Sabine Lenk, and Martin Loiperdinger, vol. 3: *Oskar Messter: Erfinder und Geschäftsmann*, Basel and

Frankfurt: Stroemfeld/Roter Stern, 1994.

Kosok, Lisa, and Mathilde Jamin (eds.), *Viel Vergnügen: Öffentliche Lustbarkeiten im Ruhr-gebiet der Jahrhundertwende*, Essen: Ruhrlandmuseum, 1992.

Kracauer, Siegfried, *From Caligari to Hitler: A Psychological History of the German Film*, Princeton, NJ.: Princeton University Press, 1947.

Loiperdinger, Martin (ed.), *Oskar Messter: Filmpionier der Kaiserzeit*, Basel and Frank-furt: Stroemfeld/Roter Stern, 1994 (KINtop Schriften 2).

Müller, Corinna, *Frühe deutsche Kinematographie: Formale, wirtschaftliche und kulturelle Entwicklungen 1907-1912*, Stuttgart and Weimar: Metzler, 1994.

Narath, Albert, *Oskar Messter: Der Begründer der deutschen Kino- und Filmindustrie*, Ber-lin: Deutsche Kinemathek, 1966.

Paech, Joachim, *Literatur und Film*, Stuttgart: Metzler, 1988.

Panowsky, Walter, *Die Geburt des Films: Ein Stück Kulturgeschichte*, 2nd ed., Würzburg: Triltsch, 1944.

Sannwald, Daniela (ed.), *Red for Danger, Fire, and Love: Early German Silent Films*, Ber-lin: Henschel, 1995.

Schlüpmann, Heide, *Unheimlichkeit des Blicks: Das Drama des frühen deutschen Kinos*, Basel and Frankfurt: Stroemfeld/Roter Stern, 1990.

Schwarz, Alexander, *Der geschriebene Film: Drehbücher des deutschen und russischen Stummfilms*, Munich: diskurs film, 1994.

Seidel, Renate, and Allan Hagedorff (eds.), *Asta Nielsen: Ihr Leben in Fotodokumenten, Selbstzeugnissen und zetgenössischen Betrachtungen*, Berlin: Henschel, 1981.

Warstat, Dieter Helmut, *Frühes Kino in der Kleinstadt* [Eckernförde], Berlin: Spiess, 1982.

Zglinicki, Friedrich von, *Die Wiege der Traumfabrik: Von Guckkästen, Zauberscheiben und bewegten Bildern bis zur Ufa in Berlin*, Berlin: Transit, 1986.

ARTICLES AND CHAPTERS IN JOURNALS AND (MULTI-AUTHOR) BOOKS

Bergstrom, Janet, 'Asta Nielsen's Early German Films,' in *Before Caligari*, pp. 162-185.

Birett, Herbert, 'The Origins of Official Film Censorship in Germany,' in *Before Caligari*, pp. 50-57.

Convents, Guido, 'Film and German Colonial Propaganda for the Black African Territories to 1918,' in *Before Caligari*, pp. 58-77.

Curry, Ramona, 'How Early German Film Stars Helped to Sell the War(es),' in *Film and the First World War*, ed. Karel Dibbets and Bert Hogenkamp, Amsterdam: Amsterdam Uni-versity Press, 1995, pp. 139-148.

Curtis, Scott, 'The Taste of a Nation: Training the Senses and Sensebility of Cinema Audi-ences in Imperial Germany,' *Film History 6, 1994*, pp. 445-469.

Dagrada, Elena, 'A Fly, Two Films and Three Queries: *Eine Fliegenjagd oder Die Rache der Frau Schultze* by Max and Eugen Skladanowsky,' in *Before Caligari*, pp. 424-437.

Diederichs, Helmut H., 'Die Anfänge deutscher Filmpublizistik 1895 bis 1909. Die Filmberichterstattung der Schaustellerzeitschrift "Der Komet" und die Gründung der Filmfachzeitschriften,' *Publizistik* 1, 1985, pp. 55-71.

--- 'The Origins of the "Autorenfilm",' in *Before Caligari*, pp. 380-401.

Elsaesser, Thomas, 'National Subjects, International Style: Navigating Early German Cinema,' in *Before Caligari*, pp. 338-355.

--- Filmgeschichte, Firmengeschichte, Familiengeschichte: Der Übergang vom Wilhelminischen Kino zum Weimarer Film,' *Joe May: Regisseur und Produzent*, ed. Hans-Michael Bock and Clauia Lenssen, Munich: edition text & kritik, 1991, pp. 11-30.

--- 'Early German Cinema: Audiences, Style and Paradigms,' *Screen*, vol. 33, no. 2, Summer 1992, pp. 205-214.

Engberg, Marguerite, 'The Influence of Danish Cinema on German Film 1910-1920,' *Griffithiana*, no. 38/39, October 1990, pp. 127-133.

Fischli, Bruno, 'Das Goldene Zeitalter der Kölner Kinematographie (1896-1918),' in *Vom Sehen im Dunkeln: Kinogeschichten einer Stadt*, ed. Fischli, Cologne: Prometh, 1990, pp. 7-38.

Göktürk, Deniz, 'How Modern is it? Moving Images of America in Early German Cinema,' in *Hollywood and Europe: Experiences of a Cultural Hegemony*, ed. David W. Ellwood and Rob Kroes, Amsterdam: VU University Press, 1994, pp. 44-67.

--- 'Market Globalization and Import Regulation in Imperial Germany,' in *Film and the First World War*, pp. 188-197.

Hansen, Miriam, 'Early Cinema – Whose Public Sphere?' In *Early Cinema: Space, Frame, Narrative: Space, Frame, Narrative*, ed. Thomas Elsaesser with Adam Barker, London: BFI Publishing, 1990, pp. 228-246.

Herbst, Helmut, 'The "Altmeister." Guido Seeber, 1879-1940: Film Pioneer, Cameraman, Technician and Publicist,' in *Before Caligari*, pp. 264-291.

Horak, Jan-Christopher, 'Laughing until it Hurts: German Film Comedy and Karl Valentin,' in *Before Caligari*, pp. 202-229.

--- 'Oskar Messter: Forgotten Pioneer of German Cinema,' *Historical Journal of Film, Radio and Television*, vol. 15, no. 4, October 1995, pp. 569-574.

Hunt, Leon, '*The Student of Prague*: Division and Codification of Space,' in *Early Cinema*, pp. 389-402.

Jacobsen, Wolfgang, 'The Flying Producer: Notes on Erich Pommer,' in *Before Caligari*, pp. 186-201.

--- 'Frühgeschichte des deutschen Films: Licht am Ende des Tunnels,' in *Geschichte des deutschen Films*, pp. 13-38.

Jansen, Wolfgang, 'Kino und Varieté,' in Jansen, *Das Varieté: Die glanzvolle Gschichte einer unterhaltenden Kunst*, Berlin: Edition Hentrich, 1990, pp. 145-154.

Jung, Uli / Walter Schatzberg, 'Robert Wiene's Film Career before *caligari*,' in *Before Caligari*, pp. 292-311.

Kaes, Anton, 'Mass Culture and Modernity: Notes Toward a Social History of Early American and German Cinema,' in *America and the Germans: An Assessment of a Three-Hundred-Year History*, eds. Frank Trommler and Joseph McVeigh, vol. 2, Philadelphia: University of Pennsylvania Press, 1985, pp. 317-331.

--- 'The Debate about Cinema: Charting a Controversy (1909-1929),' *New German Critique* 40, Winter 1987, pp. 7-34.

Kahlenberg, Friedrich P., '*Der geheimnisvolle Klub* and *Auf einsamer Insel*: Two German Feature Films Made by Eiko-Film in 1913,' in *Before Caligari*, 326-337.

Kessler, Frank, 'A Highway to Film Art?' In *Before Caligari*, pp. 438-451.

--- 'Le portrait-repère: l'actrice et le modèle,' *Iris*, no. 14/15, 1992, pp. 99-106.

--- 'Le théâtre dans les cinémas allemands des années 10,' *Conférences du Collège d'Histoire de l'Art Cinématographique*, no. 3, 1992-93.

Koebner, Thomas, 'Der Film als neue Kunst – Reaktionen der literarischen Intelligenz: Zur Theorie des Stummfilms (1911-1924),' in *Literaturwissenschaft-Medienwissenschaft*, Heidelberg: Quelle & Meyer, 1977, pp. 1-31.

Lichtenstein, Manfred, 'The Brothers Skladanowsky,' in *Before Caligari*, pp. 312-325.

Loiperdinger, Martin, 'Ludwig Stollwerk, Birt Acres, and the Distribution of the Cinématograph Lumière in Germany,' in *Cinéma sans frontières/Images Across Borders, 1896-1918*, eds. Roland Cosandey and François Albera, Lausanne/Québec: Editions Payot/Nuit Blanche Editeur, 1995, pp. 167-177.

Martinelli, Vittorio, 'Kino-Lieblinge,' *Griffithiana*, no. 38/39, October 1990, pp. 9-72.

Müller, Corinna, 'Emergence of the Feature Film in Germany between 1910 and 1911,' in *Before Caligari*, pp. 94-113.

Paech, Anne, 'Wie das Kino in die Provinz kam 1897-1918,' in Paech, *Kino zwischen Stadt und Land. Geschichte des Kinos in der Provinz: Osnabrück*, Marburg: Jonas, 1985, pp. 11-44.

Pehla, Karen, 'Joe May und seine Detektive: Der Serienfilm als Kinoerlebnis,' in *Joe May*, pp. 61-72.

Rother, Rainer, '*Bei unseren Helden an der Somme* (1917): The Creation of a "Social Event",' *Historical Journal of Film, Radio and Television*, vol. 15, no. 4, October 1995, pp. 525-542.

Quaresima, Leonardo, '"Dichter heraus!": The Autorenfilm and German Cinema of the 1910's,' *Griffithiana*, vol. 13, no. 38/39, October 1990, pp. 101-126.

--- 'L'*Autorenfilm* allemand: Un cinéma produit par des sociétés étrangères (1913-1915),' in *Cinéma sans frontières/Images Across Borders, 1896-1918*, pp. 237-248.

Salt, Barry, 'From German Stage to German Screen,' in *Before Caligari*, 402-423.

Schlüpmann, Heide, 'Kinosucht,' *Frauen und Film*, no. 33, October 1982, pp. 45-52.

--- 'The first German Art Film: Rye's *Der Student von Prag*,' in *German Film and Literature: Adaptations and Transformations*, ed. Eric Rentschler, New York and London: Methuen, 1986, pp. 9-24.

--- 'The Sinister Gaze: Three Films by Franz Hofer from 1913,' in *Before Caligari*, pp. 452-479.

--- 'Wahrheit und Lüge im Zeitalter der technischen Reproduzierbarkeit: Detektiv und Heroine bei Joe May,' in *Joe May*, pp. 45-60.

--- 'Early German Cinema – Melodrama: Social Drama,' in *Popular European Cinema*, eds. Richard Dyer and Ginette Vincendeau, London/New York: Routledge, 1992, pp. 206-219.

--- 'Cinema as Anti-Theater: Actresses and Female Audiences in Wilhelminian Germany,' *Iris*, no. 11, Summer 1990, pp. 77-93.

--- 'Cinematographic Enlightenment versus 'The Public Sphere': A Year in Wilhelminian Cinema,'*Griffithiana*, no. 50, March 1994, pp. 75-85.

--- '"Quo vadis cinéma?" Le rôle du film italien dans l'Allemagne du Guillaume II,' in *Cinéma sans frontières/Images Across Borders, 1896-1918*, pp. 329-339.

Simeon, Ennio, 'Music in German Cinema before 1918,' in *Before Caligari*, pp. 78-93.

Smith, Bradford, 'On the Opposite Shore: Max Reinhardt and Film, 1910-1914,' in *Before Caligari*, pp. 114-137.

Stark, Gary D., 'Cinema, Society and the State: Policing the Film Industry in Imperial Germany,' in *Essays on Culture and Society in Modern Germany*, eds. Stark and Bede Karl Lackner, Arlington/Texas: Texas A&M University Press, 1982, pp. 122- 166.

Thompson, Kristin, '"Im Anfang war...": Some Links between German Fantasy Films of the Teens and the Twenties,' in *Before Caligari*, pp. 138-161.

Uricchio, William, 'The "Kulturfilm": A Brief History of an Early Discursive Practice,' in *Before Caligari*, pp. 356-379.

Publication Acknowledgements

Martin Loiperdinger, 'Das frühe Kino der Kaiserzeit: Problemaufriß und Forschungsperspektiven,' published in Uli Jung (ed.), *Der deutsche Film: Aspekte seiner Geschichte von den Anfängen bis zur Gegenwart*, Trier: Wissenschaftlicher Verlag, 1993 (= Filmgeschichte international 1), pp. 21-46. Reprinted in translation in a shortened version by permission of the author and the publisher.

Martin Koerber, 'Oskar Messter - Stationen einer Karriere,' published in Martin Loiperdinger (ed.), *Oskar Messter - Filmpionier der Kaiserzeit*, Basel and Frankfurt: Stoemfeld/Roter Stern, 1994 (= KINtop Schriften 2), pp. 27-91. Reprinted in translation in a shortened version by permission of the author and the publisher.

Sabine Lenk and Frank Kessler, 'The French Connection: Franco-German Film Relations before World War I,' will appear in German in Sibylle Sturm (ed.), *Allo Berlin, ici Paris: Deutsch-französische Filmbeziehungen der zwanziger und dreißiger Jahre*, Munich: edition text & kritik, 1996. Printed in English by permission of the authors and the publisher.

Evelyn Hampicke, 'Vom Aufbau eines vertikalen Konzerns: Zu David Olivers Geschäften in der deutschen Filmindustrie,' in Manfred Behn (ed.), *Schwarzer Traum und Weiße Sklavin: Deutsch-dänische Filmbeziehungen 1910-1930*, Munich: edition text & kritik, 1994, pp. 22-29. Reprinted in translation by permission of the author and the publisher.

Peter Lähn, 'Die PAGU: Ein Filmunternehmen aus Frankfurt,' published in *Lebende Bilder einer Stadt: Kino und Film in Frankfurt am Main*, Frankfurt: Deutsches Filmmuseum, 1995, pp. 52-59. Reprinted in translation by permission of the author and the publisher.

Jan-Christopher Horak, 'Munich's First Feature Film: DIE WAHRHEIT.' Orginal contribution.

Deniz Göktürk, 'Neckar-Western statt Donau Walzer: Der Geschmack von Freiheit und Abenteuer im frühen Kino,' *KINtop 2*, Basel and Frankfurt: Stroemfeld/Roter Stern, 1993, pp. 117-142. Reprinted in translation in a shortened version by permission of the author.

Thomas Brandlmeier, 'Early German Film Comedy, 1895-1917.' Original contribution.

Karsten Witte, 'The Spectator as Accomplice in Ernst Lubitsch's SCHUHPALAST PINKUS' was first given as a talk at the *Early Cinema: Space, Frame, Narrative Conference*, University of East Anglia, Norwich, 1983.

Heide Schlüpmann, 'Ohne Worte: Asta Nielsen als Erzählerin im Kinodrama,' published in Manfred Behn (ed.), *Schwarzer Traum und Weiße Sklavin: Deutsch-dänische Filmbeziehungen 1910-1930*, Munich: edition text & kritik, 1994, pp. 125-135. Reprinted in translation in an abridged version by permission of the author and publisher.

Michael Wedel, 'Melodrama and Narrative Space: Franz Hofer's HEIDENRÖSLEIN.' Original contribution.

Tilo Knops, 'Cinema from the Writing Desk: Detective Films in Imperial Germany.' Original contribution.

Sebastian Hesse, 'Ernst Reicher alias Stuart Webbs: König der deutschen Film-Detektive,'

published in *KINtop 2*, Basel and Frankfurt: Stroemfeld/Roter Stern, 1993, pp. 143-162. Reprinted in translation in an abridged version by permission of the author and the publisher.

Casper Tybjerg, 'The Faces of Stellan Rye.' Original contribution.

Leonardo Quaresima, 'HOMUNCULUS: A Project for a Modern Cinema.' Original contribution.

Jeanpaul Goergen, 'Julius Pinschewer: Künstler und Kaufmann, Pionier des Werbefilms,' in *epd-Film*, 3, 1992, pp. 16-22. Reprinted in translation in a version revised by the author and by permission of the publisher.

Wolfgang Mühl-Benninghaus, 'Newsreel Images of the Military and War, 1914-1918.' Original contribution.

Rainer Rother, 'Learning From the Enemy: German Film Propaganda in World War I.' Original contribution.

Kimberly O'Quinn, 'The Reason and Magic of Steel: Industrial and Urban Discourses in DIE POLDIHÜTTE.' Original contribution.

Michael Wedel, 'Max Mack: The Invisible Author.' Original contribution.

Jürgen Kasten, 'From Peripetia to Plot Point: Heinrich Lautensack and ZWEIMAL GELEBT.' Original contribution.

Ennio Simeon, 'Giuseppe Becces Musik für RICHARD WAGNER: Paradoxien der ersten deutschen Filmpartitur,' published in *KINtop 3*, Basel and Frankfurt: Stroemfeld/Roter Stern, 1994, pp. 65-71. Reprinted in translation by permission of the author and the publisher.

Barry Salt, 'Early German Film: The Stylistics in Comparative Perspective.' Original contribution.

Sabine Hake, 'Self-Referentiality in Early German Cinema,' published in *Cinema Journal*, vo. 31, no. 3, Spring 1992, pp. 37-55. Reprinted in an abrigded version by permission of the author and publisher.

Ivo Blom, 'Of Artists and Tourists: "Locating" Holland in Two German Films.' Original contribution.

Kristin Thompson, 'Stylistic Expressivity in DIE LANDSTRASSE.' Original contribution.

Yuri Tsivian, 'Two "Stylists" of the Teens: Franz Hofer and Yevgeni Bauer.' Original contribution.

Elena Dagrada, 'Franz Hofer: un magico guardone alla corte di Gugliemo II,' published in: *Immagine* (nuove serie), no. 17, 1991, pp. 23-30. Reprinted in translation by permission of the author and the publisher.

Photo Credits

Bundesarchiv/Filmarchiv, Berlin (7), Deutches Institut für Filmkunde (2), Thomas Elaesser (4), Freunde der deutschen Kinemathek, Berlin (2), Jeanpaul Goergen (2), Müncher Filmmuseum (5), Nederlands Filmmuseum, Amsterdam (18), Barry Salt (3),Stiftung deutsche Kinemathek (1), Kristin Thompson (10), Yuri Tsivian (16), Michael Wedel (12), Zuiderzee Museum, Enkhuizen (1).

The Contributors

Ivo Blom is completing a Ph.D. in the Department of Film and Television Studies at the University of Amsterdam. Formerly an archivist and restorer at the Netherlands Filmmuseum he is the co-editor of *De vroege Italiaanse film: hartstocht en heldendom* (1988) and has published on early cinema in *IRIS, KINtop, Jaarboek Media Geschiedenis, Cinémathèque* and *1895*.

Thomas Brandlmeier is a Munich-based freelance author who has lectured on film at various Universities in Germany. He is the author of *Filmkomiker: Die Errettung des Grotesken* (1983) and several other books. His articles on comedy, melodrama, film noir and German cinema have appeared in numerous journals and anthologies.

Elena Dagrada teaches film at the University of Bordeaux. She has written her Ph.D. on *The Representation of the Look in Early European Cinema, 1895-1908* (2 vols., 1987-88) and has edited DOMITOR's *International Bibliography on Early Cinema* (2nd ed., 1995).

Jeanpaul Goergen is a Berlin-based film historian and freelance author. His numerous publications on German cinema and the visual arts of the twenties include *Walter Ruttmann: Eine Dokumentation* (1989) and, as editor, *George Grosz: Die Filmhälfte der Kunst* (1994) as well as *Urlaute dadaistischer Poesie* (1994).

Deniz Göktürk teaches film and German Cultural Studies at the University of Southampton, England. She received her Ph.D. from the Free University Berlin with a thesis on *Künstler, Cowboys, Ingenieure: Kultur- und mediengeschichtliche Studien zu deutschen Amerika-Texten 1912-1920* (1995).

Sabine Hake is Professor of Germanic Languages and Literatures at the University of Pittsburgh. She has published *Passions and Deceptions: The Early Films of Ernst Lubitsch* (1992) and *The Cinema's Third Machine: Writing on Film in Germany, 1907-1933* (1993).

Evelyn Hampicke works at the Bundesarchiv/Filmarchiv in Berlin and is member of Cine-Graph-Babelsberg. She is currently working on a project *Jewish Life in German Film before 1933*. Her articles on early German cinema have appeared in *CineGraph, KINtop* and *diskurs film*.

Sebastian Hesse is a sound radio editor at the Süddeutscher Rundfunk in Mannheim and a freelance author. He is currently completing a Ph.D. on the early German criminal and detective film and has published in *CineGraph* and *KINtop*.

Jan-Christopher Horak is the Director of the Munich Filmmuseum whose book publications include *Anti-Nazi-Filme der deutschsprachigen Emigration in Hollywwod* (1985), *Fluchtpunkt Hollywood* (2nd. ed., 1986), *The Dream Merchants: Making and Selling Films in Hollywood's Golden Age* (1989), and *Lovers of Cinema: The First American Film Avant-Garde* (1995).

Jürgen Kasten teaches film at the Free University Berlin and at the Humboldt Universität Berlin. He is Chair of the Association of German Scriptwriters and has authored *Der expressionistische Film* (1989), *Film Schreiben: Eine Geschichte des Drehbuches* (1990), as well as *Carl Mayer: Filmpoet* (1994).

Frank Kessler is Assistant Professor at the Katholieke Universiteit Nijmegen and is one of the editors and frequent contributors of *KINtop: Jahrbuch zur Erforschung des frühen Films* (since 1992). He has published widely on early cinema in journals and anthologies, such as *Iris*, *Cinémathèque* and *montage a/v*.

Tilo Knops is honorary Professor at the University of Hamburg and a freelance author for NDR television. He has published *Die Aufmerksamkeit des Blicks* (1986) and *Studienführer für Medienberufe* (1995) and is currently preparing two books: *Der Konstitutionsprozess der Filmkultur in Deutschland* (as author) and *Hollywoods populärkultureller Appeal: Filmhistorische Revisionen* (as editor).

Martin Koerber is an archivist and freelance writer who is currently in charge of a restoration project concerned with the films of Oskar Messter. Since 1996 he is also responsible for the Berlin Film Festival's annual retrospectives.

Peter Lähn is a Frankfurt-based film historian and freelance author who is currently completing a Ph.D. about architectural design in German silent film.

Sabine Lenk works at the Belgian Filmmuseum in Brussels, after completing a Ph.D. for the University of Erlangen on the relations of early film and theatre in France. She is the author of *Théâtre contre Cinéma* (1989) and one of the editors of *KINtop: Jahrbuch zur Erforschung des frühen Films*.

Martin Loiperdinger is Deputy Director of the Deutsches Film Institut in Frankfurt and is one of the editors of *KINtop: Jahrbuch zur Erforschung des frühen Films*. His publications as author include *Rituale der Mobilmachung* (1987) and *Film und Schokolade* (1996), and, as editor, *Märtyrerlegenden im NS-Film* (1991). He has also made a number of documentary films on film historical subjects, including films on Lumière and Messter.

Wolfgang Mühl-Benninghaus is Professor for Film- and Theatre Studies at the Humboldt Universität Berlin. He has published numerous articles on legal and institutional aspects of Germany's media history in anthologies and journals, including *CineGraph* and *KINtop*.

Kimberly O'Quinn is currently completing a master's degree in Film- and Television Studies at the University of Amsterdam. She has been working the last five years as a location manager for feature films and television in the United States.

Leonardo Quaresima is Professor for Film at the University of Bologna. He is the author of *Leni Riefenstahl* (1985) and *Cinema e teatro in Germania* (1990) and the editor of *Walter Ruttmann: Cinema, Pittura, Ars Acustica* (1994).

Rainer Rother is Head of the Film Department at the Deutsches Historisches Museum, Berlin. He is the author of *Die Gegenwart der Geschichte: Ein Versuch über Film und Literatur* (1990) and has edited *Bilder schreiben Geschichte: Der Historiker im Kino* (1991), *Die Ufa 1917-1945* (1992) and *Die letzten Tage der Menschheit: Bilder des Ersten Weltkrieges* (1994).

Barry Salt is a trained physicist and dancer. An internationally known film historian, he is the author of *Film Style & Technology: History & Analysis* (2nd ed., 1992).

Heide Schlüpmann is Professor for Film at the Johann Wolfgang Goethe Universität Frankfurt whose books include *Friedrich Nietzsches ästhetische Opposition* (1977) and *Unheimlichkeit des Blicks: Das Drama des frühen deutschen Kinos* (1990). She is also one of the editors of the feminist film journal *Frauen und Film*.

Ennio Simeon teaches history and aesthetics of music at the Conservatory 'Claudio Monteverdi' in Bolzano and film at the University of Trento (Northern Italy). He also works as a freelance author, publishing widely on music and early cinema.

Kristin Thompson is an honorary fellow in the Department of Communication Arts at the University of Wisconsin-Madison. With David Bordwell she has published *Film Art: An Introduction* (1979ff) and *Film History: An Introduction* (1994), and with Bordwell and Janet Staiger, *The Classical Hollywood Cinema: Film Style and Mode of Production to 1960* (1985). Her other books include *Eisenstein's IVAN THE TERRIBLE* (1981) and *Breaking*

the Glass Armor: Neoformalist Film Analysis (1988). She is currently at work on a history of European avant-garde film styles of the twenties.

Yuri Tsivian is a film historian, semiotician, and researcher in Riga. A Visiting Professor at the University of Southern California, his books include *Silent Witnesses: Russian Films 1908-1917* (1989) and *Early Cinema in Russia and its Cultural Reception* (1994).

Casper Tybjerg is completing a Ph.D. on the history of the Danish silent cinema at the University of Copenhagen. Among his publications is an essay on Benjamin Christensen's German career.

Michael Wedel is a graduate of the University of Amsterdam currently completing his Ph.D. entitled 'The Early Cinema of Max Mack : Narrative, Authorship, Intertextuality.' He is also one of the main contributors to the *Encyclopedia of European Cinema* (1995) and reviews for *Medienwissenschaft, Film und Fernsehen* and *Iris*.

Karsten Witte was Professor for Film Studies at the Free University Berlin and the editor of the writings of Siegfried Kracauer. His books include *Theorie des Kinos* (editor, 1979), *Der Passagier-Das Passagere: Gedanken über Filmarbeit* (1988) and *Lachende Erben, toller Tag: Filmkomödie im Dritten Reich* (1995). Karsten Witte died in 1995.

The Editor

Thomas Elsaesser is Professor at the University of Amsterdam, and Chair of the Department of Film and TV Studies. His books as author and editor include *New German Cinema: A History* (1989), *Early Cinema: Space Frame Narrative* (1990), *Writing for the Medium: Television in Transition* (1994), *Double Trouble* (1994), *Hoogste Tijd voor een speelfilm* (1995) and *Fassbinder's Germany* (1996).